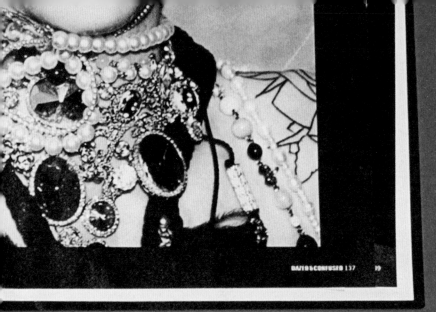

DAZED&CONFUSED 137 19

&CO

FACE TO FACE INTERVIEWS WITH
LENNOX LEWIS
BILL VIOLA
TONY WARD
EXCLUSIVE
BILLY BRAGG
MEETS
ELVIS COSTE
Chl
STAR
Lan
ON M
+ SPA

9 770

DON'T TH
£2.50
ISSN 09

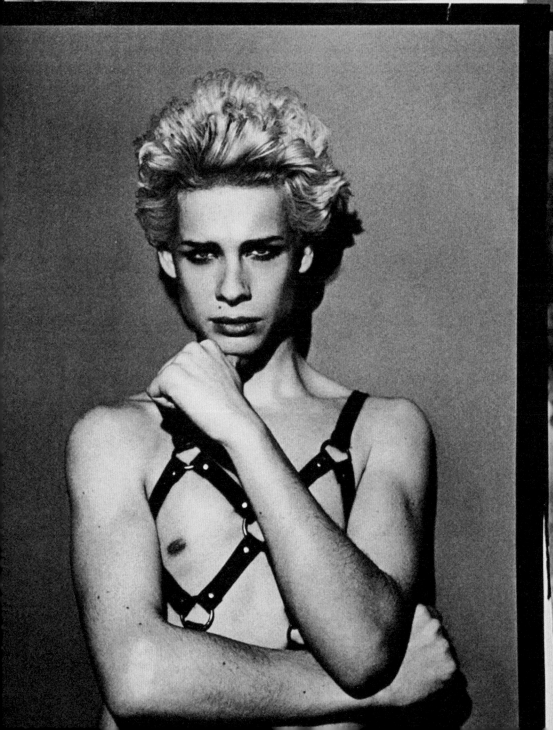

DAZED &CONFUSED

MAKING IT UP AS WE GO ALONG

A Visual History Of The Magazine That Broke All The Rules
Edited By Jefferson Hack And Jo-Ann Furniss
Foreword By Ingrid Sischy

RIZZOLI
NEW YORK

New York · Paris · London · Milan

First published in the United
States of America in 2011
by Rizzoli International
Publications, Inc.
300 Park Avenue South
New York, NY 10010
RIZZOLIUSA.COM

2011 2012 2013 2014 /
10 9 8 7 6 5 4 3 2 1

ISBN-13: 978-0-8478-3692-5

Library of Congress Control
Number: 2011933462

Printed in Hong Kong

"*Dazed & Confused* is a burgeoning style mag staffed by youths who are prone to talking absolute shit. If that sounds harsh then maybe I'm just too old, but this bunch make you want to subscribe to *The Spectator*."

TIME OUT

FOREWORD

As I remember it, Rankin greeted me from behind a video camera that was rolling and Jefferson Hack was pimped out in a skinny suit when we first met, almost twenty years ago in New York City, in the lobby of *Interview*, where I was then working as the editor-in-chief. As newcomers to the world of indie magazines, they'd popped in to the office to introduce themselves and were recording our hello. A suite of Andy Warhol's colourful Mao prints were silently observing us from their positions on the walls.

I don't know how Mao felt, but to me these two seemed like magazine naturals, right from the start. They were already living and breathing it, which is what it takes. I also got a bang out of the name of their new publication, *Dazed & Confused*, which nailed the mood of the zeitgeist so cleverly, especially in post-Thatcher Britain, where they were based. Lots of people start new magazines claiming to be the voice of a new generation, a new era, a new style, a new art movement, a new sexual freedom, a new something or other, but usually it's all talk – empty, copycat stuff. Pity the trees. The only reason to start a magazine is if there's a void, where there are words and images stirring to be seen and heard. It was clear that Hack, the editor, and Rankin, the photographer, had jumped into the void with *Dazed & Confused*.

Twenty years later the magazine that they co-founded and own together is still alive and well, and still independent. While new generations have stepped into the shoes that the original posse once wore, *Dazed & Confused* is still "Rankin's and Hack's first-born." (Although Rankin has spread his wings wide, he continues to photograph for the magazine. Hack now serves as the magazine's editorial director; ten years ago he added an additional publication to his beat when he created *AnOther Magazine*.) The title they chose for this anniversary book says it all: "Making It Up As We Go Along." With their fellow travellers they approached the magazine the way artists come at things, with an openness and an instinct about the importance of experimenting, making mistakes, and even failing. No wonder so many of the painters, sculptors, photographers, and filmmakers who were creating a veritable explosion in British art at the time came on board. But it wasn't and isn't an art magazine, or a fashion magazine, or a film magazine, or a music magazine, or a culture magazine – at its best it's a petri dish where it all cooks together. A far cry from that old Hollywood classic about publishing, aptly named *His Girl Friday*. Just don't ask me which of them could have played the Rosalind Russell character, and which one could pull off Cary Grant.

INGRID SISCHY

MAKING IT UP AS WE GO ALONG
The Conceptual Genesis Of Dazed & Confused

It's doubtful that when an 18-year-old Jefferson Hack answered a call from a 23-year-old photographer to meet in a student canteen and discuss launching a magazine he thought it would significantly change his life. But there must have been something that struck him in that fateful meeting with Rankin, because within months he had dropped out of college to work on the project full-time, and neither of them ever looked back. Given its unparalleled influence in the worlds of fashion, art and music it seems strange to consider that the internationally renowned style and culture magazine *Dazed & Confused* began its illustrious life as a fold-out zine funded by weekly club nights famed for their hedonism. But in its fledgling incarnation it was a fiercely independent, anti-establishment and often shocking do-it-yourself publication that garnered the kind of love-them-or loathe-them media attention that had not been seen since the rise of The Sex Pistols – a fact perhaps unsurprising given that both Hack and Rankin cite Malcolm McClaren as their preferred manager had the title been a rock'n'roll band.

Rankin will always cite a degree of right place/right time when he talks about those early days because the world was changing – culture was fragmenting and London was the vibrant centre of the storm. And it's certainly true that there was a synchronicity between the upstart outsider aesthetic of the *Interview*-inspired *Dazed & Confused* and the in-your-face YBA movement, the barricade-storming actors at the vanguard of a burgeoning British film industry and, of course, the Britpop explosion. But it's not quite as simple as that. The real thing that drove the success of the publication was dedication, hard work and – as you will find in the coming pages – a fervent belief in the people involved and the power of instinct; the power of doing it exactly the way you want to do it come hell or high water… and hell and high water came. On more than one occasion the magazine was removed from stockists for its situationist-inspired in-jokes – such as publishing the work of the entirely fake self-mutilating artist Bruce Louden, and scrawling *'If You Can't Buy It, Steal it'* over the barcode – and its profoundly challenging fashion famously refused to kowtow to advertisers, setting a new bar with stories such as *Fashion-Able*, in which Alexander McQueen, Nick Knight and Katy England presented people with severe physical disabilities in the glamour-tinged firmament of the high-end fashion shoot.

In fact, what the gang of club-kids that came together to create *Dazed & Confused* gave birth to was a unique academy that has borne some of the most renowned and talented stylists, photographers and editors of our age – people whose instinctive ideas have shaped the visual culture that we live within today. And it's precisely an unflinching belief in those intuitive ideas that is at the beating heart of *Dazed & Confused*, the kind of belief – as any of its ever-growing mycelial web of international contributors will tell you – that can only come from a gang, or indeed a family that allows every member to do their own thing. And why is that freedom so important? Well, another world-renowned gang called The Rolling

Stones perhaps put that best in 1966 when they penned the track "Who's Driving Your Plane?", because when all is said and done, it had better be you in the pilot's seat. In the following interview, the two founders of the magazine come together to discuss how *Dazed & Confused* has resolutely steered it's own high-flying course for the past two decades, and why if you stand for nothing, you'll fall for anything.

RANKIN: We haven't done an interview together for ages, have we?

JEFFERSON: It's been about 14 years, probably.

RANKIN: … Wow.

JEFFERSON: Can you remember when we first met in the canteen at the London College of Printing? You had already done three years of photography and were recruiting for the student magazine.

RANKIN: *(Laughs)* Yeah. I actually remember the first day I walked into college – which was a little bit before you – and being given a magazine at the front door. I was like: 'This is *amazing*!' They'd produced it in college – I just couldn't believe you could do that.

JEFFERSON: I remember you coming into one of the journalism lessons and saying, 'If any of you guys are interested in joining the student magazine, come to the canteen on Wednesday afternoon.' I came and it was just you and me there – you said to me: 'Do you know much about journalism?' I was like, 'Not really, no…' Then you said: 'Well, you're interviewing Gilbert & George, and I'm taking the pictures.'

RANKIN: There was another guy who was sort of the editor wasn't there, a political activist guy… but we kind of took it over.

JEFFERSON: Well, I did all the interviews and you did all the photos, so that was sort of it. Then I commissioned a few things… we were really cutting our teeth in journalism and portraiture. I think the fourth issue won a Guardian Media Award for photography and

design, and it was like, 'Wow, we can do this…'

RANKIN: I think our crossover point was that we both really loved *Interview* magazine, and we figured, 'Well, if they can do that, then why can't we do *this*?' That was despite the fact we were working a on a hulking great Apple Mac and had to scroll down to look at the different elements on a page! It was very funny.

JEFFERSON: It was pre-desktop publishing. You could never get a full page…

RANKIN: Yeah, you couldn't see it.

JEFFERSON: We were still working on one of those when we left college, weren't we? I think the first seven issues of *Dazed* were put together on a black-and-white screen. *(Laughs)* I can still distinctly remember you saying to me, 'Do you want to stay at college and like, finish your course, or do you want to be the editor of a national magazine at the age of 19?' I was like, '*Woah…*' That really got me thinking. I think there was about a year between issue one and issue two coming out though. We had made this fold-out poster magazine as the first one, and once it went out there we were like, '*Okaaay*, now what do we do? How do we make the next issue?'

RANKIN: We were hungry to keep on publishing but had no *real* idea how to do it – how to get the money and so on.

JEFFERSON: Yeah, the first issue came about through me ringing every single marketing director that I could get the number of and asking them if they would sponsor the project. When we actually got some interest, we drove up to see them in your Ford Fiesta, with the wheel falling off!

RANKIN: *(Laughs)* Was it a Ford Fiesta? No. It was an Escort! That car literally wouldn't start. Do you remember bump-starting it outside the meeting? We nearly didn't get there in time because I had oil all over my hands.

JEFFERSON: *(Laughs)* We definitely looked like chancers. They gave us

ISSUE 1 £1.50
NEW! NEW! NEW! NEW! NEW!

EDITORIAL

This is not a magazine. This is not a conspiracy to force opinion into the subconscious of stylish young people. A synthetic leisure culture is developing - plastic people force fed on canned entertainment and designer food. Are you ready to be Dazed & Confused? **Get high on oxygen! This is urban ideas for creative people. People who want to read - something else.**

BLACK BUSH

WILLIAM BURROUGHS
JOHN GODBER
TOMMY COOPER
ASTRODOLL
AUDIO 1
MIRAGE
SUBGENIUS
HEROES
ZAP ART

URBAN IDEAS FOR CREATIVE PEOPLE

This issue of Dazed & Confused is sponsored by Black Bush Irish whiskey

CONTRIBUTE CONTRIBUTE CONTRIBUTE CONTRIBUTE CONTRIBUTE CONTRIBUTE

WILD ABOUT VIDEO

Dazed & Confused is looking for talented new directors/video & film makers to contribute. We would like to feature stills and highlight the work of innovators in these fields. All work will be returned. Thank you.

Don't hesitate to contribute to *Dazed & Confused*. This is an open access magazine - for your ideas and your hopes. Please send written details, photographs, illustrations and videos etc to: The editorial team, *Dazed & Confused*, Top Floor, 52 Bermondsey Street, London SE1 3DU.

CONTRIBUTE CONTRIBUTE

Photo: Mexican Tourists in London; Nickole Moss-Philips at Old Time Photographs, Basement, Trocadero, Piccadilly Circus.

"We arrived on Friday and will stay here until next Sunday. Then we're onto Czechoslovakia, Germany and then back home to Mexico. We've been to Windsor Palace, Camden Town and the shopping is great."

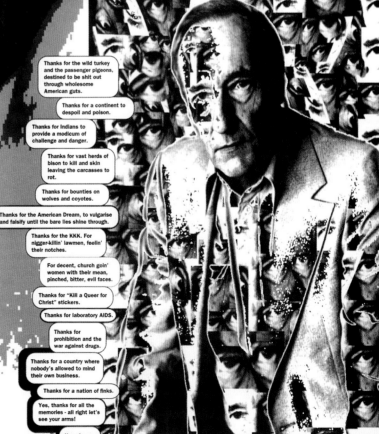

Thanks for the wild turkey and the passenger pigeons, destined to be shit out through wholesome American guts.

Thanks for a continent to despoil and poison.

Thanks for Indians to provide a modicum of challenge and danger.

Thanks for vast herds of bison to kill and skin leaving the carcasses to rot.

Thanks for bounties on wolves and coyotes.

Thanks for the American Dream, to vulgarise and falsify until the bare lies shine through.

Thanks for the KKK. For nigger-killin' lawmen, feelin' their notches.

For decent, church goin' women with their mean, pinched, bitter, evil faces.

Thanks for "Kill a Queer for Christ" stickers.

Thanks for laboratory AIDS.

Thanks for prohibition and the war against drugs.

Thanks for a country where nobody's allowed to mind their own business.

Thanks for a nation of finks.

Yes, thanks for all the memories - all right let's see your arms!

You always were a headache

three grand to sponsor the first issue but we couldn't really see how to get issue two in print. We were waiting for another sponsor to come along but there was no one else, so we did the *Blow Up* project – you taking pictures in nightclubs all over London. We were really actively going out a *lot* at that time, and lots of things came from clubs. I mean, we met *everybody* through clubs or bars – Phil Poynter, Katie Grand, Katy England, Mark Sanders…. everybody that became a part of the framework of what was to be *Dazed & Confused*.

RANKIN: 100 per cent – we met everybody through the club scene.

JEFFERSON: I remember thinking, 'Why should we pay to go to other people's clubs?' We had to start earning money, and the only way we could do it was by running nights like *Been There Seen It Done It* and doing one-off parties. We knew no one in the industry. Neither of us knew another person who was working on a magazine.

RANKIN: I think the timing was interesting – there was not much opportunity, unemployment was at its height, there was a recession, there wasn't much media… There was no way in.

JEFFERSON: Yeah, but there was a lot of confidence that you could kind of survive but not have to be part of the system, and there were definitely a lot of people who were helping each other do that. With the early McQueen shows, for example, there was no money for anything – just lots of people helping make it happen.

RANKIN: Yeah, and once you had some initial success, you were boosted. When we got the first £3,000, we were like, 'Fucking hell, we can get £3,000? Let's get £5,000! Then £6,000…"

JEFFERSON: Momentum.

RANKIN: Momentum… and a bit of that attitude of going, 'Right… I'm gonna do it!' I think it was weird for you to go, 'Right. I'm going to be an editor!'

JEFFERSON: *(Laughs)* I was signing on the dole in Peckham! I never thought I'd be able to pay myself a wage from *Dazed*. At that time there was no notion that you could be creative and make serious money.

RANKIN: No, not at that age.

JEFFERSON: And there was no notion that you could make a

magazine that was independent. It was a different time, and I think people took advantage of the opportunities that were there to create independence. We had a sense that we had nothing to lose and everything to gain – we both had a strong work ethic.

RANKIN: Yeah, we were very hedonistic but we were always working – we always had a goal…

JEFFERSON: We paid great attention to detail and had a perfectionist attitude – we always wanted our magazine to be better, otherwise we felt there was no point putting it out. We would never let each other go on too much of a bender. You might have a weekend but then

I'd pick you up, or someone else in our gang would, and we didn't take any holidays…

RANKIN: That's true. I didn't have a holiday until I was 30. I honestly didn't think *Dazed & Confused* was going to go on at the time though. We were just kind of like, living in a moment.

JEFFERSON: There were certain periods of the first few years when it felt more like a youth club than a magazine, because there wasn't a central office. It would just be a flat somewhere, or we would kind of borrow someone's space for a little while…

RANKIN: … Newburgh Street.

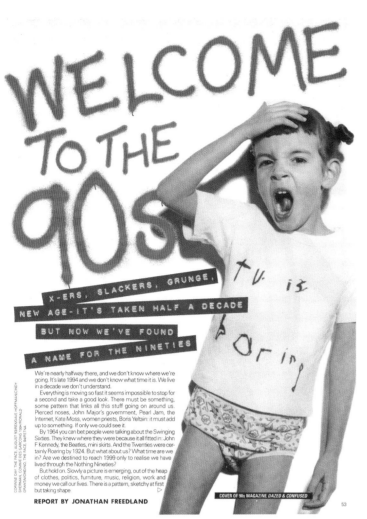

WELCOME TO THE 90s

X-ERS, SLACKERS, GRUNGE, NEW AGE—IT'S TAKEN HALF A DECADE BUT NOW WE'VE FOUND A NAME FOR THE NINETIES

We're nearly halfway there, and we don't know where we're going. It's late 1994 and we don't know what time it is. We live in a decade we don't understand.

Everything is moving so fast it seems impossible to stop for a second and take a good look. There must be something, some pattern that links all this stuff going on around us. Pierced noses, John Major's government, Pearl Jam, the Internet, Kate Moss, women priests, Boris Yeltsin: it must add up to something. If only we could see it.

By 1964 you can bet people were talking about the Swinging Sixties. They knew where they were because it all fitted in: John F Kennedy, the Beatles, mini skirts. And the Twenties were certainly Roaring by 1924. But what about us? What time are we in? Are we destined to reach 1999 only to realise we have lived through the Nothing Nineties?

But hold on. Slowly a picture is emerging, out of the heap of clothes, politics, furniture, music, religion, work and money we call our lives. There is a pattern, sketchy at first but taking shape. ▷

REPORT BY JONATHAN FREEDLAND

CORINNE DAY, THE FACE, AUGUST 1991. SEAN & HOFFMAN/CINDY SHERMAN, CORINNE DAY, GARY CLARK/MACDONALD GRANT/NOMKHO, THE FACE, BAREFELYA

COVER OF 90s MAGAZINE *DAZED & CONFUSED*

53

JEFFERSON: Yeah, Newburgh Street, opposite Pam Hogg's shop – it was like a one-bedroom apartment with one computer, one phone line and one computer... Then we went to Brewer Street, underneath Corrine Day's flat.

RANKIN: We had two rooms!

JEFFERSON: That felt much more real – that was another ship; that was a ship with a bigger clubhouse, with more people and a different set of influences. That was when we went more conceptual with visual arts and photography...

RANKIN: *(Laughs)* We did a cover called *Weep* because we wanted someone to be crying on the cover.

JEFFERSON: ... the one before that was *Death Of A Cover Star*.

RANKIN: *Death Of A Cover Star, TV Is Boring, Kids In Fashion...* we were kind of making it a bit weirder; a bit strange.

JEFFERSON: Was *TV Is Boring* before the weeping one?

RANKIN: I think so... I can never remember the numbers. Katie [Grand] and I were going out with each other at the time so we would be going home together, talking about these ideas and then doing them. Katie was obsessed by big fashion houses from the very beginning, but when Katy England came onboard it gave it a balance, and that was the concept, wasn't it? We had our feet very much in both camps. I think we originally met Katy England doing the door to a club – she used to be so great on the door and we were just like, 'You're *so* fucking cool...'

JEFFERSON: *(Laughs)* She had the *Night Porter* look... There were so few pages in those early issues, and so many ideas!

RANKIN: We were all fighting for pages, fighting! It was about fighting for your ideas...

JEFFERSON: ...to be on the cover, to be the main story.

RANKIN: Phil Poynter was involved quite early on, wasn't he? He became my photographic assistant when he was about 17.

JEFFERSON: What's interesting about Phil is that he became the first official photo editor of the magazine when there really wasn't one – as your assistant he inherited that role. He started doing these really big-scale and epic fashion stories. There always seemed to be ambition in them. It was from very early on that we wanted to take on something like *The Face*.

RANKIN: What I wanted to see for *Dazed* was fashion as more of an art form, and Phil's instincts about art were very good. We did so many strange art projects back then, and I think we were all really interested in art. We didn't have any pretension about it – I mean, I never considered myself an artist and Phil didn't consider himself one, and neither Katie or Katy ever considered themselves artists. We were fascinated by it but we didn't put it on a pedestal. I think all of us just had a gut feeling about art. There were amazing things that happened. The first time we met Damien Hirst was amazing, becoming quite friendly with him and just thinking, 'This guy is completely different to anybody I've ever met...'

JEFFERSON: How punk he was really influenced you.

RANKIN: Yeah, he totally influenced me. It was really interesting because he was coming from such a similar place to where I felt I was coming from conceptually, and if anybody said, 'Who's your favourite artist?', I'd say, 'Well, he's my

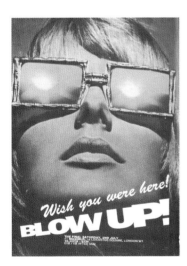

Blow Up was a house night started by *Dazed & Confused* at Maximus in Leicester Square in 1992 in order to fund the magazine.

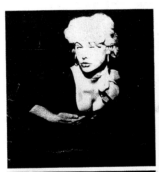

Striking a Blow

Dressing up has always been an art, now its got its own exhibition. *Blow Up!* is a photographic show dedicated to street style, and more specifically club style. All the photographs capture London clubbers, doing what has become second nature – striking a pose.

The show organisers, Jefferson Hack and photographer Rankin Waddell (indeed), set up a simple white sheet backdrop in a selection of the Capital's hippiest hangouts: The Ministry of Sound, Subterrania, The Milk Bar and Maximus, to name but a handful of their frequented nightspots. They had little trouble persuading raunchy ravers, preened peacocks and whoever else caught their attention, to look towards the camera. For Waddell, it was all about catching what his subjects wanted to say about themselves. They're the ones making the statements, they're the ones putting on the public show.

Notwithstanding, the result is a fascinating selection of stark but vibrant black and white prints, that capture the re-emergent individuality of trendy, nocturnal fashion, and the many characters and personalities at play. Waddell deliberately avoided giving the 'models' any direction, and this is partly why many of the pictures have a wonderful freedom, spontaneity and honesty. A quirk reality that many professional models and fashion shoots rarely catch. As a result Waddell says: "It's not our exhibition. I didn't give the models any poses to strike, so I don't really feel they're my photographs."

The organisers of *Blow Up!* are also responsible for *Dazed and Confused*, one of a handful of clubland born, small magazines that have sprung up in the last few months, thumbing their noses at the recession. The exhibition, though, is a profit free venture, with all the proceeds from the sales of prints (marked at £50 each) going to the Terrence Higgins Trust.

Obviously *Blow Up!* will be attracting the attention of clubbers out to spot their friends, or pick up the latest fashion trends. But it also works as a serious portrait show, even documentary insight into the face of the so-called rave culture today. There are plenty of fascinating studies for collectors, photographers, and squares to appreciate. "We wanted to demystify fashion, we're not photographing a select group and selling back to the masses," explains Jefferson.

The high quality of Waddell's photographs are particularly impressive considering the unconventional nature of the shoots. And certainly worth a view.

Blow Up! is sponsored by Wrangler and following the overwhelming success of its first exhibition at The Collection last month, it is being exhibited at several London clubs over the coming months. You can catch it at The Fridge on May 2 or ring Dazed and Confused on 071-223 7422.

STEPHEN LEIGH

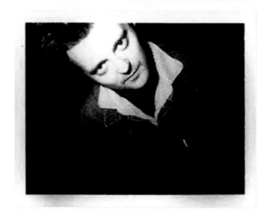
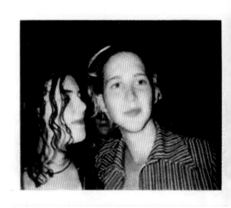
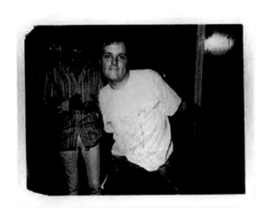
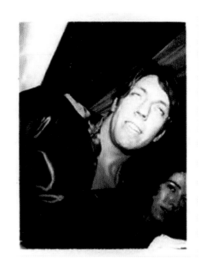
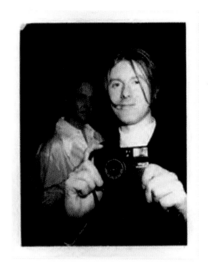
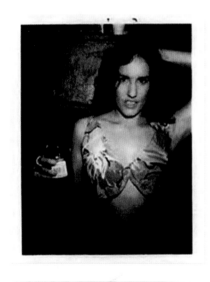

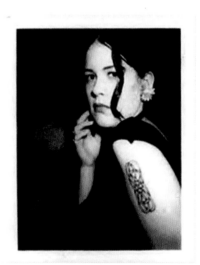

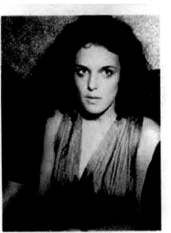

favourite artist.' I remember when I went to meet him at the Serpentine show and I saw *Away From The Flock*. I suddenly realised that he was trying to create something that felt emotional – it punched you in the stomach. He combined this cerebral approach to his art with an emotive aspect. I always thought that that's what we were trying to do visually with the magazine. When you look at the early issues, a lot of the art coverage was about Mark [Sanders] following his instincts, and even though I disagreed with him a lot, I think that's what made it interesting. I think we all considered *Dazed* a cultural vehicle, not a youth culture magazine.

JEFFERSON: We were definitely looking at what we were inheriting from our competitors such as *The Face* and *iD*, and realising that it really didn't mean that much to us, although we respected them for operating.

RANKIN: Yeah, we kind of looked up to them.

JEFFERSON: But we wanted them to be a point of difference, we didn't want to be the next 'them' – we definitely wanted to separate ourselves, because there was a culture in which these magazines had created a point of view and it was omnipresent.

RANKIN: ... and it was paid for

JEFFERSON: Yeah, *NME, The Face...* there was a kind of, what's it called?

RANKIN: It was kind of a pervading notion of what was *cool* and what wasn't cool and we were like, 'We're not interested!' I mean, we never really wanted to be cool – it was about being significant or interesting, or trying to change things, and we all talked so much about how we could do things differently; how can we approach this differently, how can we do an interview differently... That's how you get Thom Yorke interviewing himself, because we knew we had to do something with Thom that was different. Then there were always the ideas that came from being out for four days in a row and needing to come up with something on the spur of the moment. That's when I think drugs were amazing – on the comedowns or on the hangovers we came up with great ideas. We were living this very hedonistic lifestyle, but at the same time we wanted to challenge things and that really gets to the heart of *Dazed* – it's an art magazine, really. I think we were really lucky to find Mark,

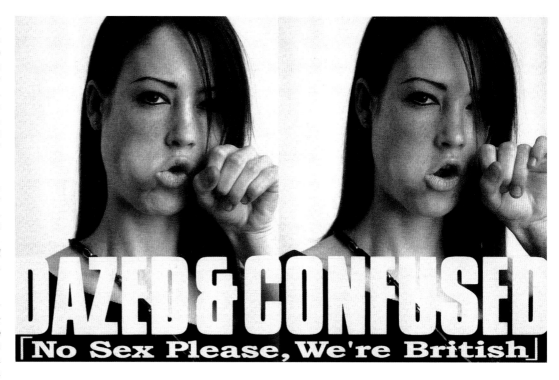

Phil, Katie and Katy because when we started, it was really more about Warhol and McLaren for us – we were like, 'We want to do what they're doing!'

JEFFERSON: Yeah, the first magazine we ever visited was *Interview*, wasn't it? Ingrid Sischy showed us around and talked to us about how they put the magazine together, and that was a great encouragement. Then there was meeting Malcolm and getting his... you know, his energy about being independent.

RANKIN: He was so positive about it, do you remember? He used to always say, 'Do it yourself, do it yourself!' That was incredible.

JEFFERSON: We did our own rock'n'roll swindle as well – we got like, 80 grand out of one of the record companies to start a label that never put any music out! We did a lot of very interesting things! The curatorial aspect of the

magazine happened very early on too – this idea of being multimedia; being more than a magazine. People like Sam Taylor-Wood would come to us and be like, 'How do I take 360-degree photographs?' All sorts of people would come in and want to realise their dreams or their next project, and we would become a kind of exhibition in print, if you like. Everyone was facilitating each other, both in the magazine and off the page, and that was good because it was a great energy of helping and sharing. It was never really commercial, which was interesting because work wasn't easy to get then.

RANKIN: That was exactly what we wanted. We had massive ambitions. It was never just supposed to be just a magazine was it? We realised the people working in our field weren't any smarter than us, and that we could make it a success.

JEFFERSON: It's funny because at that time you were saying 'right

time, right place,' and you were right – we had Britart and then Britpop came very quickly. When they were still in emergence, these things were very accessible to us and they were very accessible because we were very open to them, so those stories and curatorial projects with the first wave of YBAs like Damien Hirst, Sarah Lucas, Angus Fairhurst and the first wave of bands like Pulp and Blur came quite fast. Then of course the connection with New York was the next thing that happened… When we first went to New York and met Chloë [Sevigny], and then Harmony [Korine].

RANKIN: Do you remember when I saw *Kids*? I saw a preview screening and was calling you going: 'I've just seen the most amazing fucking film, it's going to be massive – it's brilliant!' Then it was like, 'Right, how do we meet these people?' I didn't even know Larry Clark at that time – I didn't know who he was, I was just obsessed by this girl that I'd seen in the movie. Then we met her, and through her we met Harmony, and then suddenly it started to be like, 'Oh, they have the same attitude and approach.'

JEFFERSON: For me, they represented this idea of the interdisciplinary aesthetic, you know? Where music was influencing art, art was influencing film, film was influencing fashion… Chloë had that as a young star. I guess she became a poster-girl for

the magazine, and she introduced us to so many people.

RANKIN: We have always had a real openness to people, and people always led us to other people. There is a line you can draw through our stylists – Katy England found Nicola Formichetti and Alister Mackie, Nicola found Katie Shillingford.

JEFFERSON: It had a lot to do with the fact that people could see the quality of what they were doing and they wanted to be a part of that – they were attracting people. Also, the way that we structured our first real office in Old Street was very much like an artist's studio…

RANKIN: It was a great office! I'd always be shooting, or someone would always be shooting in the studio, so you always had that kind of live element with the gallery at the front and my studio at the back. That was kind of exciting actually, because it wasn't like you'd go to *The Face* who would use The Works or whatever. We were using the studio as our office, so whoever was going to be on the cover of the magazine would meet everyone in the office. It was like you'd come to this place and you were interviewed and you were photographed and…

JEFFERSON: … and you played pool.

RANKIN: *(Laughs)* You'd play pool! We used to play pool with everybody.

JEFFERSON: It was really different, and we were always very open to people using that space of ours for other things. I think it's significant that very early on we never had art directors – the stylists or the fashion directors took a lot of control on the visual side.

RANKIN: I think that Katy and Lee's *Fashion-Able* is one of my favourite *Dazed* creations. That was an incredible piece of work and it crossed over internationally the minute we did it as something that was trying to break down the barriers between what is acceptable and what is unacceptable in fashion, and in life.

JEFFERSON: I think that issue was the first time I really felt like we had gone international. The feedback was so significant, and people really thought 'Wow, you can make a magazine that has a small circulation but that has international impact.'

RANKIN: And then you'd have all these little magazines springing up in different countries that were very similar to *Dazed*.

JEFFERSON: The curatorial way of putting a magazine together became a template people could copy – people could see how powerful it was.

RANKIN: I always say that we were very lucky because we were very much in the right place at the right time with the right equipment – because we were all totally Mac-orientated right from the beginning, and we just happened to be creating something that represented what a lot of people were feeling at that time, because culture was diversifying so much. I think that's why we got readers – we were getting it and they were thinking, 'Well, I'm thinking that, and I'm feeling that, too…'

JEFFERSON: I think at that time, everything felt like some weird postmodern art project. Early on we got that comment: 'They're like the *Late Show* on Ecstasy'. But it wasn't us trying to be that kind of 'authority' – or the idea that we were taking drugs. Our idea was simply to break the rules, to change the way that youth culture is packaged, and to present it in such a way that in some sense, you felt like you were closer to the truth.

FOREWORD BY JOHN-PAUL PRYOR
INTERVIEW BY JO-ANN FURNISS

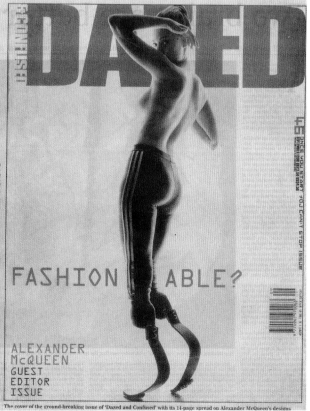

Fashion breaks the last taboo

Style magazines don't often change the way we think. But a feature on clothes designed for people with disabilities is causing quite a stir. By Cayte Williams

The photographer Nick Knight, Alexander McQueen, the fashion designer and Jefferson Hack, a magazine editor, have collaborated to produce a photoshoot which breaks down one of the last bastions of body fascism.

"Accessable", a 14-page feature in the style magazine *Dazed & Confused*, shows people with disabilities looking powerful and beautiful in designer clothes. "In a world where the mainstream concept of what is and isn't beautiful becomes increasingly narrow," reads the introduction, "you have to be young, you have to be thin, you should preferably be blonde, and of course, pale skinned."

Aimee Mullens, a blonde, delicate woman with two artificial legs, models a woollen fan jacket and a suede T-shirt by Alexander McQueen, Helen Mcintosh, a person of restricted growth, wears a tweed draped dress by Roland Mouret, while Mat Fraser, a thalidomide man with a shaved head, wears a pleated waistcoat by Catherine Blades. Each person's attractiveness and spirit shines through, and sometimes it is quite difficult to see what their disability is. There is no victim culture here.

In late 1997, McQueen decided that he wanted to start a project with people with disabilities. He and his stylist, Katy England, began contacting disability organisations throughout the country and received an overwhelming response. More than 50 people wanted to be involved, and from that they selected eight. "Ninety nine per cent of the organisations we contacted were positive," says England. "It

took a lot of explaining, because of people's impressions of the fashion industry. They were immediately sceptical and wondered why we would want to do it. We had to break down those barriers with them and be very honest."

Other designers involved in the project included Hussein Chalayan, Philip Treacy and Commes des Garçons. To get the clothes right, each designer was paired with a disabled person so that each model's personality was reflected in the clothes.

It is possible that McQueen's

'We had to break down the barriers with disability groups and be very honest'

idea is a head of creative steam he has let out after a year of producing clothes for perfect, rich, privileged women. But McQueen has always had an eye for what is different. "When we started we were only interested in individuality and originality when choosing models, and perhaps this is taking it a little bit further," says England.

The spread's photographer, Nick Knight, is also no stranger to pushing the boundaries of fashion photography. He was the first person to photograph the size 14 model Sophie Dahl, for the fashion bible *Visionaire*. His pictures of the size 16 model Sara Morrisson for *Vogue* in 1997 caused the fashion world to gaze at an image they'd never seen before: the first proper look at all of his cam-

onds. He also used octogenarian ranchers for his Levi's Red Tab campaign in August 1996. There are those who think that Knight is making the fashion industry aware of body fascism, although that may not be the main reason for his work.

Many believe he is exorcising his demons. He has always expressed a hatred of violence and his photographs for the Spanish publication *Big* in May 1997 were so graphic that the magazine had to carry a warning label.

So what do those outside the fashion industry think of the *Dazed & Confused* photographs? "As an organisation, we want to change society's attitudes to disabled people," says Karen Edmunds, director of Glad (the Greater London Association for Disabled People). "They have the right to do what everyone else does, and it's really good that a magazine such as *Dazed & Confused* is producing a positive image like this.

"Most people's views of a disabled person is of someone helpless in a wheelchair, or someone they have to help across the road. People don't even see the disabled on television, so to see them in less stereotypical roles in a fashion magazine is wonderful. Disabled people want to look as attractive as anyone else does, so why can't they wear nice clothes?"

Tim Johnson is a 33-year-old architect who lost his arm in a traffic accident when he was 15. "I think *Dazed & Confused* has taken a great big risk with this photoshoot," he says, "but I think it has paid off. I don't have a clue who Alexander McQueen or Nick Knight are, but I think they've handled it very sensitively."

FASHION ABLE?

ALEXANDER McQUEEN GUEST EDITOR ISSUE

The cover of the ground-breaking issue of 'Dazed and Confused' with its 14-page spread on Alexander McQueen's designs

TV IS BORING
The Fashion Of Katie Grand

It is often repeated that a 17-year-old Katie Grand wrote a letter to Liz Tilberis, then editor of *British Vogue* asking how she could one day have her job – she was never short on ambition. Yet, as destiny would have it, instead of taking the tried and tested fashion magazine route, within a few years Grand would become one of the founding members of *Dazed & Confused*.

It was here she would make a brand new mark in publishing, particularly in the realm of fashion, and help usher in a new era in the history of British style magazines. "I had always wanted to work in the fashion industry, well, from the age of 13. But there was this whole thing of not being very good at it... so I had to negotiate my way into Saint Martins."

As with many of the successive fashion editors of *Dazed & Confused* to come, Katie Grand's training was as a designer – and a knitwear specialist at that – but it wasn't the career-to-be: "I decided I wasn't really that interested in being at college – I was much more interested in actually doing something. I had worked with Rankin on the Student Union magazine *Eat Me* for pretty much the whole of my year out. And then I was helping out on *Dazed*. I tried to go back to college for my fourth year and lasted about a week. That's when they pulled me into the Dean's office and said, 'You're going to mess up either your degree or the magazine and we think you should make a choice.' I walked out of the room and on the wall there were all of these tear sheets from *Dazed* that I had done and I thought, 'Well, I should probably do that then.'"

Katie Grand was very much a star of the early magazine's system and set a new "post-grunge" agenda for fashion within its pages. "It was one of those things that when you have so few staff all the voices in the magazine are quite loud. Nothing was really being commissioned out at first and we were all spending quite a lot of time together – and it is not as if those relationships are diffused with five assistants between you; nobody had assistants. Everyone sort of hung out together and it was a very close unit. Phil Poynter and I always worked really closely together and, of course, he had ambitions as a photographer as I did as a stylist. At the same time, we were both very used to commissioning other people and trying to make the overall thing as good as it could possibly be. And I would get involved in all of the picture commissioning, not just the fashion." This commissioning included the first pictures of Mert & Marcus, of Liz Collins, Sølve Sundsbø and Sean Ellis to appear in any magazine – working relationships she still maintains.

"These days Sean Ellis is an Oscar-nominated director. But he ended up working for us because he lived upstairs!" Such was the ethos behind the discovery of new *Dazed* talent. "We just thought we'd work with people we knew, we didn't for a second think that anybody famous would want to work for us. I suppose we were all a bit scared of rejection as well, so we'd just ask someone we knew who was going to say yes."

Above all, she had an eye for constructing and working on striking cover images, as well as a distinct view on celebrity, something she has maintained a deserved reputation for as founder and Editor-In-Chief of *Pop* and *Love* magazines. The first cover she felt really proud of was the picture of the little girl Fellina in the *TV Is Boring* t-shirt.

"The *TV Is Boring* cover was a pastiche of a David Sims or Corrine Day picture for *The Face* – a pastiche of grunge. But when we saw it, we thought it was far more interesting than what they were doing... We were so arrogant! I now look back on some of those issues and think, 'How terrible!' But at the time we thought they were *amazing*. We really thought we were phenomenal.

"We would tease Rankin from time to time and say, 'Oh that was a shit cover – you and your bloody crap ideas.' But at the time, Rankin was taking the pictures, shooting the covers – he was very obviously the identity of the magazine. He was such a big character – and still is – and his bull-in-a-china-shop not-giving-a-fuck reputation shaped *Dazed*. We would sometimes criticise his shoots, but not *really*. Or we would say something about what Mark Sanders had come up with being a bit boring – 'oh here he is again, peddling some artist who was about to go off and be the biggest star in the world' – but Mark was looking at those artists before Charles Saatchi was."

They did indeed garner a reputation as a group of "show-offs", but Grand points out that she was less "bullish" than Rankin. "In the fashion industry I did feel like this kid and everyone else was so... Well, it was kind of like heaven. There were all of the wonderful people up there and we were just down here, muddling through.

"I think around issue six or seven I had kind of learned enough within our group, and was confident to get involved with some bigger names. I suppose we did a bit of climbing. I think the first thing we did was an article on Nick Knight. The issue after that we did an interview with Carine Roitfeld – and it was the first interview she had ever done. She sent me a pair of Pucci knickers as a thank you for that. We also did an interview with Mario Testino and Juergen Teller around that period. Richard Habberley was the first booker to ever phone me with a request. He was representing Helena Christensen at that time and asked whether I would like to put Helena on the cover. I danced round the office! I thought, 'Oh my God, we've made it!' That was issue 10 I think. That was a proper fashion issue and we got lots of people to do things. Fabien Baron and Alex White did things – lots of those very successful people. That was probably the first of the secure moves into the proper fashion industry. But it took a long time." At the same time, this move into the established fashion industry probably spelled the beginning of the end for Katie Grand's time at the magazine. She was by now undoubtedly "good at fashion", yet those early dreams of *Vogue* had vanished.

'The whole time at *Dazed* it never crossed my mind to be one of those *Vogue* girls. Even now that is something I imagine posh girls do, and I realised I wasn't that thing. And once you have tasted that kind of independence... Well, it is one thing working for Rankin and Jefferson when you are all vaguely the same age and you all go out together – there was so much freedom you kind of didn't really know what to do with it – but the idea of answering properly to somebody... By that point it wasn't something I think any of us could do."

Rather it is the blueprint she established at *Dazed & Confused* that has stayed with Grand, and has led to her success as an editor and stylist elsewhere, always on her own terms. "It's like that thing where you work out what your taste is at 13, and it never really goes away. I suppose your first job will always be very sentimental to you in that sense, especially when you learnt so much at such a rapid pace – and very quickly – coming straight out of college and starting to meet famous people. I was shooting the cover of *The Face* with Guinevere when I resigned from *Dazed* – that issue of *The Face* became my first one as their Fashion Director. I called *Dazed* from the shoot in tears..."
JO-ANN FURNISS

[right]
June 1998
KATE MOSS
photography by Rankin
styling by Katie Grand

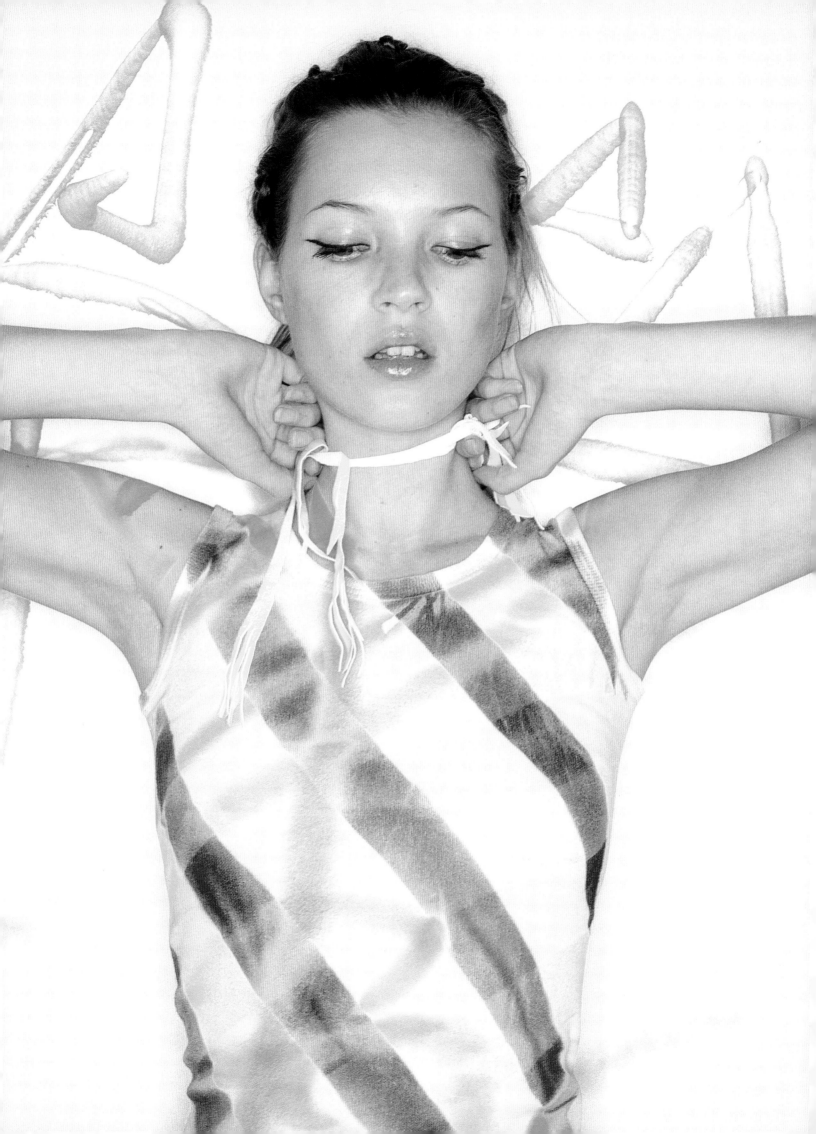

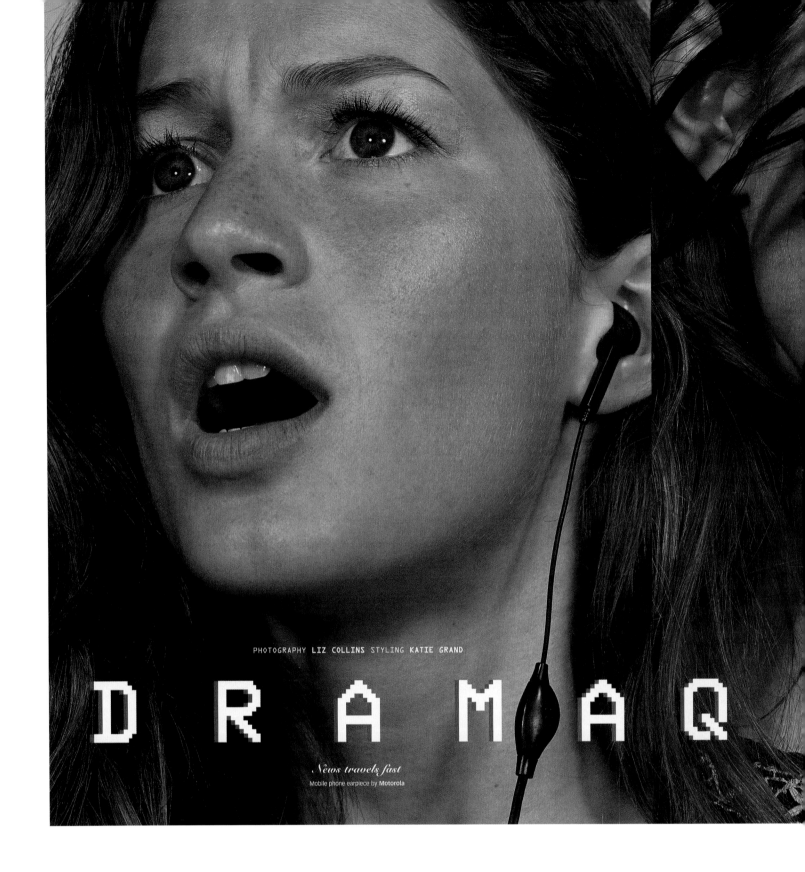

PHOTOGRAPHY LIZ COLLINS STYLING KATIE GRAND

D R A M A Q

News travels fast

Mobile phone earpiece by **Motorola**

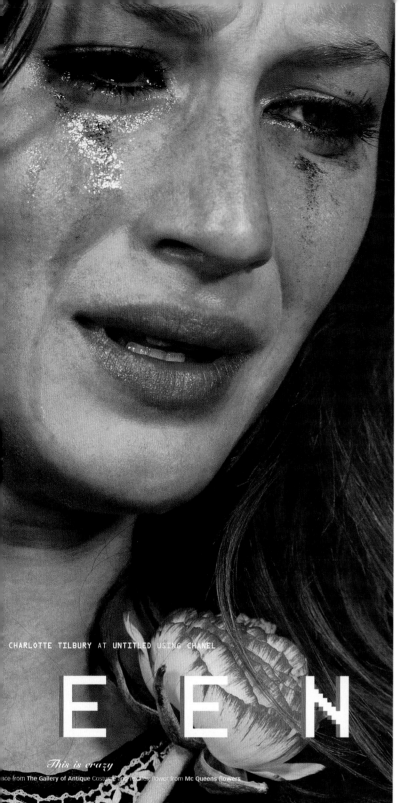

CHARLOTTE TILBURY AT UNTITLED USING CHANEL

E E N

This is crazy

ace from **The Gallery of Antique** Costume and Textiles, flower from Mc Queens flowers

July 1999
DRAMA QUEEN
photography by Liz Collins
styling by Katie Grand

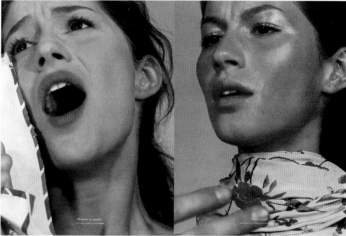

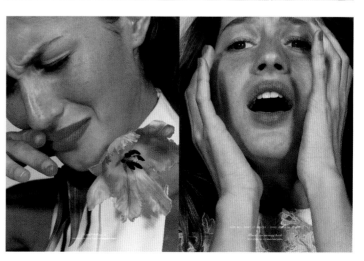

August 1997
FLESH FOR FANTASY - COVER
photography by Rankin
styling by Katie Grand

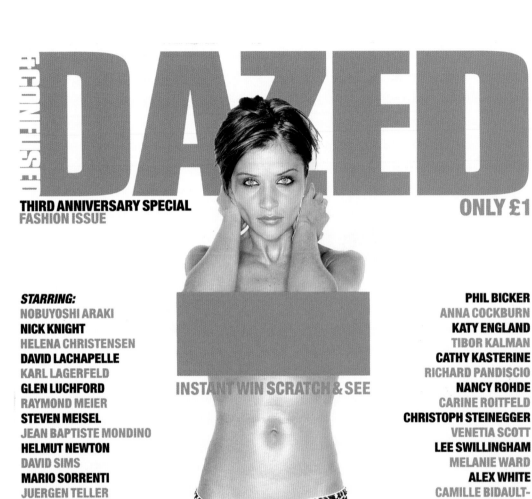

DAZED

PIONEER ISSUE!

THIRD ANNIVERSARY SPECIAL
FASHION ISSUE

ONLY £1

INSTANT WIN SCRATCH & SEE

STARRING:
NOBUYOSHI ARAKI
NICK KNIGHT
HELENA CHRISTENSEN
DAVID LACHAPELLE
KARL LAGERFELD
GLEN LUCHFORD
RAYMOND MEIER
STEVEN MEISEL
JEAN BAPTISTE MONDINO
HELMUT NEWTON
DAVID SIMS
MARIO SORRENTI
JUERGEN TELLER
MARIO TESTINO

PHIL BICKER
ANNA COCKBURN
KATY ENGLAND
TIBOR KALMAN
CATHY KASTERINE
RICHARD PANDISCIO
NANCY ROHDE
CARINE ROITFELD
CHRISTOPH STEINEGGER
VENETIA SCOTT
LEE SWILLINGHAM
MELANIE WARD
ALEX WHITE
CAMILLE BIDAULT-
WADDINGTON

33 SCRATCH & SEE
AUG 1997 UK£1.00 US$4.95

1994
TV IS BORING
photography by Rankin
styling by Katie Grand

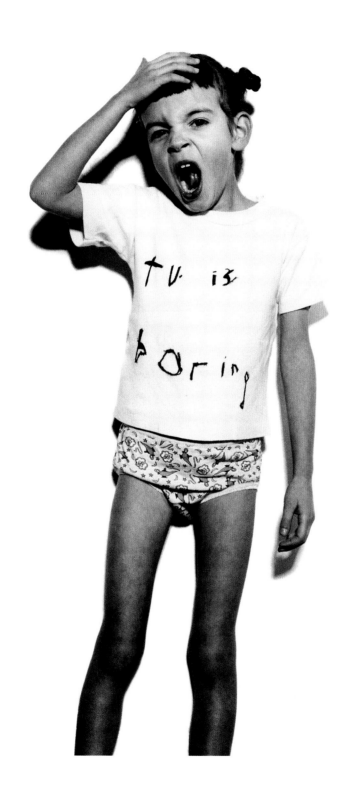

[this spread]
October 1999
DREAM ACADEMY
photography and styling by
Mert Alas & Marcus Piggott

[following spread]
November 1997
KATE MOSS
INTASTELLA OVERDRIVE
photography by Juergen Teller
styling by Katie Grand

[second spread left]
1995
PATSY KENSIT
photography by Rankin
styling by Katie Grand

[second spread right]
1995
WEEP
photography by Rankin
styling by Katie Grand

White sheer net top by Chloé, white scarf from The Gallery Of Antique Costume & Textiles.

Corset and cream chevron skirt by Chloé
Throughout Kate Moss wears Hard Candy 'Vinyl' nail polish from Liberty.
Throughout Juergen Teller wears his own Levis jeans and Converse 'All Star Lows'.

Pale pink chiffon dress by Chloé

Pale pink chiffon dress by Chloé

Pale mint pleated top and cream skirt by Chloe. Grey shoes by Givenchy

Pale pink sheer blouse and cream skirt by Chloe. Fawn suede tassled bag by Simon Robins (to order 0171 490 7117)

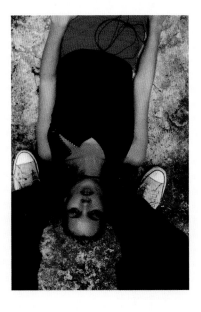

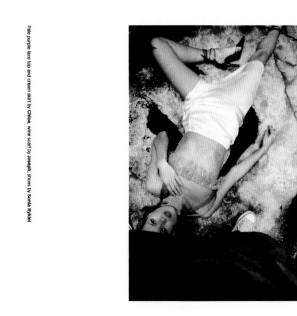

Pale purple lace top and cream skirt by Chloe, wine scarf by Joseph, shoes by Sonia Rykiel

Black diamonte top and cerise ruched skirt by Chloe, black leather thonging from The Bead Shop

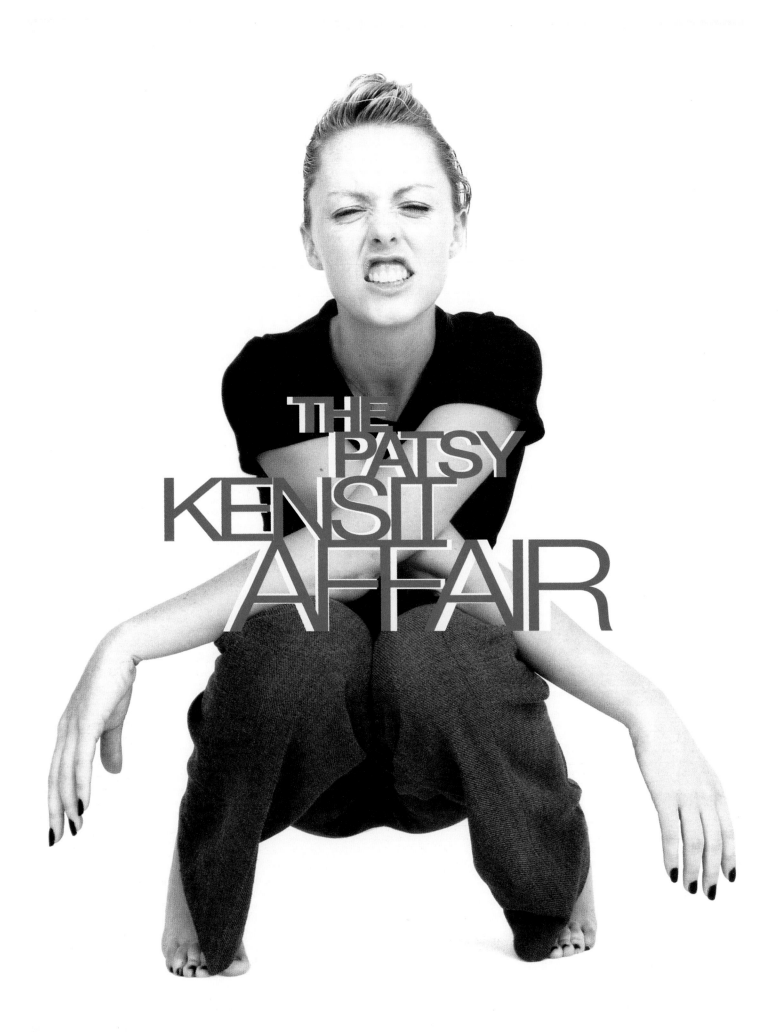

THE PATSY
KENSIT
AFFAIR

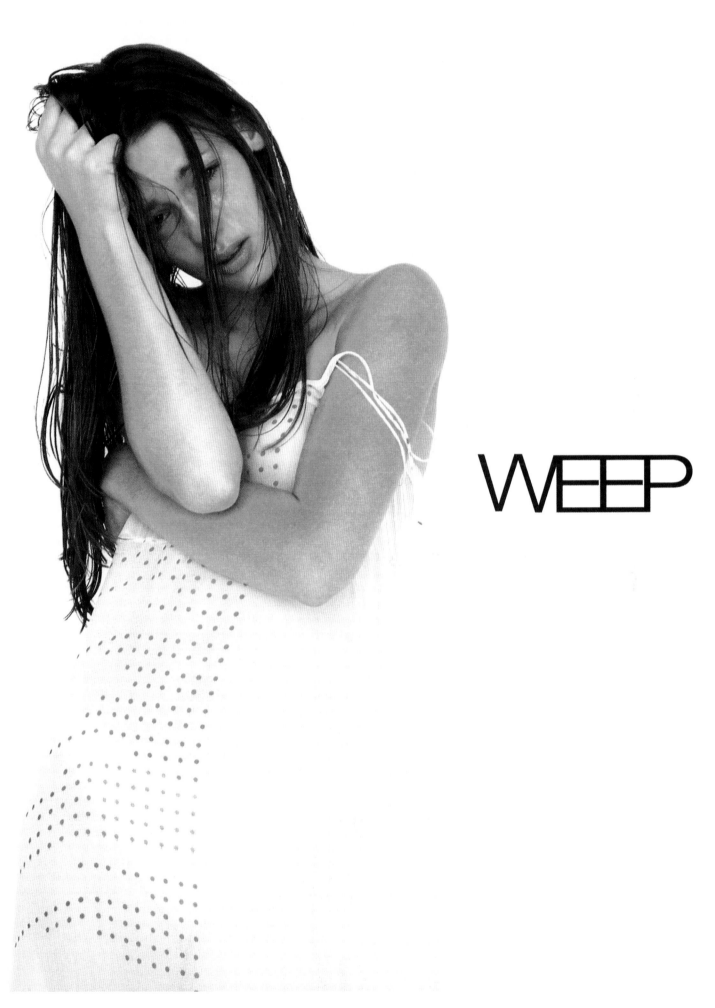

WEEP

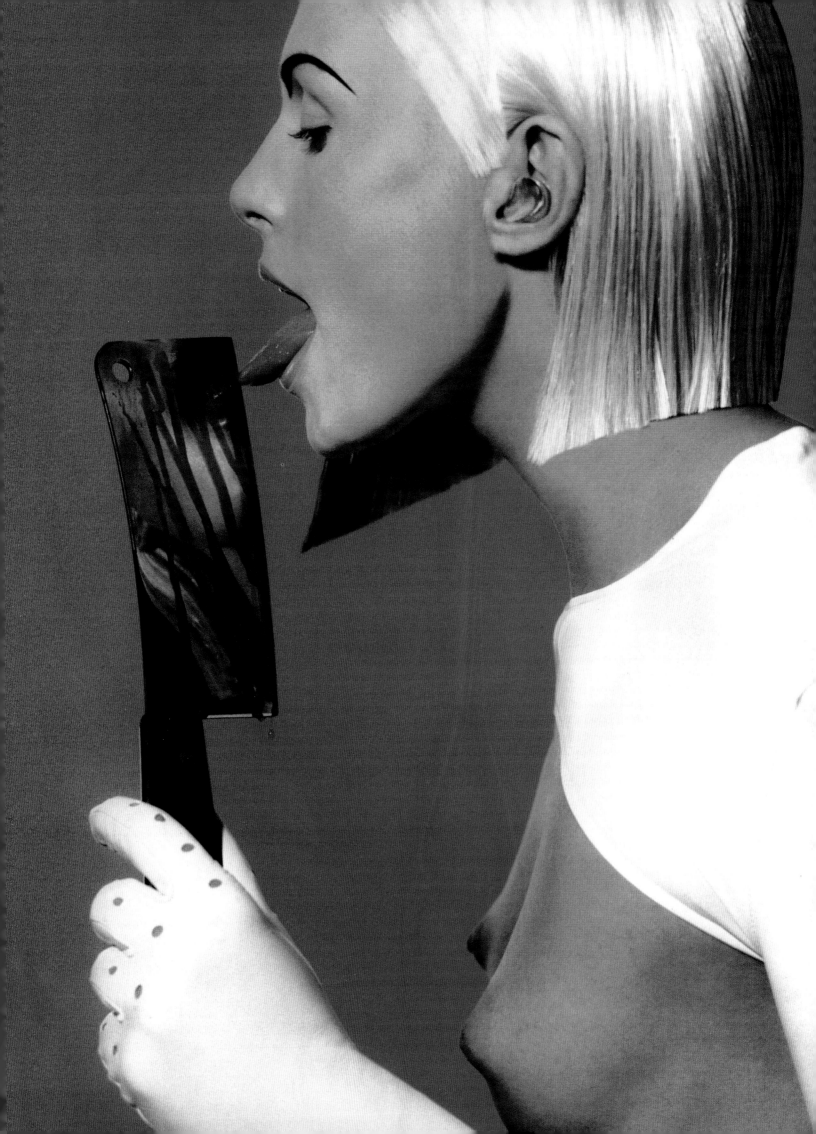

[above]
1995
NO ENTRY
photography by Sean Ellis
styling by Helena Saddler

[left]
1995
PRESERVATION VAMP
photography by Donna Trope
styling by Katie Grand

"What *Dazed & Confused* has
done is disgusting. It's this sort
of thing which could encourage
some of these horrible murders."
APRIL DUCKSBURY
FORMER DIRECTOR OF MODELS ONE

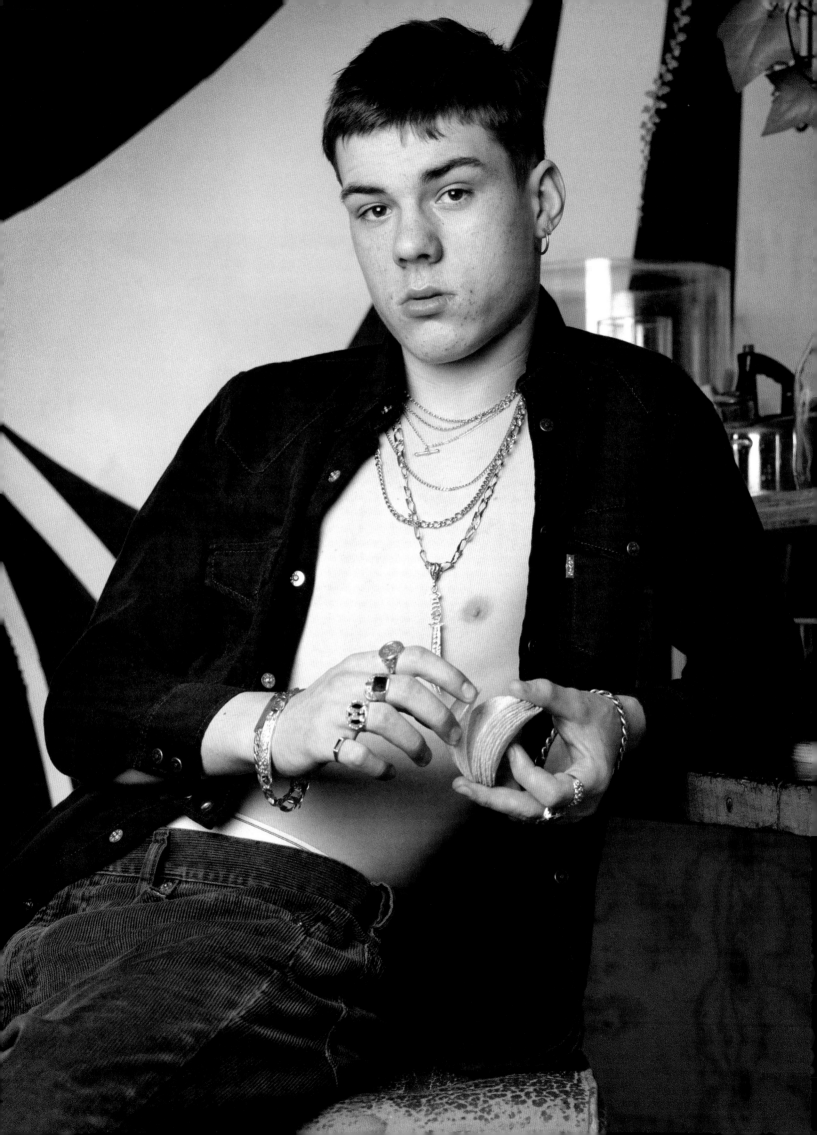

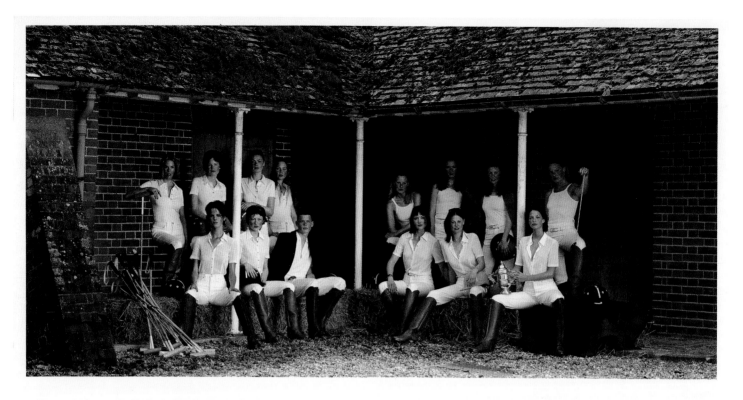

To the
MANOR
Born

PHOTOGRAPHY PHIL POYNTER · STYLING CHARLOTTE STOCKDALE

The Polo team

Standing Left to Right
Fiona Ade, Jennifer Beatty, Idanred McHugh, Brusha, Kelly, Phoebe Arnold, Tamara Welch, Stacy

Sitting Left to Right
Michelle Ferrexi, Vanessa Castillejo, Sebastian Wilson, Scosia Lubro, Sarah Vestor, Lauren Gold

All models from Take 2

All whites by Versace Jeans Couture and Versus, shirts by HUGO, polo accessories by Argosy, blanket by Hermes, sunglasses by Kangol and D&G

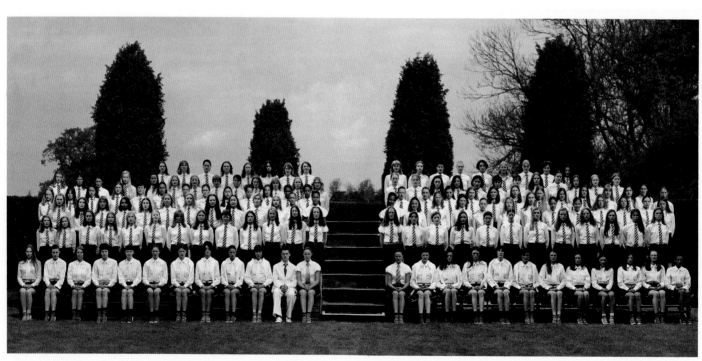

The Class of 99

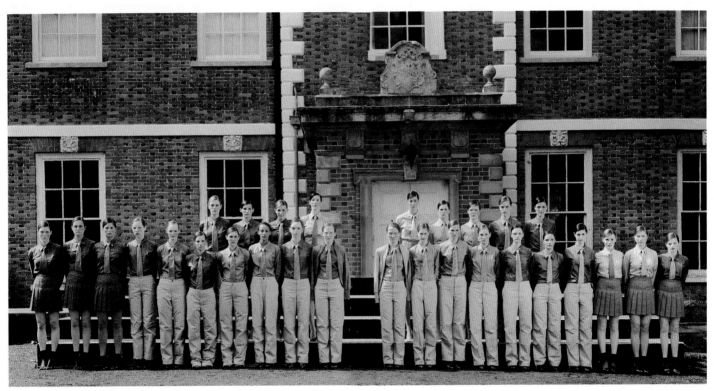

The Cadet Class

Back Row Left to Right
Kate Naylor, Francesca Knowles, Anna Milligan, Zoe Grey, Karen Wright, Elizabeth Kerry, Kirsty Lee Axford, Sarah Holland, LuCiana Curtis

Front Row Left to Right
Lauren Galle, Linda Taylor, Caroline Salisbury, Easy Lyons, Elizabeth Turner, Zoe Morel, Michelle Mockie, Robyn Bright, Sarah Giles, Emma Jaques, Amy Jaques, Jenny Duncan, Piper Steel, Laura Corbett, Stacy Gaskon, Danielle McDonnell, Sarah Challis, Victoria Townley, Elis McManey, Jane McManus

All models at Models 1
Grey shirts by Agnes b, Preen, Paco Rabanne, and S.D. ties by Thomas Pink, trousers by Lady Soul, shirts by Trutex, Rebren socks by Jonathan Aston and DKNY, shoes by Sergio Rossi, leather jackets by Raffo Research

[previous spread]
May 1997
SPUDULIKE
photography by Liz Collins
styling by Katie Grand

[this spread]
July 1999
TO THE MANOR BORN
photography by Phil Poynter
styling by Charlotte Stockdale

fashion / katie grand / 31

[this spread]
December 1997
ESCAPE INTO FASHION
photography by
Juergen Teller and Helmut Newton
compiled by
Katie Grand and Phil Poynter

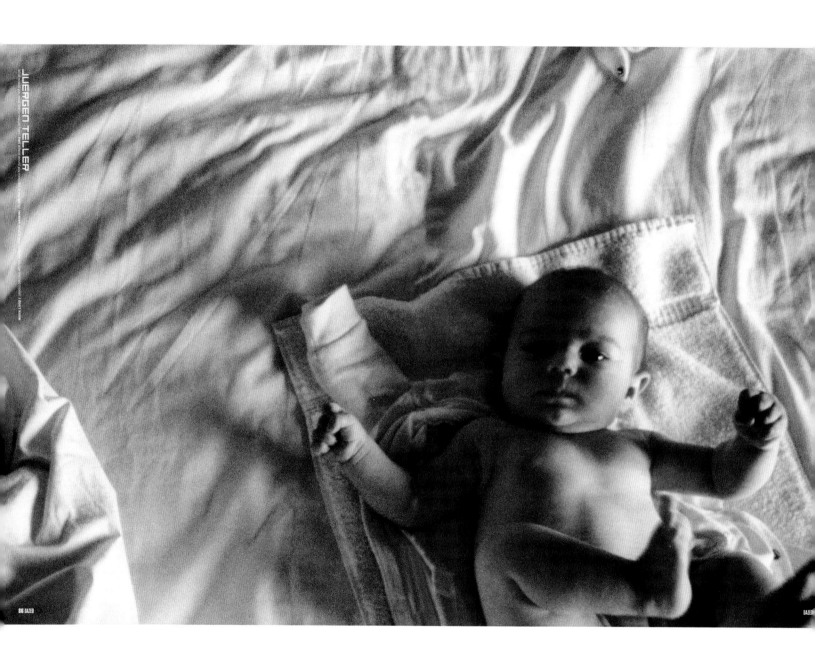

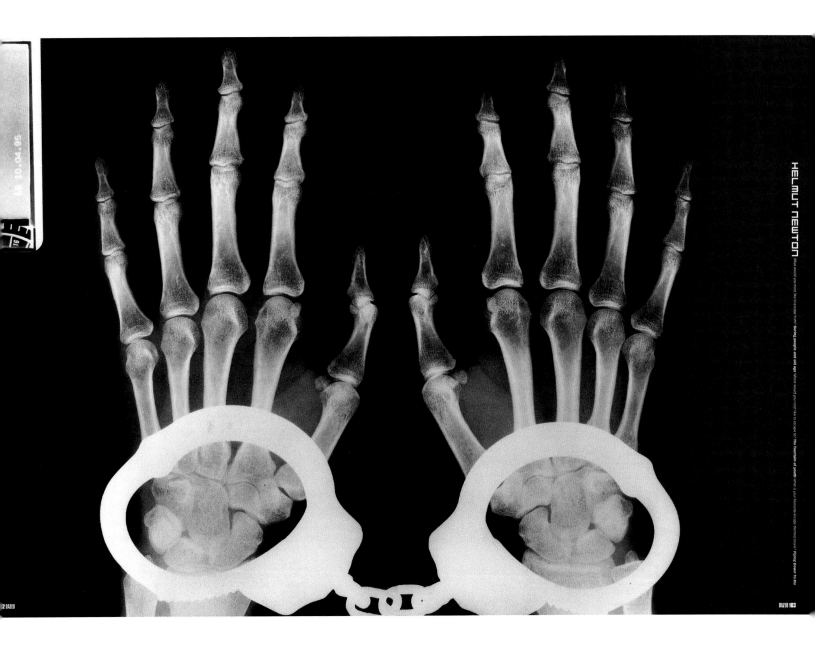

[following spread]
August 1996
THE ROLLING SLOANES
photography by Donna Trope
styling by Katie Grand

[second spread]
1997
SHARLEEN SPITERI
MIAOW MIU
photography by Liz Collins
styling by Katie Grand

THE ROLLING SLOANES

PHOTOGRAPHY **DONNA TROPE** STYLING **KATIE GRAND** ASSISTED BY **HARRIET ORMAN**
HAIR **PAUL PERCIVAL@STREETERS** MAKE-UP **SHARON IVES@STREETERS** MODEL **PAULA THOMAS** C/O 0171.336.6044

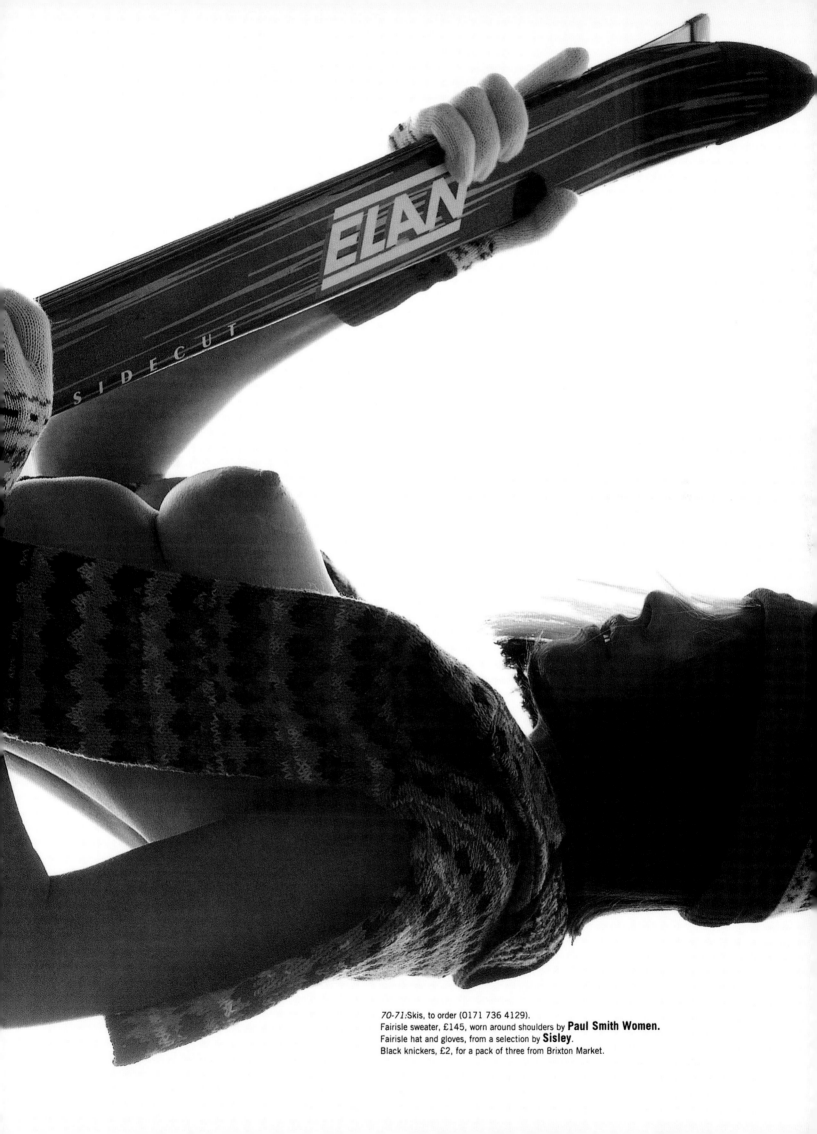

70-71:Skis, to order (0171 736 4129).
Fairisle sweater, £145, worn around shoulders by **Paul Smith Women.**
Fairisle hat and gloves, from a selection by **Sisley**.
Black knickers, £2, for a pack of three from Brixton Market.

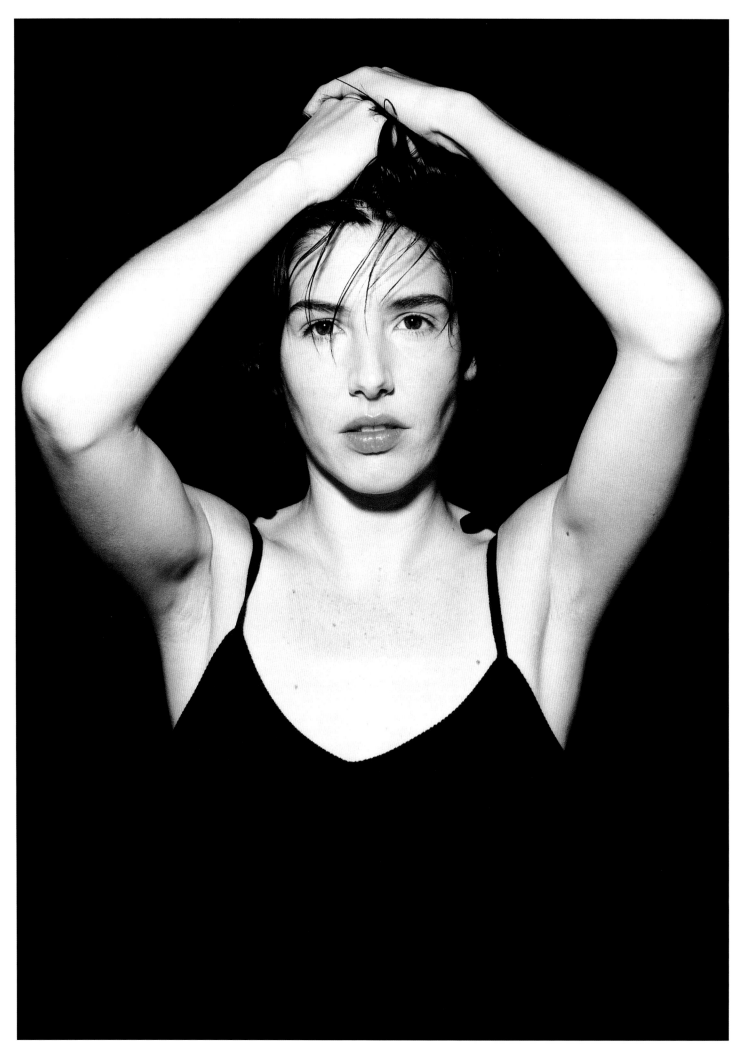

[this spread]
August 1999
FIRST BLOOD
photography by Terry Richardson
styling by Sabina Schreder

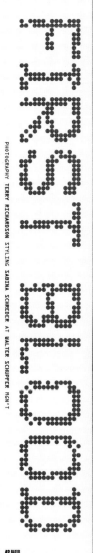

FIRST BLOOD

PHOTOGRAPHY TERRY RICHARDSON STYLING SABINA SCHREDER AT WALTER SCHUPFER MGM'T

42 DAZED

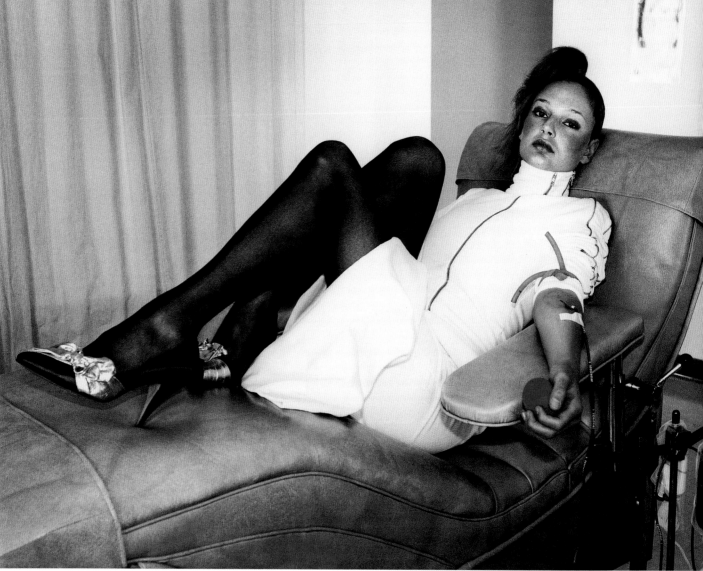

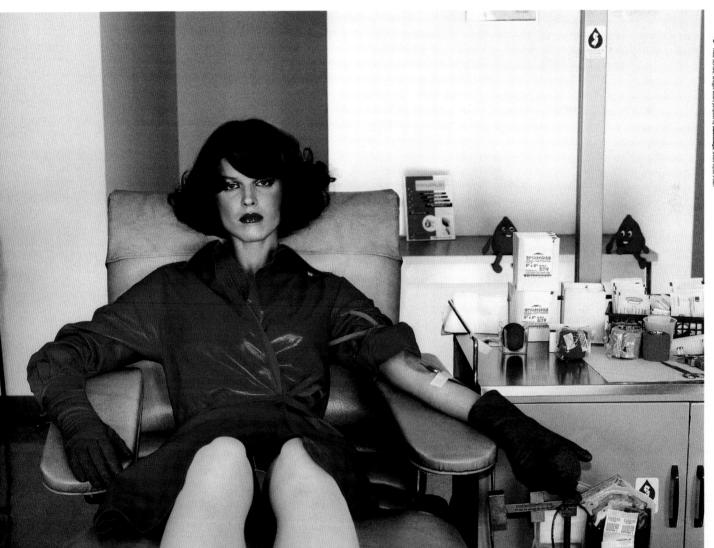

● Eva wears red cold-dress by **Yves Saint Laurent rive gauche**, gloves stylist's own
● PAGE BEFORE: Bridget wears jumpsuit by **Balenciaga**, shoes stylist's own

[following spread]
September 1999
LUCKY SADDLE
photography by Liz Collins
styling by Katie Grand

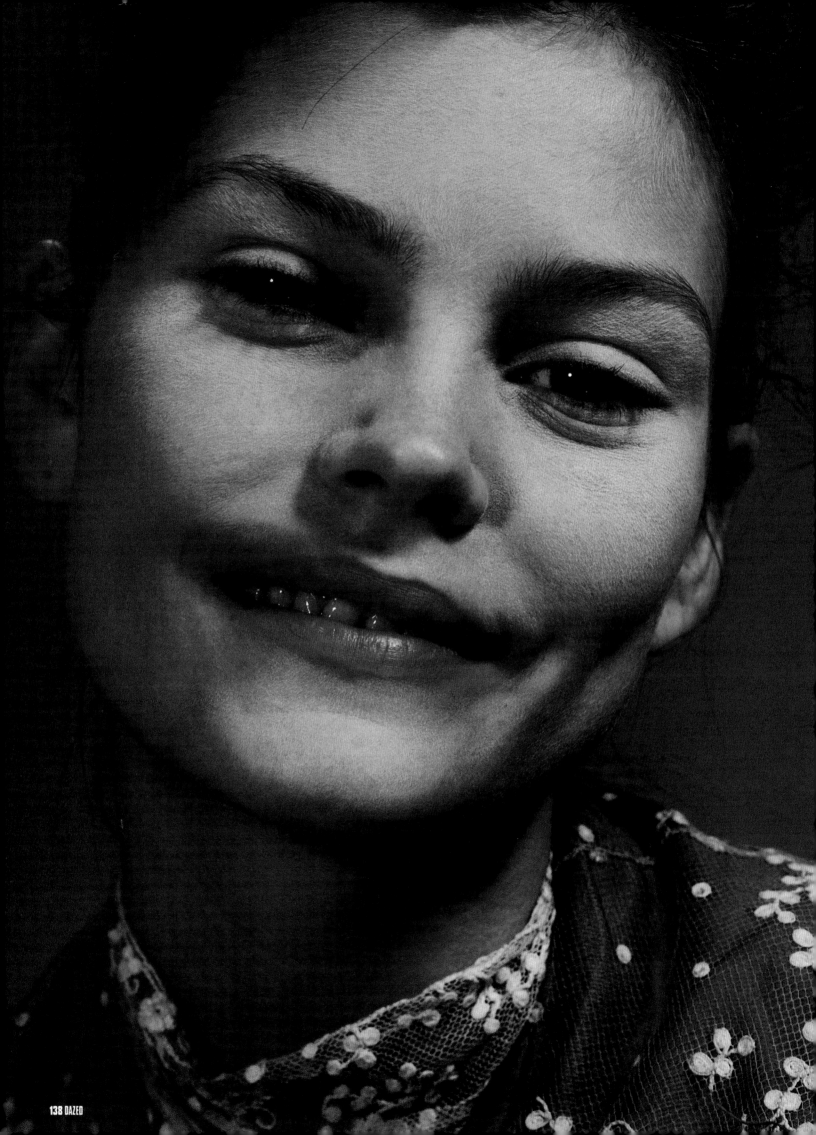

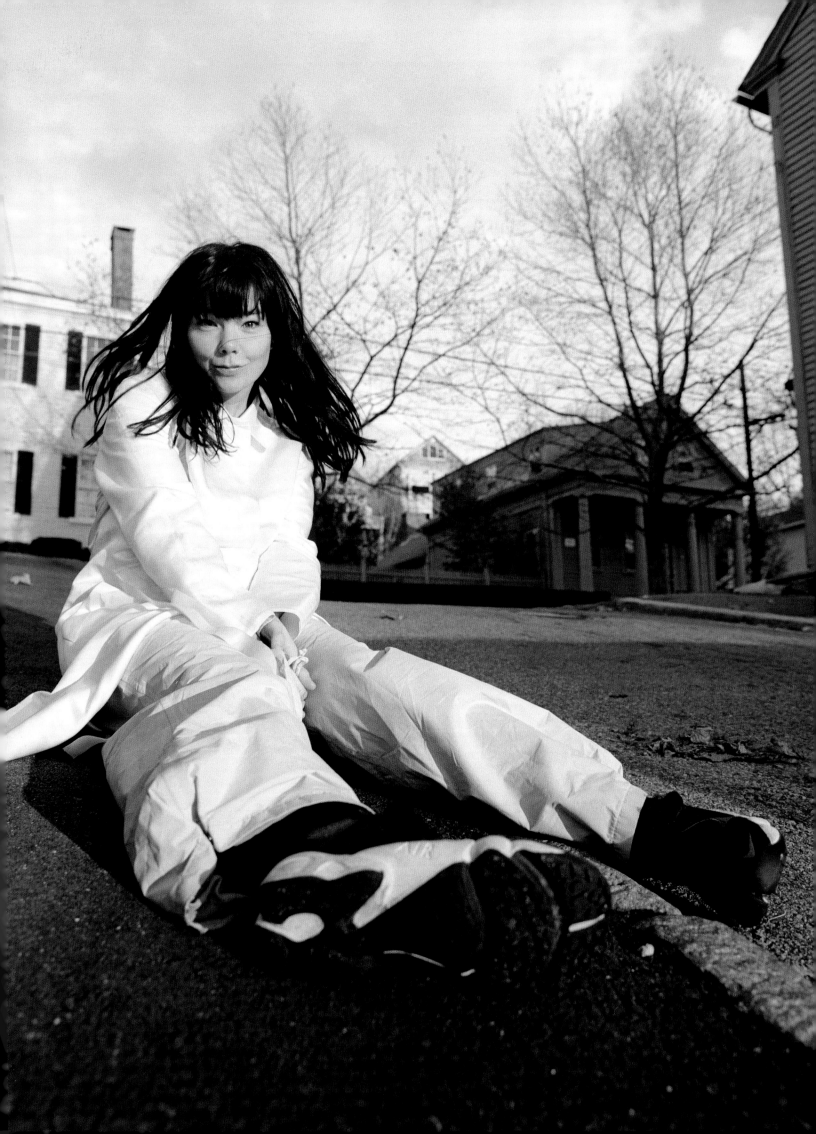

PORTRAITS
The First Decade

"We were always wanting to bring conceptual art photography
into fashion photography and I think, in a way, we spearheaded that.
It was a combination of wanting to be seduced by fashion images, but also
of wanting to bring a critique about culture or society into the picture.
We were always trying to conceive those kinds of images, and as a team
we were always trying to come up with ideas to better each other."

RANKIN

[left]
1995
BJÖRK
photography by Rankin

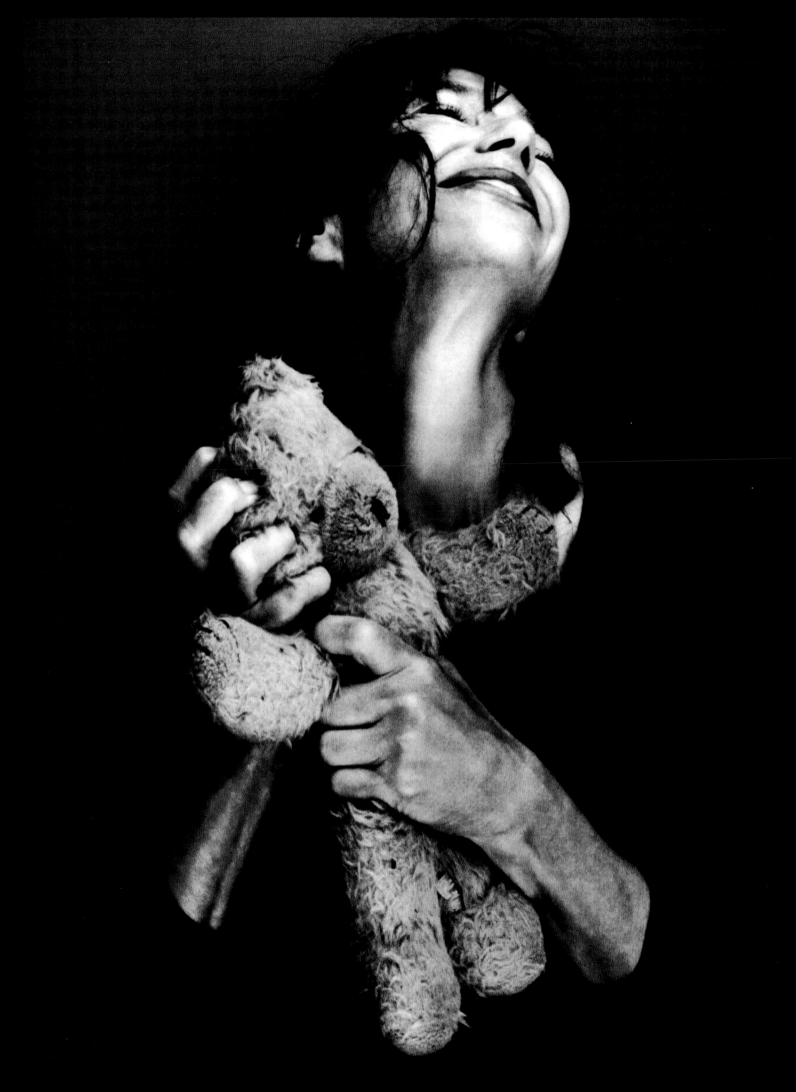

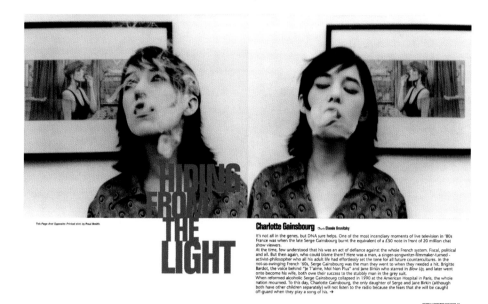

Charlotte Gainsbourg Photo Claude Brunitzky

It's not all in the genes, but DNA sure helps. One of the most incendiary moments of live television in '80s France was when the late Serge Gainsbourg burnt the equivalent of a £50 note in front of 20 million chat show viewers.

At the time, few understood that his was an act of defiance against the whole French system. Fiscal, political and all. But then again, who could blame them? Here was a man, a singer-songwriter-filmmaker-turned - activist-philosopher who all his adult life had effortlessly set the tone for all future countercultures. In the not-so-swinging French '60s, Serge Gainsbourg was the man they went to when they needed a hit. Brigitte Bardot, the voice behind "Je T'aime, Moi Non Plus" and Jane Birkin who starred in *Blow Up*, and later went onto become his wife, both owe their success to the stubbly man in the grey suit.

When reformed alcoholic Serge Gainsbourg collapsed in 1990 at the American Hospital in Paris, the whole nation mourned. To this day, Charlotte Gainsbourg, the only daughter of Serge and Jane Birkin (although both have other children separately) will not listen to the radio because she fears that she will be caught off-guard when they play a song of his. →

"People always think I am this sad person who would watch Bergman films but I'm not into that at all. In fact, I'm into Billy Wilder and comedies in general. My all-time favourite film would have to be The Apartment, with Shirley MacLaine."

In 1994, Charlotte and her dad released a much-criticised duet called "Lemon Incest". The song, which turned out to be a hit, in spite of its suggestive libidinous overtones, led to Charlotte being blamed for her early negroistic success. But it didn't take long for her to prove herself in her prodigious performance in Bertrand Blier's *Merci La Vie*. With increasing celebrity, she began to withdraw from public life. "It's not that I hate doing interviews," she says, "It's that journalists always ask me about my parents or really personal stuff." Her Garbosque dismissal of press interference has contributed to her (now irrevocable) enigmatic nature. The recurring incestuous themes of 1993's *The Cement Garden* did not change that either; "People always think I am this sad person who would watch Bergman films but I'm not into that

at all. In fact, I'm into Billy Wilder and comedies in general. My all-time favourite film would have to be *The Apartment*, with Shirley MacLaine." When Charlotte ventured into the slipstream between the viaducts of our dreams, she resurfaced a stronger, stranger and altogether more significant actress.

Although her latest role in Zeffirelli's *Jane Eyre* might open yet more doors, Charlotte refuses to move to England, "I couldn't live without my dog."

The new Charlotte has just finished shooting with Franco Zeffirelli. The new Charlotte recently made a cameo appearance in MK Solkar's video and yet the new Charlotte continues to hide from the limelight. That's the kind of role model we need.

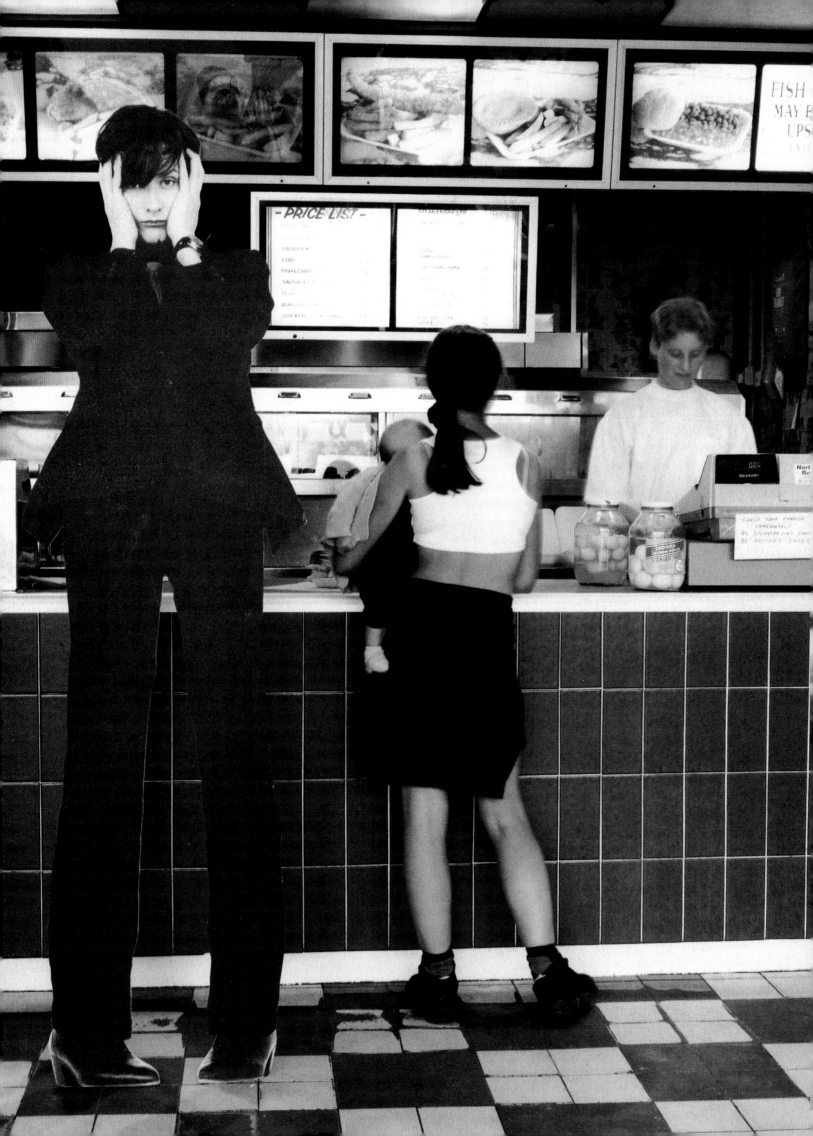

**1995
PULP
IT'S A WRAP**
photography by Rankin

Rankin was commissioned by Jarvis Cocker to shoot portraits for the seminal Britpop album *Different Class*. The rapport he developed with the band led to the concept of re-photographing studio portraits of them in everyday environments for the magazine.

"Jarvis liked the conceptual photography we were doing in *Dazed* and asked me to come over to the studio when they were recording *Different Class*. I remember him showing me this black-and-white image that had been placed in a location and had people moving past it. I drove up to my parents' house and started taking my cut-out portraits of the band around Yorkshire, where they were from. The isolation thing was what they were going for – that thing of being two-dimensional in a three-dimensional world. I think we had an affinity with Pulp at the magazine – all of the band felt like outsiders and we felt like outsiders, too... The weirdest thing was that the cut-out of Jarvis with his arm up ended up on the Chris Evans show every Friday night. It was so strange because it kind of channelled them to the media establishment. I think that's what was kind of interesting about the band and us – we both kind of crossed over into the mainstream, because we always wanted to be successful, but we both retained independence." RANKIN

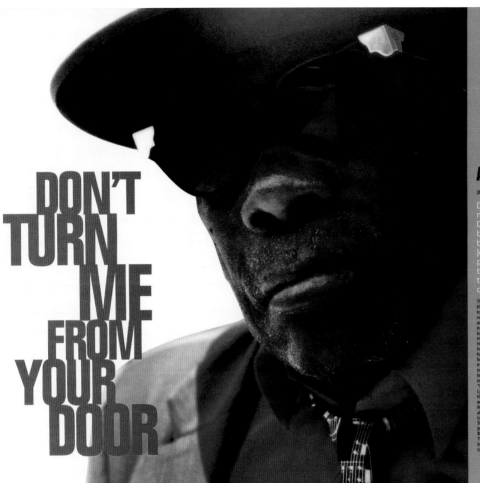

DON'T TURN ME FROM YOUR DOOR

At Home With John Lee Hooker

Interview: Peter J. Relic *Photography:* Danny Hole

Derived from Afro-American spirituals and field chants, moulded in the American Deep South, the Mississippi Delta, Louisiana, eastern Texas and eastern Arkansas, the blues is a music traditionally played in three line, twelve bar cycles, like a car trawling slowly past familiar sights. John Lee Hooker's blues follows no such repeating pattern, but is an organic, changing music, a one-way train that follows the topography of his soul, with hills that must be climbed, valleys we all fall into, and occasional spots to rest in and have a bit of fun.

The American poet Hayden Carruth once posited that the idea of the musical scale does not apply to the blues, because the confining concepts of note, tone, intonation and playing in tune are all antithetical to the spirit of a music whose very expressiveness defines itself. What we are left with is pitch alone, "The primordial root of all and any musics". These primordial roots hold John Lee Hooker's tuneful teeth inside his mouth, crowning his stuttering tongue, a stumbling block transformed by an electric jolt into a starter's brick, his licks run through the crackling terrain of the blues. In the holy sacrament that joins music and electricity, Hooker stands high in the pulpit wielding his guitar like a divine lightning rod, taking downtroddenness and throwing it high into the sky. "Electric sound is so lovely," he says in Michael Lydon's book *Boogie Lightning*: "I felt drawn to it. It's the feel...You barely have to touch the guitar, and the sound comes out so silky." If the fabric of life, sometimes coarse, sometimes silky smooth, is about paying dues, then John Lee Hooker (who recorded under aliases as varied as: Texas Slim, Birmingham Sam and his Magic Guitar, Johnny Williams and The Boogie Man, John Lee Booker) are those dues personified.

The state of Michigan is shaped like a hand with its fingers crimped around the Great Lakes' neck (water whose blue is a shade of black). The city of Detroit is a cleft blown by Lake Erie's brittle winds into the bottom knuckle of Michigan's thumb. John Lee Hooker arrived in Detroit in 1942, part of the exodus of blacks who were leaving the American South to find employment in factories in the North during a time of increased wartime production. Hooker's route to Detroit began in Clarksdale, Mississippi, where he was born into a family of cotton sharecroppers on August 22, 1917. His interest in music was encouraged by a grandfather who nailed strips of innertube to a barn door for John Lee to pluck, followed by the comparatively formal training in the hands of his stepfather Willie Moore, a locally-touted bluesman whose friends included Blind Blake (who sang the immortally sly line *I wish somebody would tell me what diddie wa diddie means*) and Blind Lemon Jefferson. Hooker soaked up the spirit of these men and, by age 14, had moved to Memphis. He worked in a movie theatre, before continuing on to Cincinnati, where he entered the employ of a cesspool-cleaning company. He arrived in Detroit at the age of 24. Clubs along Hastings Street were where he honed his blues after working in automotive and steel plants during the days. *I am a pilgrim and a stranger, travelling through this world alone, got no place to call my own,* Hooker once sang, *Don't turn me from your door,* a plea that passed beyond desperation into a weary, sage-like

DAZED & CONFUSED MAGAZINE **89**

The Verve's Richard Ashcroft

Interview: Paul Moody *Photography:* Rankin

"There's songs we've got on the new album, and I've got no idea where they've come from. I started listening back to them and I don't know who I'm listening to, man. It just comes. I think the key to it all is soul. I really believe that a lot of people haven't got it. The thing about us is that we're harnessed to the past through it. And when you've got something like that, you hang on to it, y'know?"

"Music is a soundtrack to my life and my emotions. It has the power to change the way I see the day."

DAZED & CONFUSED MAGAZINE

"If anybody is influenced by punk, it is us. That is, if punk means doing your own thing and avoiding all the things that you're supposed to be doing, doing things with soul and depth."

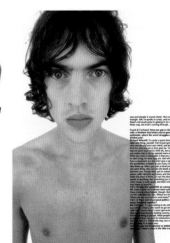

[above]
1995
JOHN LEE HOOKER
photography by
Danny Hole

[right]
1995
RICHARD ASHCROFT
photography by Rankin

[following spread left]
1995
TRICKY
photography by
Richard Varnden

[following spread right]
1995
HOWIE B
photography by Rankin

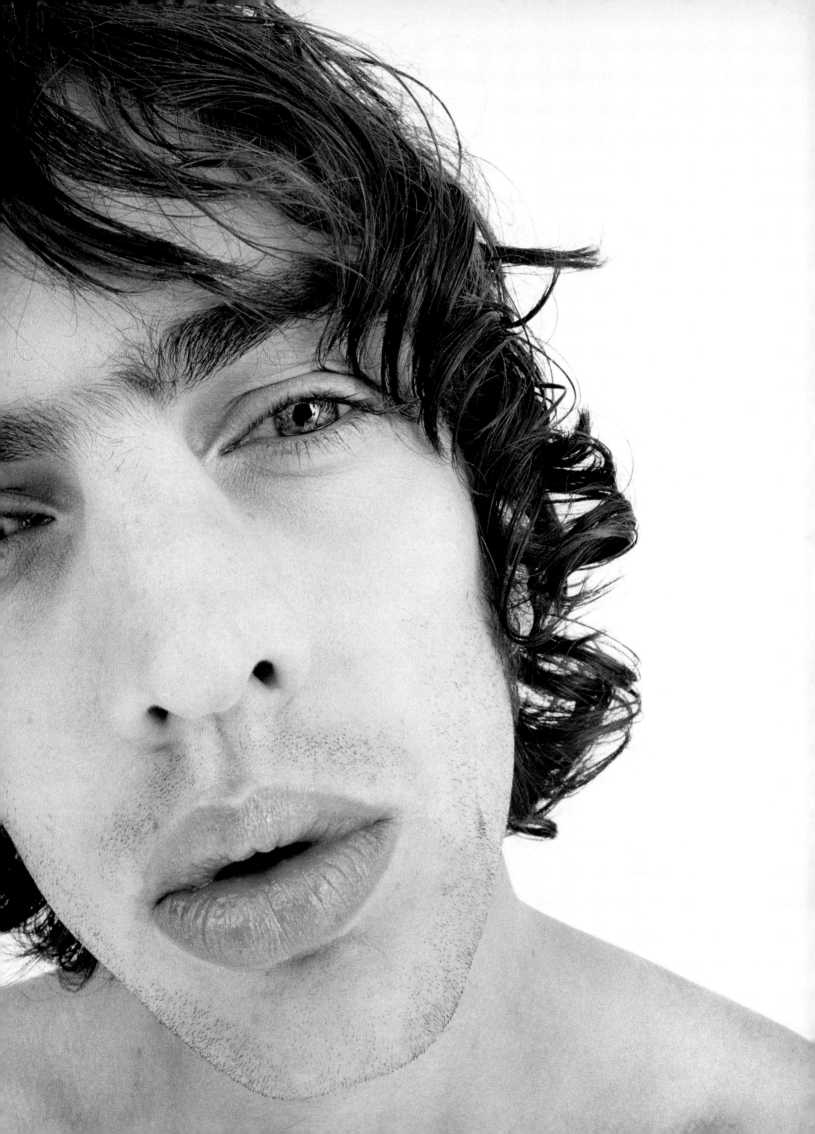

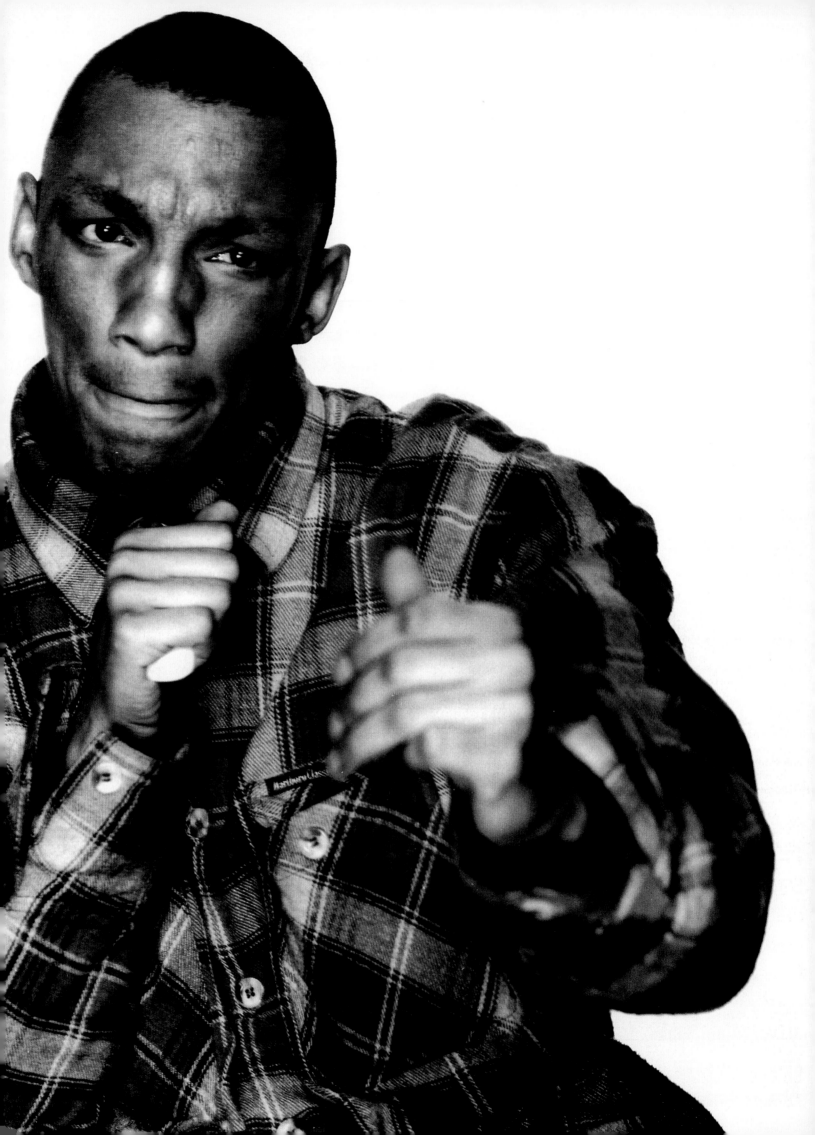

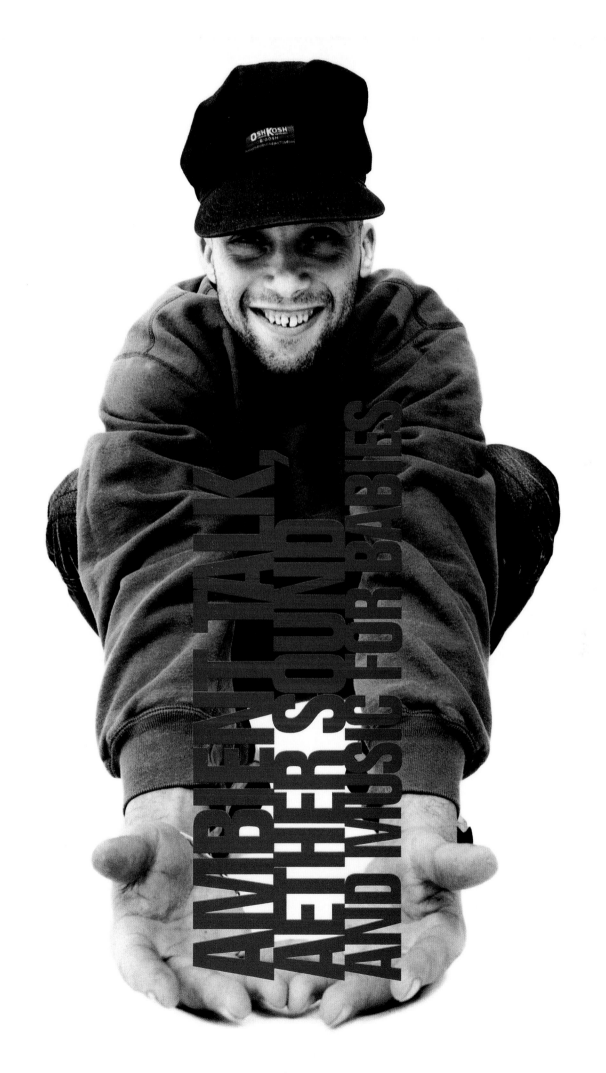

AMBIENT TALK 2
AETHER SOUND
AND MUSIC FOR BABIES

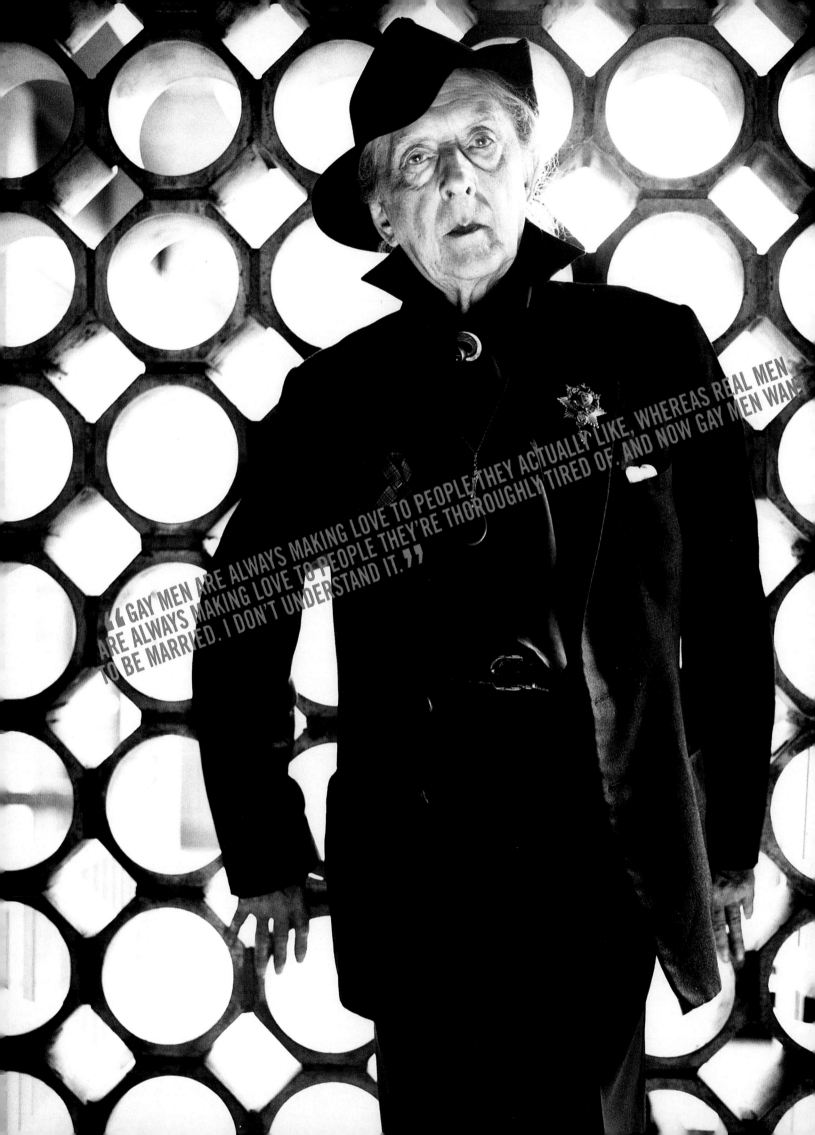

"GAY MEN ARE ALWAYS MAKING LOVE TO PEOPLE THEY ACTUALLY LIKE, WHEREAS REAL MEN ARE ALWAYS MAKING LOVE TO PEOPLE THEY'RE THOROUGHLY TIRED OF. AND NOW GAY MEN WANT TO BE MARRIED. I DON'T UNDERSTAND IT."

CLOSE-UP
AND PERSONAL

MANIC STREET PREACHERS

> "We did the Hacienda on Friday and it was just the most terrible feeling I've ever had when I came off stage and, you know, just uncontrollably crying... it's only the second time after Richey's been missing that I've cried."

JON SAVAGE MEETS NICKY WIRE

JAMES DEAN BRADFIELD

> "I loved him and so did Nicky and so did Sean. But what am I supposed to do? I can't sit in my room forever with the curtains closed being a cold fish."

> "The thing that actually maddened me the most was the speculation. All these strange and wild stories were being concocted by these so-called 'close friends' of Richey's, who probably only met him for 30 seconds."

SEAN MOORE

[left]
August 1996
QUENTIN CRISP
photography by Barry J. Holmes

[above]
June 1996
MANIC STREET PREACHERS
CLOSE-UP AND PERSONAL
photography by Rankin

The *Close-Up And Personal* feature was one of the first occasions when The Manic Street Preachers talked publicly about the disappearance of their friend and band member Richey Edwards. Rankin's incredibly detailed close-up portraits were an attempt to reflect the sensitivity of what the band had been through.

"The Manics was another feature that came from me doing a photo shoot with a band outside of the magazine. The album cover shoot was very much conceived by a guy called Mark Farrow, who is an amazing art director. He wanted to make an album sleeve that felt like you were actually at an exhibition when you looked at it, and, of course, at that time we were still making covers for a twelve-inch format. What informed the shoot in the magazine was this idea that we wanted to look at the band even more closely, almost to kind of see them more clearly... They had been very visual as a band up until that point and had used a lot of quite specific rock'n'roll references. They really wanted to do something different after Richey disappeared. I never really talked to them about that because I never felt comfortable talking to them about it, but I think there was a shift in them and a shift in what they wanted to do. They had definitely moved on as a band."
RANKIN

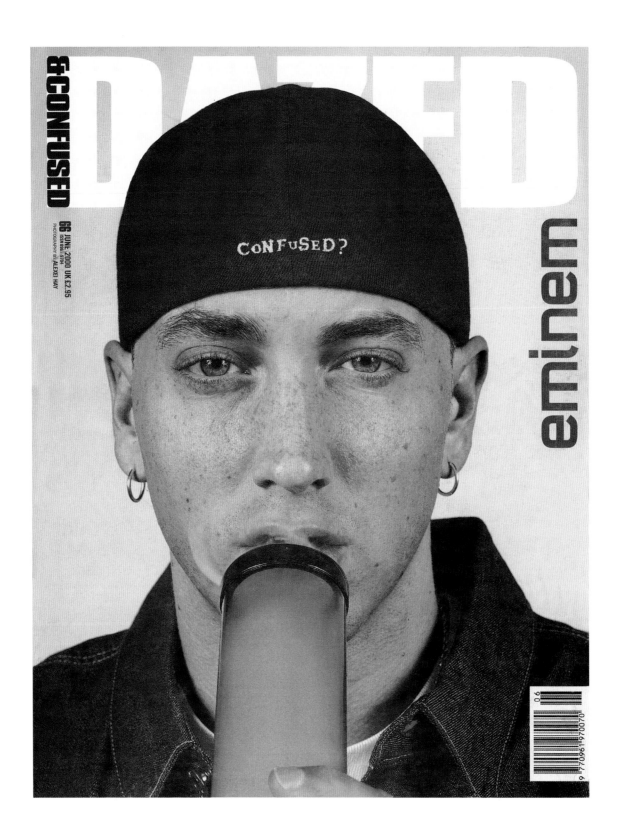

&CONFUSED

DAZED

66 JUNE 2000 UK £2.95
ISSN 0961-9704
PHOTOGRAPHY BY ALEXEI HAY

CONFUSED?

eminem

9 770961 970070

June 2000
EMINEM
photography by Alexei Hay

Alexei Hay shot Eminem for the cover, and the interview inside revealed a reflective side to the rising star that had never been seen before, illustrating his attitude to becoming a role model.

"I remember someone telling Eminem that cannabis smoke would show up better on film than tobacco. After the sixth binger he spilt the bong all over himself. Jefferson looked at the contact sheets and said: 'This looks like a GAP ad gone wrong.' I didn't know quite how to take that." ALEXEI HAY

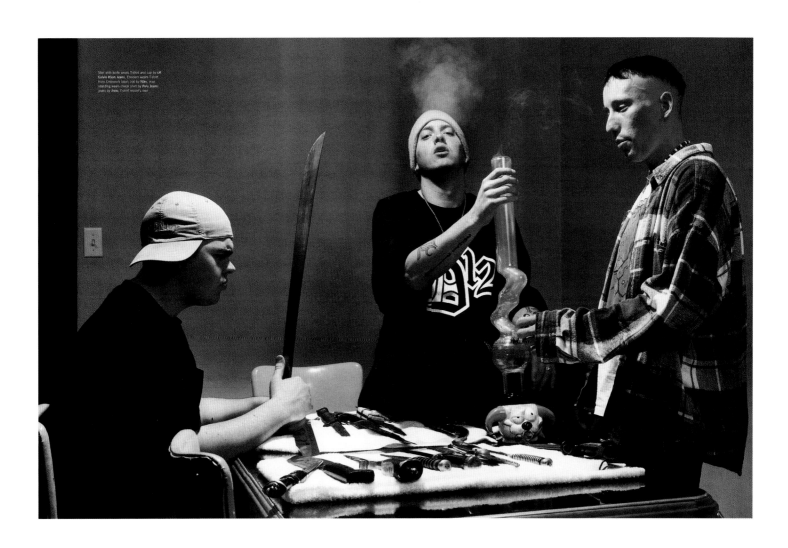

Man with knife wears T-shirt and cap by LK
Calvin Klein Jeans, Eminem wears T-shirt
from Eminem's label, hat by **Nike**, man
standing wears check shirt by **Polo Jeans**
jeans by **Jnco**, T-shirt model's own

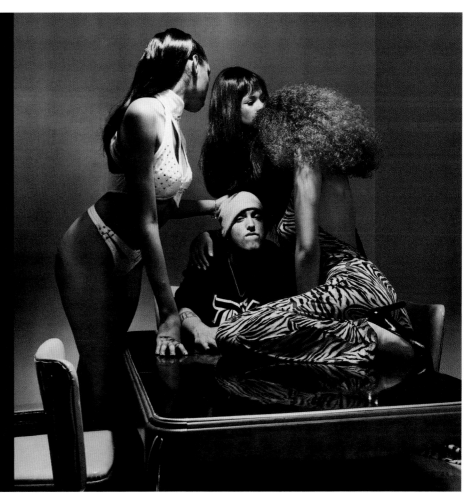

shit. I swallowed a bunch of pills one time, threw up. I don't think I was really trying to kill myself."

Ironically, all this had just occurred right before a rogue Eminem tape landed in the offices of NWA legend Dr Dre. It was Dre who was to become Eminem's personal gateway to the subsequent success of *Slim Shady* which, swerving between Eminem's vivid hyperbolics and synaptic beats, blasted him into the dizziest of pop stratospheres.

Of course the point being that the Eminem now zipped up in a white adidas tracksuit sitting in this Chelsea restaurant, with his Interscope record deal, his new house and his three and a half million album sales, has all the cash he needs to buy into the American Dream™ wholesale. In fact you could almost say that Eminem's rags-to-riches story is the ultimate Dream narrative.

And, like all good American tales, there are lawsuits involved. It turns out that Eminem's grandmother is threatening to sue if he uses a voice sample of Ronnie. Meanwhile in the period following his debut album release, Eminem's mother, Debbie Mathers Briggs, took out a lawsuit against her son for alleged character defamation after he proclaimed *95 per cent of my life I been lied to/ I just found out my mum does more dope than I do* on "My Name Is".

And just like all good American tales, there are also heroes and villains. Only, in the twisted universe of Eminem, he is both. Because not only is Eminem the anti-hero, the moral detractor, the blight on clean-living society; he's the hero that everyone, it would appear, wants a piece of. Not just hip hop heads but brace-teethed girl fans, hearts a-flutter beneath trainer-bras, like the two glossy-haired almost-teens who accost Eminem as he slopes the 50 yard stretch between the hotel's swinging doors and the restaurant.

"Ohmigod! Are you Eminem? it's Eminem! You're my god! My boyfriend loves you!" they squeal as Eminem briefly stops, barely registering (or wanting to register) the hysteria he's just triggered.

And it's not just underage girls but gay boys who dream about Eminem at night. For all that on his new album, *The Marshall Mathers LP*, he configures "faggot" as a term of disrespect. The idea of gay fans rankles him, it is the very macho persona from which Eminem feels they detract, which provides a source of attraction. A tough guy? Acting out fantastical imaginary scenarios? He couldn't get more camp if he tried. Although, once cross-examined about his appearance (unbeknown to him) in a gay publication, Eminem graciously conceded, "That's okay, they're just fucked up, too".

"I've had dudes crying and shit," he rolls his eyeballs. "Trying to kiss my hand and looking at me like I'm not human, like I'm a god or something. Some of them even faint. You get people that think they're entitled to you, the way you put yourself out there. You give them your music but that's not enough, they want more, they want to feel like they are in touch with you. I get a lot of crazy fan mail and meet people at concerts who say ridiculous things to me."

Magnetising not just girl fans or gay fans, Eminem is the first white rapper to coalesce the African-American hip hop fraternity - his rapier-sharp raps effervescing with the same extremity as those of his NWA connections. So it's no wonder that Snoop Dogg, Nas, Missy Elliott, Wyclef and Ice Cube are all fans.

And Eminem's fans are not just rap fans but Korn fans, Limp Bizkit fans.... white middle-class suburbanites transubstantiating their urbane shopping mall existences via his hyperreal concoction of rebellion, nihilism and anything that might shock the neighbours.

Eminem's delinquent nemesis Slim Shady is effective because, like all the best horror movies, he represents a threat to society. But he's not some kind of external, alien threat. Slim Shady is scary precisely because his nihilism reflects a society gone awry from the inside; a fucked-up star, in other words, for a fucked-up world.

Perhaps, like William Blake's apocalyptic poetics before him, Eminem might say

GROOMING MARCOS "RUGGIE" TAYLOR AT
LIFE BARBER STUDIO
SPECIAL THANKS TO CAROLINA GONZALEZ

LIKE ALL THE BEST HORROR MOVIES, EMINEM
REPRESENTS A THREAT TO SOCIETY. BUT HE'S
NOT SOME KIND OF EXTERNAL, ALIEN THREAT:
HE'S SCARY PRECISELY BECAUSE HIS
NIHILISM REFLECTS A SOCIETY GONE AWRY
FROM THE INSIDE

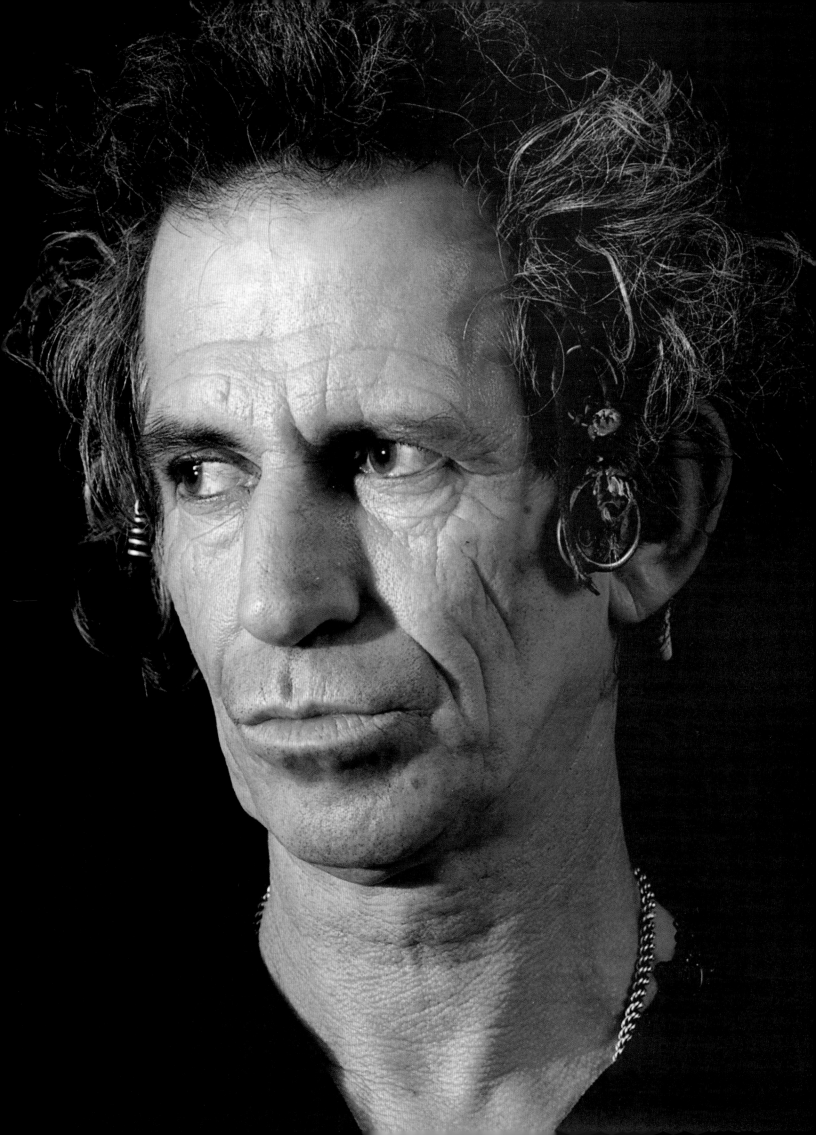

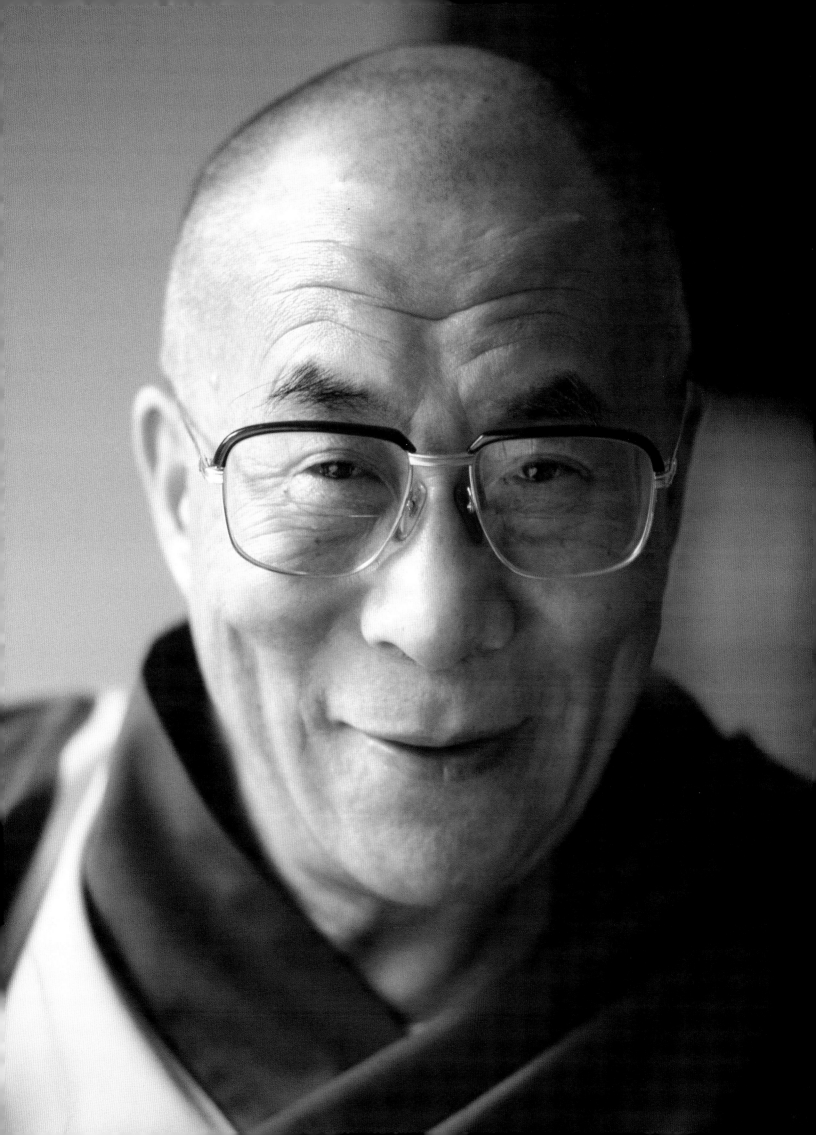

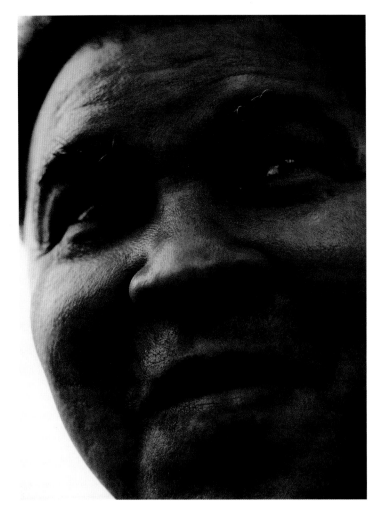

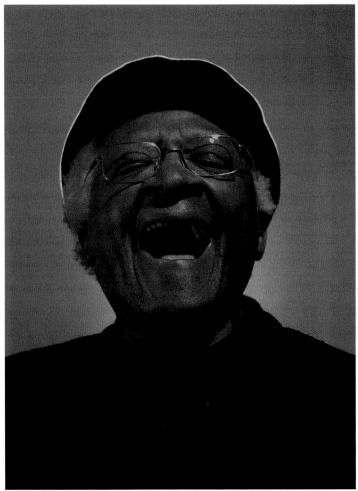

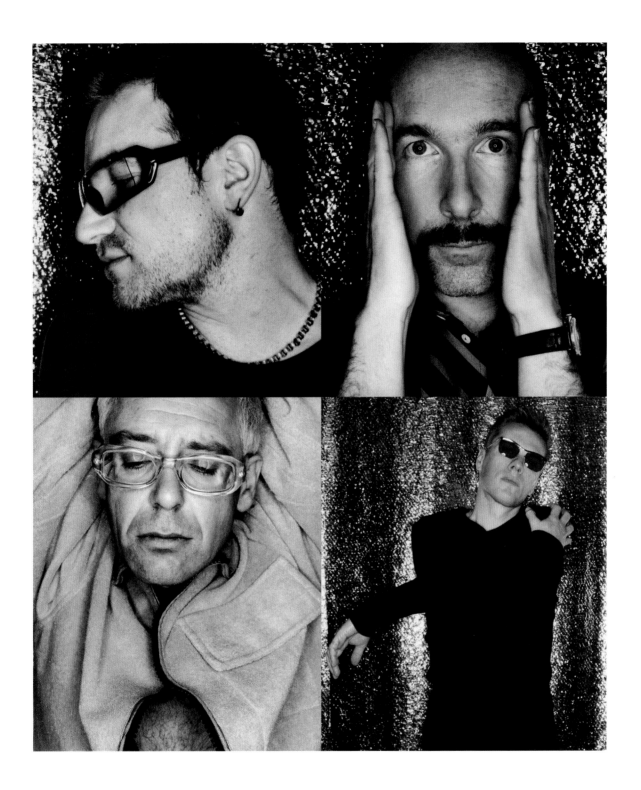

May 1997
U2
TWISTING MY LEMON MAN
photography by Rankin

Rankin was booked to shoot
U2's press campaign at a
time when the band wanted to
reintroduce themselves to a new
generation. Jefferson interviewed
the band, and the relationship

that developed with Bono after
this shoot led directly to the
inclusion of people such as the
Dalai Lama and Muhammad Ali
in the magazine's *Jubilee 2000 –
Drop The Debt* campaign (which
addressed the issue of third-world
debt) and subsequently led to
the creation of the South Africa
issue, which shone a light on the
country's battle with Aids.

forgive his mood-was the momentum
bitterness that made him ?
he was wholly on the side of
freedom
he was wholly on the side of
light

WHOLLY ON THE SIDE OF LIGHT

HARMONY KORINE
MEETS WILL OLDHAM

will oldham
harmony korine

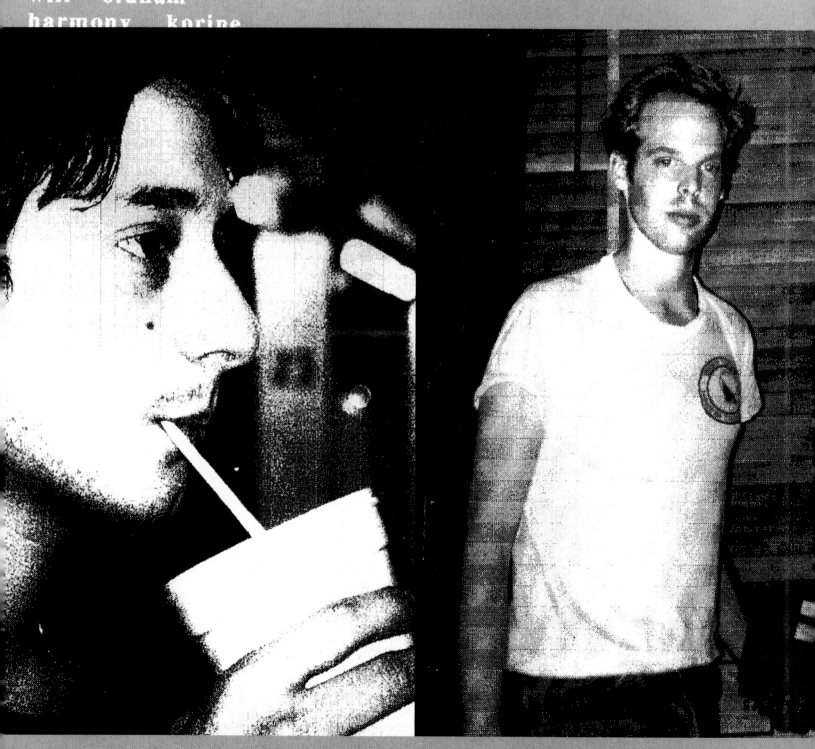

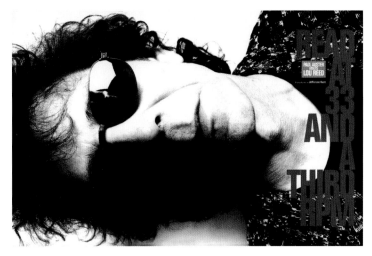

[above]
April 1996
**PAUL AUSTER MEETS
LOU REED**
photographer unknown

[left]
August 1998
**HARMONY KORINE MEETS
WILL OLDHAM**
photographer unknown

[below]
July 1996
ICE-T MEETS GEORGE CLINTON
photography by Dean Chalkley

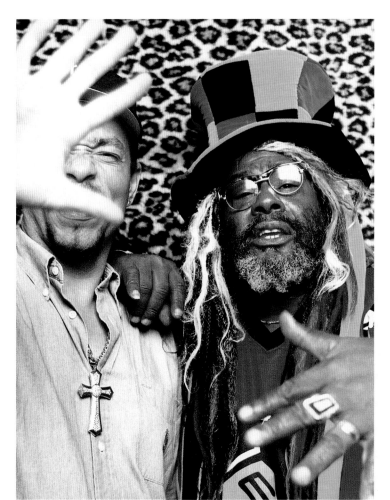

THE MINIDISC INTERVIEW

SUPERFLY
ON THE WALL
ICE-T AND GEORGE CLINTON IN CONVERSATION

Co-ordinated by **Ayo** *Photography* **Dean Chalkey** *Grooming* **Andrew McDonagh**

George Clinton: Remember when we did the New Music Seminar and everybody's talking about 'no censorship'? And everybody agrees. I said, 'I'll see about that shit' and I did 'Niggerish'. I did it to see if they really meant that shit. When I did that poem a black chick from one of those papers came up to me and said, 'Why did you do that? We was in agreement 'til you done that. You know we gotta censor that shit'. 'Cos if there is an exception, then they're full of shit.
Ice-T: That's right! I've been through it. I know I ain't the first, but I've come to the conclusion now there ain't no free speech.
GC: Free speech costs too much (*laughs*). We said that a long time ago, we can't afford free speech.
Ice-T: Yeah. So, as an artist, just be prepared and know that they're going to censor it.
GC: You know, 'Nigga' is a pop word now. White groups are learning how to say it (*laughs*). 'Nigga', not 'nigger'. And the only way you going to get rid of it is to say it to death. If you hide it, it gets more steam and becomes more of a bad word.
Ice-T: When I go to college lectures I say, 'I'm going to use extensively all the vernacular available to me. So what you call 'profanity', I really don't understand. I look up 'profanity' in the dictionary and it says 'blasphemous'. If I look up 'blasphemous', it says 'irreverence'. I challenge anybody to tell me how the word 'shit' is going to send me to hell. 'Shit' has nothing to do with

it. The only word that can be considered irreverent would be 'Goddamn', used in the sense 'God be damned'. Words aren't, they're just slang that your daddy would use as exclamation points.
GC: I'm the dude who could tell you 'Fuck' is the most beautiful word in the English language. You can use it in every way. As a noun, a pronoun, an adjective, compound it. It's like: 'Fuck!'; 'I'll be fucked!', 'fuck off!', 'how the fuck?!'; 'Oh my fucking God!'. And when you finish with it, a conjunction, predicate... you look at it and it's three or four of those motherfuckers. It's the *only* word in the English language that can be used like that.
Ice-T: Great word!
GC: It's a beautiful motherfucking word!
Ice-T: True.
GC: Next. What we doing? We'll fuck on stage.
Ice-T: Let's fuck on stage?
GC: I've seen it. The only nasty thing I saw - it wasn't nasty because I was offended by it. Two motherfuckers getting to get down, gay guys. I mean, that's their thing, right? But I didn't want to look at it on my stage. I didn't want to be confronted with it doing my four hours. They was testing us, seeing if we were going to stop. I was like, 'You win the prize!'. I ain't got nothing against nothing.
Ice-T: I can't watch it.
GC: I can't watch it.
Ice-T: You got anything on the backstage?

GC: Oh yeah, 'No head, no backstage pass'. That was the first T-shirt, right?
Ice-T: I'll never forget. I was on tour with Jane's Addiction. I was in the audience and they were playing, and some girl was, like, singing a song. I was trying to get it with her and I was like 'You want to go backstage?'. Shit like that, I was being nice. I said, 'You like Jane's Addiction?', she says 'Yeah'. I was like 'You want to meet Perry Farrell?'. Perry's standing backstage with his wife. I opened the door; this girl moved on Perry across his wife. Perry looks at me like, 'What the fuck are you doing?'. She's gonna go down on him right in front of his wife. He looks at me, like, 'Why did you let her at me?'. I said, 'I thought she was going to shake your hand, dude. I thought I was getting points from letting her meet you', but no. That backstage shit is a trip. I know that shit... or the hotel?
GC: I got so used to it; my room wouldn't be full, it would be the *fullest*. I would leave. You ain't gonna be throwing motherfuckers out. You wouldn't want to wreck the vibe. It was like 'I love you too'. I think I like what Ice Cube says; 'Dude, get off my dick, and send your bitch over here'. That's some funny shit.
Ice-T: What's the wildest thing anybody ever said?
GC: Motherfucker, six foot four, just got out of prison says, 'I ain't no motherfucking fag, but I'll

[above]
June 1998
KIM GORDON/THURSTON MOORE
SONIC YOUTH
photography by Donald Christie

The face of a generation has konked out. 2-D, the zero-eyed urchin poster boy from Gorillaz, nods forward into a multi-storey sandwich and buries his nose in the snack. There's no sound, but in the air above his head a grafitti scrawled word forms and then vanishes: "SPLAAAAAAAAAT!"

Face down and besmirched by pickle, the graphically scrawny cypher-singer sleeps on, oblivious to the fact that his fellow Gorilla, twisted speedfreak bassist Murdoc, has wedged a lighted cigarette in his ear. Weird scenes inside the slag heap, anybody? Welcome to the flatlands at the furthest point of the pop frame.

As the first one allowed into the Gorillaz warren of crash pads'n'studios I was expecting peculiarity. For months now the Dark Pop Kings have been the subject of scurrilous rumour and tabloid mendacity. Are they 4 real? Who's behind them? How does 2-D get his hair looking like an acid house balloon? And is the precognitive mesh of their ghetto-ghost punk beatz a vile cardboard cut-out commodification of youth's primal anomie, or cutting edge cool that pisses all over Coldplay?

All of these questions prong right out the window the moment the hack stumbles in on 2-D, Murdoc, Russel and Noodle. Amongst the chaos of lo-tech gear and bad lifestyle junk cluttering the Gorillaz studio den, a disorientating inner band chemistry bubbles.

Hulk-like American drummer Russel frowns down at his zombied-out frontman. "If 2-D chokes on his sandwich, you're going to jail Murdoc," he growls, towering over his scrot-faced bass player.

"Death by saaaandwich, man!" gurgles Murdoc. "Fook off! He attacked me sandwich. That is a Swedish Death Metal Special and his dumb-assed face is trespassing in it." Russel folds his arms. "Remove him from the snack, Murdoc!" he orders.

"That is a Sandwich Of Odin. Black Pork'n'pickle!" Murdoc reluctantly complies, muttering satanic mantras under his halitoseid breath, "Each pig that went into that butty was individually tattooed with a satanic emblem by Ozzy's tattooist. War Pigs in the area! 'Witches gather at black maaaasses/Bodies buring in red aaaashes!'"

So Murdoc's singing and air-guitaring and Russell's glaring and 2-D's turning blue and suddenly, from the corner of the studio, a dwarf baboon robot with a radio antenna in its head somersaults into Murdoc's arse, butting him across the room. The bassist collides with the sandwich, Murdoc slides in front of 2-D and a burning fag drops from the singer's ear onto Murdoc's arse.

"Noodle you friggin' Wasabi bitch, I'm on fire!" Murdoc yells, running to plonk his flaming behind in the studio goldfish tank. The small Japanese girl clutching the baboon's remote control shrugs and opens her Mao jacket to reveal a t-shirt. The slogan reads 'NO PAIN : NO PUBLICITY'.

"Gorillaz!" yelps Noodle, hugging 2-D and wiping pickle off the singer's face. "Atashitachi wa chikyu o osaeru zo!! [We're on a non-stop mission to take over the world!!]"

"Hey guys," mutters a semi comatose 2-D. "What time are we on stage?"

Ten years dragging your typewriter through the gutters of pop and you encounter some strange shit: Trustafarian skate-metal bible-bashers, dick-fixated drum'n'bass DJs, Finnish reggae bands, puking Northern disco clans, Argentinian Nazi midget bands, neanderthals, Godfunk-robots, alienated Sloanes, Martians, wannabe-Martians, gristle, jellyfish, pond life. Nothing, however, compares to Gorillaz.

The story goes that Stoke On Trent-born bassist Murdoc put the band together after encountering the pretty boy singer 2-D when he attempted a heist at the organ shop where 2-D worked. Murdoc's Vauxhall Astra rams the shop window hitting Crawley kid 2-D in the head. Injuries are sustained, community service is handed out and a flickerbook of 'formative' events is set in motion.

US beats envoy Russel turns up in a Soho hip hop shop after leaving behind a trail of spook in New York. A posh boy who got tangled with the downtown brothers, he allegedly ingested the spirits of a rapper when he was the only survivor from a drive-by shooting. A ghost rapper named Del now lives inside Russel. As for the Japanese guitarist, Noodle, she came by mail order. In a crate, apparently.

The globally correct, haunted dancehall dub punk profile sounds suspiciously hipper-than-thou. The tale of double-denting eyeball fractures, transatlantic out-of-body wassups! and ten-year-old Manga-Metal girl axe heroines has the ring of hype.

Or at least that's what it sounded like until the taxi swung off the road in the gloomy flatlands of South Essex and I took the climb up the slagway to their haven, feeling somehow more animated with every step.

Weird Scenes Inside The Slag Heap: Part 2.

As his hair sleeps on, 2-D shakes himself half-awake. "F'ing, is right, I'm up for it," mumbles the front man. "Rock'n'roll is like space, right? It's infinite, innit, so you can like, be whatever. And I am whatever. Whatever is my father and my muvver. And my nan. You just gotta let it out. Forever, and whatever, amen."

"Yeah thanks, pal," sneers Murdoc. "Want some diazepam to help you think more clearly? Mind like an unfurnished black hole that kid. You're not going to write any of that dribble down are you mate? Owzabout we listen to our album now."

Creative chemistry is vital for a great band. Chemicial warfare is more the Gorillaz style. We have convened for a playback of the band's debut album, but first Murdoc decides to get a "vibe" going. For the next half an hour we are forced to listen to Sabbath's "Paranoid" three times, plus an entire Deicide album while Murdoc makes the devil sign, shouts "Tune!" and swigs from a bottle of black vodka.

"Alright my friend, I am not feeling these compositions," declares Russel. The drummer stomps to the decks, and removes the offending vinyl, gouging a deep scratch into the surface. "Oh I'm sorry Murdoc. Guess that's slightly unplayable now."

"Oi! MC Grandmaster Twat!" yelps Murdoc. "Scratch one more of my tunes and I'll

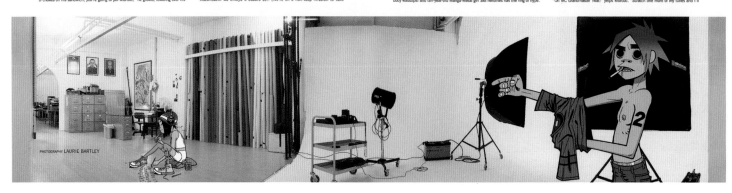

PHOTOGRAPHY LAURIE BARTLEY

[above]
January 2001
GORILLAZ
photography by
Laurie Bartley
illustration by Jamie Hewlett

[right]
July 1999
BLUR
BOYS WHO LIKE GIRLS
photography by Rankin

The Blur portraits were one of the magazine's forays into multiple covers and were shot in the Dazed Studio by Rankin. Later in his career, Damon Albarn launched Gorillaz with *Dazed & Confused* and suggested that Jamie Hewlett draw the characters in the band hanging out in the Dazed Studio. It was a highly self-referential piece of work that perfectly captured the vibe of the *Dazed & Confused* office.

BOYS WHO LIKE GIRLS
The rules are these: Graham – meet Sam Taylor-Wood. Dave – meet Daisy Donovan. Alex – meet Marianne Faithfull. Damon – meet Kathy Burke. →

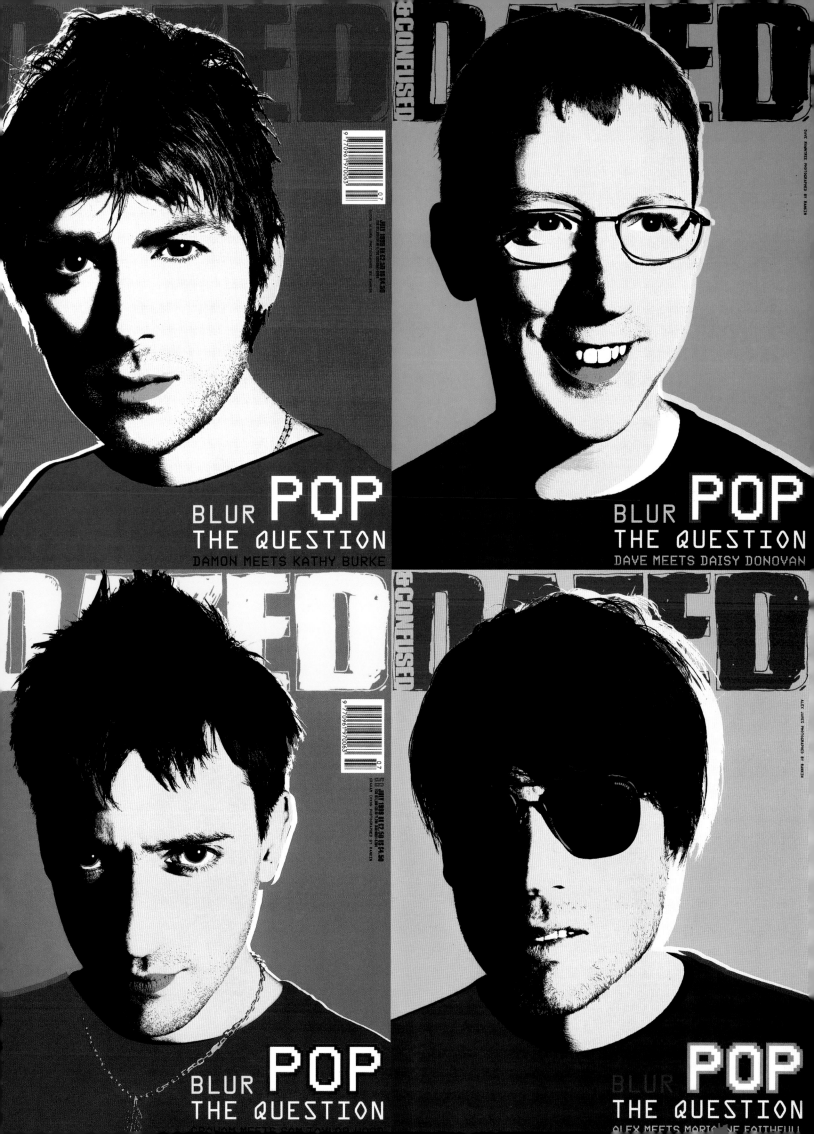

DAZED &CONFUSED

BLUR POP THE QUESTION
DAMON MEETS KATHY BURKE

BLUR POP THE QUESTION
DAVE MEETS DAISY DONOVAN

BLUR POP THE QUESTION

BLUR POP THE QUESTION
ALEX MEETS MARIANNE FAITHFULL

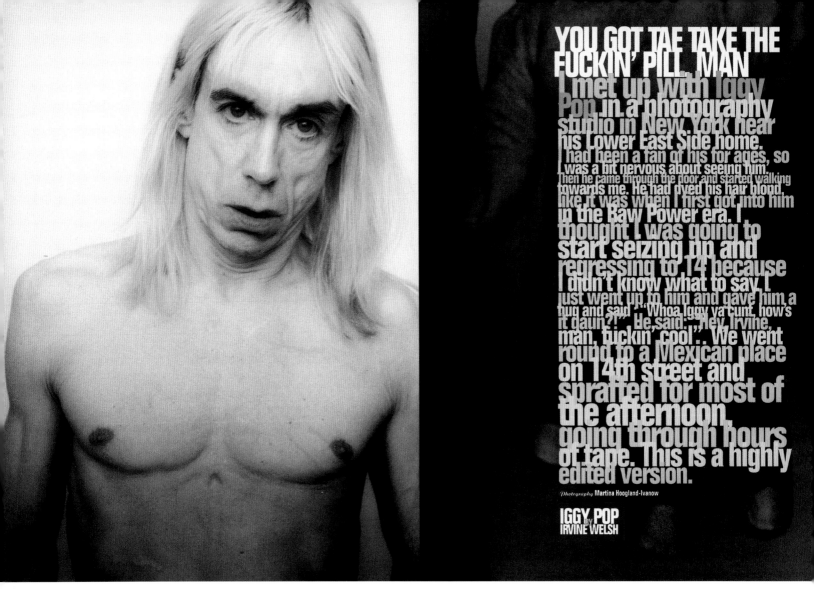

YOU GOT TAE TAKE THE FUCKIN' PILL, MAN

I met up with Iggy Pop in a photography studio in New York near his Lower East Side home. I had been a fan of his for ages, so I was a bit nervous about seeing him. Then he came through the door and started walking towards me. He had dyed his hair blond, like it was when I first got into him in the Raw Power era. I thought I was going to start seizing up and regressing to 14 because I didn't know what to say. I just went up to him and gave him a hug and said : "Whoa Iggy ya cunt, how's it daun?". He said : "Hey Irvine, man, fuckin' cool". We went round to a Mexican place on 14th street and sprafted for most of the afternoon, going through hours of tape. This is a highly edited version.

Photography **Martina Hoogland-Ivanow**

IGGY POP
BY
IRVINE WELSH

[above]
March 1996
IGGY POP
photography by
Martina Hoogland Ivanow

[right]
March 1998
IRVINE WELSH
MEETS DENNIS COOPER
photography by
Donald Christie

These interviews between Irvine Welsh and Dennis Cooper, and Irvine Welsh and Iggy Pop, marked early experimentation in bringing strong personalities together in two-way interviews, which became an integral part of the magazine's editorial identity.

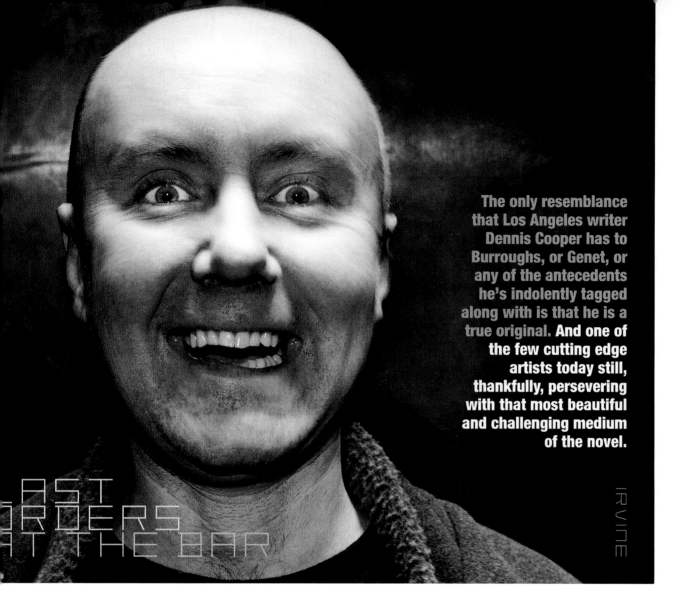

The only resemblance that Los Angeles writer Dennis Cooper has to Burroughs, or Genet, or any of the antecedents he's indolently tagged along with is that he is a true original. **And one of the few cutting edge artists today still, thankfully, persevering with that most beautiful and challenging medium of the novel.**

LAST ORDERS AT THE BAR

IRVINE

I came across Dennis Cooper's writing a few years back and checked out a reading of his in Edinburgh. The one thing that struck me was the audience, firstly how small it was; secondly how everyone there seemed to be a writer, or a musician, or artist of some sort. It was reminiscent of Eno's comment about the Velvet Underground's first album: how hardly anybody bought it, but all those who did tended to go out and make records of their own. In the same manner, Dennis Cooper's writings have a powerful cult influence which stretches way beyond his sales profile.

As is the general nature of such scenarios, there has been no shortage of voices suggesting that this a far from positive influence. It's true to say that Cooper pushes the limits of liberal tolerance as far as it can go; obsession, disengagement, and mental collapse invariably manifest themselves in torture, murder, and paedophilia. Some would argue that this is one of the key functions of art. Personally, I've always inclined to the view that anything can, and should, go onto the blank page, if the intent is honest. I also think that most people can intrinsically distinguish between genuine artistic intent and crass exploitation. Powerful figures in politics, business, and the media have always been fond of hamming up the extent to which art forms can exert a (negative) influence on people, usually in order to smokescreen their own dirty deeds and shortcomings.

I personally found Dennis Cooper's new book *Guide*, his most unsettling, not due to its content, but because I felt that the writer employed a stylistic device which served to blur the lines between selective internal biography (ie: personal fantasy and obsession) and fiction. In *Guide*, the author attributes his own name 'Dennis' to the central protagonist and narrative voice. This was also the case in his earlier novel *Frisk*. This character then obsesses over real people like the guitarist from Menswear, the actor Leonard DiCaprio, and most chillingly, the bassist Alex James from Blur (or, more accurately, the media construction of those people) with the standard Dennis Cooper outcomes. By taking this route I felt the writer had introduced an unsettling and perhaps unnecessary element to his fiction and could even be guilty of 'stalking through the page'. I couldn't really see what the point of doing this was, outside of unsettling or confusing the people in question. This was one of the major themes I wanted to explore with Dennis Cooper. What follows was a discussion in a north London pub.

Incidentally, in person Dennis Cooper was humorous, relaxed and playful, far removed from the intense, tortured predators who are the protagonists of his novels.

DAZED 43

Irvine Welsh: Maybe the best thing to do is for me to pick out some themes from the book. One thing is that use your own name for the narrator. And you've got characters who can be identified as real people, various Britpop stars. Do you see that as a literary mechanism? Can you explain why you've changed your approach?

Dennis Cooper: I guess I have to say that all the books are part of the same project. It's like the same book written five times. In this case, mostly I was interested in just exposing the mind creating the novel. It was a device. I feel this idea about making this book sort of "architectural". I was thinking a lot about building this sculptural thing, out of words... so that it was somewhere inbetween the spaces. I wanted to have the mind working, which is like the depth, the bottom of it, and then I wanted the pop-cultural references to give a this real, light, recognisable surface. But hopefully it's not about either one.

IW: It's kind of like a film. You can see these major representations of rock stars. It's like their media stereotype characters that come out.

DC: Yeah, they're totally cartoons. Everything they say is, like, the most clichéd.

IW: That's what I found most unsettling about the book - that you're rushing between 'fact' and fiction. It's quite a dangerous, subversive device because it breaks down the division between the two. I've never met Alex James but I know Damon Albarn quite well. To see them popping up as characters in a work of fiction is quite strange.

DC: What was the effect?

IW: It brought the excesses of fiction and made them more real. It brought together these two worlds, the real world and the created world.

DC: The Blur characters and the other characters are so falsified. Ostensibly all the thought processes, all the nuances, the apologising and the confessions and all that - they're not true. I wanted the Blur thing to kind of meet with 'the other'. One of the characters says that what he really wants is to be at that moment when he is about to die and know what that's like. I was thinking about that for the whole book. And acid was a great device for creating that space. The book's doing that on every level.

IW: Have you felt that kind of frustration, when you're tripping on acid, and you're in this world where you're seeing things in a different way... and when you come back, it's like waking up from a dream, and it's all slipped through your hands. You think - is there a way I can access that, and take it back? You get the idea that there's so much here. You can break through the barriers but there's no terms of reference to bring it back.

DC: Yes. That's what the book's really about. And how you isolate. There are things in the book where everything just goes completely haywire... but it's all in a language of sanity. Yeah, I was totally trying for that. I mean, that whole thing in the book is true... about how I took acid every day for a month and had a nervous breakdown. At the end of it, I couldn't talk for about six months. I was so wiped out. That was my big attempt to... bring it back. I thought if you took enough of it, you would just stay there. My mind had been in that state so long that I thought it would always be in that state. Of course, that's the kind of thing you think when you're on acid!

IW: You think to yourself - why is there this sort of inhibition? Is it a way of maintaining your sanity, is it something that evolution has given to us in degrees? Or have we not developed in an intellectual way, and in a social way, to be able to process that information?

DC: Language is so inadequate to get it out. It's so tough. Also, sex is such an on-acid thing. It's so weird to bring that into the equation - what would happen to sex if you were on acid? When I took acid I was never horny.

IW: There's too much going on to construct a sexual

DAZED

DENNIS

DAZED

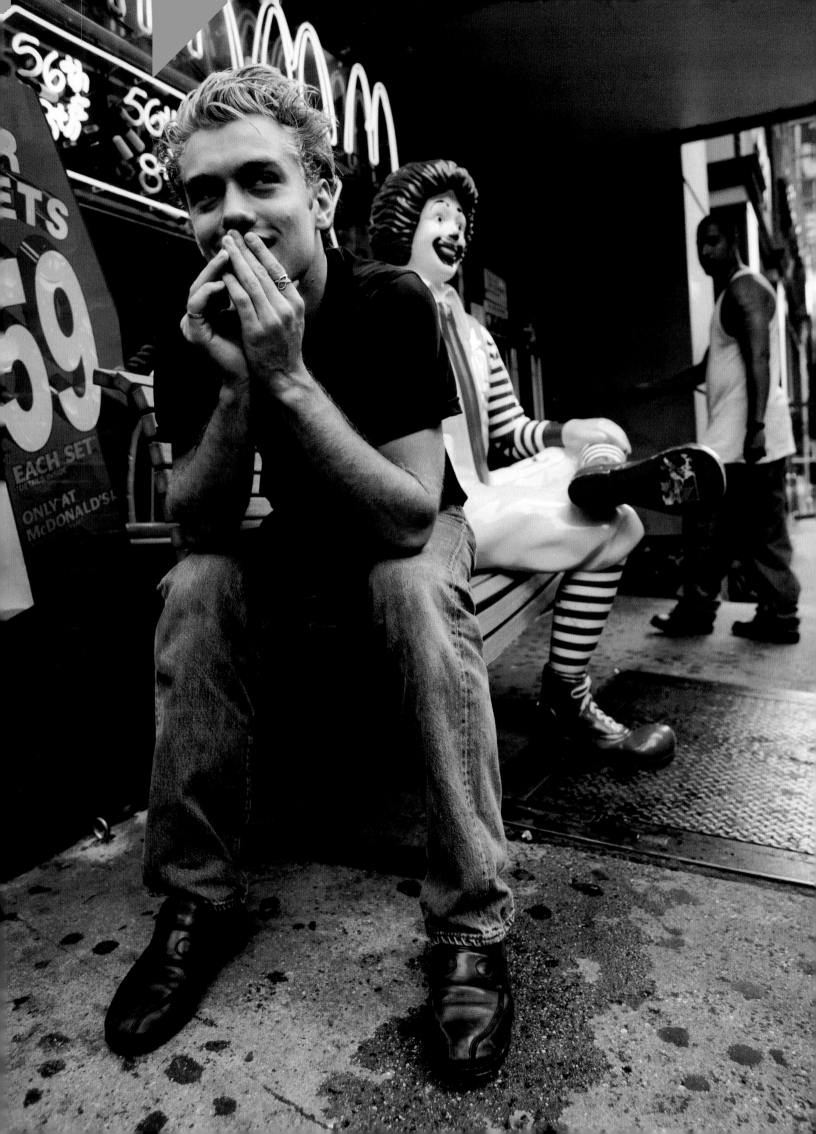

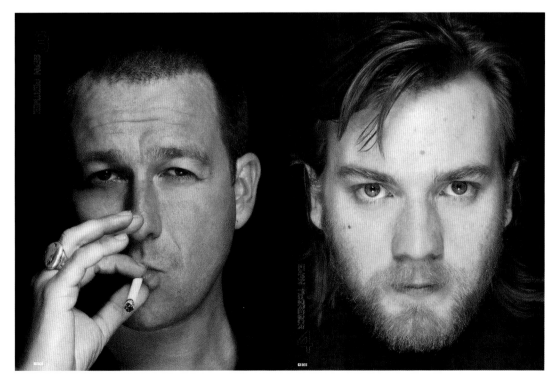

[this page]
April 1999
JUDE LAW, SADIE FROST,
SEAN PERTWEE &
EWAN MCGREGOR
photography by Rankin

[left]
1995
JUDE LAW
photography by Rankin

This very early shot of Jude Law on Broadway was taken at a time when British film was garnering a lot of international attention. The accompanying feature was on the vanguard of British acting, all of whom had come together to form the Natural Nylon production company.

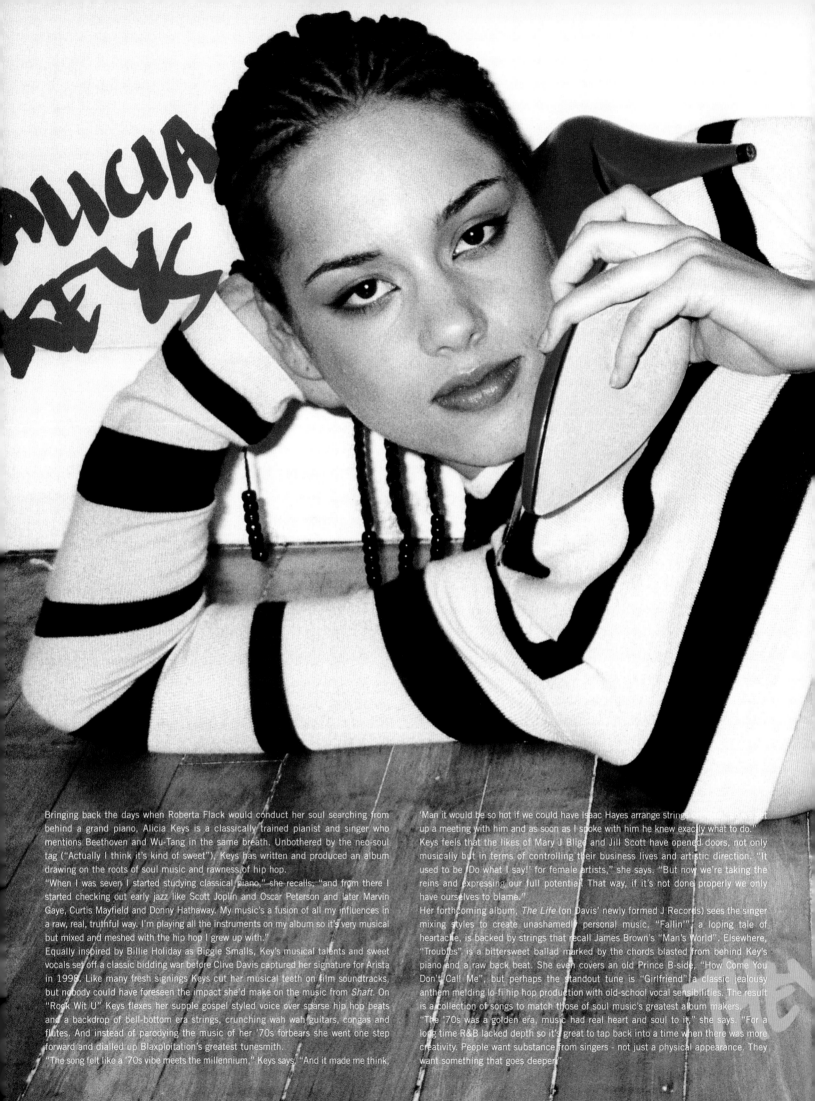

ALICIA KEYS

Bringing back the days when Roberta Flack would conduct her soul searching from behind a grand piano, Alicia Keys is a classically trained pianist and singer who mentions Beethoven and Wu-Tang in the same breath. Unbothered by the neo-soul tag ("Actually I think it's kind of sweet"), Keys has written and produced an album drawing on the roots of soul music and rawness of hip hop.

"When I was seven I started studying classical piano," she recalls, "and from there I started checking out early jazz like Scott Joplin and Oscar Peterson and later Marvin Gaye, Curtis Mayfield and Donny Hathaway. My music's a fusion of all my influences in a raw, real, truthful way. I'm playing all the instruments on my album so it's very musical but mixed and meshed with the hip hop I grew up with."

Equally inspired by Billie Holiday as Biggie Smalls, Key's musical talents and sweet vocals set off a classic bidding war before Clive Davis captured her signature for Arista in 1998. Like many fresh signings Keys cut her musical teeth on film soundtracks, but nobody could have foreseen the impact she'd make on the music from *Shaft*. On "Rock Wit U" Keys flexes her supple gospel styled voice over sparse hip hop beats and a backdrop of bell-bottom era strings, crunching wah wah guitars, congas and flutes. And instead of parodying the music of her '70s forbears she went one step forward and dialled up Blaxploitation's greatest tunesmith.

"The song felt like a '70s vibe meets the millennium," Keys says, "And it made me think,

'Man it would be so hot if we could have Isaac Hayes arrange strings. [...] set up a meeting with him and as soon as I spoke with him he knew exactly what to do." Keys feels that the likes of Mary J Blige and Jill Scott have opened doors, not only musically but in terms of controlling their business lives and artistic direction. "It used to be 'Do what I say!' for female artists," she says. "But now we're taking the reins and expressing our full potential. That way, if it's not done properly we only have ourselves to blame."

Her forthcoming album, *The Life* (on Davis' newly formed J Records) sees the singer mixing styles to create unashamedly personal music. "Fallin'", a loping tale of heartache, is backed by strings that recall James Brown's "Man's World". Elsewhere, "Troubles" is a bittersweet ballad marked by the chords blasted from behind Key's piano and a raw back beat. She even covers an old Prince B-side, "How Come You Don't Call Me", but perhaps the standout tune is "Girlfriend" a classic jealousy anthem melding lo-fi hip hop production with old-school vocal sensibilities. The result is a collection of songs to match those of soul music's greatest album makers.

"The '70s was a golden era, music had real heart and soul to it," she says. "For a long time R&B lacked depth so it's great to tap back into a time when there was more creativity. People want substance from singers - not just a physical appearance. They want something that goes deeper."

PEOPLE WANT SUBSTANCE FROM SINGERS NOT JUST A PHYSICAL APPEARANCE WANT SOMETHING THAT GOES DEEPER

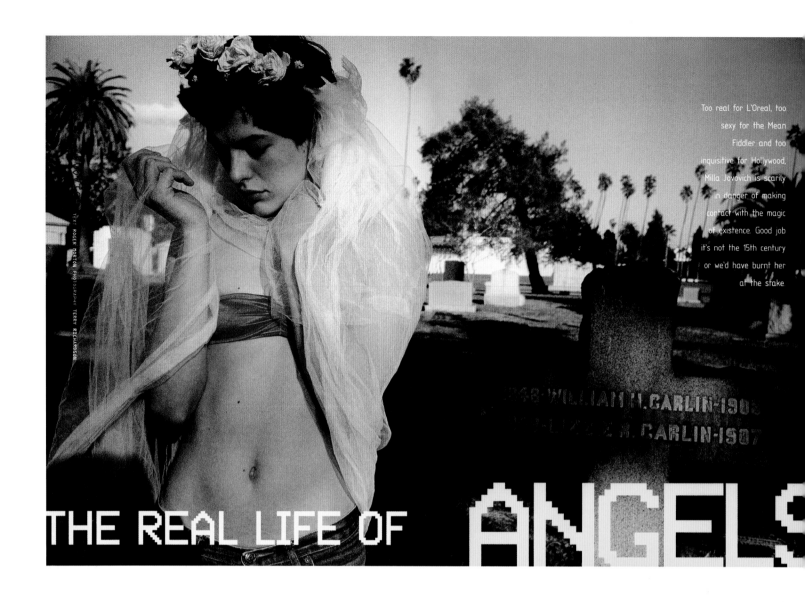

TEXT ROGER MORTON PHOTOGRAPHY TERRY RICHARDSON

Too real for L'Oreal, too sexy for the Mean Fiddler and too inquisitive for Hollywood, Milla Jovovich is scarily in danger of making contact with the magic of existence. Good job it's not the 15th century or we'd have burnt her at the stake.

THE REAL LIFE OF ANGELS

[this spread]
June 1999
MILLA JOVOVICH
photography by
Terry Richardson

[previous spread]
June 2001
ALICIA KEYS
photography by
Terry Richardson

"Terry Richardson has such a sense of community and he has a continual dialogue with the people he tends to approach to shoot. He treats celebrities like Alicia in exactly the same way he treats everyone else – it's a light approach; it's fun. He's such an amazing character to be around because he's like a child trapped in a man's body – he's just very, very amusing. I think that his innate enthusiasm always comes through in his portraiture – it's kind of become his trademark. My favourite shoots he did for the magazine were always the more personality-based ones. There had been a long era of digital manipulation and his approach felt refreshing – much more real, much more human, with much more energy in it. There is always a very real feeling with Terry's work that you have gotten to know the people he shoots, even if you never meet them." EMMA REEVES

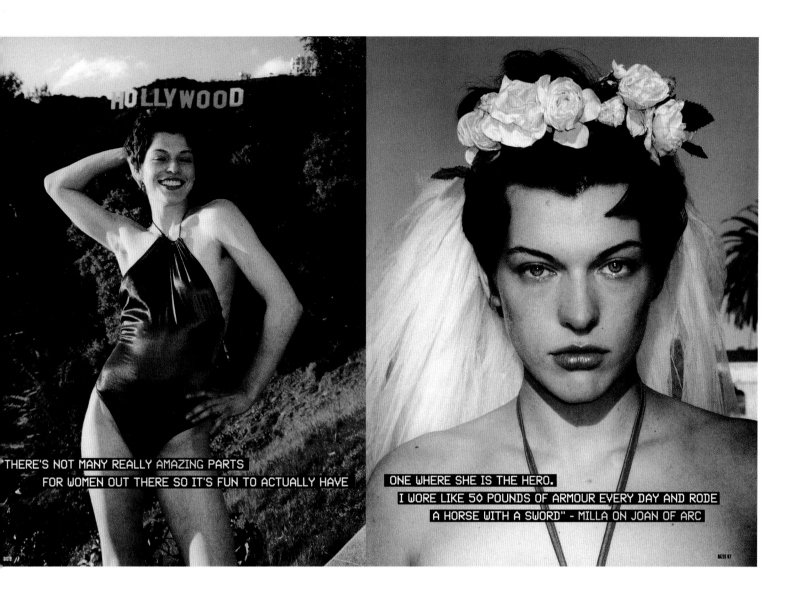

THERE'S NOT MANY REALLY AMAZING PARTS
FOR WOMEN OUT THERE SO IT'S FUN TO ACTUALLY HAVE

ONE WHERE SHE IS THE HERO.
I WORE LIKE 50 POUNDS OF ARMOUR EVERY DAY AND RODE
A HORSE WITH A SWORD" - MILLA ON JOAN OF ARC

June 2000
SUSAN SONTAG
photography by
Dana Lixenberg

[left]
April 2000
JIM JARMUSCH
photography by
Ellis Parrinder

ICONOGRAPHY

Grace Jones is
the very definition
of an icon, a
person whose
unmistakable
image has come
to symbolise all
the incredibly
diverse and often
contradictory
elements of her
own life.

"I DON'T WANT TO PLEASE EVERYBODY.
ACTUALLY THERE'S CERTAIN PEOPLE I
DEFINITELY DON'T WANT TO PLEASE
(LAUGHS). THERE'S SOME PEOPLE I'M LIKE,
OH NO! PUH-LEEEEZE DON'T LIKE ME!"

"REAL LOVE IS UNLIMITED, UNCONDITIONAL, IT'S IN THE AIR,
YOU CAN'T DENY IT TO ANYBODY WHO NEEDS IT. HOW CAN YOU
MEASURE LOVE...? YOU CAN'T BUY MINE, THAT'S FOR SURE"

[this spread]
September 1998
GRACE JONES
photography by Juergen Teller

This shoot marks the very
first time the hatmaker Philip
Treacy met Grace Jones and
it kickstarted a professional
relationship that witnessed him
go on to create work for her stage
shows and performances.

[following spread]
March 2000
YVES SAINT LAURENT
photography by Juergen Teller

"We had the idea of getting Juergen Teller backstage to shoot Yves Saint Laurent. He walked backstage, took one shot and that was it – the shot that we published. The thing with Juergen is that he's very specific – he'll do the one shot, and you don't say, 'Can I see more?', you say, 'Thank you.' It's a truly incredible image"
EMMA REEVES

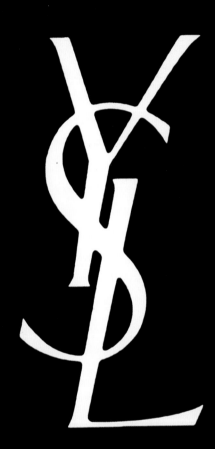

THE SAINT

YVES SAINT LAURENT

TEXT SUSANNAH FRANKEL
PORTRAIT JUERGEN TELLER

FASHION-ABLE
The Fashion Of Katy England

"I used to go out all the time," says Katy England. "I was in my 20s — loving London, loving dressing up. I remember *Dazed & Confused* was in this tiny office in the middle of town — Corinne Day was in the same building — and they had to come up with all these inventive ways to finance the next issue of the magazine."

Among such money-raising endeavours was the *Dazed & Confused* club night, on Saturdays, at Maximus in Leicester Square. "They asked me to do the door and I was absolutely up for that," England says. "The outfits were amazing."

Dressed in particular in a John Galliano trouser suit ("tight, with a really cutaway jacket, beautiful shoulders and flared sleeves – it was the best suit ever"), Union Jack flag tied across her torso and a Charlotte Rampling *Night Porter* hat, England must have cut quite a dash. "Jefferson was reminding me about my look just the other day. We're pretty close now."

Soon after, she began working with Rankin. "We did a rock'n'roll story, funnily enough. It was all leather and Rankin wanted it to be silver. We did a silver cover. I'd never worked for a style magazine before. I'd only done commercial work and for me, it was like, 'Wow. I can do what I want to do – there are no constraints.' It was heaven."

Having previously graduated from Manchester Polytechnic, where she studied fashion and worked as a stylist for *ES Magazine*, England became a fixture at *Dazed & Confused*. "I was there all the time. Phil [Poynter, then picture editor] was always into conceptual stories – there had to be a narrative, they didn't just want conventional fashion shoots. It was just the pure energy – the youth of the magazine – that I thought was incredible."

In the meantime, England had met Alexander McQueen and been appointed his creative director – the designer was credited on the magazine's masthead as fashion editor. "We went off to a wasteland in East London with the Chapman brothers and Lee made miniature clothes for their mannequins. He put them in bumsters. They'd never met before but they were really supportive of each other. *Dazed* wanted to pair a young British designer with a young British artist. That was their thing, mixing it all up."

In September 1998, McQueen guest-edited an issue of the magazine, featuring Paralympic champion Aimee Mullins on the cover and a sequence of images of more people with physical disabilities inside. The shoot was photographed by Nick Knight, art-directed by McQueen and styled by England.

"People have never forgotten that shoot. It was definitely the hardest thing I'd ever done. Working as I did in fashion, coming from such a completely different place, one that might be perceived as superficial, I felt quite embarrassed. It involved a huge amount of time talking to different charities and organisations for casting and convincing them that we were seriously trying to show that everybody can be beautiful."

Later, Knight and England collaborated again on a story of women living with breast cancer.

In fact, casting from life – and working with her friends – is one of the signatures of England's aesthetic. "It was always just something I wanted to do, or somebody I'd met, someone I wanted to photograph who I'd met in my neighbour's flat. The thing I love best is finding real people inspiring. It's the style of the person that I'm attracted to more than their physical beauty. Sometimes you book a model and, yeah, they're five foot ten and gorgeous, but they put the clothes on and they can't bring them to life... For me, that's totally depressing, like they're not really doing it. I always think: 'Why aren't you doing it?'"

England shot two cover stories with Björk – one photographed by Nick Knight again, with the subject dressed in McQueen, the other a David Sims beauty story – Sims's earlier work with Melanie Ward, England says, was the reason she wanted to work in fashion in the first place.

"Björk's just the most special person. She's like a unique being. She has this extraordinary spirit. She's confident, strong and super-generous. She puts her trust in the people she works with and allows them to do their thing. She's open, experimental and loves the process. That's incredibly rare these days."

Norbert Schoerner, Martina Hoogland Ivanow, Paulo Sutch and Horst were all England's contributors. Her assistant – and soon to become best friend – was Alister Mackie. "As usual, I was looking for strange models," she says of meeting Mackie for the first time. "Remember Nicky Lawler – Lawler Duffy. She said: 'I've got this friend in Scotland and he's beautiful. He goes to Glasgow School of Art.' I phoned Alister up at his mum's house and asked him to send Polaroids. He was really good. He had long, red shaggy hair. We met him off the coach from Scotland and he was wearing this pinstripe 70s suit. Perfect."

Other stylists during England's tenure were Camille Bidault-Waddington, Hector Castro, Venetia Scott, Cathy Edwards and Nicola Formichetti.

"My claim to fame," she says of the latter now. "I found him working in The Pineal Eye and he was just so enthusiastic about fashion. I love people like that. I said, 'Okay, we're going to do a notebook page. You're going to tell me what you like, where you've been, and we're going to do snappy snaps and write a bit about it.' I wanted it to look stuck in and really raw. It was Nicola's early blog."

England also put her husband, Bobby Gillespie, on the cover on two separate occasions.

"I didn't concern myself too much with catwalk trends and they certainly weren't where my story ideas came from. Instead, I used what was on my doorstep. My work's always a bit punky. I can never leave a designer look alone – if it's already been on the runway, what's the point of that? I also love to work on the proportion and volume of the outfit – I studied fashion, and working with Lee for ten years taught me such a lot about that – so you end up hoicking something up, twisting something tighter, pinching in a sleeve... These exaggerations help to make the silhouette strong, which in turn helps the image. I can honestly say that I have never, ever worried about what anyone else was going to think. It would never occur to me that something might be outrageous or controversial."

When England was pregnant with her first child, working at McQueen during the day and going to the *Dazed & Confused* offices at night, *AnOther Magazine* launched and she was asked to be fashion director of that title, too. "I really worked hard, although it never felt like it because I loved what I was doing so much. There came a point, though, where I realised I couldn't do it all any more. Because *Dazed* was the youngest one it seemed the logical thing to pass it on. Still, I was gutted. I thought giving it up would be much easier."

Katy England remains one of the world's most respected stylists. "I've always felt really loyal to *Dazed* though. Even when I go there now, I feel at home. Most of the staff have changed but it's still like my place to be. It's all about the confidence of youth – the arrogance of youth and sometimes the ignorance of youth. That's what I think *Dazed* is and what it should be."

SUSANNAH FRANKEL

[right]
February 2001
DENIM THEORY
photography by David Sims
styling by Katy England

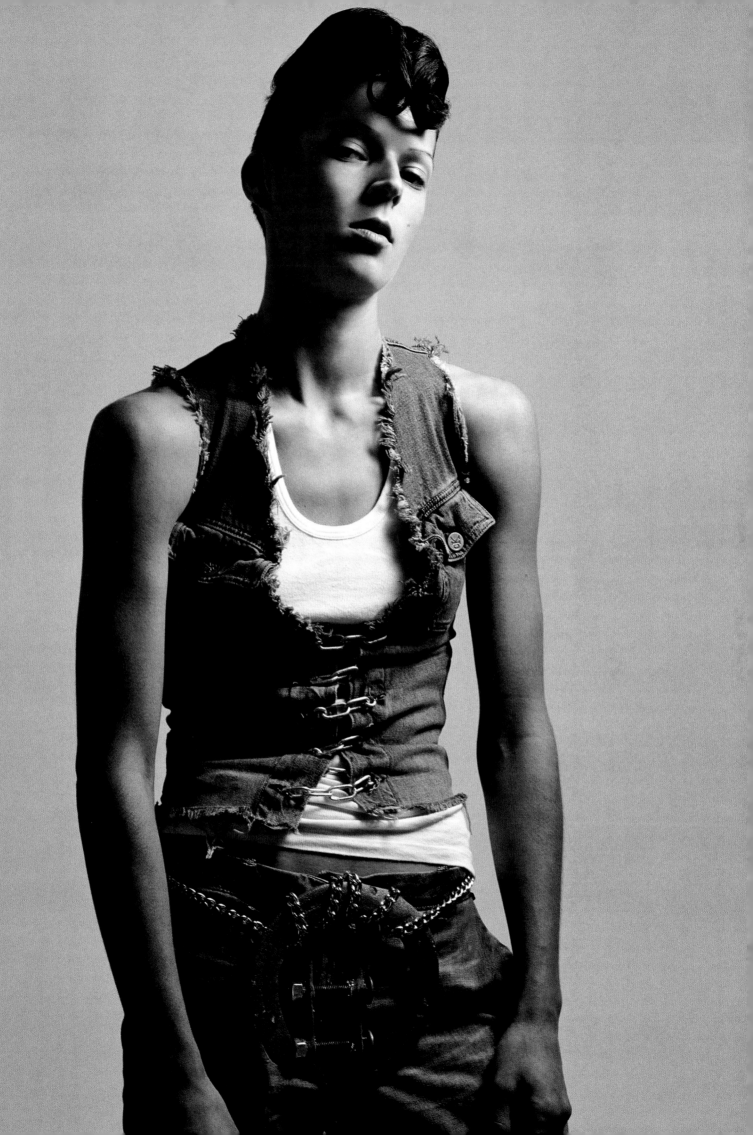

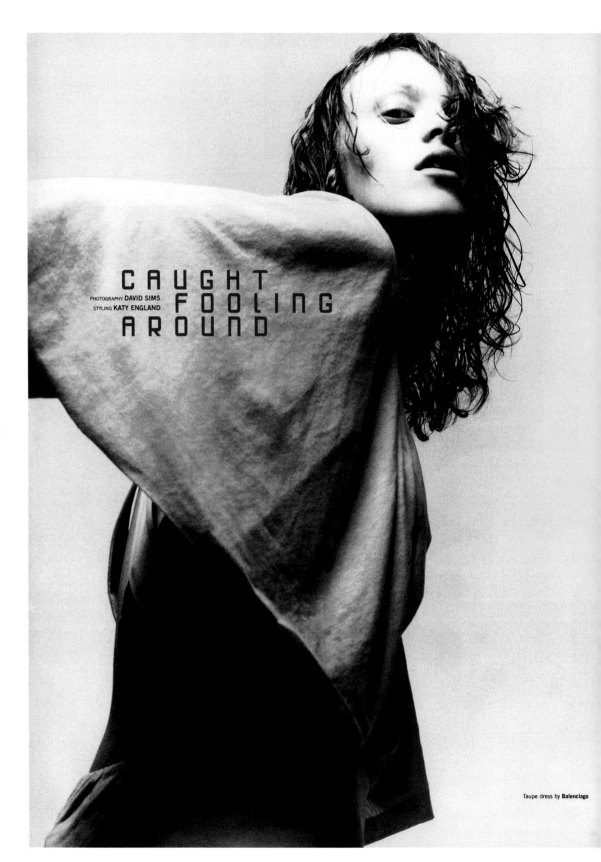

December 2000
KAREN ELSON
CAUGHT FOOLING AROUND
photography by David Sims
styling by Katy England

PHOTOGRAPHY **DAVID SIMS**
STYLING **KATY ENGLAND**

CAUGHT
FOOLING
AROUND

Taupe dress by **Balenciaga**

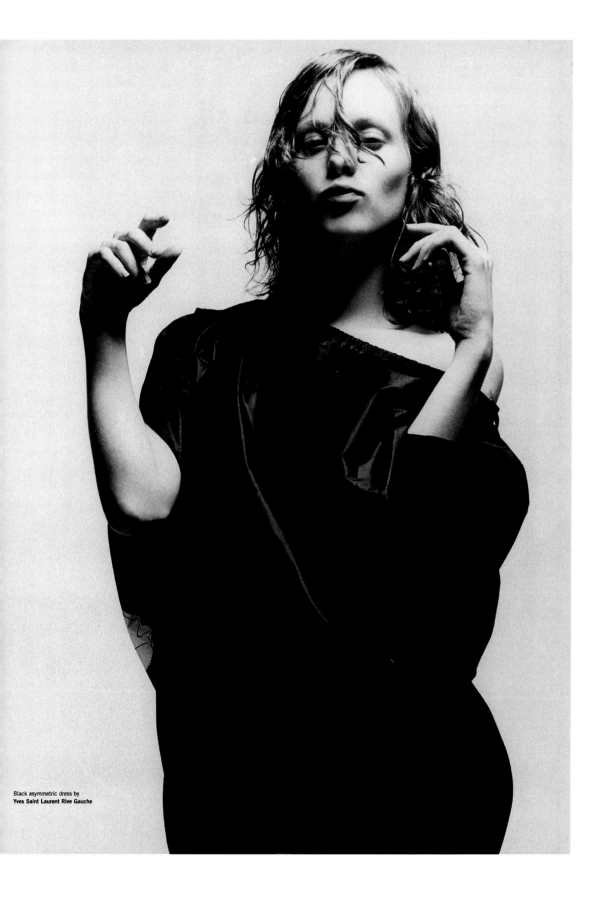

Black asymmetric dress by
Yves Saint Laurent Rive Gauche

Screen test # 1: Girls on film

Photography Corrine Day
Video Camera Mark Szaszy and Dan Brooks
Styling Katy England
Hair Neil Moody at Premier for Aveda Debbie Stone at
Premier for Ruby and Milly
Make-up Kate Lee at Forward using Shu Uemura and
Debbie Stone at Premier for Ruby and Milly
Styling assistant Sara Burn

Lisa Ratliffe, age 19 English

Clare Durkin, age 22 English

[this spread]
December 2000
GIRLS ON FILM
copyright *Corinne Day Estate*
courtesy of *Gimpel Fils gallery*
styling by *Katy England*

[following spread]
1995
RIAN & CORI
photography by *Phil Poynter*
styling by *Katy England*

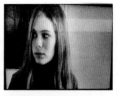

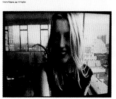

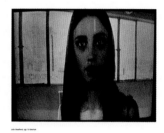

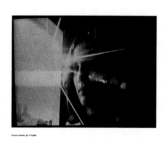

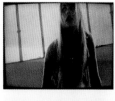

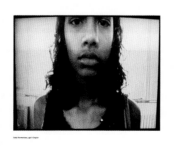

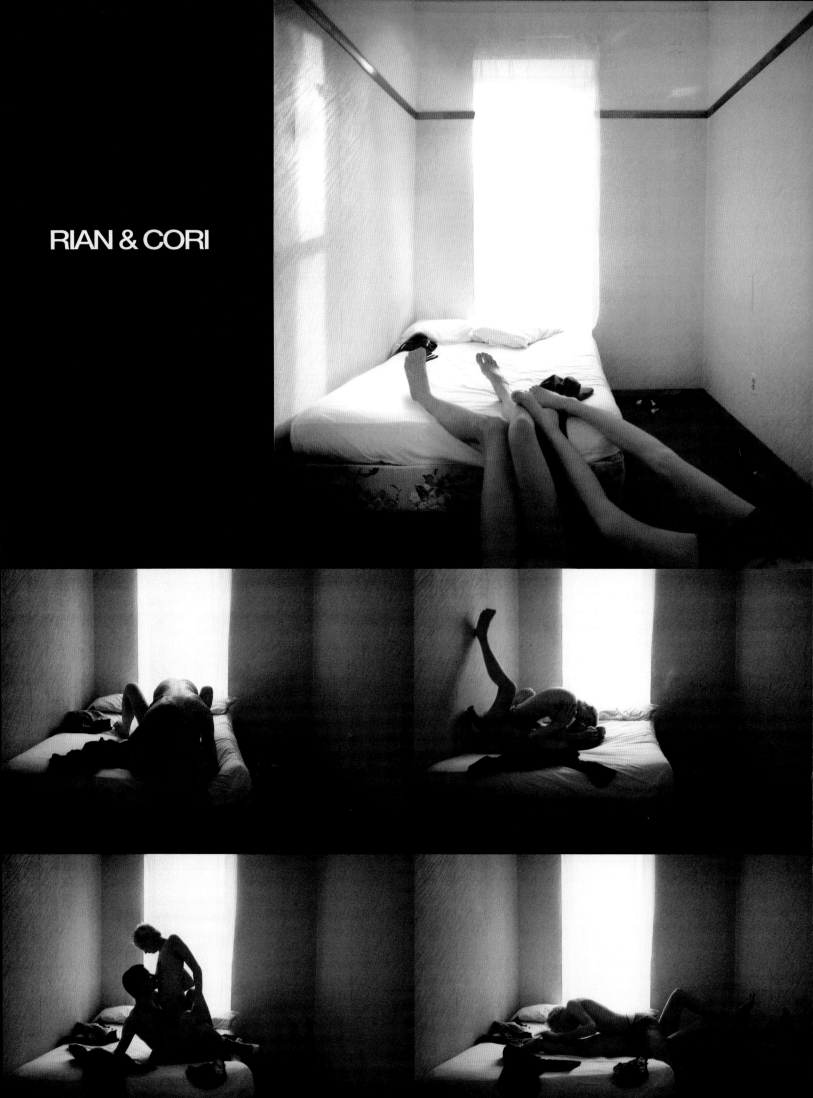

RIAN & CORI

an wears Tiger jacket and grey patent shoes from **Cheap Jacks**, 841 Broadway, NY 10003. Trousers from **Vintage Clothing**, West Broadway, NY 10013. T shirt by **Liza Bruce**. Cori wears Bra from **Canal Jean Co.**, 504 Broadway. Shirt from **Liza Bruce**. Skirt from **Corinne Cobson**. Cowboy boots from **Domsies**, 495 Whyte Avenue, Williamsberg, Brooklyn.

Story by **Phil Poynter** and **Katy England.** Make up: **Ian Jeffries** at Debbie Walters. Models: **Rian** and **Cori**. Shot at Hotel 17, 225e 17th Street, New York, NY 10003. Telephone, 212 475 2845. All film processed at **West Side Laboratories**, 148 West 24th Street, NY, NY, 10011. Telephone 212 675 9100. All equipment hired from **Adorama Rentals**, 42 West 18th Street, NY, NY, 10011. Tel: 212 627 8487. All photographic printing by **Metro Imaging** Tel: 0171 855 0000. Thanks to Ronald (for all his help) at **Guru Studios**, 148 West 24th St, NY, NY, 10011. Tel: 212 675 9100 / Fax: 212 675 9266. Love and Respect to Rian & Cori, Billy, Jessie and everyone at Hotel 17 who cared for us. We miss you all.

September 1998
FASHION-ABLE
photography by Nick Knight
styling by Katy England

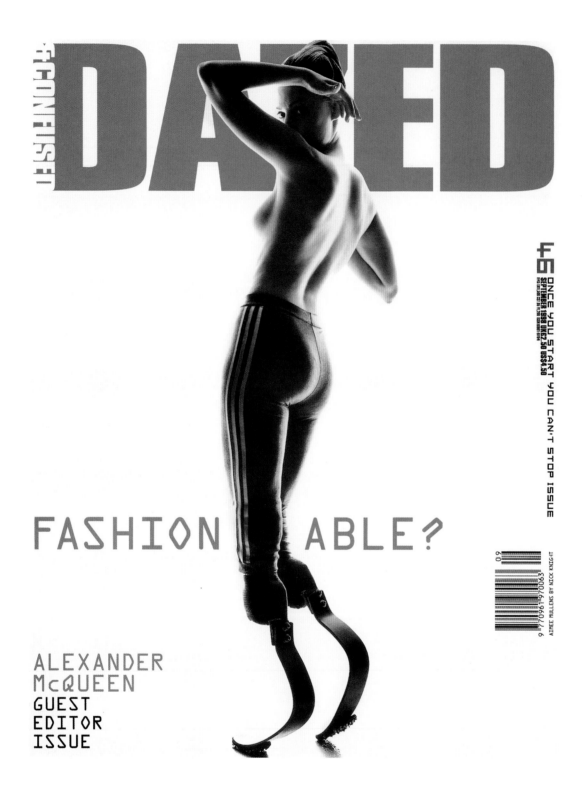

DAZED & CONFUSED

FASHION ABLE?

46

ONCE YOU START YOU CAN'T STOP ISSUE

SEPTEMBER 1998 UK£2.50 US$4.50

AIMEE MULLENS BY NICK KNIGHT

ALEXANDER
McQUEEN
GUEST
EDITOR
ISSUE

In 1998's September issue, Alexander McQueen, Nick Knight and Katy England produced a shoot which represented disability in a frank and beautiful way – something that no other magazine had done before.

"The disability story is one of the most important shoots that I've done. We thought that perhaps when we approached people they might say, 'You want to use somebody with thalidomide for fashion? Fuck off!' But they weren't at all like that. What you aspire to, there actually isn't a difference. We should look beyond physicality when it comes to defining beauty." NICK KNIGHT

ACCESS-ABLE

ALEXANDER McQUEEN NICK KNIGHT
KATY ENGLAND VAL GARLAND
JIM CROSLEY

In a world where the mainstream concept of what is and isn't beautiful becomes increasingly narrow – you have to be young, you have to be thin, you should preferably be blonde and, of course, pale skinned. Some of fashion's most influential talents have come together to challenge these presumptions. All the subjects in these pictures are physically disabled. They were cast in the normal way would-be applicants asked to send in their pictures. The response was overwhelming which gave everyone involved the confidence to proceed.

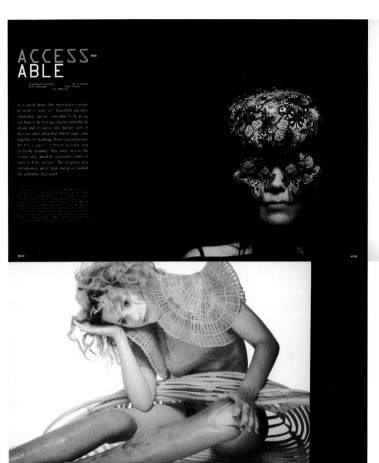

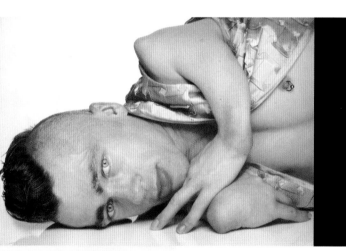

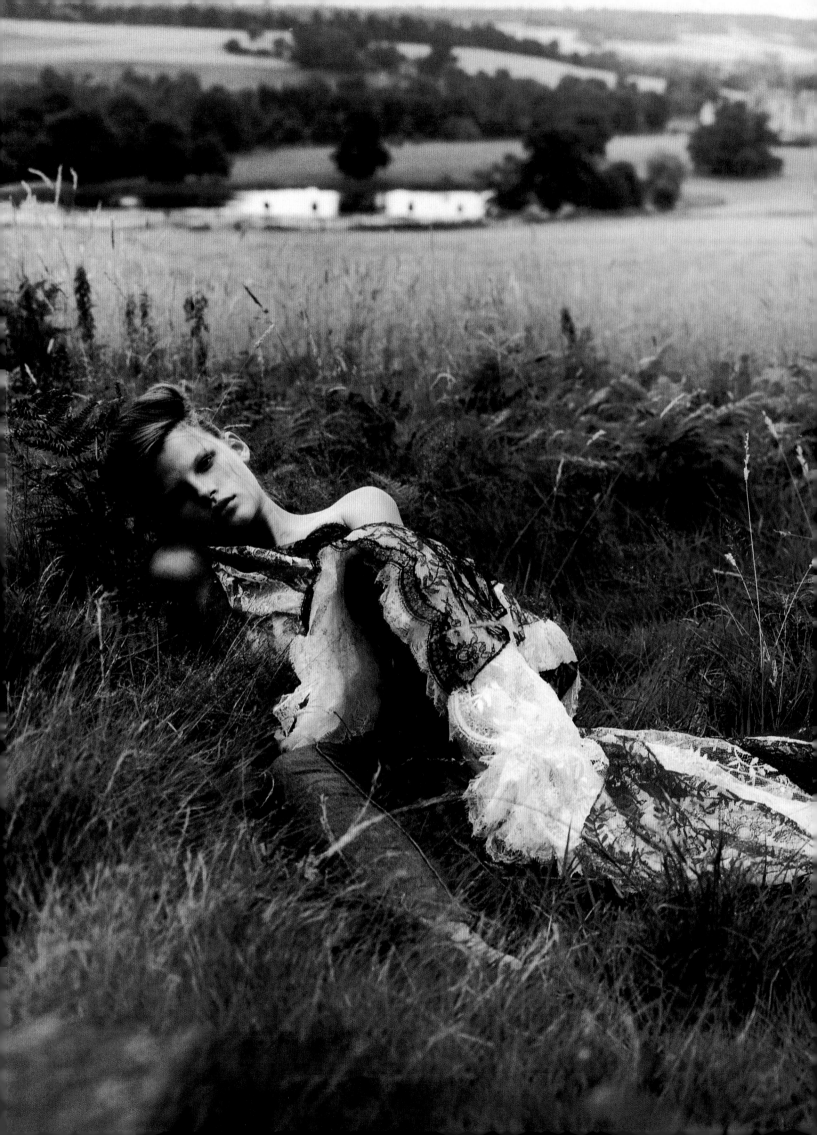

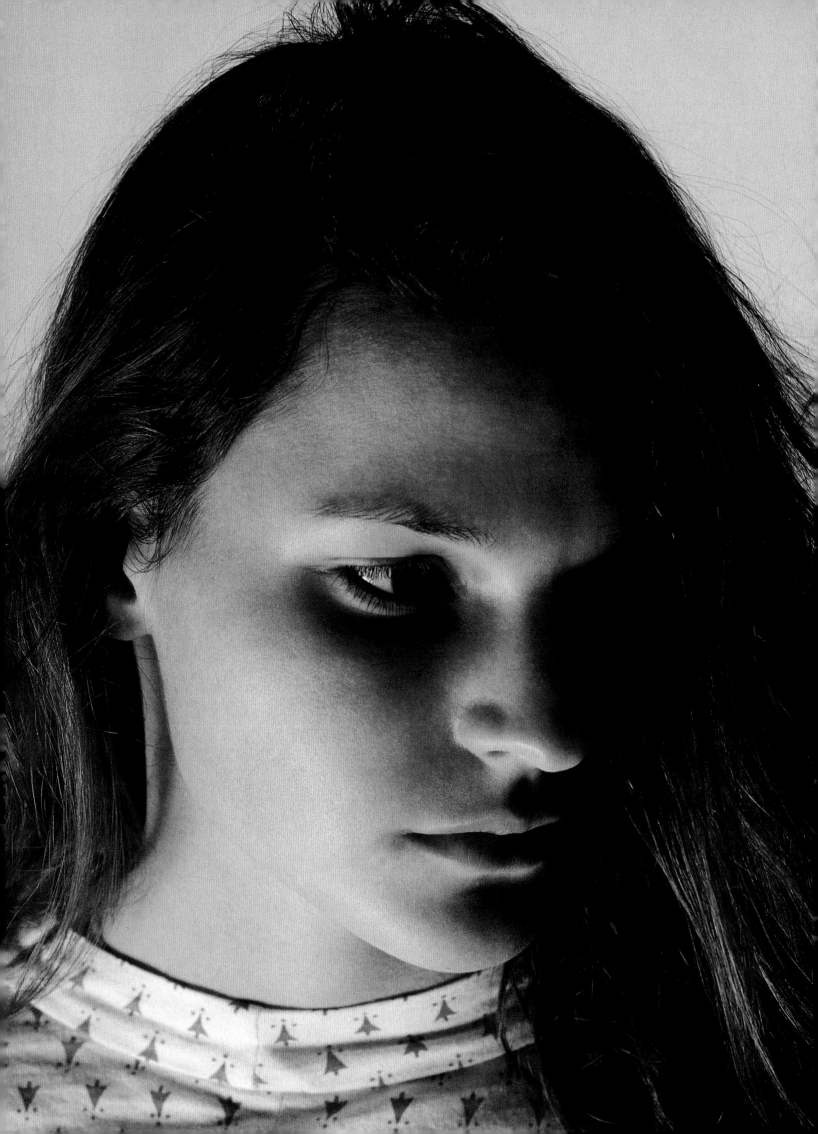

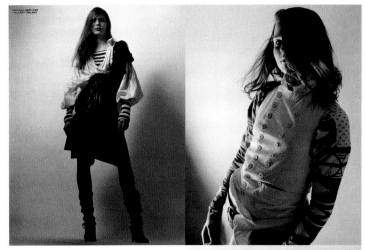

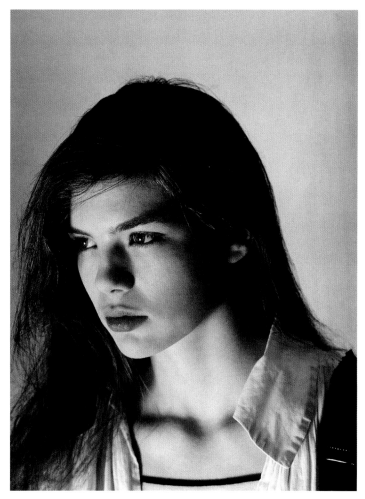

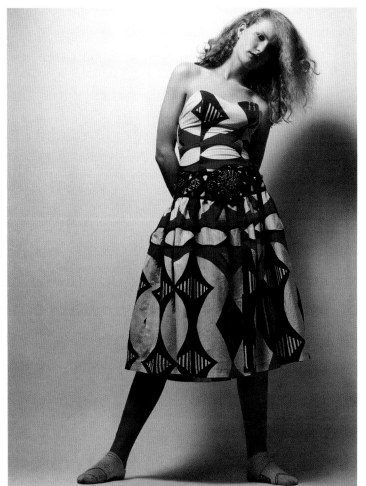

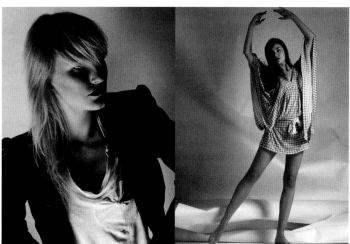

[previous spread]
October 2000
JUBILEE
photography by Paulo Sutch
styling by Katy England

[this spread]
April 2001
VIVIENNE WESTWOOD
WORLD'S END
photography by David Sims
styling by Katy England

May 2000
BJÖRK
photography by David Sims
styling by Katy England

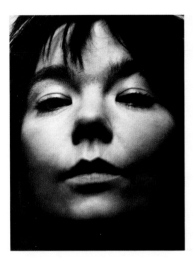

björk *versus reality*

HAIR **MALCOLM EDWARDS**
AT **UNTITLED°**
MAKE-UP **LINDA CANTELLO** AT **DEBBIE
WALTERS** USING **SURFACE**
STYLING ASSISTANT **SARA BURN** AND
BRYAN MCMAHON

ANTIQUE DRESS FROM STEINBERG &
TOLKIEN; T-SHIRT BY **NOKI**

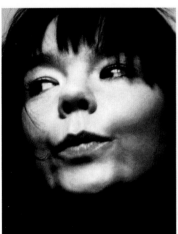

"ONE THING THAT IS QUITE DEFINITE IS THAT MY
INTROVERT IS ICELAND AND MY EXTROVERT IS ENGLAND"

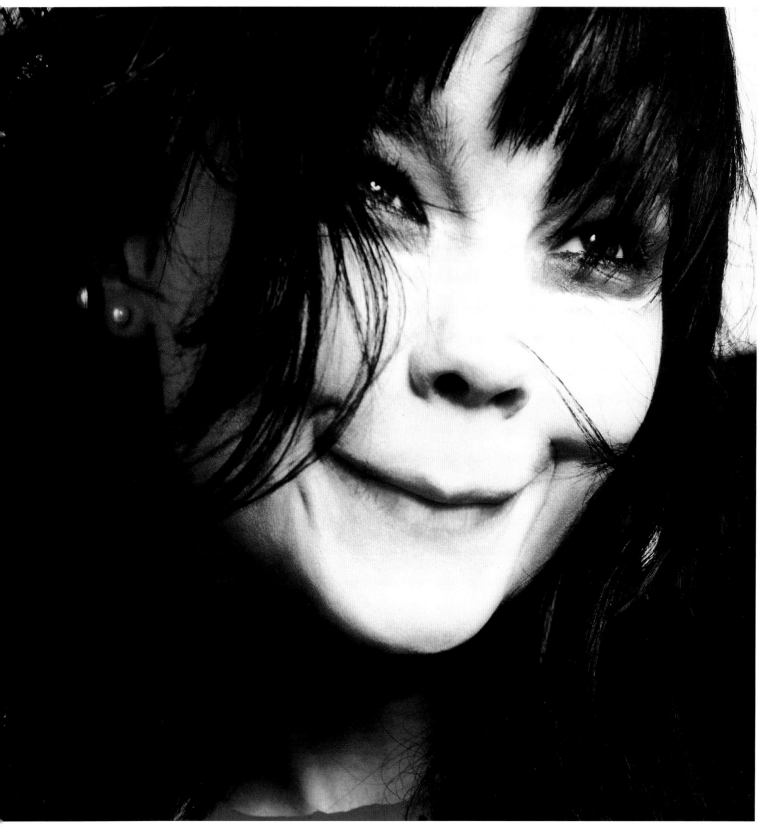

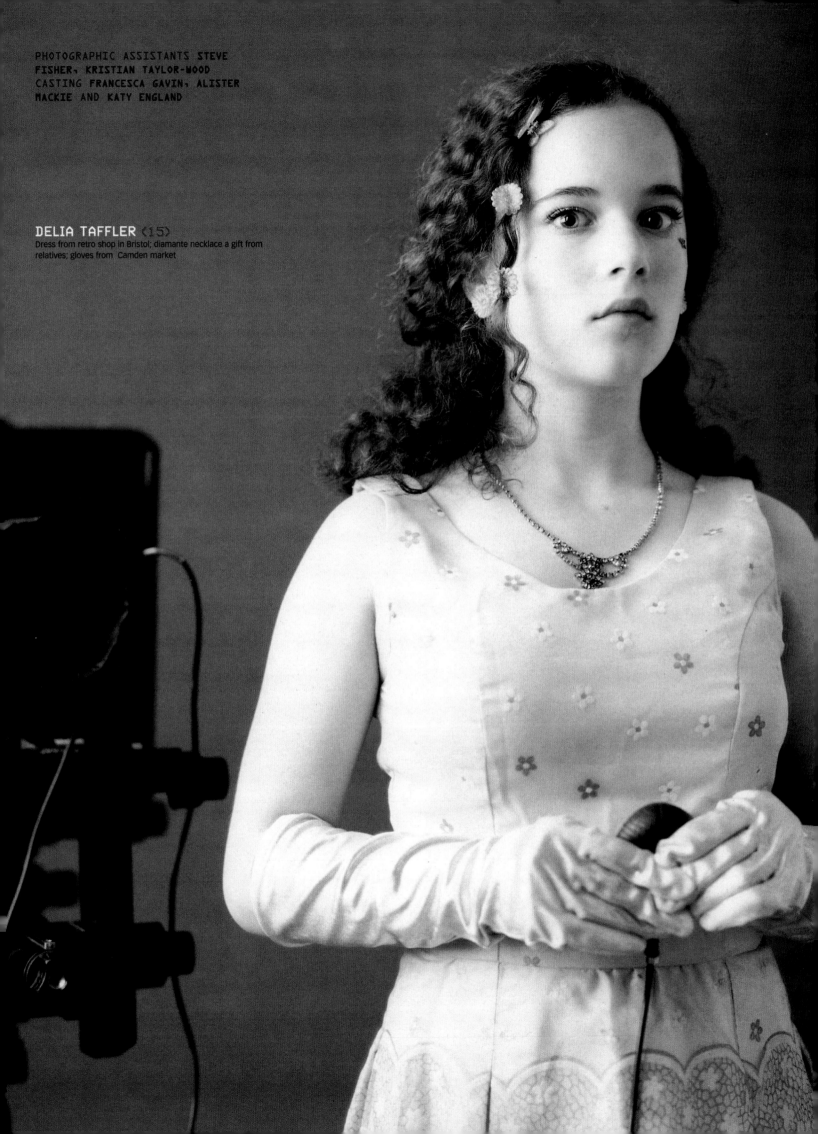

PHOTOGRAPHIC ASSISTANTS STEVE
FISHER, KRISTIAN TAYLOR-WOOD
CASTING FRANCESCA GAVIN, ALISTER
MACKIE AND KATY ENGLAND

DELIA TAFFLER (15)
Dress from retro shop in Bristol; diamante necklace a gift from
relatives; gloves from Camden market

Katy England has taken the theme of childhood and fashioned the following 24 pages to represent different visions of what it's like to be young in Britain today. Along with photographers

KIDS

Project co-ordinator Francesca Gavin. Thanks to everyone at the Crown and Manor Boys Club, Northwold Primary School, Islington YMCA Youth Group, Parliment Hill School and Central Foundation Boys School

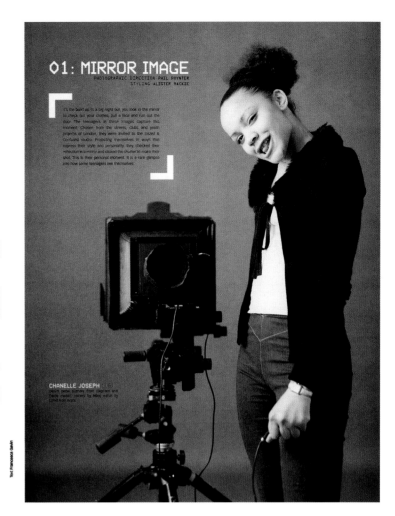

01: MIRROR IMAGE

PHOTOGRAPHIC DIRECTION PHIL POYNTER
STYLING ALISTER MACKIE

It's the build up to a big night out, you look in the mirror to check out your clothes, pull a face and run out the door. The teenagers in these images capture this moment. Chosen from the streets, clubs and youth projects of London, they were invited to the Dazed & Confused studio. Projecting themselves in ways that express their style and personality, they checked their reflection in a mirror and clicked the shutter to make their shot. This is their personal moment. It is a rare glimpse into how some teenagers see themselves.

CHANELLE JOSEPH

Nick Knight, David Simms and Phil Poynter, Katy has collaborated with different youth groups to create a unique and unselfconscious exploration of childhood.

Whether it's through the experimental theatre of an Islington youth project, a self-styled and self-shot series of portraits, or the pertinent images of childhood spaces, each project has managed to somehow capture the fleeting phenomenon that is the fearless self-expression and boundless imagination of youth.

This is the result of an experiment in working with teenagers and the very young. This is about turning the tables on fashion and photography, taking the direction away from the professional photographer, stylist, art director, editor and their teams and putting it in the hands of the subjects.

Text Francesca Gavin

66 DAZED

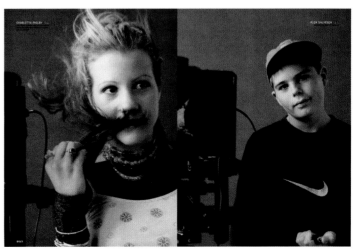

August 1999
KIDS R US
photography by Phil Poynter,
Nick Knight & David Sims
styling by Katy England

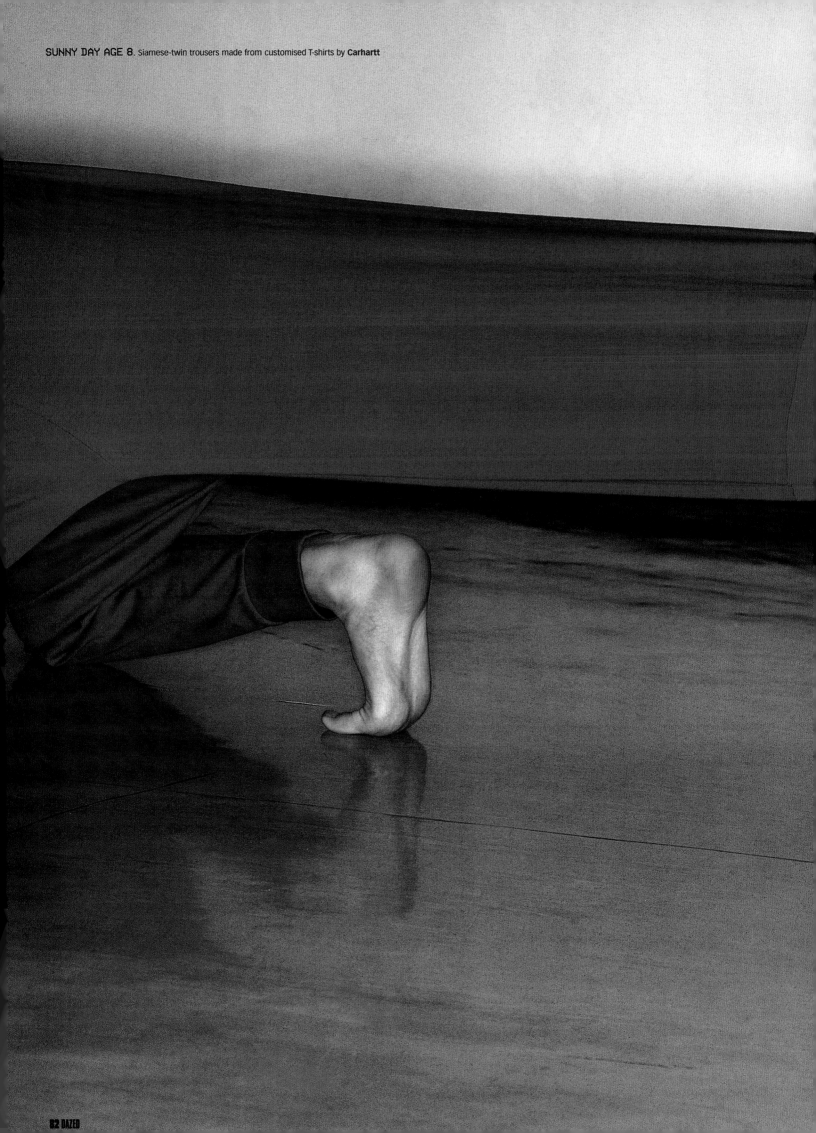

SUNNY DAY AGE 8. Siamese-twin trousers made from customised T-shirts by **Carhartt**

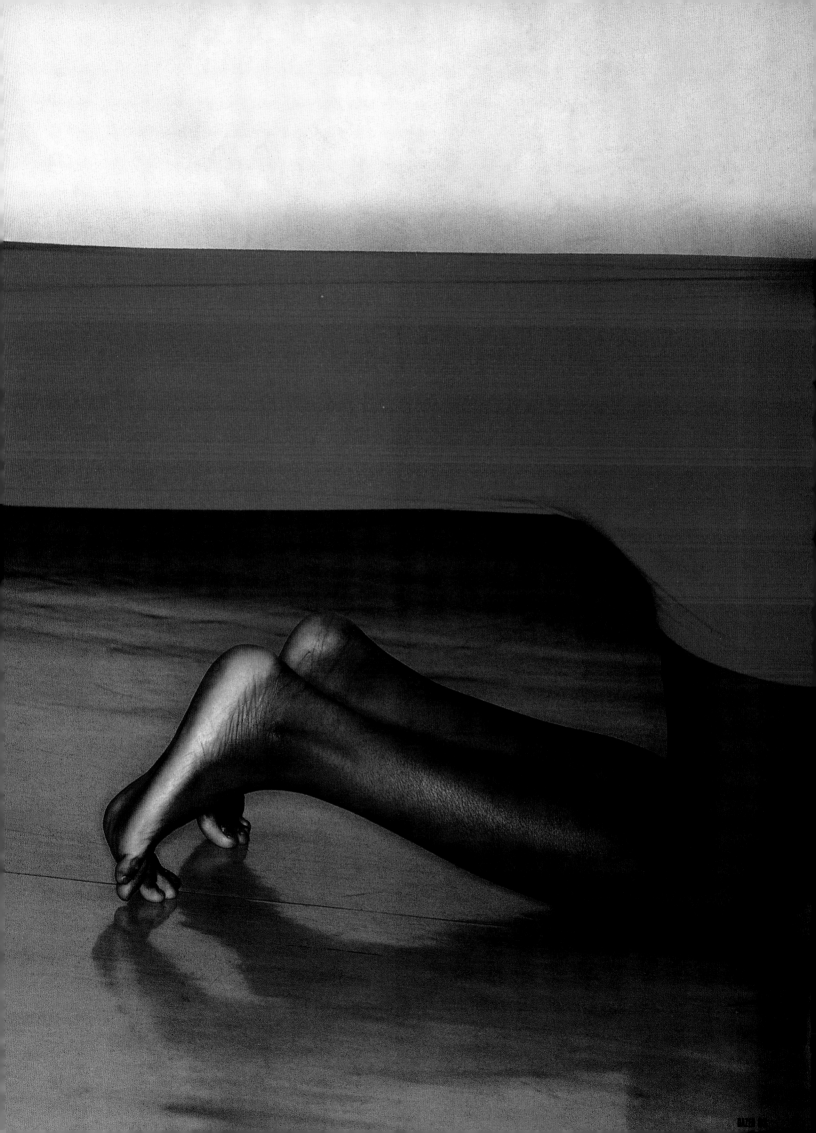

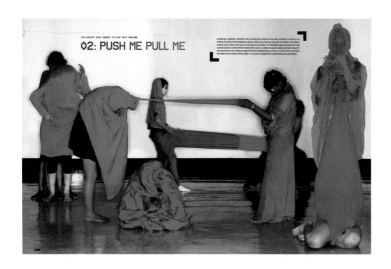

PHOTOGRAPHY MICK BRENNT STYLING KATY ENGLAND

02: PUSH ME PULL ME

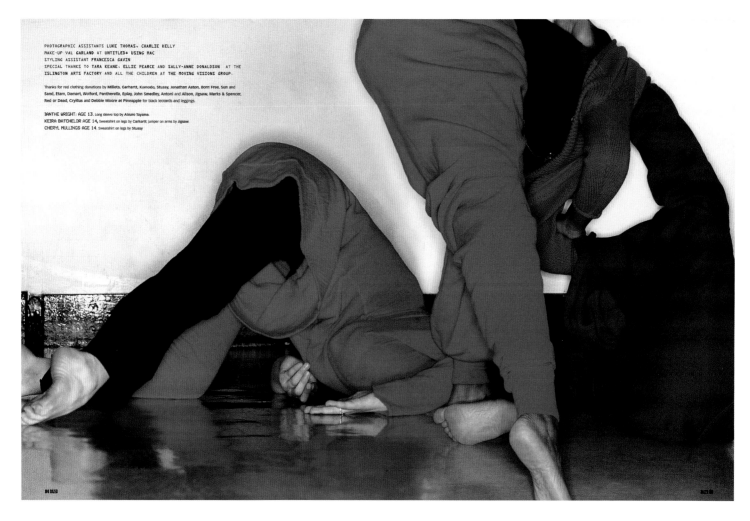

PHOTOGRAPHIC ASSISTANTS LUKE THOMAS, CHARLIE KELLY
MAKE-UP VAL GARLAND AT UNTITLED+ USING MAC
STYLING ASSISTANT FRANCESCA GAVIN
SPECIAL THANKS TO TARA KEANE, ELLIE PEARCE AND SALLY-ANNE DONALDSON AT THE
ISLINGTON ARTS FACTORY AND ALL THE CHILDREN AT THE MOVING VISIONS GROUP.

Thanks for red clothing donations by Milletts, Carhartt, Komodo, Stussy, Jonathan Aston, Born Free, Sun and
Sand, Etam, Damart, Wolford, Pantherella, Eplay, John Smedley, Antoni and Alison, Jigsaw, Marks & Spencer,
Red or Dead, Cryillus and Debbie Moore at Pineapple for black leotards and leggings.

IANTHE WRIGHT: AGE 13. Long sleeve top by Atsuro Tayama.
KEIRA BATCHELOR AGE 14, Sweatshirt on legs by Carhartt; jumper on arms by Jigsaw.
CHERYL MULLINGS AGE 14. Sweatshirt on legs by Stussy

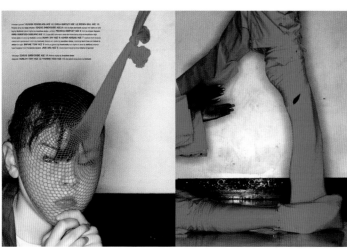

◇3: SCHOOL'S OUT

PHOTOGRAPHY DAVID SIMS

Empty classrooms and deserted playgrounds lent tone to the notorious estate used graffiti on the bathroom walls. Stylist Anna departs to it's old school to capture the atmospheric threshold after the bell has rung.

DEVIATION

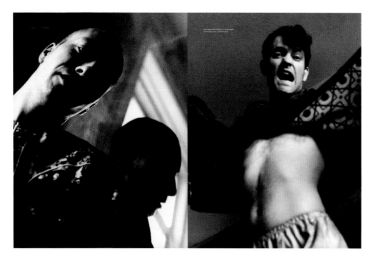

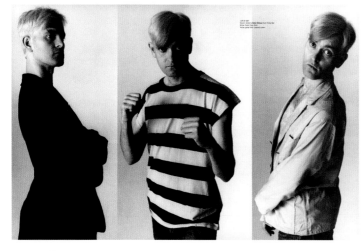

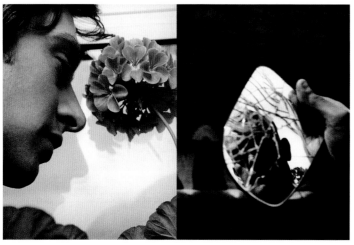

red and black curtain from **The Gallery of Antique Clothing And Textiles**

August 2000
DEVIATION
photography by David Sims
styling by Katy England

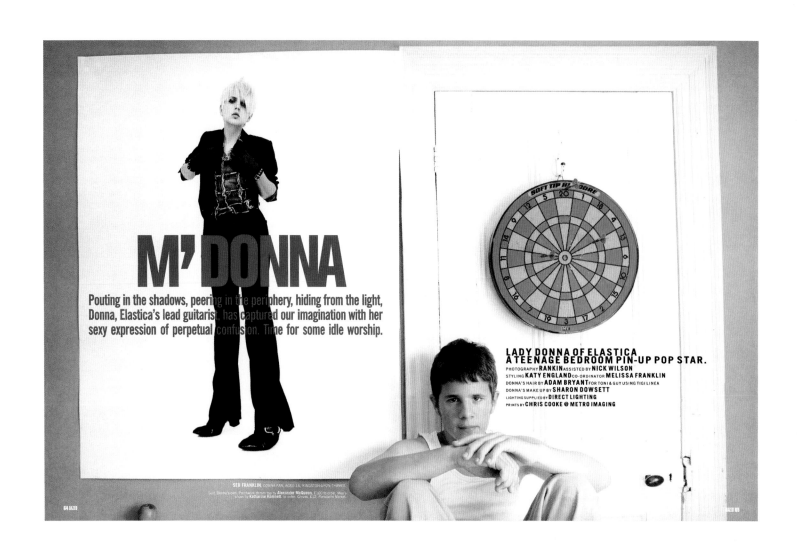

M'DONNA

Pouting in the shadows, peering in the periphery, hiding from the light, Donna, Elastica's lead guitarist, has captured our imagination with her sexy expression of perpetual confusion. Time for some idle worship.

LADY DONNA OF ELASTICA
A TEENAGE BEDROOM PIN-UP POP STAR.
PHOTOGRAPHY RANKIN ASSISTED BY NICK WILSON
STYLING KATY ENGLAND CO-ORDINATOR MELISSA FRANKLIN
DONNA'S HAIR BY ADAM BRYANT FOR TONI & GUY USING TIGI LINEA
DONNA'S MAKE UP BY SHARON DOWSETT
LIGHTING SUPPLIED BY DIRECT LIGHTING
PRINTS BY CHRIS COOKE @ METRO IMAGING

SEB FRANKLIN, DONNA FAN, AGED 14, KINGSTON-UPON-THAMES.
Suit, Donna's own. Patchwork denim top by Alexander McQueen, £160 to order. Man's shoes by Katharine Hamnett, to order. Gloves, £12, Portobello Market.

EDINE TALHI, DONNA FAN, AGED 12, TWICKENHAM
Vintage sheer £25, Available Market. Tube ring & vest, £4, Cenworthe.

SAM TALHI, DONNA FAN, AGED 14, TWICKENHAM
White leather dress £340 and white leather jacket, £940 by Ann Demeulemeester from Harvey Nichols.

September 1996
DONNA ELASTICA
photography by Rankin
styling by Katy England

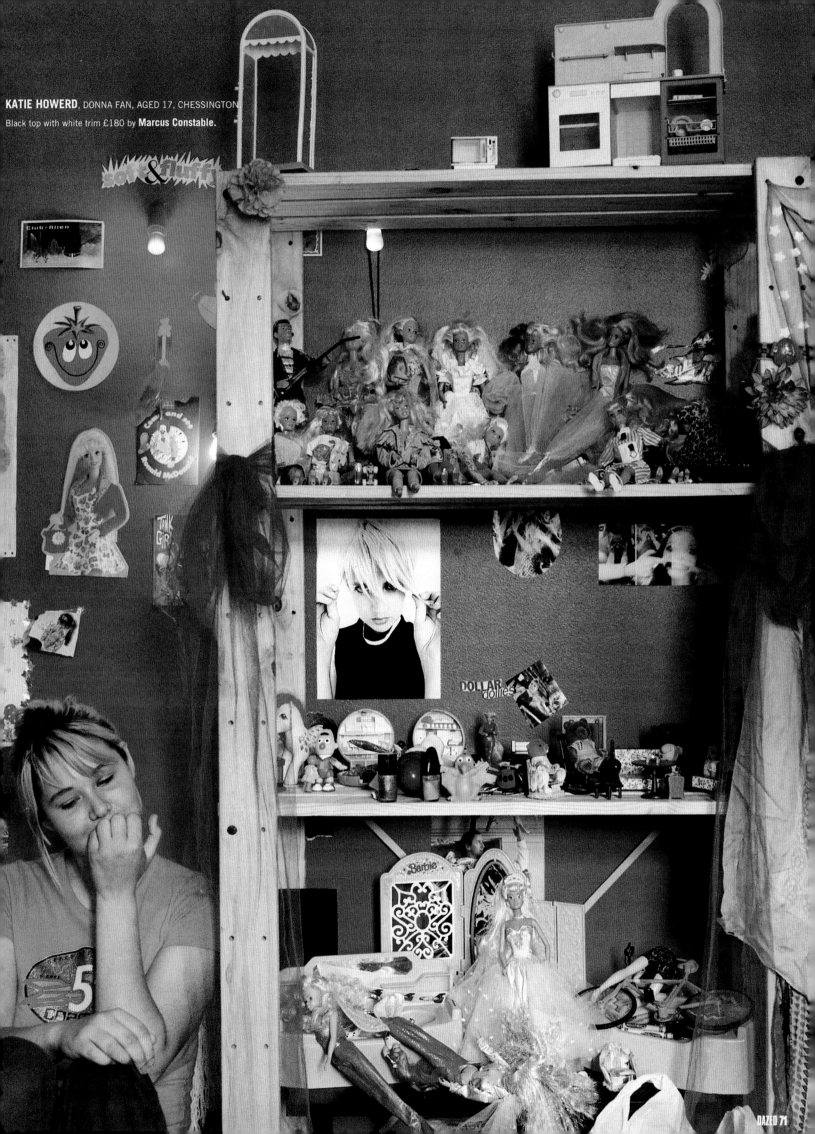

KATIE HOWERD, DONNA FAN, AGED 17, CHESSINGTON.
Black top with white trim £180 by **Marcus Constable.**

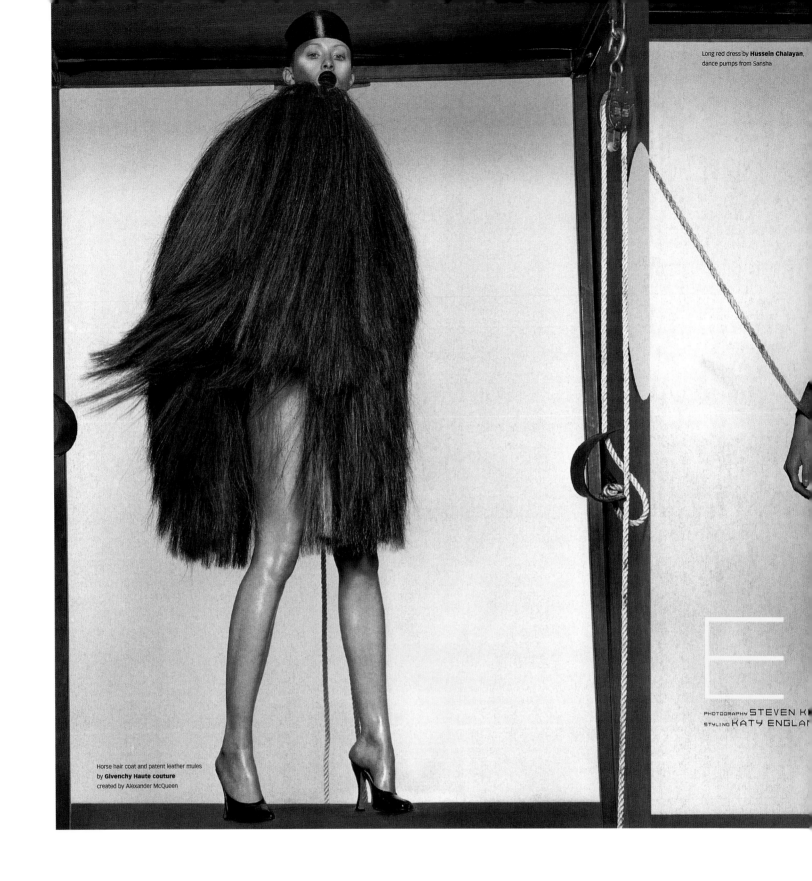

Long red dress by **Hussein Chalayan**, dance pumps from Sansha

Horse hair coat and patent leather mules
by **Givenchy Haute couture**
created by Alexander McQueen

PHOTOGRAPHY STEVEN K
STYLING KATY ENGLAN

April 1998
E=MC²
photography by Steven Klein
styling by Katy England

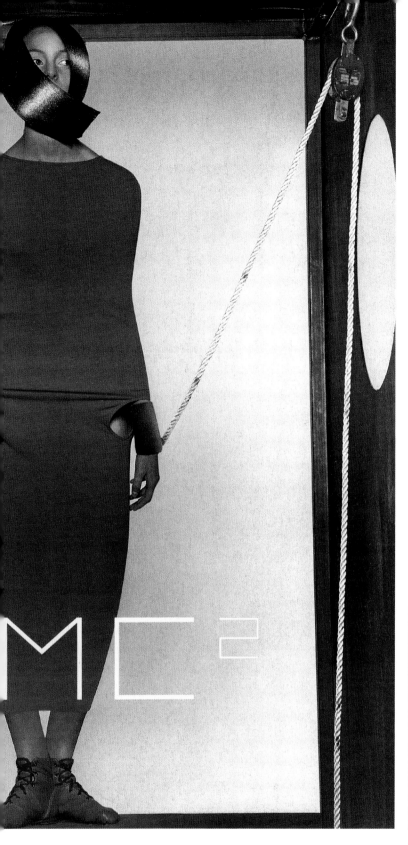

MC²

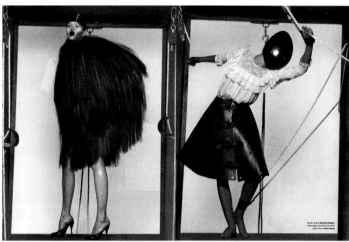

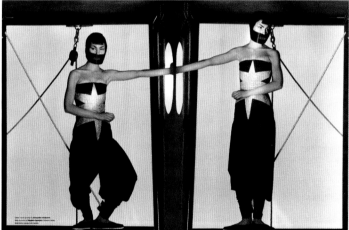

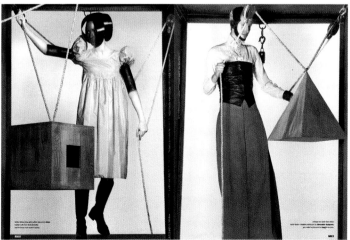

September 1998
MACUMBA
photography by
Inez van Lamsweerde & Vinoodh Matadin
styling by Katy England

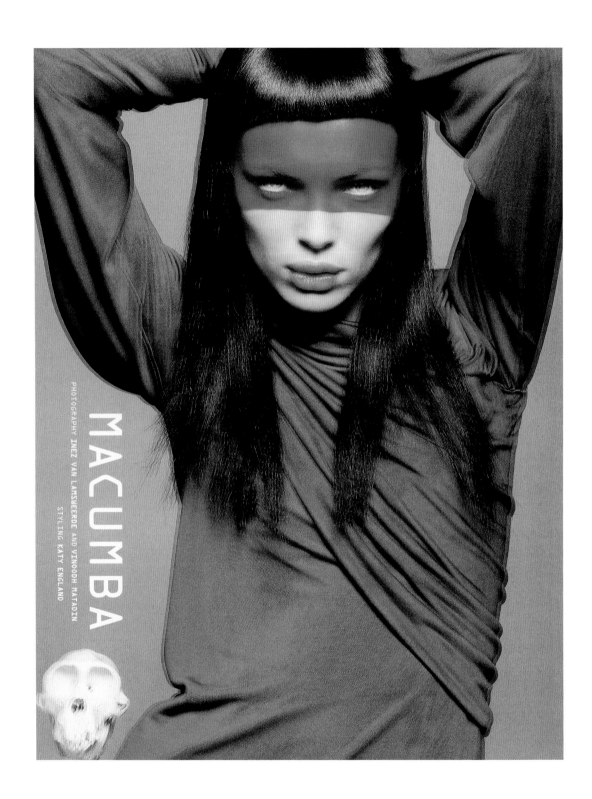

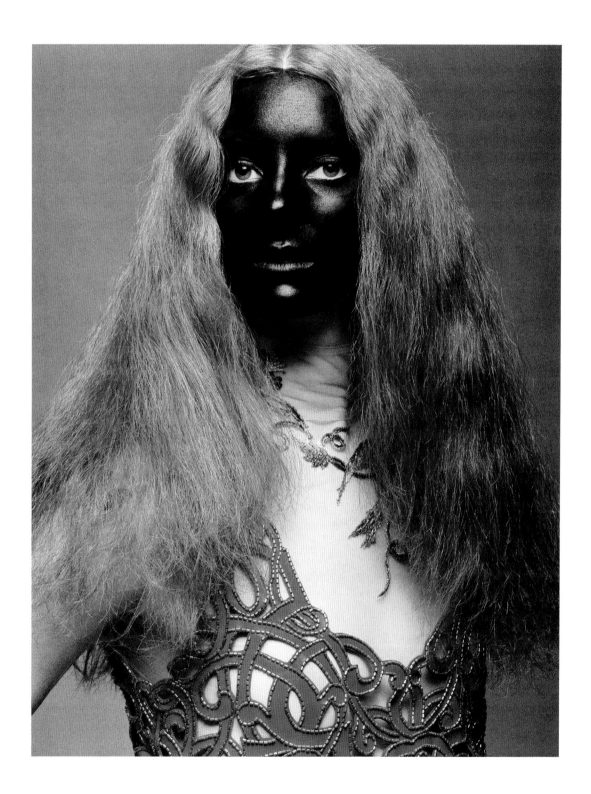

December 2002
COME AS YOU ARE
photography by Nick Knight
womenswear styling by
Katy England
and Cathy Edwards
menswear styling by
Alister Mackie
and Nicola Formichetti

Come As You Are was
a collaborative project with
Nick Knight celebrating the
magazine's ten-year anniversary.
All of the images were digitally
collaged to showcase past and
present shoots, collections and
fashion stories in a tribute to
some of the magazine's most
influential contributors.

BEAUTY IS IN THE STREET
Social Reportage And Projects

In 1990 the world was changing, and it was changing fast. It was a moment that was full of promise – with the Cold War finally drawing to a close and apartheid swiftly crumbling – but it was also one heavy with the threat of a sinister New World Order, with oil fields blazing in Kuwait and McDonalds opening its first outlet in Moscow.

In Britain, there was mass unemployment for university graduates, and the long-simmering anger of a generation that had grown up under Tory rule was reaching tipping point. While the Ecstasy culture was taking the club culture to a whole new level with smiley love-thy-neighbour vehemence, the people clashed with the establishment in the Poll Tax Riots and the kids lined up KLF-blaring soundsystems like sonic tanks in protest against the Criminal Justice Bill. To a thoroughly disenfranchised and disenchanted generation, increasingly familiar with the sweaty grip of the dancefloor embrace, the rampant capitalism of Thatcher's Britain seemed like precisely the wrong thing to have been pursuing – even to the Iron Lady's own party. Importantly, the advent of satellite technology and the clunky dawn of the information age was also busy tearing apart the previous paradigm of a shared visual culture – the family unit no longer sat around a television set that had a mere four channels, now they had access to thousands, and the result was a new and increasingly fragmentary view of scoiety. The kids who came together to create Dazed & Confused were a product of these shifting cultural sands, and the big question for all of them was what was going on, and what comes next. "I think we were all reacting," claims Phil Poynter, the magazine's first photo editor, who was responsible for commissioning content that would come to shape the magazine's cutting-edge aesthetic and in-your-face reputation. "I think the beauty of Dazed was that we didn't really have a plan, we were all kids living in that moment and it was our reaction – my social documentary commission, Katy England's fashion commission, Mark's art commission, Mike Fordham's writing... We were throwing our ideas into the pot and finding people that hadn't been published anywhere; that hadn't even got to the point of publication. Jefferson took all these ideas and managed to pull together a really balanced issue every time."

For a generation that felt alienated by an old-school mainstream media that was increasingly hegemonous, this attitude hit a significant one-for-all and all-for-one nerve. "Most magazines are an expression of the ego of two or three people but what was important to us was not to have an ego – the way we operated was to try and understand artists' ideas and present their work as they really wanted it presented – it was about giving people a voice. When we got bad reactions from advertisers or stockists we didn't just back down – we reacted." Given this penchant for confrontation it's perhaps unsurprising that the social reportage commissioned by the magazine provided a powerful clarion for those so often under-represented or misrepresented in the mainstream – from children with autism to survivors of genocide and marginalised sex-addicts. "I'm particularly proud of publishing the work of Jack Webb. Jack came to me after going to see everyone else and being turned away. I literally opened this box of his work and one picture after another was amazing – social documentary of a standard that I hadn't ever seen before. It was truly, truly magical – there was the autism story, there was one on a guy who had obsessive compulsive disorder... He was clearly an amazing talent and he didn't have a voice. Dazed was a vehicle for that voice." Webb became one of those image-makers intrinsic to the magazine's social reportage, shooting everything from New Year's Eve in a post-war Sarajevo to domestic sexual mores in the gay fetish underground scene.

"Phil Poynter was brilliantly encouraging of so many people at that time," says Webb, whose work graces many of the coming pages. "He was a photographer and yet he was commissioning, so that says a lot – he was very selfless like that. There was this great energy at Dazed that we were doing something right – a sense that these were stories that were worth telling and that the fact we were telling them was a good thing. I think Rankin himself had got a lot of knock-backs early on, so he said, 'Fuck you. I'm going to do my own magazine.' That in itself is a metaphor for trying to get your voice heard, and it shows that if no one's going to listen you're just going to have to build a big building, stand on top and shout even louder."

This "do-it-yourself" intuitive attitude manifested itself in many ways, not least in Poynter's own shoots for the magazine, which often provided a transdisciplinary counterpoint between art and fashion. "I remember shooting this story called Rian & Cori – which was basically just two people making out – and Calvin Klein pulled their advertising because they deemed the magazine too sexual; too risky," explains Poynter. "The next month, I did a story that was also based on a couple having sex but we retouched out the bodies so they were invisible – the riposte came out of a reaction, we were like, 'Oh, come on... really?'"

These were provocative risks that most in publishing would never choose to take with their advertisers, and the devil-may-care approach was very much a product of the times. "Out of recession comes creativity," asserts Poynter. "You're pushed to find a way to present your ideas if there's no financial support. People come together at those times and challenge each other, and that always turns into something." What that turned into in terms of the social reportage in 20 years of Dazed & Confused was an unflinching commitment to bringing an angle or viewpoint to society that would simply never be published anywhere else – be that an issue devoted to the issue of HIV/Aids in Africa or an environmental call to arms – and a growing aesthetic of activism. "We always had a political position at the magazine but I don't think we really knew how to gear it up and utilise it at first. Meeting Bono was very significant in that sense," says Rankin. "He was really doing things and he trusted Jefferson's judgement on ideas and positioning. He ended up introducing us to the Comic Relief people, to the Project RED people... I mean, we were highlighting issues all along, but in the beginning they weren't kind of about 'doing good', they were more sort of about making a commentary."

"There was this sense at the beginning that if one can bring a particular perspective and a particular view, then the images can become memorable and create a new kind of awareness," says Webb. "I was very emotionally charged at that age and there was often an intriguing, emotive or interesting angle in the commissions. The thing with the magazine at the time was that everybody there was absolutely committed to being there. There was a good energy about the place – everyone was working really hard on something that they really believed in, and with that as an approach, only good can come."
JOHN-PAUL PRYOR

[right]
July 2008
VIVIENNE WESTWOOD KIDS
*photography by
Oliviero Toscani*

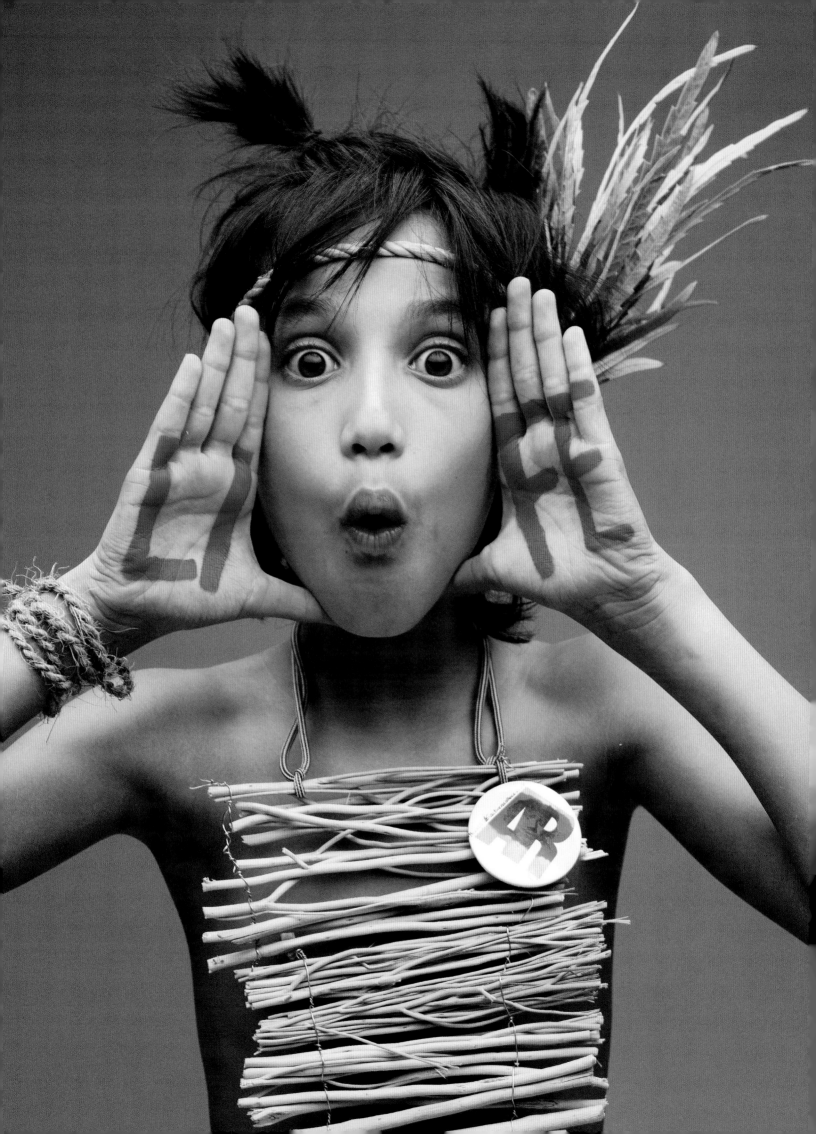

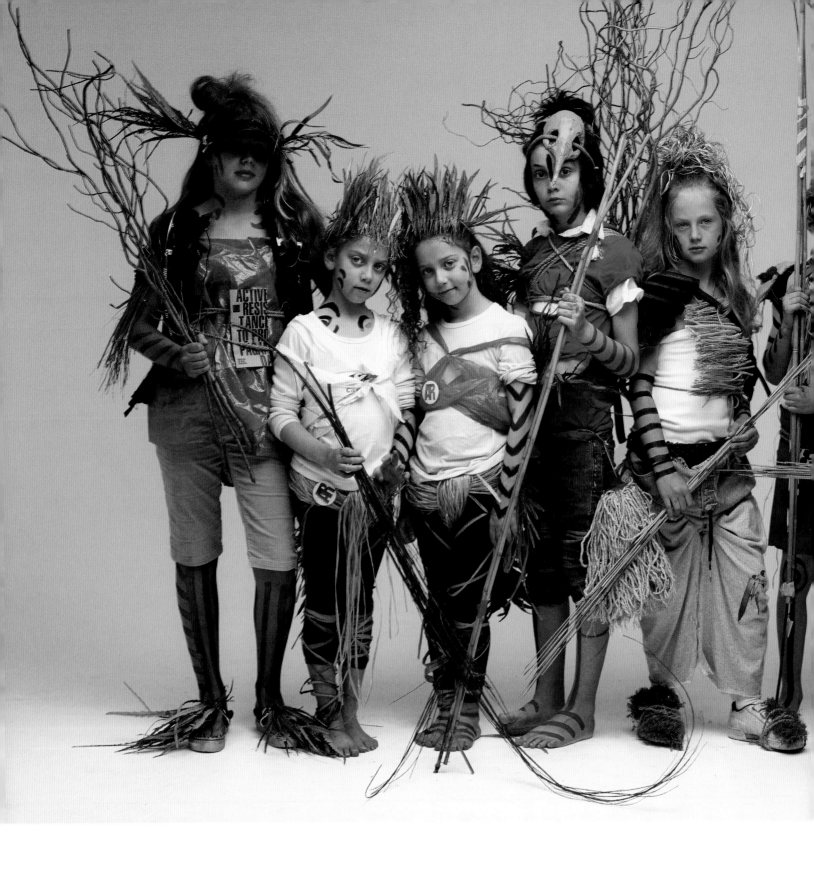

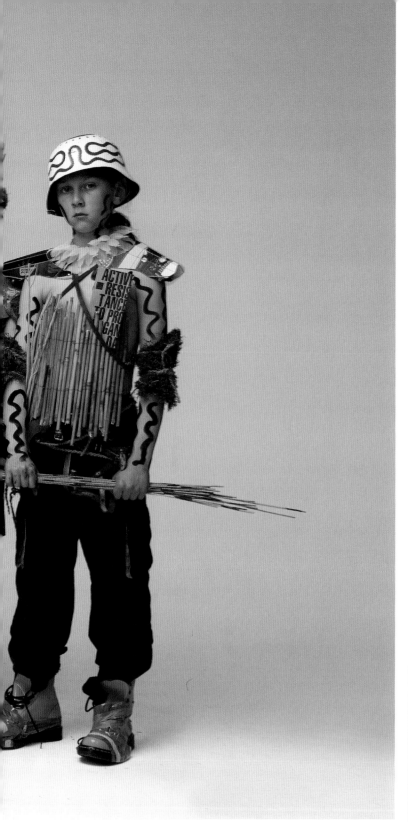

July 2009
VIVIENNE WESTWOOD MEETS
JAMES LOVELOCK
photography by
Lina Scheynius

July 2008
VIVIENNE WESTWOOD KIDS
photography by
Oliviero Toscani

In this collaboration Vivienne Westwood, Nicola Formichetti and Oliviero Toscani developed the concept of a tribe of children, reflecting Westwood's *Active Resistance* campaign, which called for action on global warming. In an exclusive feature one year on she talked to scientist James Lovelock about the future of the planet.

"When Vivienne guest-edited a special issue she suggested to us that she interview James Lovelock, the leading independent scientist and environmental pioneer. We weren't able to make it happen for that issue but her team stayed on it and I received an email one year on asking if I wanted to chair their meeting. At the meeting of minds Vivienne was passionate and knowledgeable, and James showed no signs of being surprised to be grilled by one of the country's leading fashion designers. Vivienne later said to me that she would basically do whatever it took to make his ideas more widely known. I hope that a few people who might have otherwise never been exposed to Lovelock's ideas were made to think about things differently for a moment."
ROD STANLEY

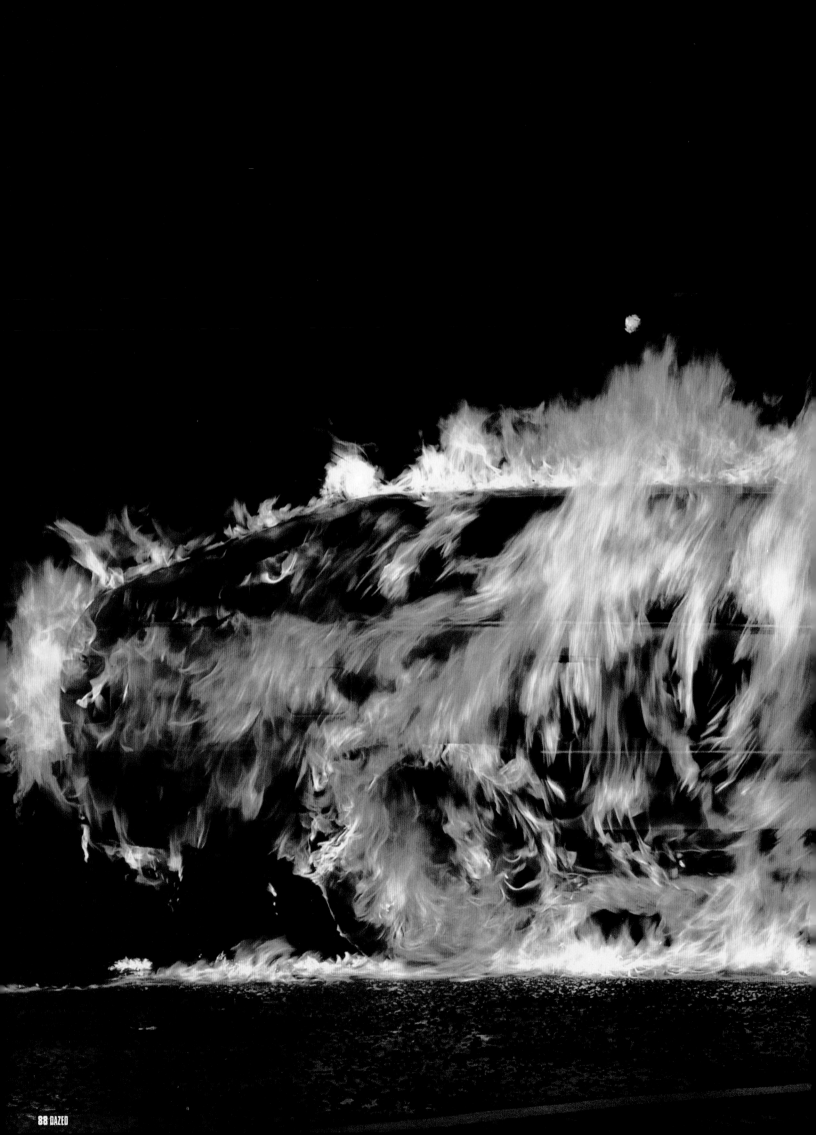

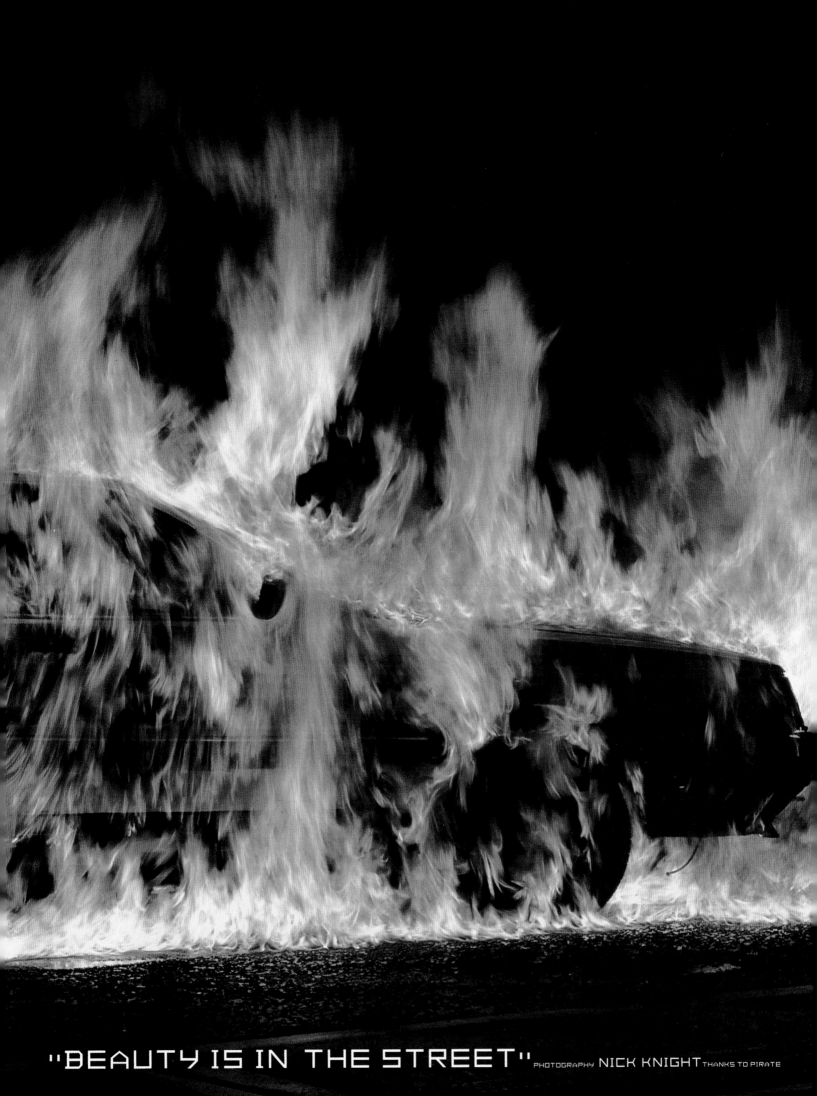

"BEAUTY IS IN THE STREET" PHOTOGRAPHY NICK KNIGHT THANKS TO PIRATE

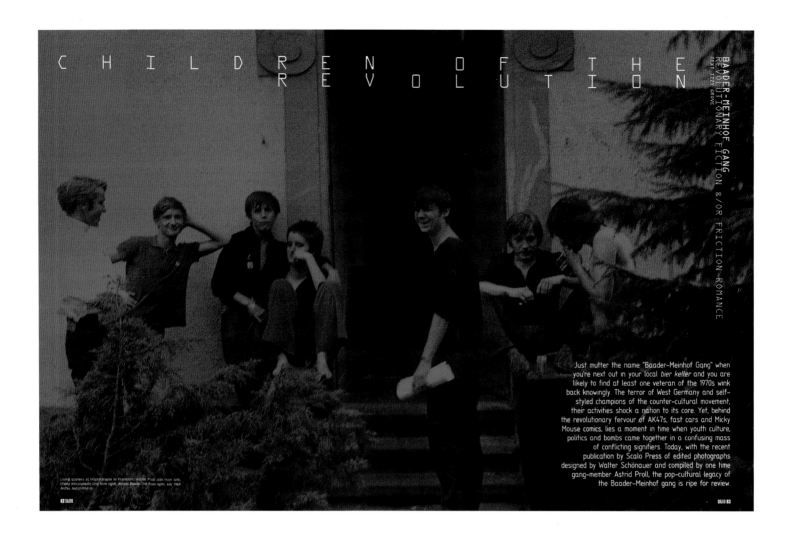

CHILDREN OF THE
REVOLUTION

BAADER-MEINHOF GANG
REVOLUTIONARY FICTION &/OR FRICTION-ROMANCE
TEXT IZZY GROVE

Just mutter the name "Baader-Meinhof Gang" when you're next out in your local *bier keller* and you are likely to find at least one veteran of the 1970s wink back knowingly. The terror of West Germany and self-styled champions of the counter-cultural movement, their activities shock a nation to its core. Yet, behind the revolutionary fervour of AK47s, fast cars and Micky Mouse comics, lies a moment in time when youth culture, politics and bombs came together in a confusing mass of conflicting signifiers. Today, with the recent publication by Scalo Press of edited photographs designed by Walter Schönauer and compiled by one time gang-member Astrid Proll, the pop-cultural legacy of the Baader-Meinhof gang is ripe for review.

Living quarters at Hügelstrasse in Frankfurt: Astrid Proll (4th from left), Charly Winczewski (2nd from right), Adreas Baader (1st from right), July 1969. Archiv, Astrid Proll ©

November 1998
BAADER MEINHOF
photography by
Astrid Proll

For the first 15 years of the magazine The Dazed Gallery provided young and established artists with the opportunity to exhibit work. The exhibition of photographs of The Baader Meinhof Komplex by Astrid Proll was among the most controversial of these shows.

"We exhibited Astrid Proll's photographs of the Baader Meinhof Komplex at The Dazed Gallery and she came over to London to help install the show. Astrid was originally the getaway driver for the Baader Meinhof gang so we thought it was safe to let her borrow my assistant Roger Tatley's car in order to pick up some art supplies. I just remember a horrified Roger coming into the office saying, 'Astrid has just crashed my car!' My reply was simply, 'Well, now we know why the Baader Meinhof gang were eventually caught. Their getaway driver doesn't know how to drive!'"
MARK SANDERS

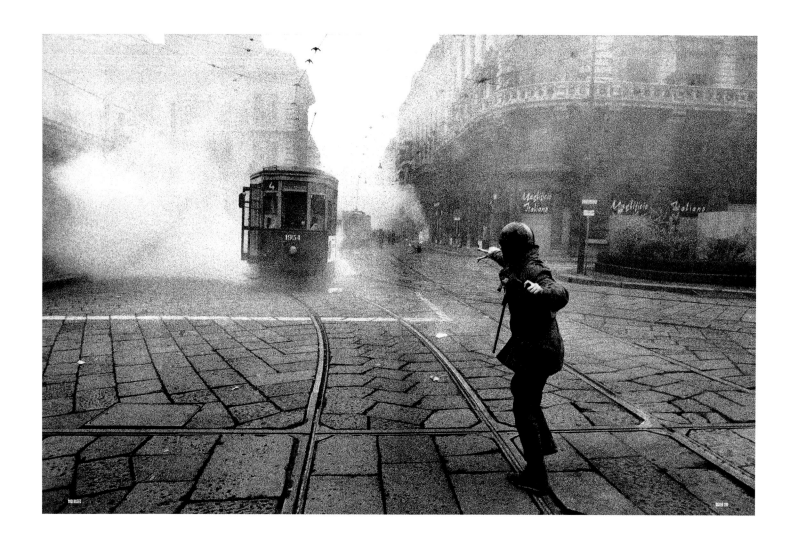

May 1998
STREET FIGHTING MAN
photography by
Aldo Bonasias

[previous spread]
May 1998
DEMAND THE IMPOSSIBLE
photography by
Nick Knight

SUBURBIA STILL

IT'S A ROAD IN THE MIDDLE OF SUBURBIA. TEA IS BREWED, SOMEONE'S WATCHING A MIDDLE OF NORMALCY. PEOPLE ARE GOING BUSINESS IS STRETCHING THE HUMAN BODY NIGHT BY THE SHEER WILL OF MIND OVER THE DEEPEST AND THE QUICKEST PHYSICAL SUBURBIA TO FIND IT. SOMETIMES YOU HAVE

IT COULD BE ANY ROAD. CARS ARE PARKED, DIANA TRIBUTE VIDEO. IT'S A ROAD IN THE ABOUT THEIR BUSINESS, ONLY SOME PEOPLE'S TO ITS ELASTIC CONCLUSION ON A SATURDAY MATTER. TO FIND THE HARDEST, THE FASTEST, HIT. SOMETIMES YOU HAVE TO STEP OUT OF TO GO TO A CLUB FOR IT. THIS IS HARDCORE.

QUIETLY PUMPING

TEXT **PAUL FLYNN** PHOTOGRAPHY **JACK WEBB** SPECIAL THANKS TO **DAVE, ALASTAIR** AND **SUZIE KRUEGER**

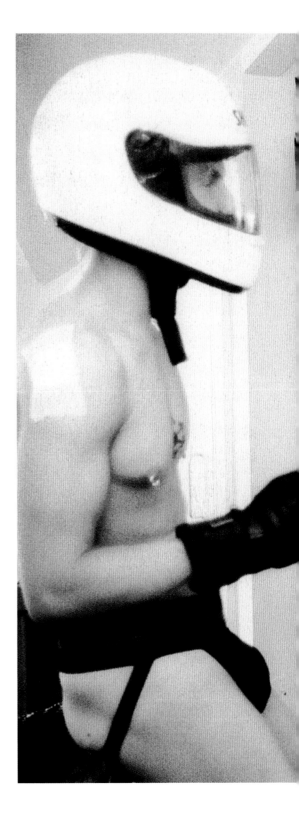

September 1998
SUBURBIA STILL QUIETLY PUMPING
photography by Jack Webb

In a guest-edited issue, Alexander McQueen commissioned Jack Webb to shoot what goes on behind closed doors in London's sex apartments, which was typical of the magazine's commitment to shining a light on marginalised micro-cultures.

"Lee [McQueen] had a friend named Suzie Krueger who ran a club down in South London called Fist, and he had this idea of doing something about that scene. We talked it through and I think – to be fair – he found it quite amusing to send a straight guy to shoot. He quite enjoyed setting me up on that one. It's funny because things like this are often much more intriguing when they're still in the fantastic – when you're actually there photographing it all the intrigue is stripped away, for better or worse. It would be wonderful to be able to ask Lee what he found so interesting about it, but obviously no one can now... it is such a great loss."
JACK WEBB

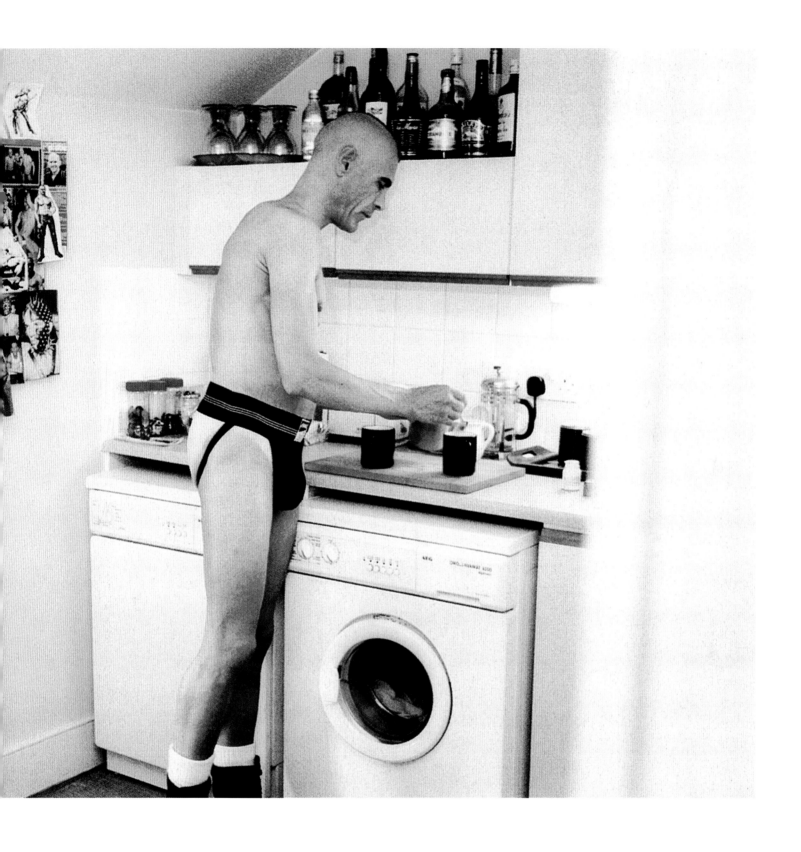

(P R O D U C T)
R E D
IS NOT
ANOTHER
CHARITY

It is not another campaign that is asking you to donate money to a cause. It is a brand. Companies are creating special ranges of RED products, and making a commitment to give a portion of the profits directly to the Global Fund to fight AIDS in Africa. So, you get something you want, and you get to do some good, too. As Russell Simmons, founder of Def Jam Records and a key supporter of the project, puts it: "I want to contribute more to the earth than I take away from it. I take a lot of shit from it, too, so I have a lot of giving to do."

Launch partners for (Product) RED are Gap, Converse, Giorgio Armani and American Express. RED was created by Bono and Bobby Shriver, the chairman of DATA (Debt, AIDS, Trade, Africa), an organisation that they founded in 2002 to lobby governments on these issues.

RUSSELL SIMMONS
Founder of Def Jam Records

How did you hear about (Product) RED and what made you want to get involved with it?
Bobby Shriver is my best friend and I'm a huge supporter of Bono. It is a cause that is dear to me – there are so many causes, but there is nothing quite as dramatic as the biggest human health crisis in the history of the planet.
What would you say to persuade someone to support it?
The Pentagon has added another $150billion for their campaign in Iraq – and we can't find the money to save people who are dying. For me, it is such an important cause – to get these corporations involved and make them hand over some of their profits and build a base for the brand RED, that's some shit right there.
How have you been showing your support?
I was with Maria Shriver at the Grammys – Maria looked hot with a little red tattoo and I was wearing a red golf sweater.
Can you see this project gaining the support of the hip hop community?
There is no better and more conscious group of musicians and artists in the history of the planet than the hip hop world.
As a successful entrepreneur, did the fact that RED is an economic initiative and not a charity make it appeal to you?
People are suffering. And the only way to relieve our own suffering is to relieve the suffering of others. We choose light for ourselves with selfish action. Do what makes you happy – be selfish, and if you know about lasting happiness, it comes from giving others lasting happiness. Relieving the suffering of others keeps you moving around and smiling, you understand? So, be selfish.

R E D
IS FOR
EMERGENCY

Every year, three million people die from AIDS. Africa is home to 60 per cent of the 40 million people worldwide that are infected with the virus, despite only having 10 per cent of the world's population. It is the leading cause of death across the continent, and women are the fastest growing population group living with the disease, while an estimated 13 million children in Africa have already been orphaned because of the disease. Dazed & Confused has an ongoing commitment to helping in the fight against AIDS in Africa.

DO THE
(R E D)
THING

For this unique portfolio, Dazed asked a number of artists to each contribute a piece of work about (Product) RED. www.joinred.com

ADO(RED)
Toyin

IN:SPI(RED)
David Sims

DO(RED)
Martin Parr

SA(RED)
Peter Blake

(RED):DEMPTION
Yelena Yemchuk

RE(RED):RED
Martina Hoogland Ivanow

(RED)HEAD
Tim Gutt

(RED):DONATE
Laurence Passera

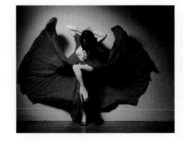

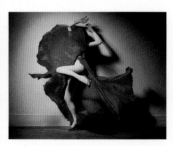

INC(RED)IBLE
Horst Diekgerdes

WI(RED)
Julie Verhoeven

AI(RED)
Helena Christensen

SCO(RED)
Gillian Wearing

(RED)RUM
Jason Nocito

COVE(RED)
Jenny Van Sommers

IGNO(RED)
Ola Bergengren

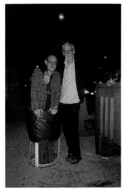

FI(RED)
Terry Richardson

PINK AND (RED)
Barry Mellon

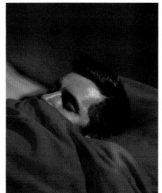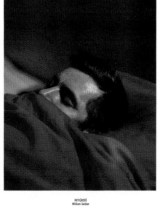

EMPOWE(RED)
Rankin

RETI(RED)
William Selden

April 2006
DO THE RED THING
by various photographers
and artists

(RED) was based upon the concept
that certain international brands
would produce red products,
the profits from which would go
towards anti-retroviral drugs for
people living with HIV/Aids.
The magazine media-partnered
on the project and created a
call-out to image-makers from
every discipline to send in red-
related pictures that would then
be published in *Dazed & Confused*.
On World Aids Day the magazine
handed over the reigns of the
project to the public – creating
a 24-hour live internet broadcast
inviting them to submit their own
red images to a huge database.

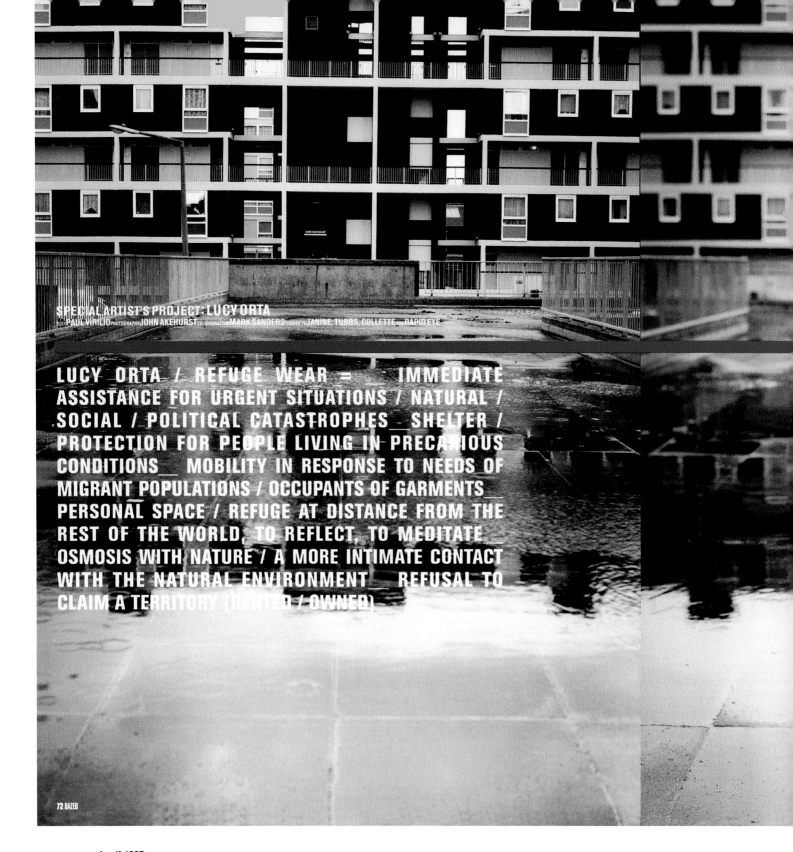

LUCY ORTA / REFUGE WEAR = IMMEDIATE ASSISTANCE FOR URGENT SITUATIONS / NATURAL / SOCIAL / POLITICAL CATASTROPHES SHELTER / PROTECTION FOR PEOPLE LIVING IN PRECARIOUS CONDITIONS MOBILITY IN RESPONSE TO NEEDS OF MIGRANT POPULATIONS / OCCUPANTS OF GARMENTS PERSONAL SPACE / REFUGE AT DISTANCE FROM THE REST OF THE WORLD, TO REFLECT, TO MEDITATE OSMOSIS WITH NATURE / A MORE INTIMATE CONTACT WITH THE NATURAL ENVIRONMENT REFUSAL TO CLAIM A TERRITORY (RENTED / OWNED)

72 DAZED

April 1997
LUCY ORTA
copyright 2011
by Lucy & Jorge Orta
photography by
John Akehurst

These images were the result
of a collaboration between the
Dazed & Confused design team
and the artist Lucy Orta, who
often created work in response
to certain social issues, such as
homelessness. The urban sleeping
bags were statement pieces
that explored the individual's
relationship to the architecture
that surrounds them.

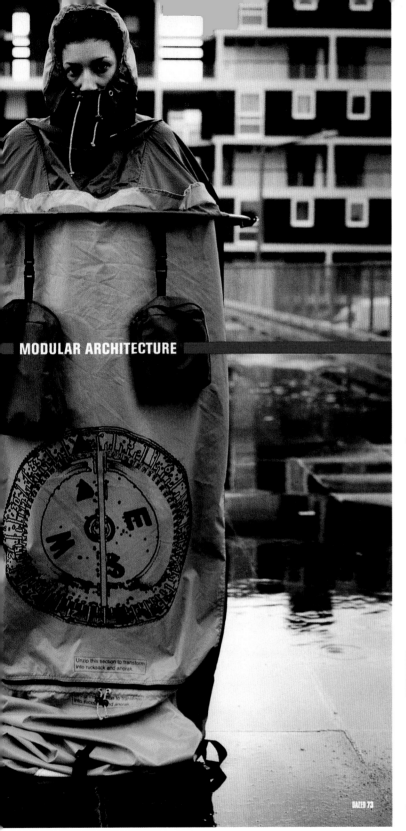

MODULAR ARCHITECTURE

Unzip this section to transform into rucksack and anorak

DAZED 73

I was first attracted to the work of Lucy Orta because of its situational nature. The problem of art today is one of deterritorialisation. Art is no longer based in galleries and museums; it is found where ever-changing social situations condense. Art is one of the elements of a world vision and this relationship with the world is a constantly-changing one. I first came across Lucy Orta's work where this relationship changes the most – in the street. I witnessed protective sleeping bags and survival kits, in the street and also at the Salvation Army. They immediately interested me by their pertinence.

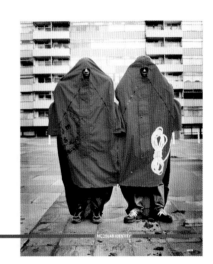

EXTENSIONS CORPORELLES

RESTRUCTURERE

MODULAR IDENTITY

LUCY ORTA: REFUGE WEAR

SITUATIONS MUTANTES

July 2006
COVER
by Barbara Kruger

Damien Hirst and Barbara Kruger
interpreted the Declaration of
Human Rights visually for a
limited-edition double cover.

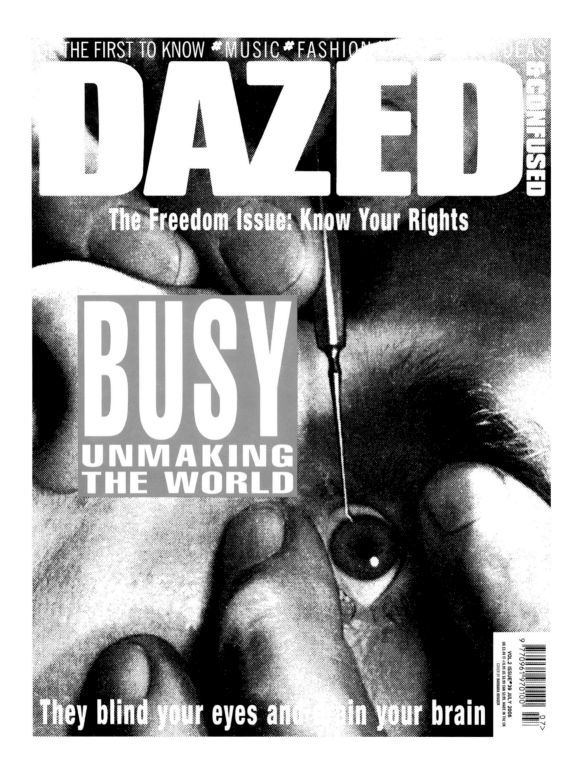

THE FIRST TO KNOW ✱MUSIC✱FASHION

DAZED &CONFUSED

The Freedom Issue: Know Your Rights

BUSY UNMAKING THE WORLD

VOL.2 ISSUE#39 JULY 2006
UK £3.40 IT c€5.95 US $8.99 CAN $9.99, MADE IN THE UK
COVER BY BARBARA KRUGER

They blind your eyes and drain your brain

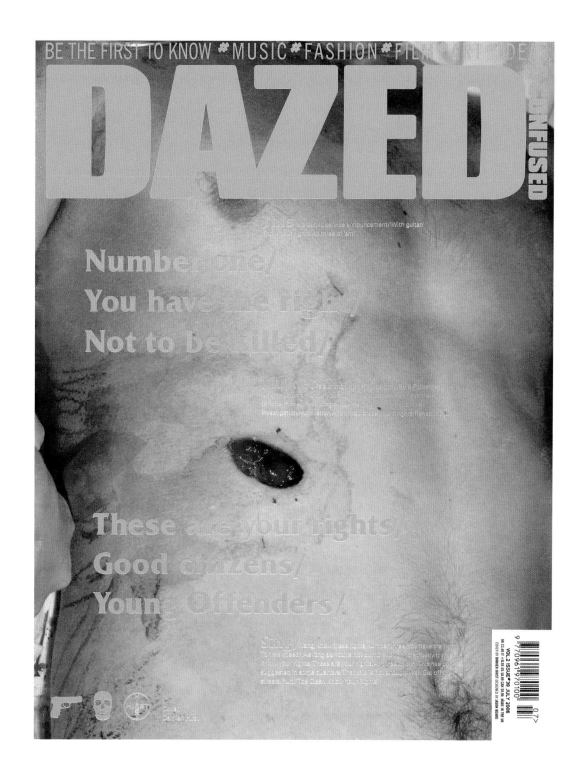

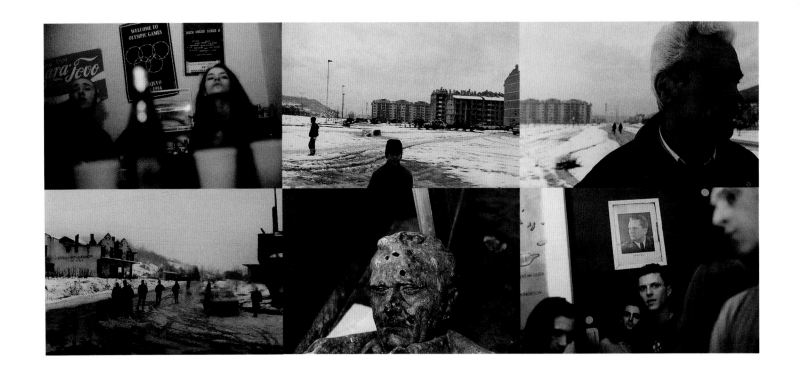

THE SOUND OF SILENCE

1997
THE SOUND OF SILENCE
photography by
Jack Webb

In this harrowing exposé of marginalised youth culture, photographer Jack Webb documented New Year's Eve in Sarajevo, visually capturing how young people coming out of the Serbian conflict celebrated the beginning of a new year.

"Futility and war are two words often used in the same sentence but there was a sense when we arrived a year on from the war that everything was fairly impotent – there was definitely an air of damaged goods. There were a lot of people who came up to me in the streets. I remember taking a photograph of one lad in a bar and afterwards he got angry, he said, 'What right have you to come here after it's all over?' I'm not saying there was ill feeling, but with any group of people who have lived through such a time, there was inevitable damage… it was awful. The piece was really about how celebrations can come after such a horrific period, and what does that look like? It was an intriguing angle – to go to a war zone and speak of celebration – and we found a great deal of celebration. It was one of the greatest New Year's Eves I ever witnessed, which is extraordinary. Although maybe not, maybe we're extraordinary in that we keep denying that celebration is a possibility."
JACK WEBB

...tle of brandy to kick off the early evening celebrations. I take it upstairs to our host, Vanja, sitting quietly in her bedroom with her friend ...ng a glass of the festive spirit, I ask if they're going out to get drunk tonight. They don't think so. "You've got to get drunk on New Year's ..., "it's tradition!". Looking up from her glass, Mija says, "Tradition? Don't talk to me of tradition. Tradition is what this war was for."

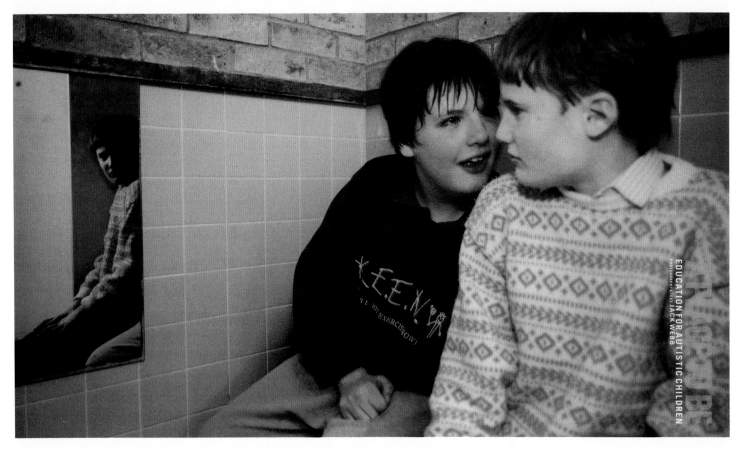

November 1996
A PLACE TO BE
photography by Jack Webb

"This autism unit was part of a regular mainstream school, and the autistic kids would play in the yard with the other kids. I met the woman who runs the unit, and all the stories that she was telling me were so visual that I became really interested. I guess autism is known through films like *Rainman*, which suggests that autistic people all have extraordinary talents, and actually that's not the case. I would keep going up to the unit every couple of weeks. There was definitely a sense that this was a story that was worth telling."
JACK WEBB

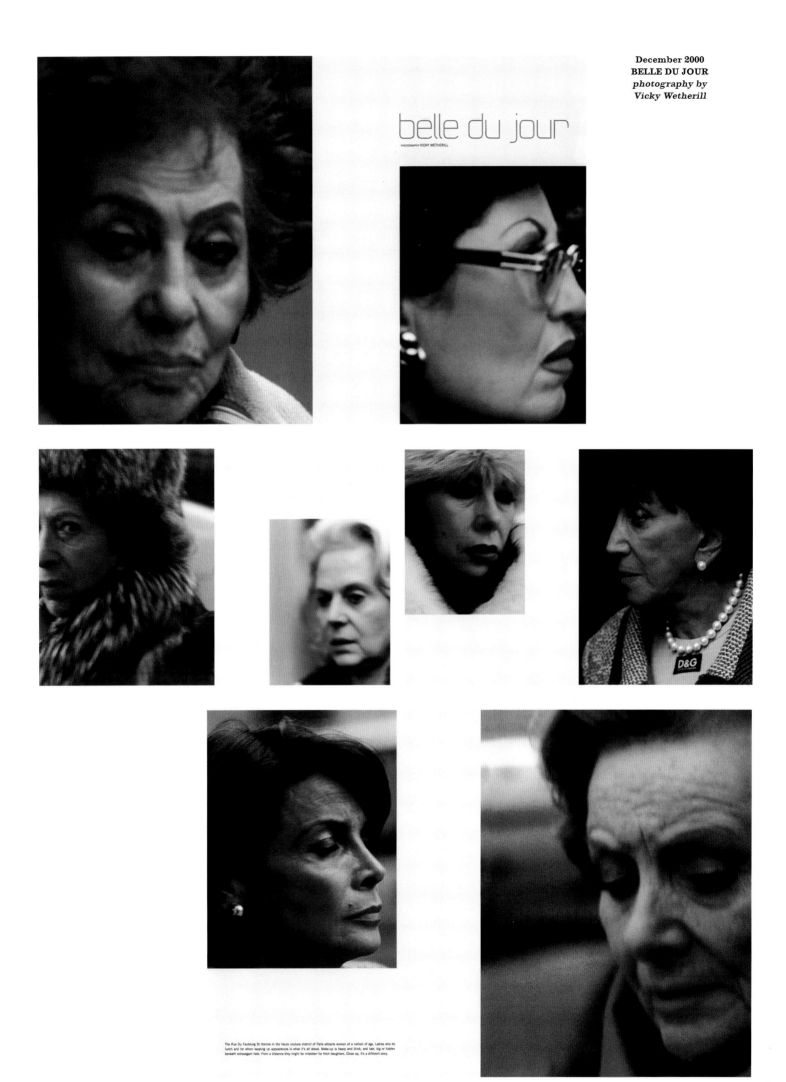

December 2000
BELLE DU JOUR
photography by
Vicky Wetherill

belle du jour

PHOTOGRAPHY VICKY WETHERILL

The Rue Du Faubourg St Honore in the haute couture district of Paris attracts women of a certain of age. Ladies who do lunch and for whom keeping up appearances is what it's all about. Make-up is heavy and thick, and hair, big or hidden beneath extravagant hats. From a distance they might be mistaken for their daughters. Close up, it's a different story.

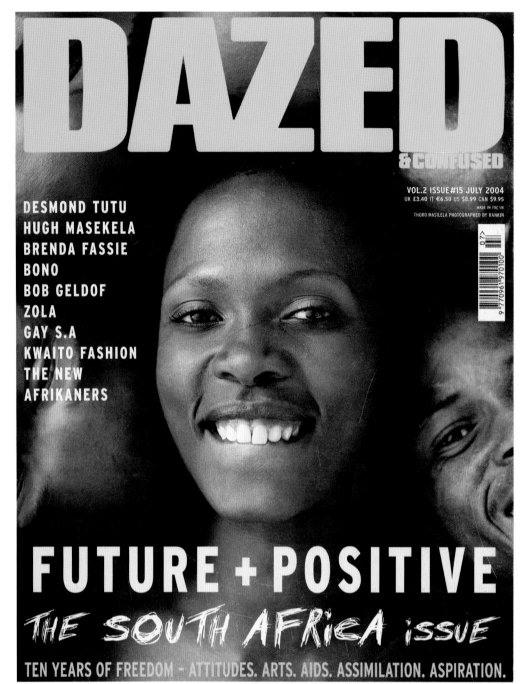

DESMOND TUTU
HUGH MASEKELA
BRENDA FASSIE
BONO
BOB GELDOF
ZOLA
GAY S.A
KWAITO FASHION
THE NEW
AFRIKANERS

VOL.2 ISSUE#15 JULY 2004
UK £3.40 IT €6.50 US $8.99 CAN $9.95
MADE IN THE UK
THOKO MASILELA PHOTOGRAPHED BY RANKIN

FUTURE + POSITIVE
THE SOUTH AFRICA ISSUE
TEN YEARS OF FREEDOM – ATTITUDES. ARTS. AIDS. ASSIMILATION. ASPIRATION.

July 2004
THE SOUTH
AFRICA ISSUE
photography by Rankin

"I have always had a real belief that photographic imagery can be democratising, because you can have a celebrity and a person who is not famous next to each other in a magazine and it kind of makes them even. The misunderstandings that happen with language is another thing that photography can cut through, and I've always been excited about the ability to say something in a photo that you can't say in language. The cover of the South Africa issue was about optimism and saying people's lives can be changed – and that just because they are HIV-positive doesn't mean they are over. I've always liked that thing of taking a person that isn't famous and putting them in the position of somebody that is famous, such as on the cover of a magazine – there is a significance to that. I feel very analytical about the packaging of things, and if I am going to package a fucking celebrity and try and sell something, then I might as well package someone with HIV in Africa, and sell an opposite view of them to the world."
RANKIN

FUTURE
+
POSITIVE

SOUTH AFRICA IS AT THE CENTRE OF A DEVASTATING HIV/AIDS PANDEMIC THAT THREATENS TO WRECK THE COUNTRY'S TEN-YEAR-OLD FREEDOM AND ITS NASCENT ECONOMY. HERE, THE EDITOR OF THE SOUTH AFRICAN DAILY PAPER "THIS DAY" TAKES A JOURNEY THROUGH TEN YEARS OF LOSS, DESPAIR, MADNESS AND HOPE.

TEXT JUSTICE MALALA PHOTOGRAPHY RANKIN INTERVIEWS BY THANDIE MCCLOY EDITED BY TIM NOAKES

DAZED & CONFUSED

[following spread]
July 2004
THE SOUTH
AFRICA ISSUE
*photography by
Marc Shoul*

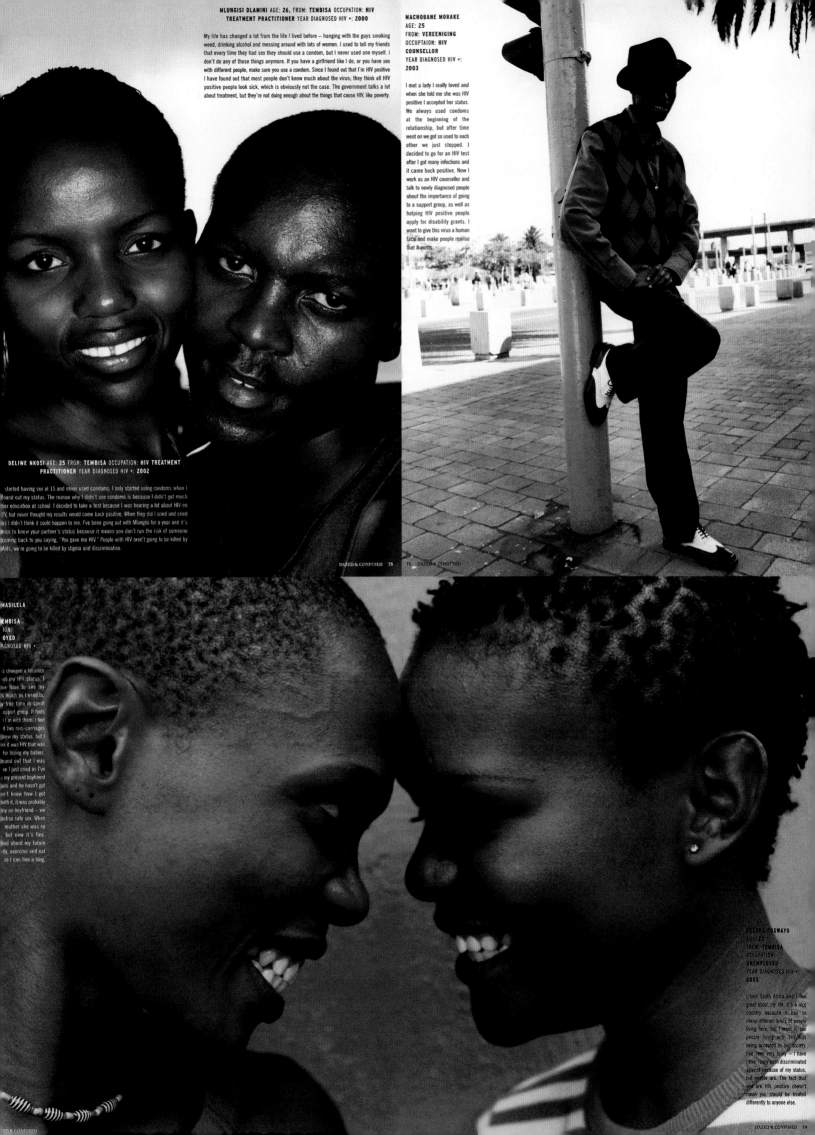

MLUNGISI DLAMINI AGE: 26, FROM: TEMBISA OCCUPATION: HIV
TREATMENT PRACTITIONER YEAR DIAGNOSED HIV +: 2000

My life has changed a lot from the life I lived before — hanging with the guys smoking
weed, drinking alcohol and messing around with lots of women. I used to tell my friends
that every time they had sex they should use a condom, but I never used one myself. I
don't do any of these things anymore. If you have a girlfriend like I do, or you have sex
with different people, make sure you use a condom. Since I found out that I'm HIV positive
I have found out that most people don't know much about the virus; they think all HIV
positive people look sick, which is obviously not the case. The government talks a lot
about treatment, but they're not doing enough about the things that cause HIV, like poverty.

MACHOBANE MORAKE
AGE: 25
FROM: VEREENIGING
OCCUPATION: HIV
COUNSELLOR
YEAR DIAGNOSED HIV +:
2003

I met a lady I really loved and
when she told me she was HIV
positive I accepted her status.
We always used condoms
at the beginning of the
relationship, but after time
went on we got so used to each
other we just stopped. I
decided to go for an HIV test
after I got many infections and
it came back positive. Now I
work as an HIV counsellor and
talk to newly diagnosed people
about the importance of going
to a support group, as well as
helping HIV positive people
apply for disability grants. I
want to give this virus a human
face and make people realise
that it exists.

DELIWE NKOSI AGE: 25 FROM: TEMBISA OCCUPATION: HIV TREATMENT
PRACTITIONER YEAR DIAGNOSED HIV +: 2002

started having sex at 15 and never used condoms. I only started using condoms when I
found out my status. The reason why I didn't use condoms is because I didn't get much
sex education at school. I decided to take a test because I was hearing a lot about HIV on
TV, but never thought my results would come back positive. When they did I cried and cried
as I didn't think it could happen to me. I've been going out with Mlungisi for a year and it's
nice to know your partner's status because it means you don't run the risk of someone
coming back to you saying, "You gave me HIV." People with HIV aren't going to be killed by
Aids, we're going to be killed by stigma and discrimination.

MASILELA

EMBISA
ION:
OYED
AGNOSED HIV +:

s changed a lot since
ut my HIV status. I
ve time to see my
s much as I used to,
y free time is spent
upport group. It feels
I'm with them, I feel
d two mis-carriages
new my status, but I
nk it was HIV that was
for losing my babies.
und out that I was
ve I just cried as I've
my present boyfriend
ars and he hasn't got
n't know how I got
with it, it was probably
my ex-boyfriend — we
active safe sex. When
mother she was so
but now it's fine.
ed about my future
dy, exercise and eat
so I can live a long,

FISEKA POSWAYO
AGE: 22
FROM: TEMBISA
OCCUPATION:
UNEMPLOYED
YEAR DIAGNOSED HIV +:
2003

I love South Africa and I feel
great about my life. It's a nice
country because it has so
many different kinds of people
living here, but I want to see
people living with HIV/Aids
being accepted in our society.
I've been very lucky — I have
never really been discriminated
against because of my status,
but people are. The fact that
you are HIV positive doesn't
mean you should be treated
differently to anyone else.

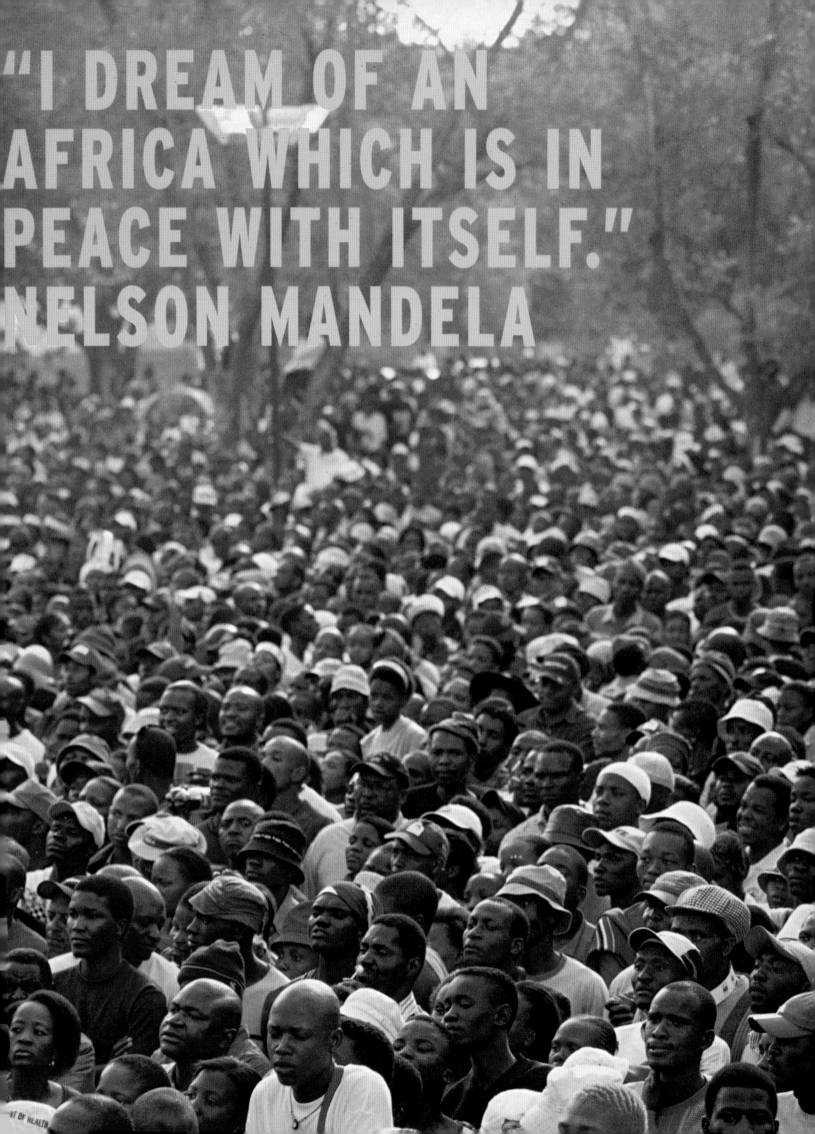

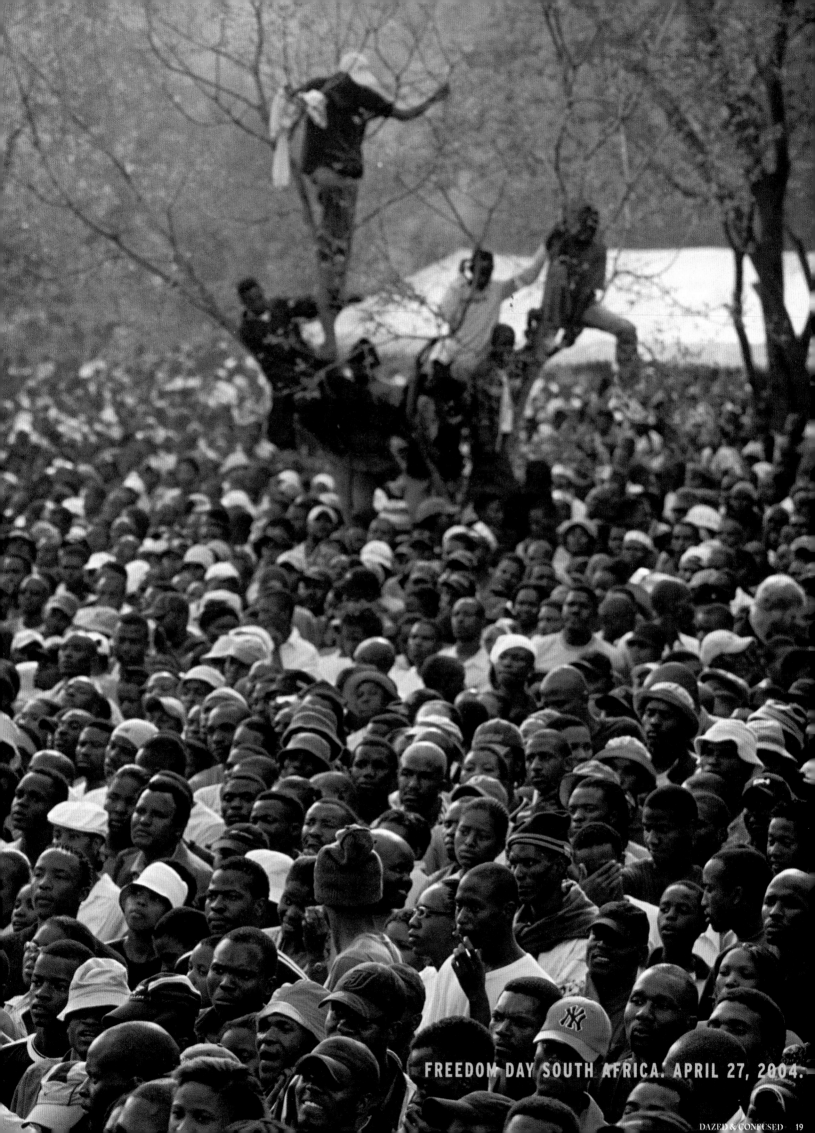

FREEDOM DAY SOUTH AFRICA: APRIL 27, 2004.

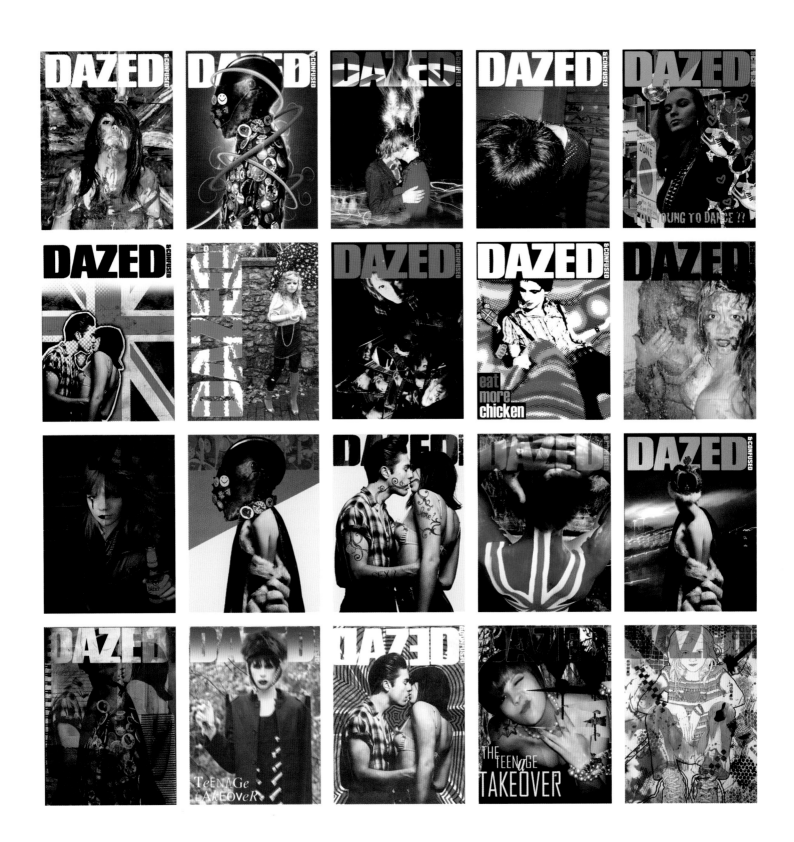

January 2009
TEENAGE TAKEOVER
various submitted illustrations
photography by
Michael Thomas Jones

"When we asked the youth of
Great Britain to guest-edit their
own issue they were getting a
particularly hard time in the
national media – being nailed
as a feral mob of knife-wielding,
skunk-smoking sociopaths. We

wanted to counter the prevailing
narrative and show some of the
creativity, energy and humour
of young people in the country.
The issue made an impact. I was
asked to give quotes for a bunch
of news pieces, and ended up on a
panel arguing with someone from
a newspapers' society about their
negative representation of young
people. If nothing else, it proved
that the kids are alright."
ROD STANLEY

[right]
February 2003
HELLNO!
illustration by Jimmy Turrell
original photography by Rankin

When the world was on
the precipice of both the Iraq
and Afghanistan conflicts,
Dazed & Confused produced
the award-winning *HELLNO!*
supplement – a tongue-in-cheek
anti-war magazine that went out
with the issue as an insert.

HELLNO!

C'MON MAKE THE EFFORT — IT'S A WAR SPECIAL

IF WAR WAS A HAIRCUT:
WHAT WOULD IT LOOK LIKE?

BATTLE FATIGUE:
IS SLAUGHTER BORING?

DOING THE GAZA STRIP!
JORDAN REVEALS WEAPONS OF MASS DISTRACTION —
ISRAEL NOT IMPRESSED

IS DEMOCRACY WORKING?
LET'S PUT IT TO THE VOTE

WHAT'S THAT SMELL?
HOW THE BLIND CAN HELP

STARVATION DIETING
THE PLUS SIDE TO SANCTIONS?

April 2011
THE MONEY ISSUE - COVER
artwork created by Jake & Dinos Chapman
photography by David Hughes

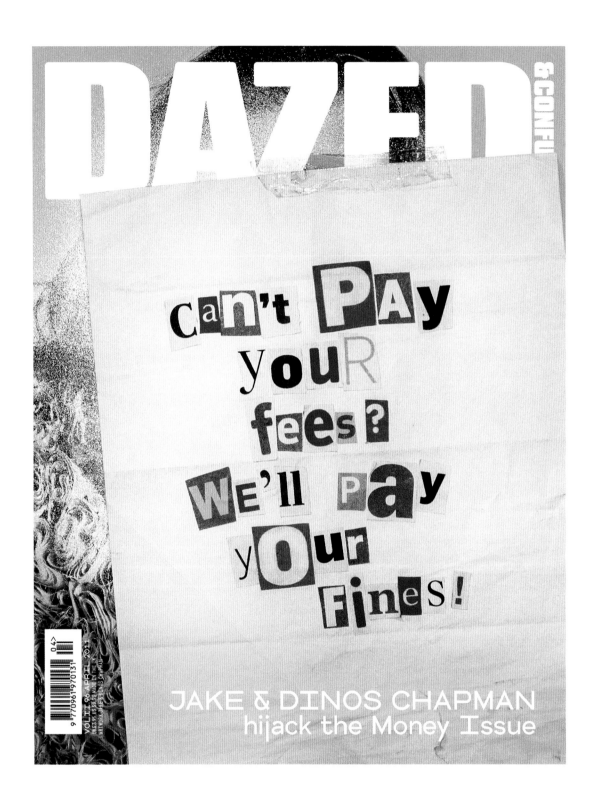

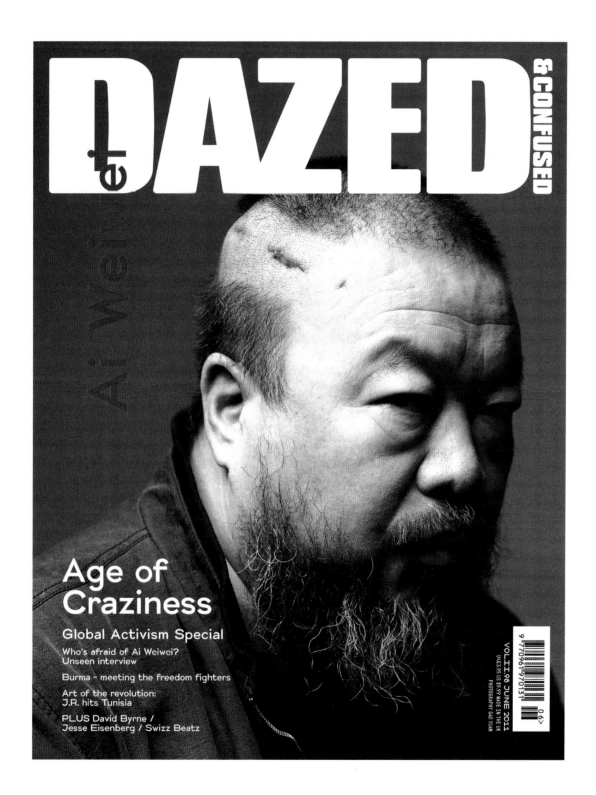

December 2000
ONE IN TEN
photography by Nick Knight
styling by Katy England

Katy England and Nick Knight
photographed women who had all
undergone mastectomies in this
erotically charged and quietly
confident lingerie story.

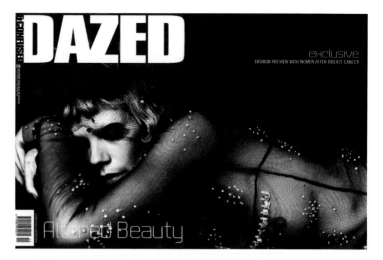

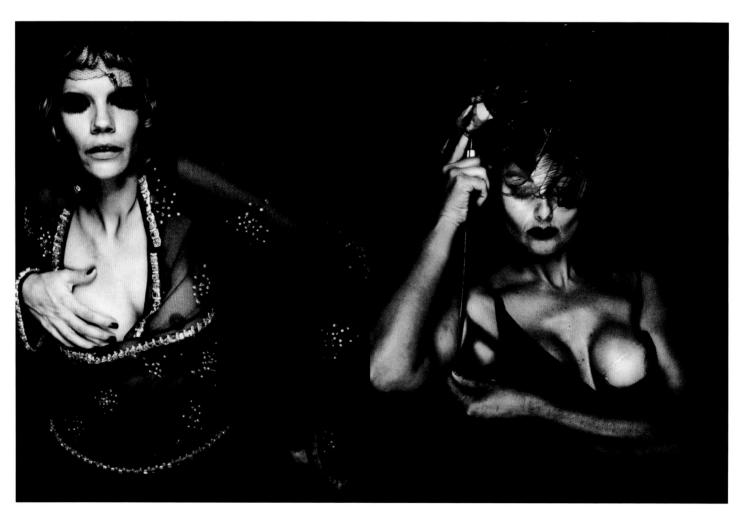

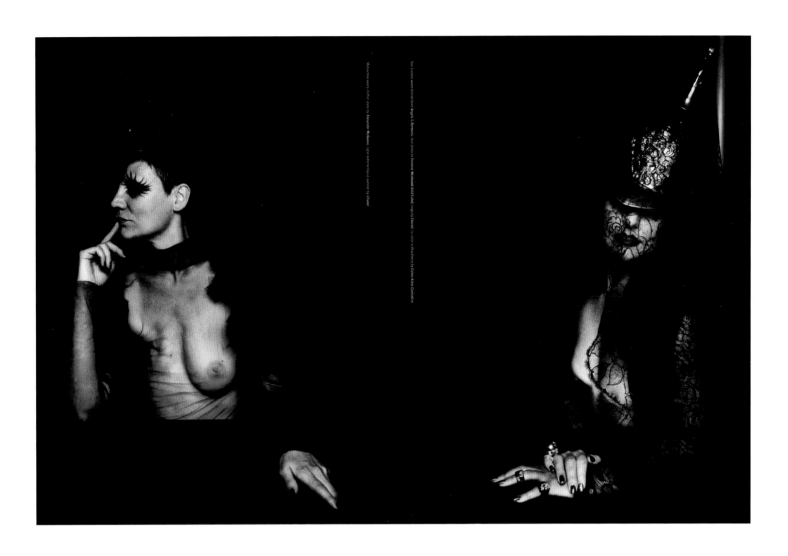

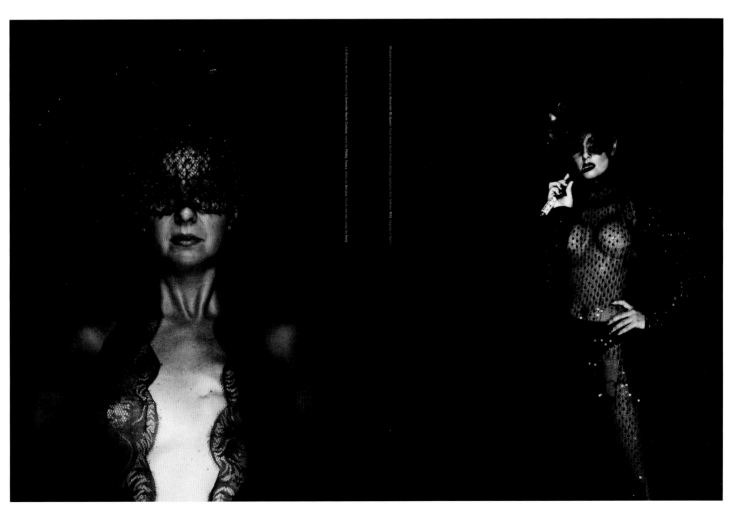

BOYS ON FILM
The Fashion Of Alister Mackie

"As young stylists we were desperate to work for *The Face* or *i-D* but they seemed so closed off to us. *Dazed* wasn't and that's what made it what it was. *The Face* had become The Bible because it had been proclaimed 'The Bible' so many times. Yet *Dazed* became the most exciting place at that time."

The similarities between the YBAs and YBFPs (Young British Fashion People) during the 1990s in London were marked. It was often a symbiotic relationship in the pages of *Dazed & Confused* and one that the stylist Alister Mackie was a regular part of. That mix of the oppositional, entrepreneurial and ambitious was very familiar to those on the inside of the magazine. "Jefferson and Rankin totally got what was going on with art in Britain and they had the most brilliant person ever to source and convey artists in Mark Sanders. That art reflected what we did in the fashion – the attitude of it. I styled Damien Hirst for the cover. We used to have those pieces from Jake and Dinos Chapman in the office – those bloody Fuckface dolls were all over the place; museum pieces being kicked about, just there being horrible. I worked on a big fashion story with Sam Taylor-Wood that was exhibited afterwards. *Dazed* was the one that was on it at that time."

Of course, that attitude and challenging mentality primarily extended to the coverage of fashion for Mackie: "I always wanted an international outlook for the magazine – storming the walls of Paris fashion, that citadel. We lived for designers who showed there – Jean Colonna, Anne Demeulemeester, Martine Sitbon, Helmut Lang, Comme... As students at Saint Martins, we would all be on a bus ready to break into the shows – that was what people did at that point, anything to get in – then you would get there and be stuck behind someone French and rarified waving a fan! Soon I would be working with Martine

Sitbon on her menswear in Paris. Then I saw how seriously they took fashion there... And how we didn't take it very seriously at all! Actually, I learned so much from that dedication."

At the same time, the ambition was to bring to "the citadel" a distinctly British attitude to conveying fashion as a stylist: "It was always about style magazines in Britain at that point. It just seemed so old-fashioned to be interested in conventional fashion magazines. They were just about clothes, some 'stuff'. We did not just want to do clothes – we wanted to make character, make reference to art, make reference to music, make reference to... a life."

Above all, Mackie's ambition was to carve out a new place and mood for men's fashion in the mid-1990s. Something he succeeded in that is evidenced by the existence of *Another Man*, the magazine where he is Creative Director. As the first of the menswear specialists at *Dazed & Confused* he formed something of a "double-act" with Katy England. "That came about because me and Katy were dividing up our approach to the fashion at the magazine and I just gravitated more towards menswear. Not as many people were shooting it and it felt like there was a place to voice something new in it. Raf Simons was just starting out and that world of that kind of man was coming together in a new way. That melancholic, dark and romantic idea around young men was something I felt was important to show. Then it became the mainstream – this alienated thing. Before, it wasn't."

Horst Diekgerdes and Cedric Buchet were emerging photographers at the point this new story of menswear was first taking shape and they were two of Mackie's most important working relationships in *Dazed & Confused*. "I started off shooting still-lifes with Cedric – the first shoot we did together was of Bernhard Willhelm's clothes in a caravan. Then we went on to shoot men in comparison to landscapes. That was in a menswear issue that I commissioned: one of the first ones we did. From that Prada came to us to shoot the advertising campaign. That showed how

much people were taking notice of the magazine, and I was very new at that point.

"There was a particular shoot with Horst where we went to Belgium and travelled around all of those squat places. We stayed on a boat in the harbour and we changed a boy's hair colour for every single picture – and he did it. We went out together, hung out and lived that weekend. But it wasn't a documentary, it was recorded but heightened and had a sort of 'magic realism' about it. It was a glamourised version of us."

In fact, like many of the *Dazed & Confused* prime movers to come, Mackie had appeared in the magazine before he actually worked on it, modelling in a Katy England shoot. "I got off the night bus from Glasgow and she changed my life. We laugh about it now but it did feel like that. You felt like you were in exactly the right place at exactly the right time. And *Dazed* did feel glamorous. But the world felt glamorous at that point, like East London – in that glamour and grime sort of way. The nightlife was glamorous, it had a spirit of dressing up, and there was a purpose to these clothes in a magazine – you wore them in a nightclub. It wasn't the forced costume-y feel of now – it wasn't like that, it seemed perfectly natural to look like that."

After modelling for her, Mackie started working with Katy England as an assistant when he was doing his Fashion MA at Saint Martins. "I was working on shoots and the McQueen shows during that time at college. After I graduated the first place I worked was *Dazed* and I have never left – well, the publishing house at least."

This "mentoring" facet of the fashion department at *Dazed & Confused* has always been a crucial part of the magazine, spotting talent and bringing through successive generations of stylists, photographers and editors. "That is part of the vocational aspect of the magazine. What you did came from who you were, who you spent time with, where you lived – it was all one story. It was about being part of a family and being part of a scene. You can see it in the *Boys And Girls On Film* stories we did. Both

Nicola [Formichetti] and Benjamin [Alexander Huseby] are in the *Boys* story. We had just met them at that point. It was Warholian in spirit – and that was the spirit of the magazine. It was always Jefferson's big reference and it is still with us now."

JO-ANN FURNISS

[right]
November 1999
SHRINK TO FIT
photography by
Horst Diekgerdes
styling by Alister Mackie

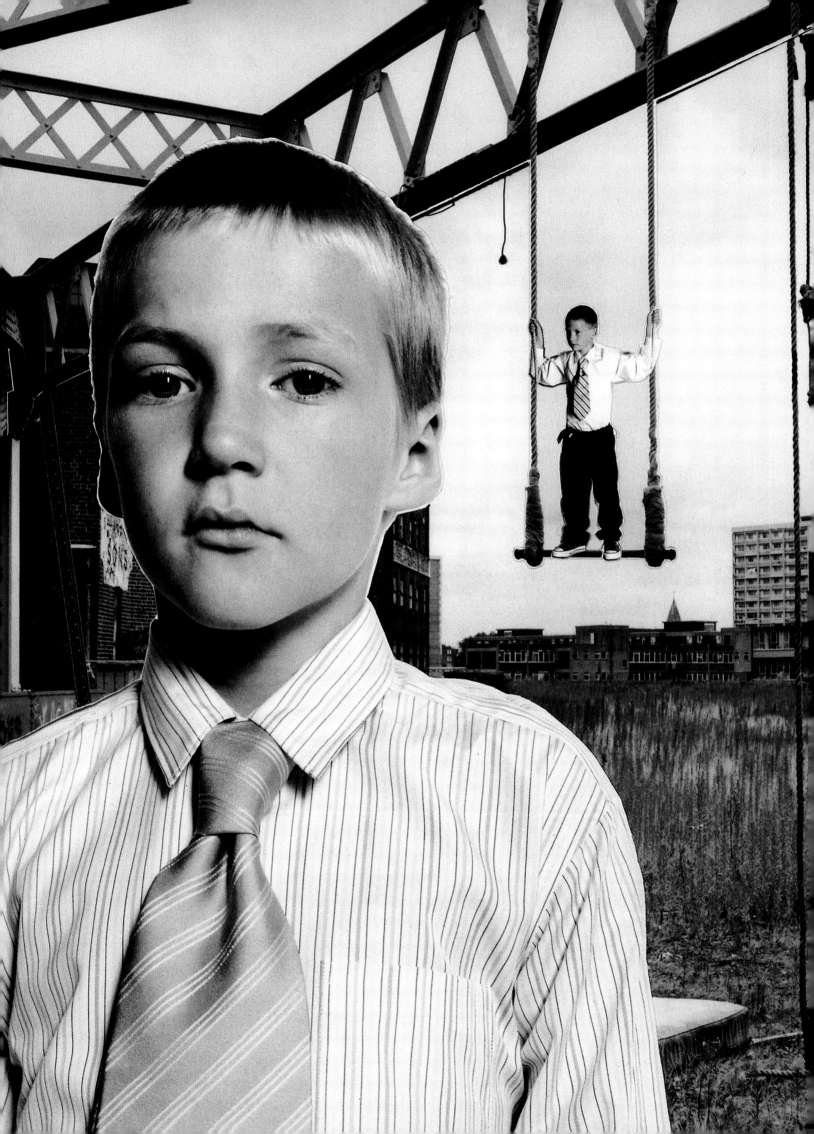

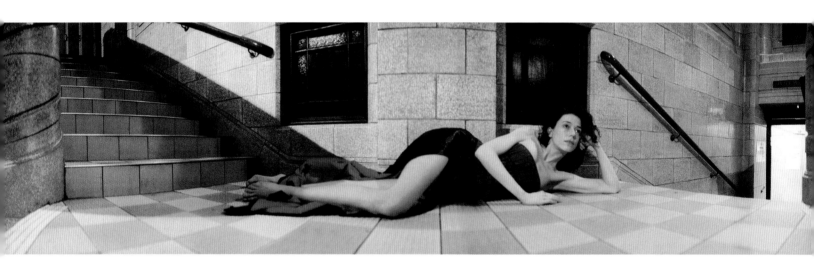

September 1998
**FIVE REVOLUTIONARY
SECONDS**
Sam Taylor-Wood
styling by Alister Mackie

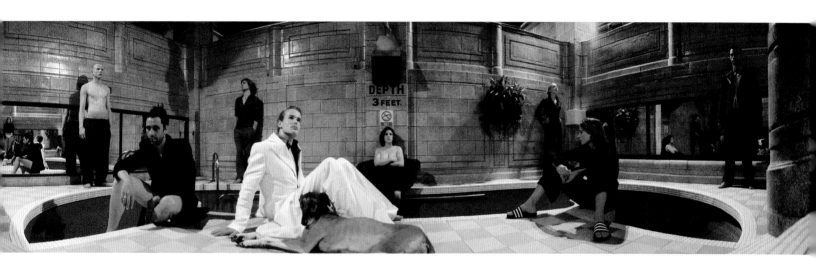

January 2000
BOYS ON FILM
cinematography by
Michael Cleary
styling by Alister Mackie

screen test # 2: boys on film

Stuart Gouldstone, age 19 Scottish

Sverrir Diego, age 17 Icelandic
Panelled Jersey top by **Raf Simons**

Film Micheal Cleary
Styling Alister Mackie
Hair Alan Pichon at Untitled+
Assisted by Shinya Nakayama for Cuts
Styling assistant Sofia de Romarate
Lighting Simon Clemenger
Sound Paul Cleary
Thanks to Andy Walsh

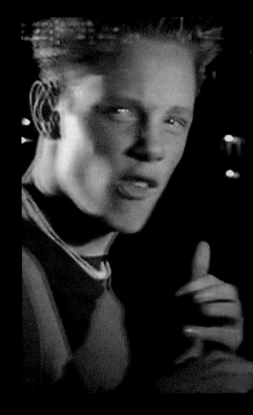

Kristinn Diego, age 17 Icelandic
wears panelled Jersey top by **Raf Simons**

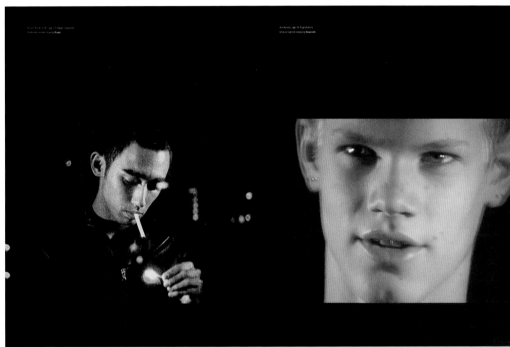

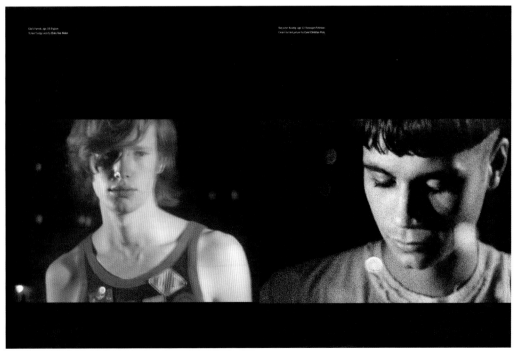

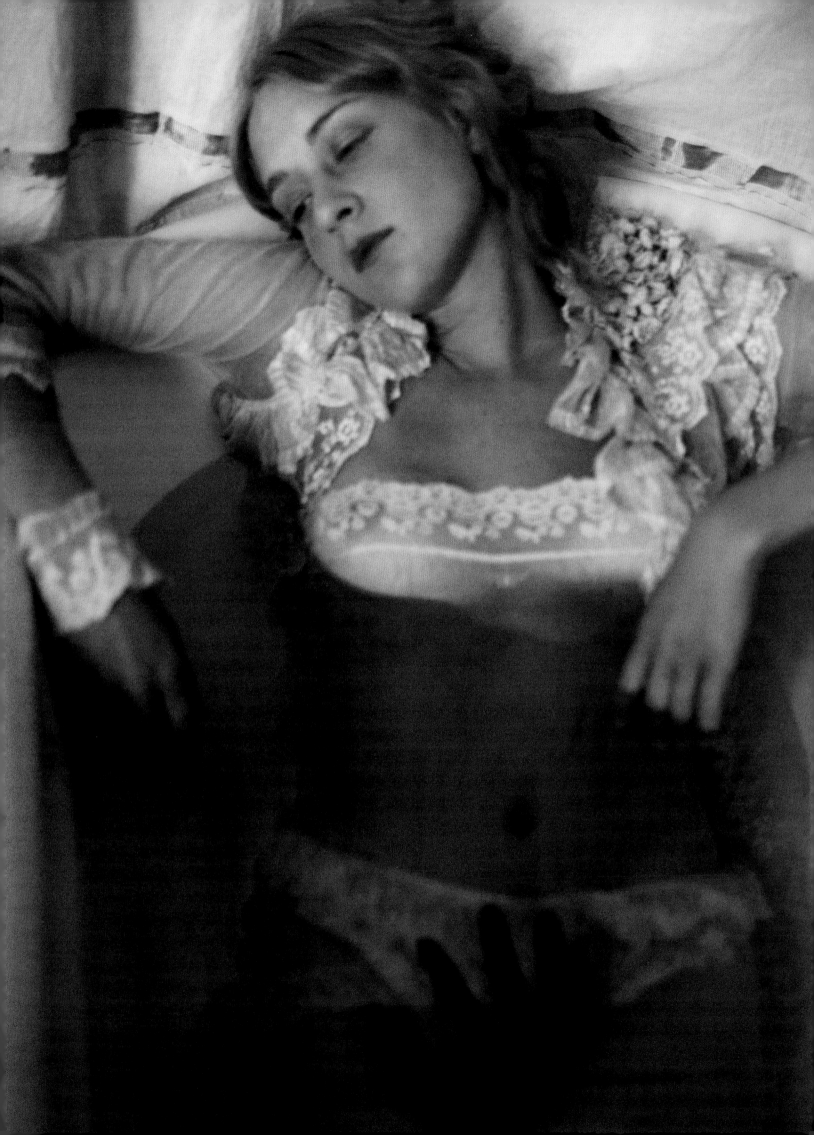

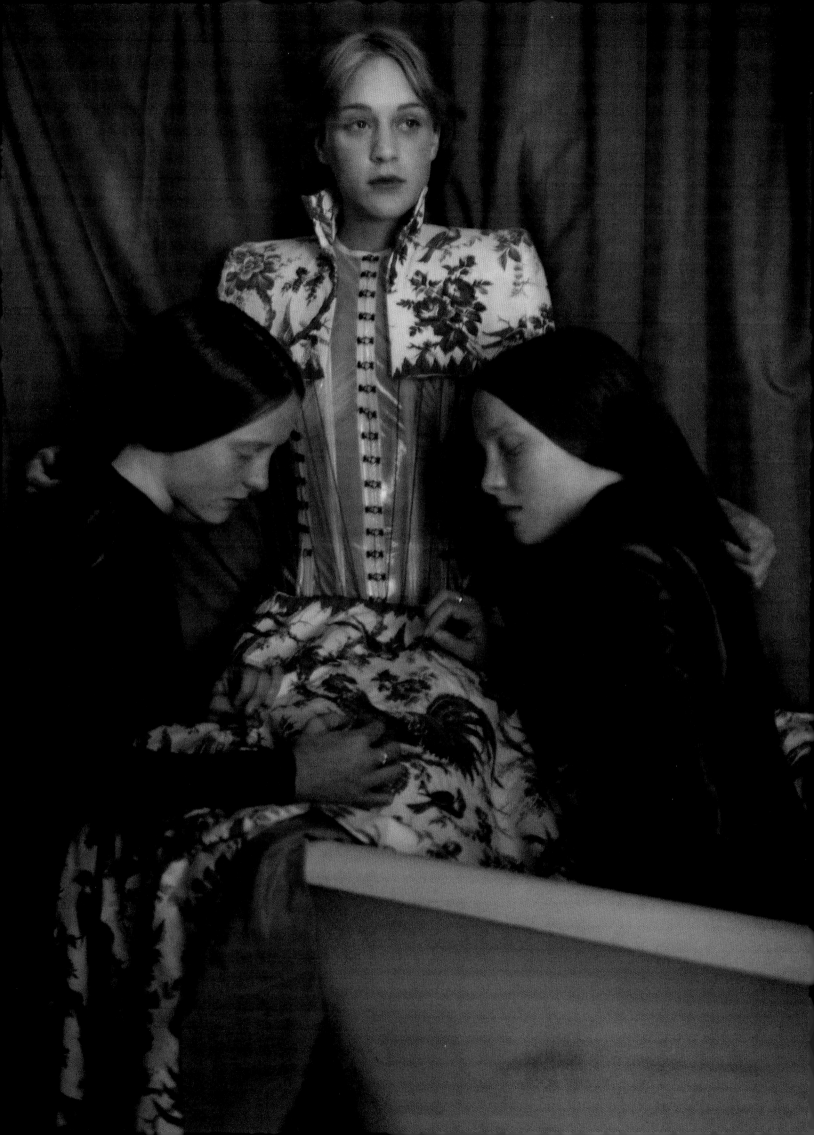

ASSOCIATION

photography CEDRIC BUCHET styling ALISTER MACKIE

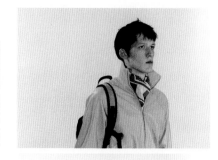

[previous spread]
October 1998
PERIOD DRAMA
photography by
Martina Hoogland Ivanow
styling by Alister Mackie

[this spread]
August 2000
ASSOCIATION
photography by Cedric Buchet
styling by Alister Mackie

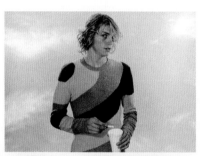

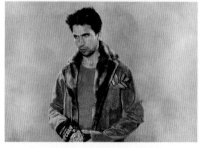

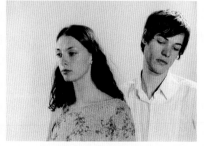

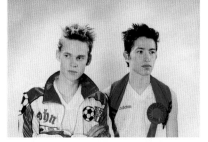

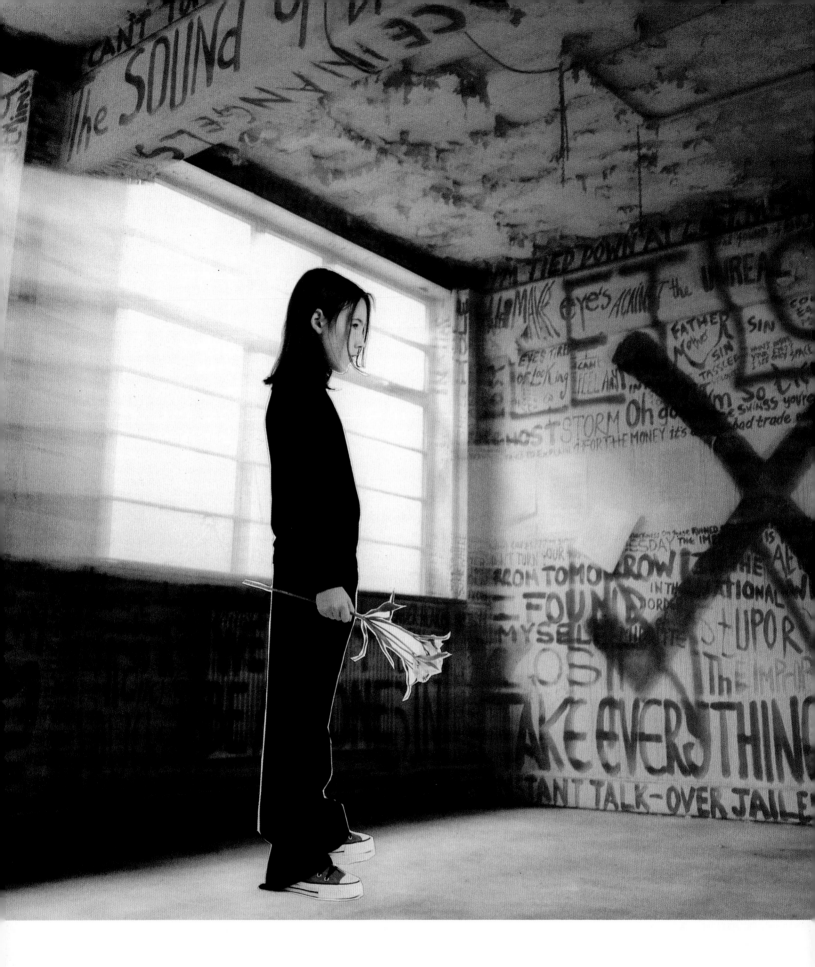

RAF SIMONS Kes wears black cape, black polo neck and elasticated evening trousers all by **Raf Simons**; shoes by **Converse**

PHOTOGRAPHY **HORST DIEKGERDES** STYLING **ALISTER MACKIE**
SPECIAL THANKS **TO ALL THE DESIGNERS WHO CREATED THE MINIATURE LOOKS FOR THIS PROJECT**

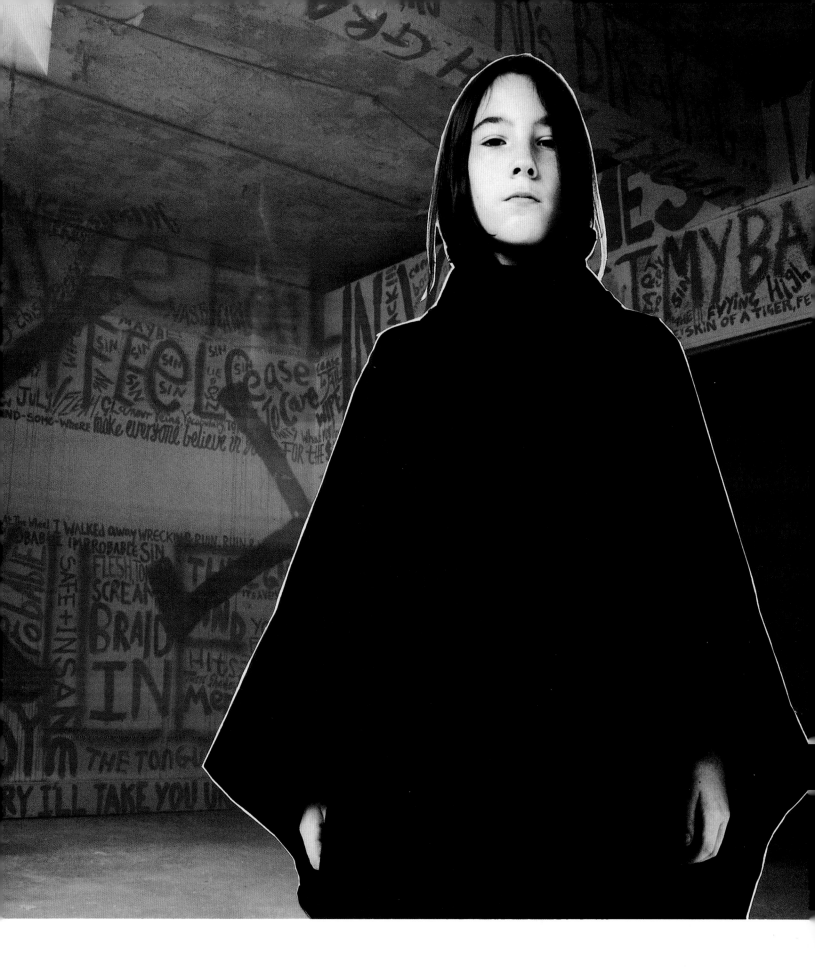

SHRINK TO FIT

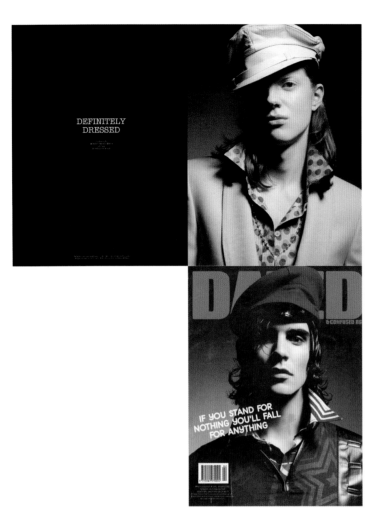

DEFINITELY
DRESSED

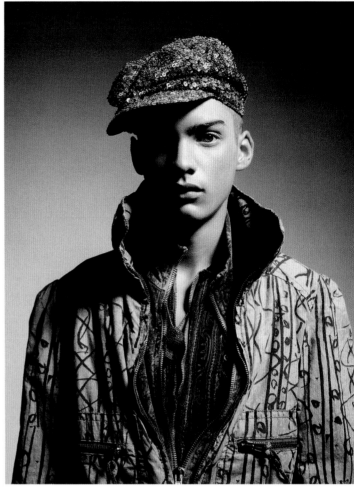

IF YOU STAND FOR
NOTHING YOU'LL FALL
FOR ANYTHING

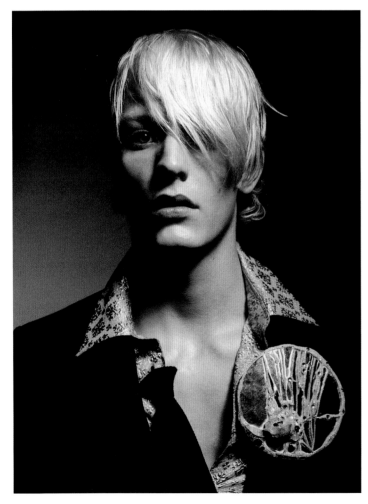

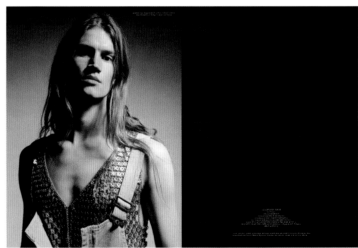

[previous spread]
November 1999
SHRINK TO FIT
photography by
Horst Diekgerdes
styling by Alister Mackie

[this spread]
February 2002
DEFINITELY DRESSED
photography by
Horst Diekgerdes
styling by Alister Mackie

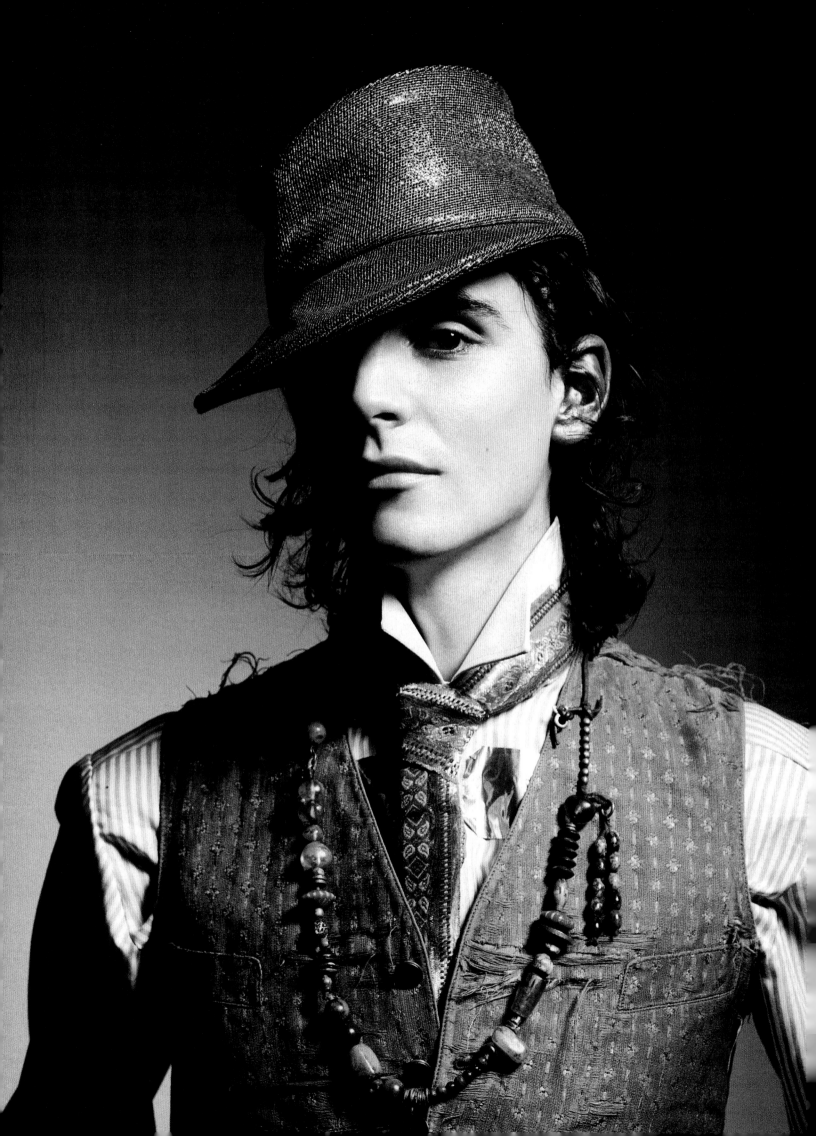

Edward wears black zip trousers, £200, by **Copperwheat Blundell** from Browns. Brick print T-shirt, £40, by **Joe Caseley-Hayford**. Black knitted T-Shirt, £59, from **Squire**. Boppo wears flesh T-shirt, £90, by **John Colonna**. Black trousers, £25, from **Lawrence Corner**. Grey knitted T-shirt, as before.

[this spread]
April 1996
SURVEILLANCE
photography by Rankin
styling by Alister Mackie

[following spread]
July 2000
STILL LIVES IN
MOBILE HOMES
photography by Cedric Buchet
styling by Alister Mackie

Above: Edward wears embroidered denim shirt, £20, from **The Cavern**. Grey army trousers, £25, from **Lawrence Corner**. Shoes as before. Boppo wears khaki denim shirt with buckles, £20, from **The Cavern**, grey work trousers, £50, by **Carhartt**.

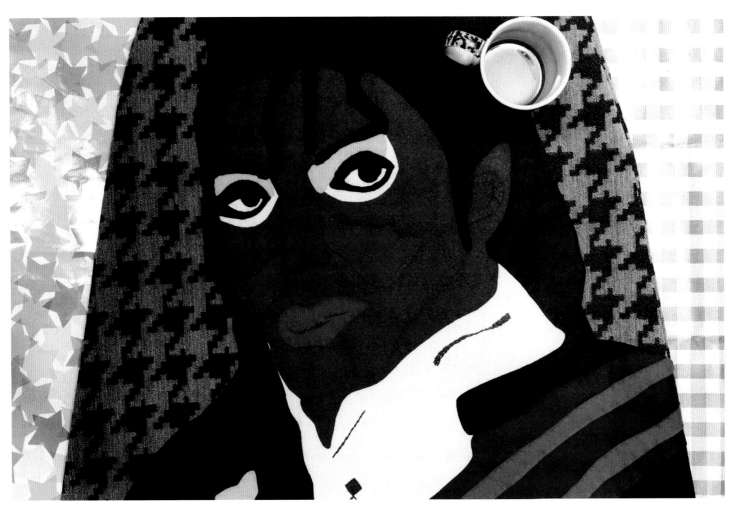

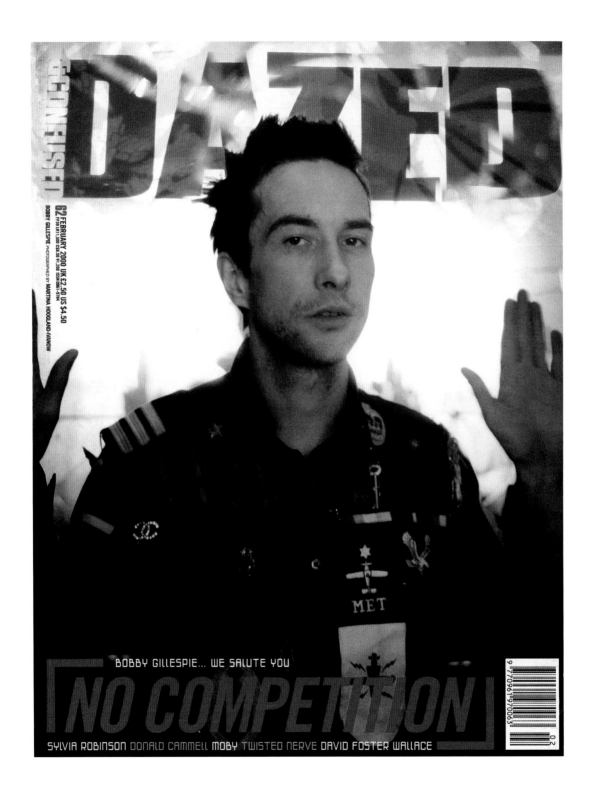

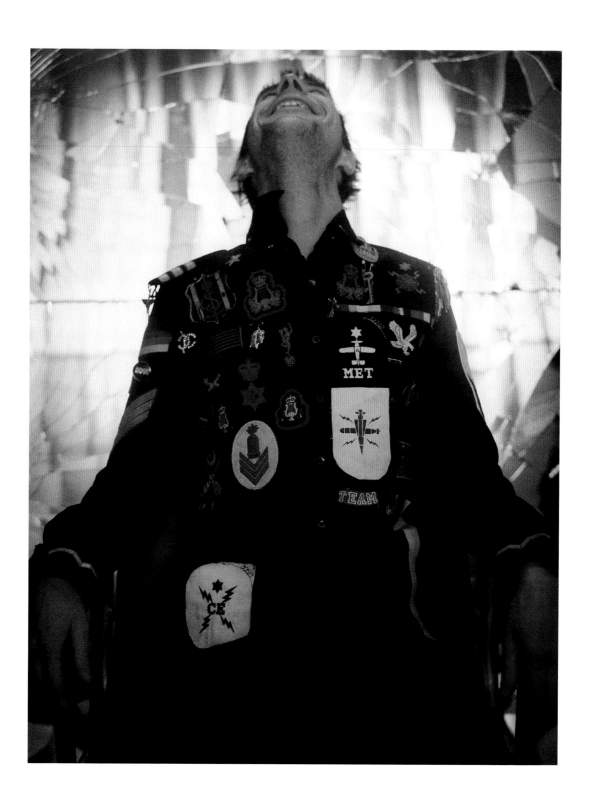

November 2000
UPRISING
*photography by
Horst Diekgerdes
styling by Alister Mackie*

Tim (*foreground*) wears customised adidas top by Maria Chen; suede leather briefs by Carol Christian Poell. Arjen wears top by Raf Simon

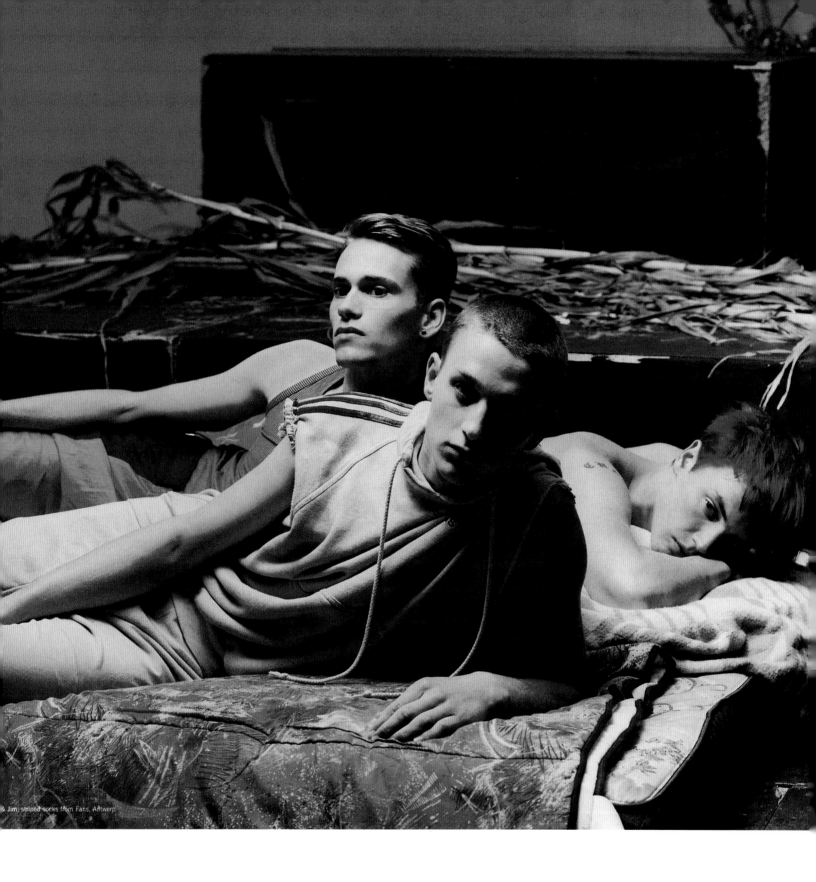

Jim; striped socks from Fans, Antwerp

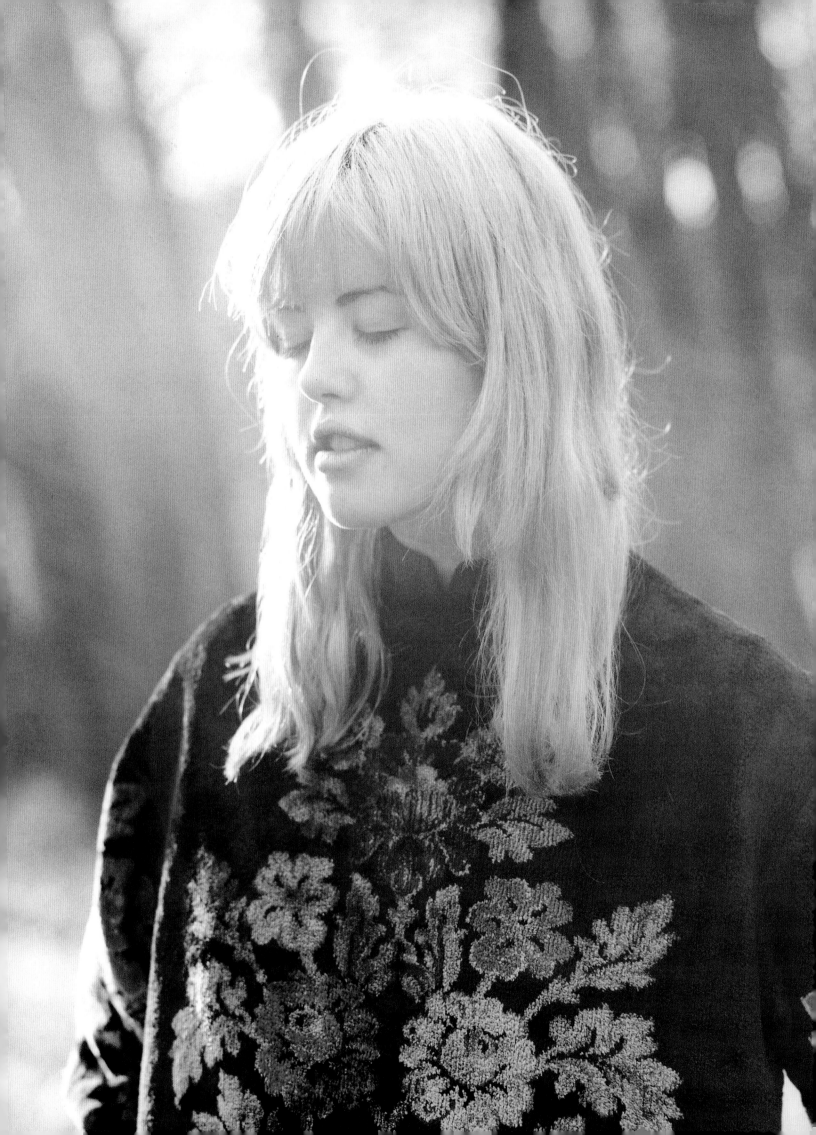

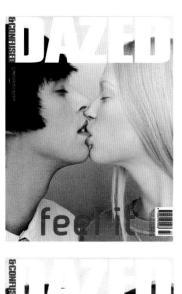
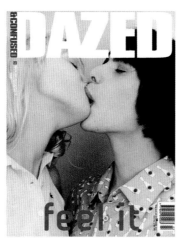
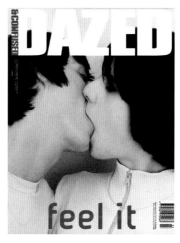
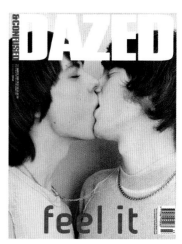
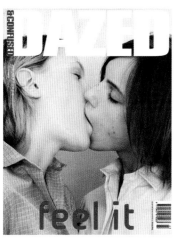
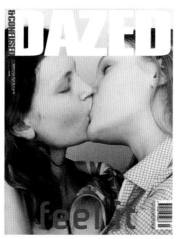
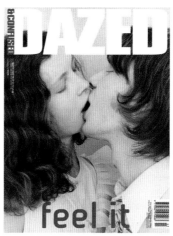
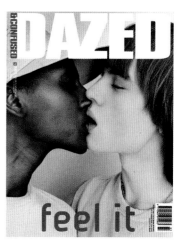

[above]
March 2000
FEEL IT
photography by Rankin
styling by Alister Mackie

[left]
February 2001
DIE HAT EINEN VOGEL
story by Horst Diekgerdes
and Phillipa Horan

HEROES AND ANTI-HEROES
The Friends And Family Of Dazed & Confused

"I believe media is art."
ANDY WARHOL

"Andy Warhol was a fucking bore and all his fuckhead friends were bores and everything he did was shit."
RICHARD PRINCE
(DAZED ISSUE V.I#27)

We were Warhol's children. We were the kids staring down the dawn of the 1990s. We were the post-pop generation with punk and Buffalo fighting for room in our collective psyche, and we were born into an acid house-fuelled Summer of Love – a long, hot summer shaping a new kind of do-it-yourself revolution in Britain while the digital re-imaging of the communication to come took embryonic shape. In a mass consumer media without an underground counterpoint, without a cultural-resistance movement of note, launching *Dazed & Confused* was never a commercial proposition. All that we saw out there was an already codified style-culture that we didn't want to belong to or buy into, we were complete outsiders; we were unknown and untrained; we were insolently anti-everything yet positively pro-everything; we were anti-style and pro-ideas; we were anti-formula and pro-invention... we were dazed, and we were confused.

The way forward seemed to have been laid out in vintage copies of *Interview* magazine, my most treasured reference. It was in those pages that the idea of a cult that becomes a culture, the influence of transdisciplinary thinking and the notion of a magazine as a hang-out (the social scene) or the production of a physical space (The Factory) was postulated as being equally important as the production of the content that lives between its covers. *Interview* took Factory unknowns and cast them alongside Hollywood superstars, creating a new lexicon, a new star system where outsiders and celebrities could sit side-by-side in the glitter of pop democratisation.

Through the genius of its editors and Warhol collaborators such as Gerard Malanga, Glenn O'Brien, Paul Morrissey, Lou Reed, and many more, it created films, exhibitions, parties, tours... created a lifestyle all of its own.

This was the lineage and we were about to subvert it and reinvent it for the 1990s and beyond. On the coming pages are the artists who helped and influenced us the most – the ones with whom we shared our adventures in print. They passed through our factory floor and took time out to collaborate and create original work for us. These are the artists who formed an international web of cultural provocateurs inspired by our ethos of collective and collaborative action.

Chloë Sevigny led us to Harmony Korine who led us to Bonnie Prince Billy and Kim Gordon... and much more. Chloë and Harmony were our poster children – outsiders who would define a generation to come. Kate Hardie would introduce us to Kathy Burke, Lili Taylor and Sam Morton, who in turn would key us into British cinema. These mycelial webs were forming and expanding quickly. In fashion, Alexander McQueen spearheaded a new generation of Saint Martins graduates – Hussein Chalayan, Stella McCartney and Giles Deacon were the emerging vanguard. It was McQueen who played a consistent role as court master of the pages of *Dazed & Confused* – his natural gift as an art director and inquisitor witnessed him guest-edit issues, interview Helen Mirren and be interviewed by David Bowie.

In art a whole new generation was changing the game and we were playing it with them. Sam Taylor-Wood would develop her *Five Revolutionary Seconds* series in the pages of *Dazed & Confused*, casting our editors and involving our team in the production process. The Chapman brothers would re-sit their GCSE examinations and create projects for the *Dazed & Confused* takeover of Channel 4 and other such interventionist excursions in media. Damien Hirst and Rankin began to forge a lifelong friendship and our

first art cover star was created. Hirst embraced the artificial, the simulacra – his image a mirror of our times. Rankin's close-up, almost microscopic lens picks out every distorted and contorted disfigurement of Hirst's face. This was the ultimate anti-portrait – a two-fingered salute that became the art rebels own code of 1990s parlance. Inside they took it one step further. Hirst art-directed advertising images for our pages and Rankin transposed his portraits into dot-to-dot renderings in a photographic echo of Hirst's now iconic dot paintings. We were curating pages, inviting the subject into the process itself. The "post-symbolic" interview, as the influential art curator Hans-Ulrich Obrist now refers to it, was forming in these early issues of *Dazed & Confused*.

Rankin took many of the portraits that appear in this section and throughout the pages of *Dazed & Confused*. As a founder and core photographer he defined an aesthetic approach that was immediate, sexual, close, challenging and exciting. In the beginning, we were super-amateurs "making it up as we went along" and Rankin flew in the face of adversity, bringing a highly conceptual approach to portraiture. In the legacy of Avedon's emotive connection with his subjects, and chanelling the potency of Leibovitz's compositions for *Rolling Stone* and later *Vanity Fair*, Rankin began to chronicle the aspirations of a new generation in the pages of *Dazed & Confused*.

Dazed & Confused has, however, continued to defy expectation by not having a defined sense of style. More established photographers of the time, such as Terry Richardson, Nick Knight, Juergen Teller and Corinne Day, brought rich diversity and powerful experience to the portraiture in *Dazed & Confused* as a necessary and urgent counterpoint. They inspired a young generation including Phil Poynter, Sølve Sundsbø, Martina Hoogland Ivanow and also Rankin to sharpen their points of view. *Dazed & Confused* never had a unified aesthetic for portraiture, it had a code of liberation.

I just force myself into cultural situations because I find them really exciting and I've got this burning curiosity to find out why things work, how artists work and the process of society, how it constructs itself."
DAVID BOWIE
(DAZED ISSUE V.I#14)

Everything came from a spirit of curiosity – a core attitude that is consistent to this day, with styles shifting in constant flux, often contrasting within a single issue, purely informed by the subject and the feeling and mood of the times.

Interviews, not cultural commentary, were key to my thinking when editing the pages of *Dazed & Confused* – the creation of original commission, not cultural investigation. This was not a magazine. It was a movement. Magazines were boring – they reviewed, they codified, they analysed, they nullified culture. *Dazed & Confused* was there to project it into a new millennial post-magazine trajectory. It is exactly this line of thinking that links all the people featured in this section, who one way or another, all led us to each other – a circumspect anti-social network, a protean countercultural movement that was just waiting to be discovered in the pages of *Dazed & Confused*... and beyond.
JEFFERSON HACK

[right]
1995
DAVID BOWIE
photography by Rankin

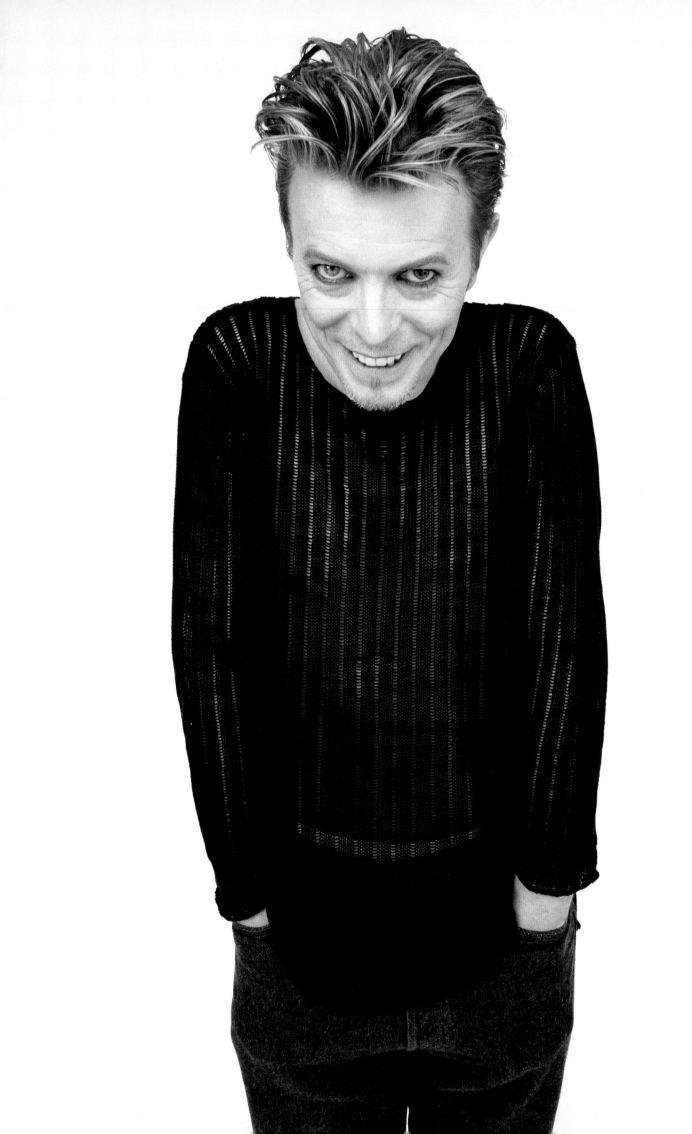

[this spread]
September 2001
SALÓ
*art-directed by
Alexander McQueen
photography by
Norbert Schoerner*

"Norbert Schoerner is an extraordinary photographer. He's got a really amazing mind and a filmic, futuristic sensibility. He really rose to the challenge on this shoot, and it turned out to be the perfect collaboration. It's a very strange story – the lighting, the oddness of it. I don't really know where any of it was coming from in Lee's mind. Lee had a very special relationship with the magazine and when he felt like he had the sudden urge to do something really exceptional, out-there and uninhibited he would always bring it to *Dazed*. I mean, it wasn't like he was doing that kind of thing all the time – it was almost like he was gestating this kind of thing and that he then had to get it out… it had to exist. There was a sense that he was exercising his creativity through the pages of the magazine, and he knew that he was not going to be curtailed in doing that." EMMA REEVES

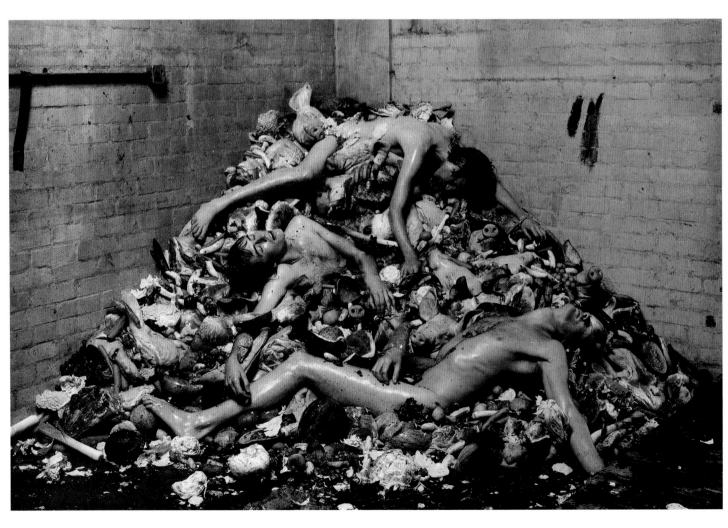

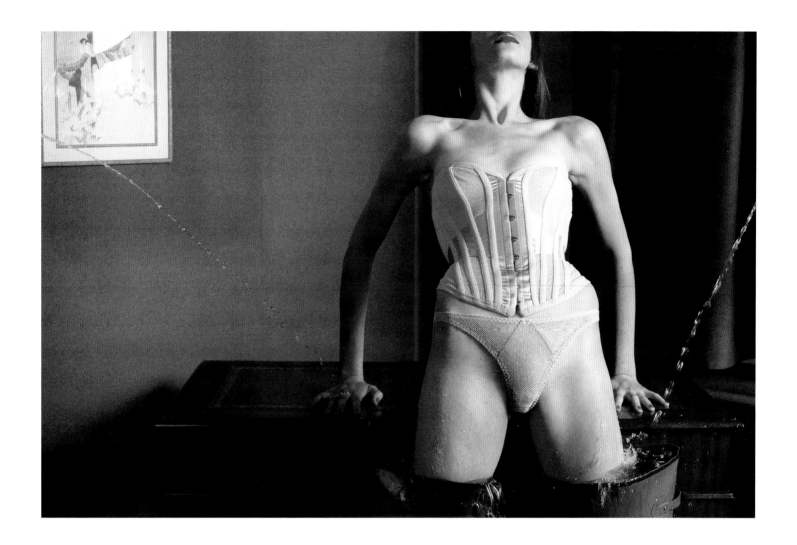

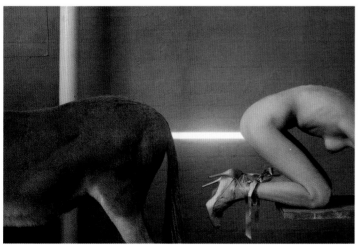

[following spread left]
September 1998
HELEN MIRREN
photography by Rankin

[following spread right]
1995
ALEXANDER MCQUEEN
*photography by
Phil Poynter*

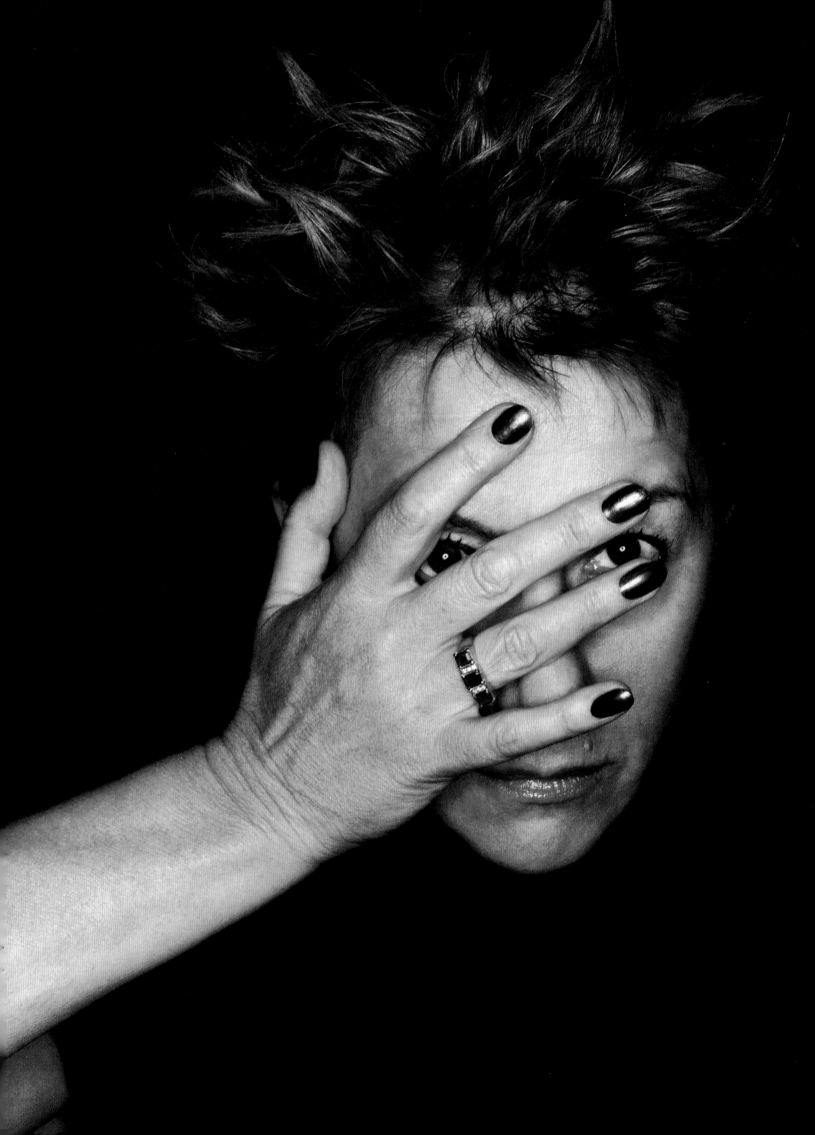

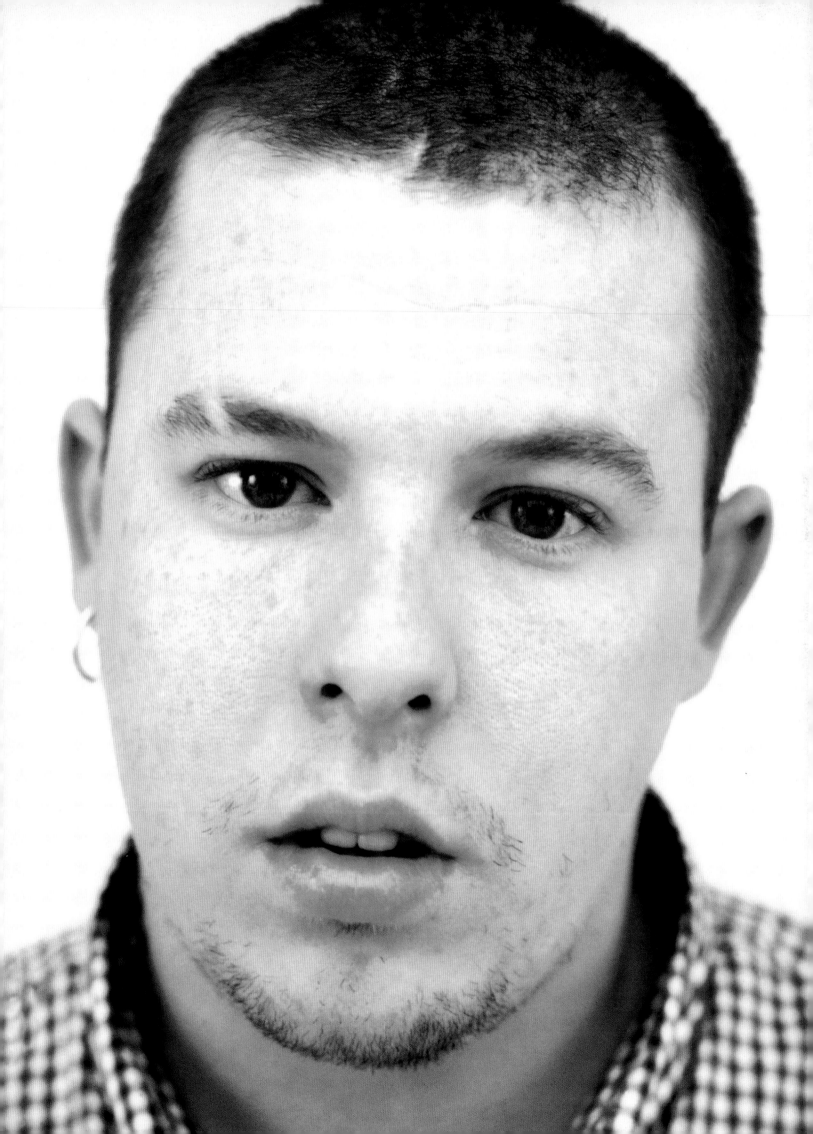

February 1999
KATE MOSS
photography by Rankin

"I remember when Rankin did this shoot. He was over the moon. He was running around the office with the contact sheets saying, 'She's amazing! There is not one frame where she doesn't look good!' Kate really opened up in the interview and said a lot more than I thought she would – she was very giving and open because she liked the magazine and already had a relationship with Katie Grand, so there was a family feel around the project. We knew each other to say hello to but had never really talked. I was just really taken by how chatty and uninhibited she was – that unguarded thing was really captivating."
JEFFERSON HACK

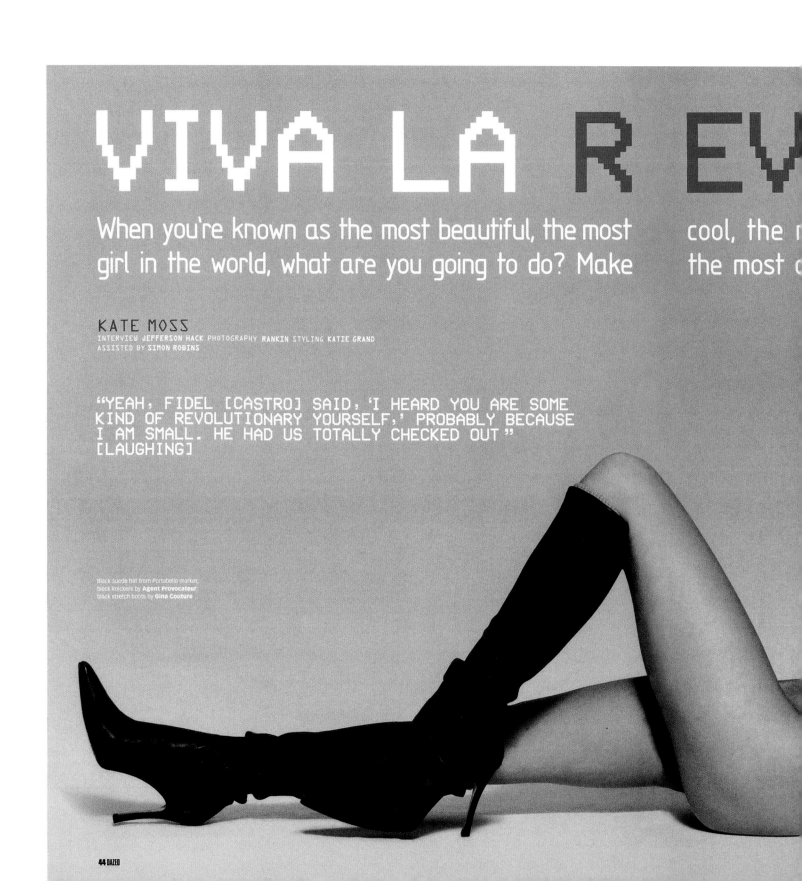

VIVA LA R EV

When you're known as the most beautiful, the most girl in the world, what are you going to do? Make

cool, the the most

KATE MOSS
INTERVIEW **JEFFERSON HACK** PHOTOGRAPHY **RANKIN** STYLING **KATIE GRAND**
ASSISTED BY **SIMON ROBINS**

"YEAH, FIDEL [CASTRO] SAID, 'I HEARD YOU ARE SOME KIND OF REVOLUTIONARY YOURSELF,' PROBABLY BECAUSE I AM SMALL. HE HAD US TOTALLY CHECKED OUT" [LAUGHING]

Black suede hat from Portabello market; black knickers by **Agent Provocateur**; black stretch boots by **Gina Couture**

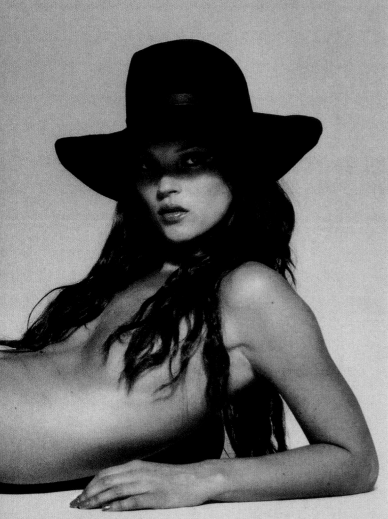

LUTION

famous and the most up for it
nd that's exactly what Kate did.

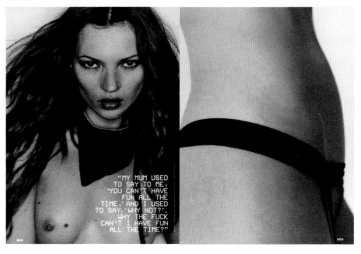

"MY MUM USED TO SAY TO ME, 'YOU CAN'T HAVE FUN ALL THE TIME,' AND I USED TO SAY, 'WHY NOT?' WHY THE FUCK CAN'T I HAVE FUN ALL THE TIME?"

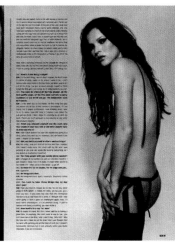

"I DON'T THINK I'VE COMPLETELY GOT OVER MY RELATIONSHIP WITH JOHNNY [DEPP] SO IT'S HARD FOR ME TO THINK ABOUT BEING IN LOVE WITH ANYONE ELSE"

**May 1996
CHLOË SEVIGNY**
photography by Rankin

When Chloë first appeared on
the scene in *Kids* everyone at
the magazine became fixated
with her, and soon she became
Dazed & Confused's conduit
to the burgeoning New York
downtown scene, introducing
the title to Harmony Korine,
with whom myriad projects
would bloom.

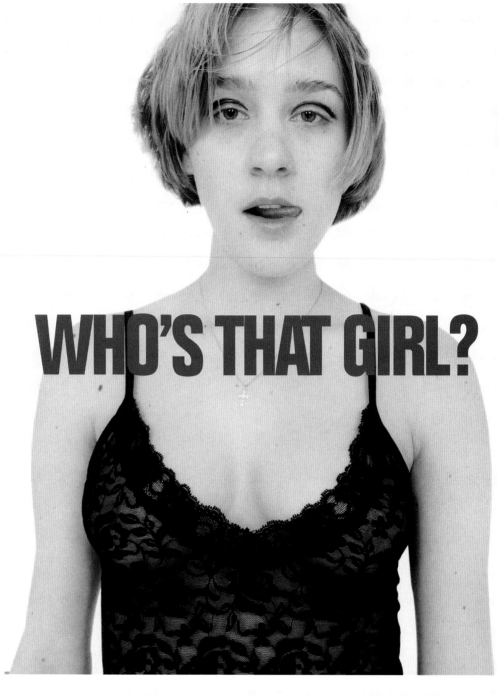

WHO'S THAT GIRL?

Zebra printed dress by **Versus** by **Versace**. Cork heeled shoes from **Blackout II**.

CHLOË SEVIGNY

Interview **Jefferson Hack**
Photography **Rankin**
Styling **Jennifer Elster**
Hair **Linda Daniele for Louise Vicari**
Make-up **Christine Huffman at Kramer and Kramer**

Black lace top by **Betsy Johnson**. Black top by **Fab 208** (776, 7th St, NYC). Skirt from **Blackout II**. Animal belt by **Hellfire**. Shoes by **Candies**.

Chloë is the girl of the moment.
She is the unaffected actress who puts
in an amazingly affective performance in
Kids. She is the girl who, styled like a northern
slag, is crouched in a pissing position, replacing Drew
Barrymore for fashion company Miu Miu. She is girl of the
moment because the moment needs her more than she
needs the attention, in a world obsessed by the
fake plastic tits of Hollywood babes in fake
plastic films. Chloë and *Kids* couldn't
have come at a better time.

DAZED & CONFUSED MAGAZINE 39

**[left]
April 1998
HARMONY KORINE**
*photography by
Martina Hoogland Ivanow*

[previous spread]
August 1996
BJÖRK MEETS STOCKHAUSEN
photography by Phil Poynter

"Björk was the first celebrity
we ever had in the magazine
and she became a really important
figurehead for us, embodying the
spirit of *Dazed* and appearing
on the cover many times over
the years. She is someone who is
always pushing things forward,
and that's very much what the
magazine is about. I think what
is interesting is that she has
always had one foot in the
mainstream and one foot in the
underground. *Dazed* very much
plays that game as well, and it's
a pretty rare talent to be able
to do both. She was a genuine
Stockhausen fan and it was great
to be able to realise her ambition
for them to meet. This photo was
taken at Stockhausen's home.
Stockhausen isn't the kind of
composer we would normally write
about, but Björk broke the spell –
her enthusiasm made him relevant
to the reader." JEFFERSON HACK

[right]
November 1999
BECK
photography by Phil Poynter

[below]
1995
LOSER TAKES ALL
photography by Chris Floyd

LOSER TAKES ALL

Beck

Interview: **Claude Grunitzky**
Photography: **Chris Floyd**

This is Beck. Not the
space cadet or slacker
archetype that everyone
wants him to be. The
goofball image is so false
Everyone wants a part of
him. But, Beck plays on
his own terms, baby. He's
signed to five different
independent labels as well
as giant Geffen, giving him
control over his creative
output. He's playing
acoustic live sets in small
venues and selling out big
rock gigs. This is the first
time Beck's been to
London and Dazed &
Confused jumped him for
an interview after his
appearance at The Splash
club.◗

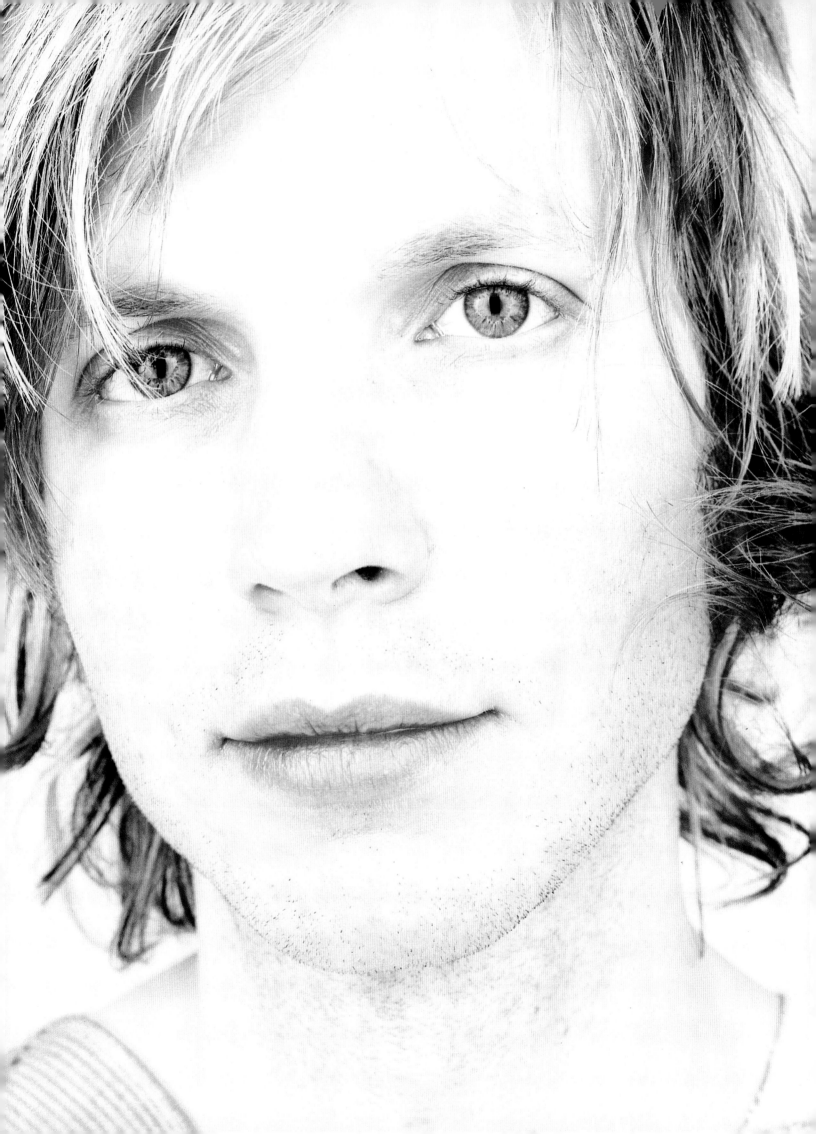

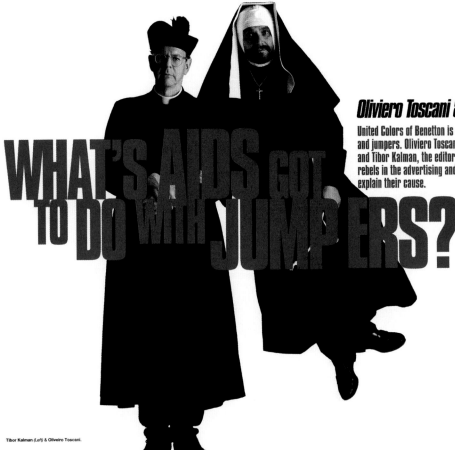

Oliviero Toscani & Tibor Kalman
Interview: Jefferson Hack

United Colors of Benetton is synonymous with controversy, censorship, advertising awards and jumpers. Oliviero Toscani, the creative director of the Benetton world-wide visual image and Tibor Kalman, the editor of *Colors*, their magazine "about the rest of the world", are rebels in the advertising and publishing worlds. Together in this rare double interview they explain their cause.

Oliviero Toscani leans over, his powerful hands grip the leading edge of the top of the speakers podium. His eyes single out individual members of the collective advertising world attending his keynote address at the MTV youth marketing conference in London. His tough, Italian accent is slow and deliberate. "It disturbs me what advertising is selling us. That we are what we consume, that we become what we pay for... Everybody is exploiting humanity to make advertising. But it depends how you do it. Do you question? Or do you just sell symbolism? Do you want to show the agony or do you want to produce the agony?" Toscani is the man responsible for the image of the new-born baby still attached to its mother's umbilical cord while in the hands of a surgeon. The still life of the remains of Bosnian soldier Mirinko Gagro, killed in conflict. The words 'HIV Positive' branded onto close-up shots of the body parts that transmit the disease. In his latest campaign, two eyes stare out of the page. The name 'Fabrica' is printed underneath. Fabrica is a school of communication financed by Benetton where a select group of young filmmakers, musicians, designers and other creatives work on collaborative projects, "To criticise advertising communication with a new vision," states Toscani.
Tibor Kalman, whom Toscani brought in to edit *Colors* is also billed on the masthead for *Interview* as 'Creative Troublemaker'. As the editor of the last 12 issues of *Colors* he has dealt with issues on themes as broad as Sport, Race and Racism, Travel and Aids. In Travel, Toscani shoots fashion in airports asking what people wear when they travel. In Sport, Kalman looks at the achievements of disabled athletes, like a wheelchair mountainclimber. In Race and Racism, Kalman produces computer-manipulated images of a black Queen Elizabeth, a white Spike Lee. *Colors* is about image first, editorial adopting the format of advertising, with short bursts of information providing the text support. Humour is the key to making it interesting. Sexy design is the key to its dynamic. It's a magazine that asks questions, presenting us with facts that question our reality, not selling us a fantasy world.
Toscani and Kalman are not interested in selling. Sure, without sales of jumpers there would be no

money to support the advertising campaigns or *Colors* magazine. Without jumpers there would be no Formula One racing team.
Toscani, Kalman and Luciano Benetton, the enigmatic owner of the Benetton corporation have had their creative differences. There have been long, unestablished arguments that have fuelled speculation of resignations and lost friendships. But when confronted with these questions Toscani advocates the courage of his boss for letting him get away with what he wants.
This is the week that Benetton opened a shop in Sarajevo and back at the MTV conference the other speakers reel out statistics, quote market research, talk about what young people want, what young people need. Toscani and Kalman huddle together at the fringes, passionately plotting their personalised speeches that will contradict the approach taken by nearly everyone else.

Dazed & Confused: Oliviero, you're 53 years old, do you still consider yourself a rebel?
Oliviero Toscani: There are some young people who are 16, they are already old, because they don't want to look for the new language. There is a new language that can be picked up anytime. But we all conform to the old one.
D&C: But you've been pushing this new language in advertising for ten years...
OT: But life and death is a big issue, sex and the real thing, agony. Life is a funny trip and it's not seen like that in advertising, so this is a change of perception completely; it's not just a trend, it's looking on the other side of the communication world, so it will take time.
D&C: Censorship has followed nearly every image, yet for every censored image there is also a prize from a different country. That highlights the different perceptions of your images.
OT: It's the culture of the people, and their sense of guilt over the past, the present and the future, that's why they censor.
D&C: For instance the baby image. In your talk you said that you couldn't believe that an image of birth could be censored in any country, yet it was one of the most censored of the Benetton images in the UK.

Tibor Kalman (*Left*) & Oliviero Toscani.

WHAT'S AIDS GOT TO DO WITH JUMPERS?

[above]
1995
OLIVIERO TOSCANI AND
TIBOR KALMAN
photography by Oliviero Toscani

[right]
July 1996
MALCOLM MCLAREN
photography by Mr Perou

"Tibor Kalman worked with Oliviero Toscani on *Colours* and had been at *Interview* in the 1980s. He was the first industry figure who paid any attention to *Dazed* and became our mentor. Both Tibor and Oliviero were very encouraging and supportive of the magazine early on. I've put them in the book with this shot of Malcolm McClaren because he was another mentor. We kind of figured that if *Dazed* was a band, Malcolm would be our ideal manager." JEFFERSON HACK

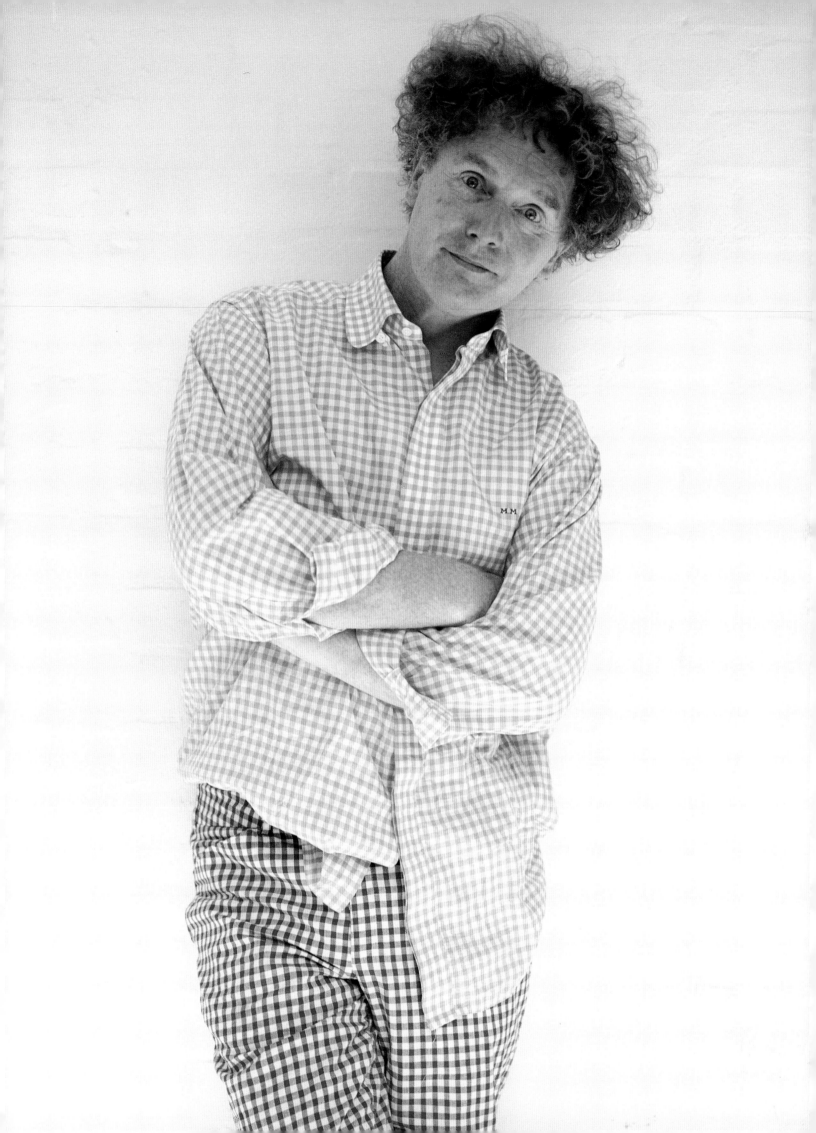

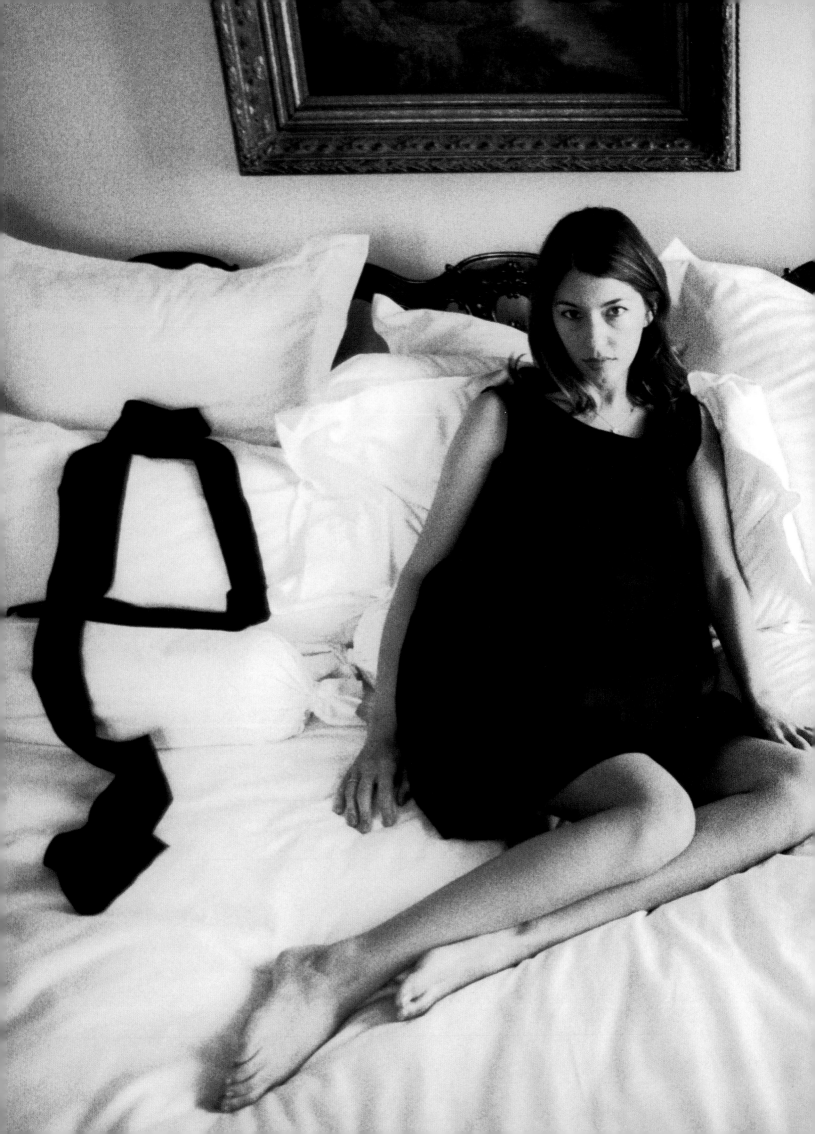

[this spread]
September 1997
GIRLS 1991 - 1997
copyright Corinne Day estate
courtesy of Gimpel Fils gallery

Dazed & Confused's first office in Berwick Street was situated directly under Corinne Day's flat. The team felt a synchronicity with her because she was pushing for reality and emotion in photography. When the magazine published these bloody knickers on a stand-alone page they caused negative feedback from advertisers and the issue was removed from certain stockists in yet another censorship issue.

emma 1997

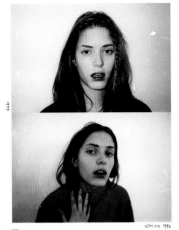

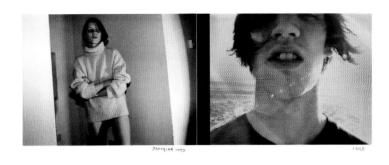

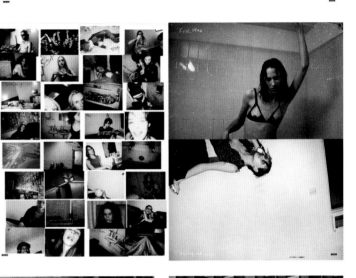

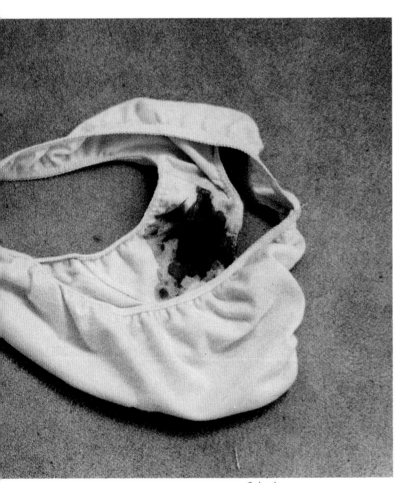

Bloody nickers 1995

[previous spread]
November 2006
SOFIA COPPOLA
photography by Yelena Yemchuk

[following spread left]
June 2002
BOBBY GILLESPIE
photography by Juergen Teller

[following spread right]
December 1999
SAMANTHA MORTON
photography by Rankin

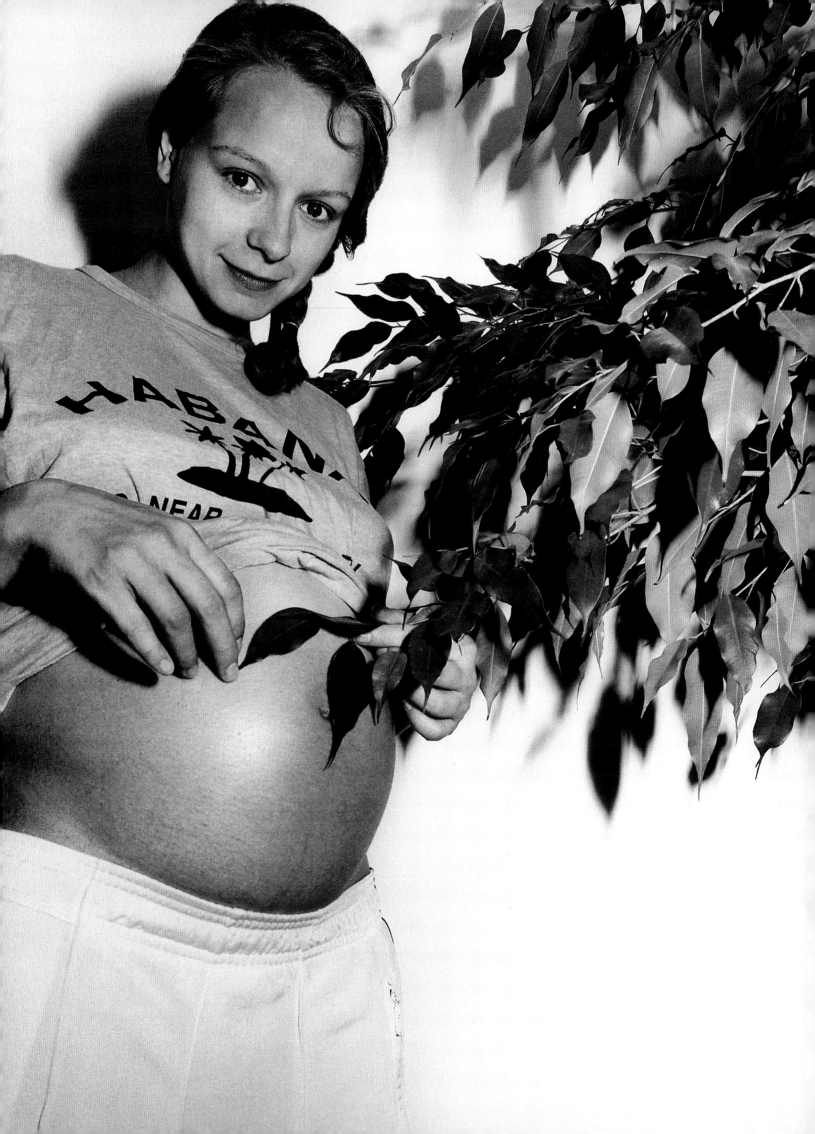

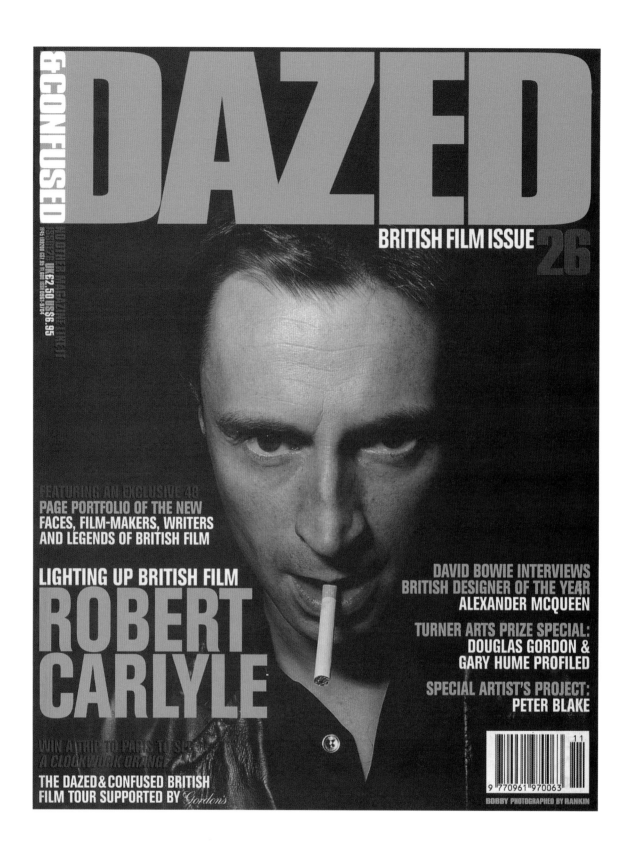

[previous spread]
April 2003
RICK RUBIN
photography by Sasha Eisenman

[this spread]
November 1996
THE CAST
photography by Rankin

The Cast was an epic 48-page portfolio of the best of British talent at a time when the British film industry was riding high. It was an epic undertaking for the magazine as all those profiled had to be shot in a very concentrated time period. Assembling all the main players would never have been possible without the collaboration of actresses Kathy Burke and Kate Hardie, both of whom were key in curating the project.

"Robert Carlyle took a shine to the jacket we had for the shoot, so I told him he could have it – unfortunately, it was a one-off press sample from Jigsaw and I shouldn't have given it away. The fashion department never let me forget it." RANKIN

OUR SELECTION OF THE ACTORS, DIRECTORS AND WRITERS CREATING A VIBRANT FORCE IN BRITISH FILM. THESE ARE THE LIVING LEGENDS, STAR TALENTS, FILM-MAKERS, RISING STARS AND NEW FACES WORKING INTERNATIONALLY IN FILM.

CONTENTS

PHOTOGRAPHIC PROMINENCE IS NOT RELATIVE TO ARTISTIC MERIT, BUT IS BASED ON THE CREATIVE, VISUAL LAYOUT OF THE IMAGES, NOT IN RELATION TO THE SUBJECTS STATUS IN BRITISH FILM.

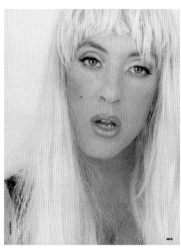
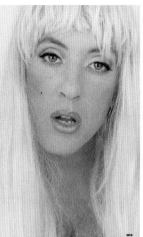

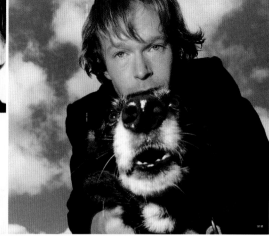
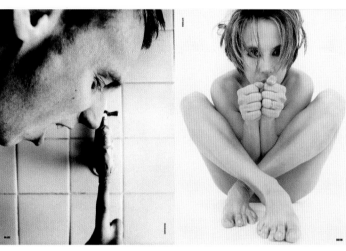

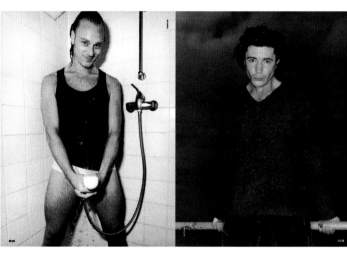

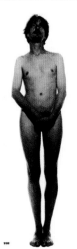

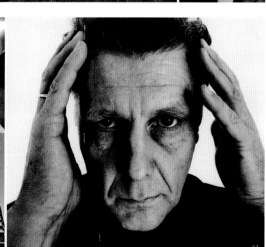

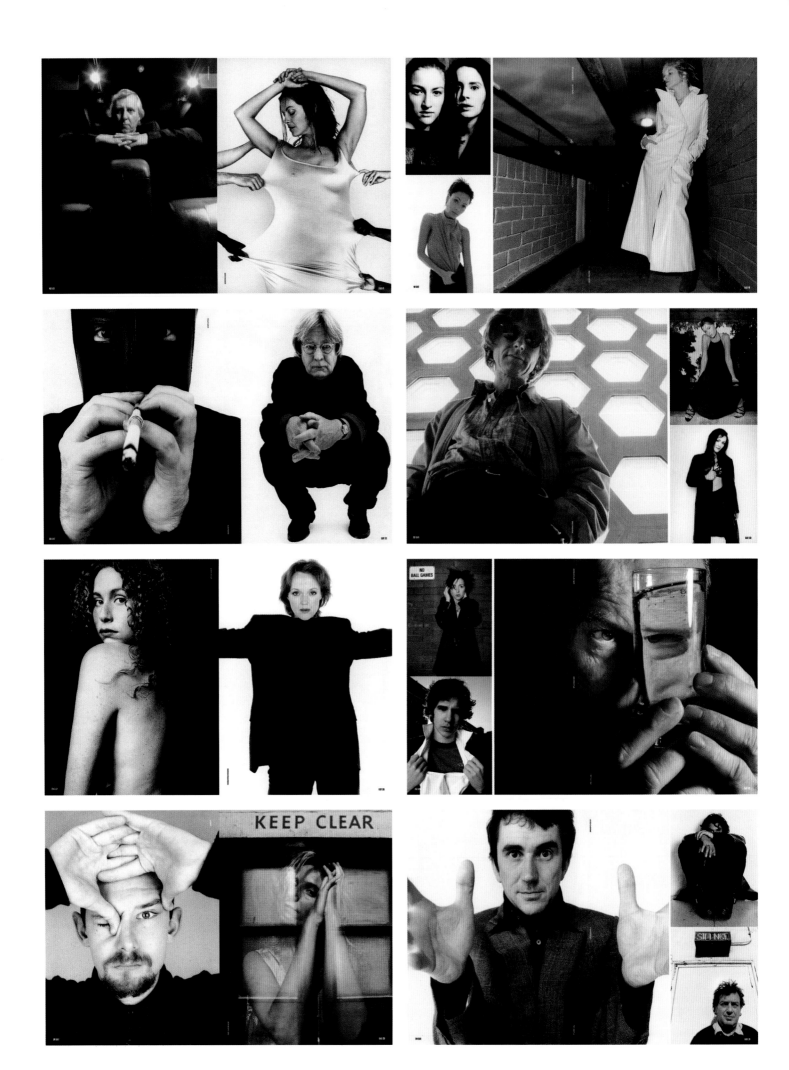

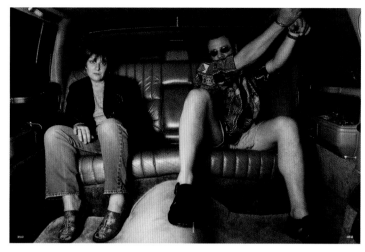

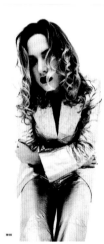

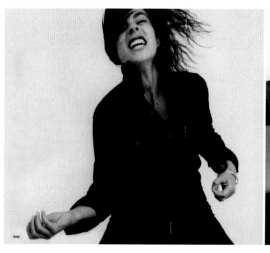

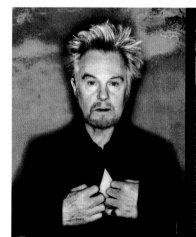

THE WISH LIST

Those we asked, but who were unable to be photographed for The Cast.

ANTONIA BIRD, SHANE MEADOWS, MICHAEL CATON JONES, KEN LOACH, MIKE LEIGH, TONY SCOTT AND RIDLEY SCOTT, NICK HYTNER, BEBAN KIDRAN, RICHARD LESTER, MIKE FIGGIS, ALEX COX, GILLIES MACKINNON.

ANTHONY HOPKINS, JOHNNY REECE MYERS, RUPERT GRAVES, EWAN MCGREGOR, TIM ROTH, DANIEL DAY LEWIS, CHRIS ECCLESTON, STEVE COOGAN, PETE POSLETHWAITE, HELEN MIRREN, BRENDA FRICKER, MAGGIE SMITH, ALBERT FINNEY, SOPHIE OKONEDO, TOM BELL, GARY OLDMAN, KRISTIN SCOTT-THOMAS, PAUL MCGANN, MARK RYLANCE, JOHN LYNCH, RALPH FIENNES, DAVID HAYMAN, DAME JUDI DENCH, JOHN THAW, IAN HOLM, MALCOLM MCDOWELL, JEREMY IRONS, NATASHA MCELHONE, DAVID O HARA, MICHAEL GAMBON, GABRIEL BYRNE, ANTHONY SHER, CLIVE OWEN, JULIE WALTERS, GEORGE COSTIGAN, JODHI MAY, BOB HOSKINS, BEN KINGSLEY, HELENA BONHAM CARTER, STEPHEN BERKOFF, TARA FITZGERALD, CLAIRE SKINNER, SASKIA REEVES, SADIE FROST.

WRITERS: ALAN BENNET, JONATHAN HARVEY, JIMMY MCGOVERN, HAROLD PINTER, JEZ BUTTERWORTH.

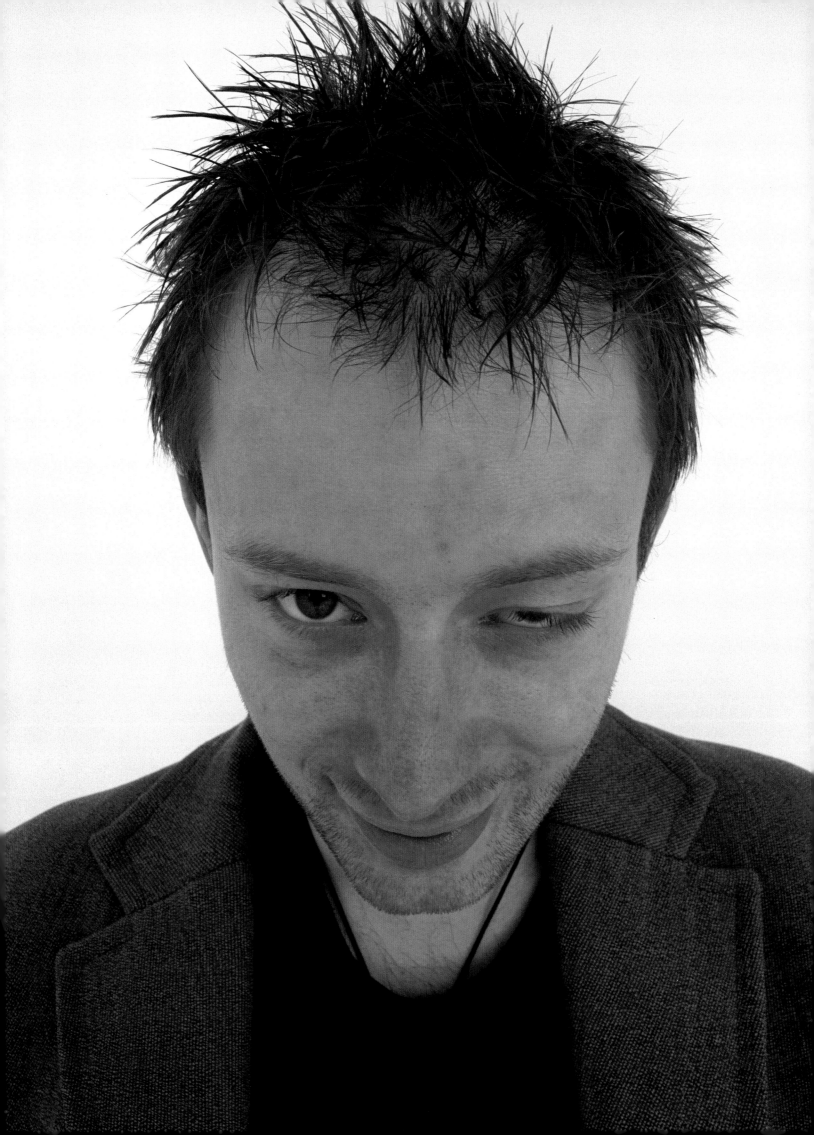

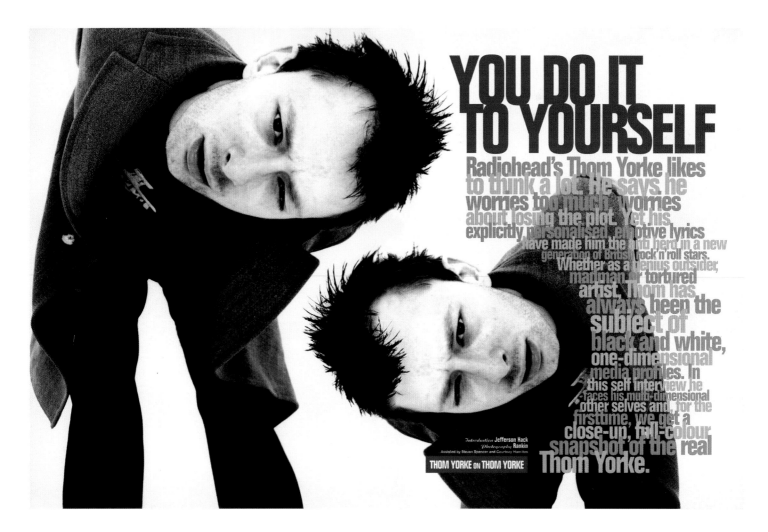

YOU DO IT TO YOURSELF

Radiohead's Thom Yorke likes to think a lot. He says he worries too much, worries about losing the plot. Yet his explicitly personalised, emotive lyrics have made him the anti-hero in a new generation of British rock'n'roll stars. Whether as a genius outsider, madman or tortured artist, Thom has always been the subject of black and white, one-dimensional media profiles. In this self interview he faces his multi-dimensional other selves and, for the first time, we get a close-up, full-colour snapshot of the real Thom Yorke.

Introduction Jefferson Hack
Photography Rankin
Assisted by Steven Spencer and Courtney Hamilton

THOM YORKE ON THOM YORKE

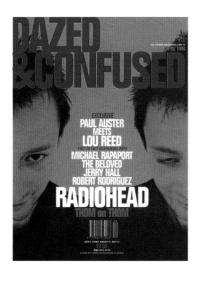

April 1996
THOM YORKE
photography by Rankin

You Do It To Yourself was a defining moment for *Dazed & Confused* and exemplifies the unique and forward-thinking approach the magazine was taking to both the format of the interview and the notion of celebrity.

"We wanted to change the usual journalist-meets-rock-star dynamic, so I approached Thom with the idea of interviewing himself. I gave him a copy of Truman Capote's self-interview as inspiration. After about a week a tape arrived with the interview on it. It wouldn't have worked with many people. It's because he's a great artist that it turned out so good." JEFFERSON HACK

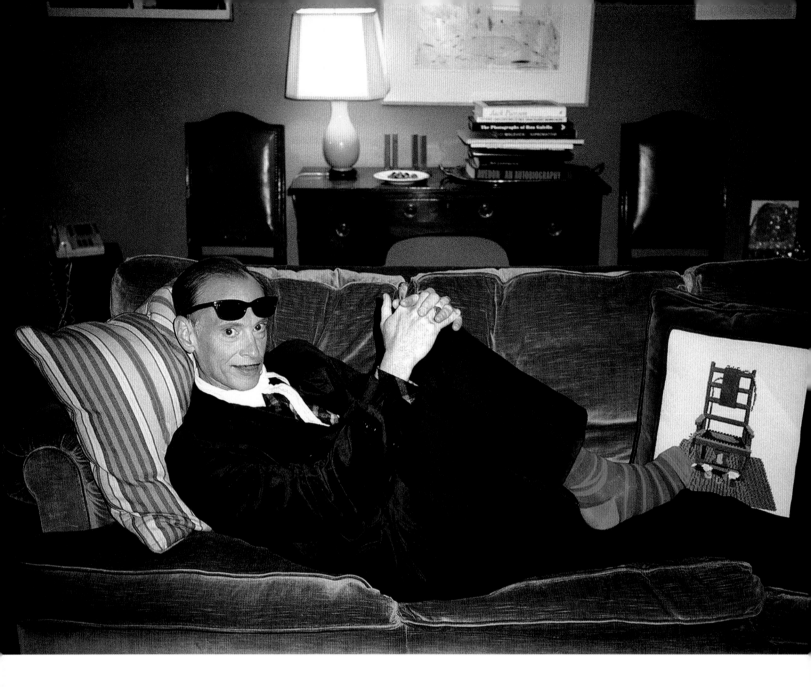

[above]
September 2004
JOHN WATERS
photography by
Jason Nocito

[right]
May 1996
LARRY CLARK
photography by
Phil Poynter

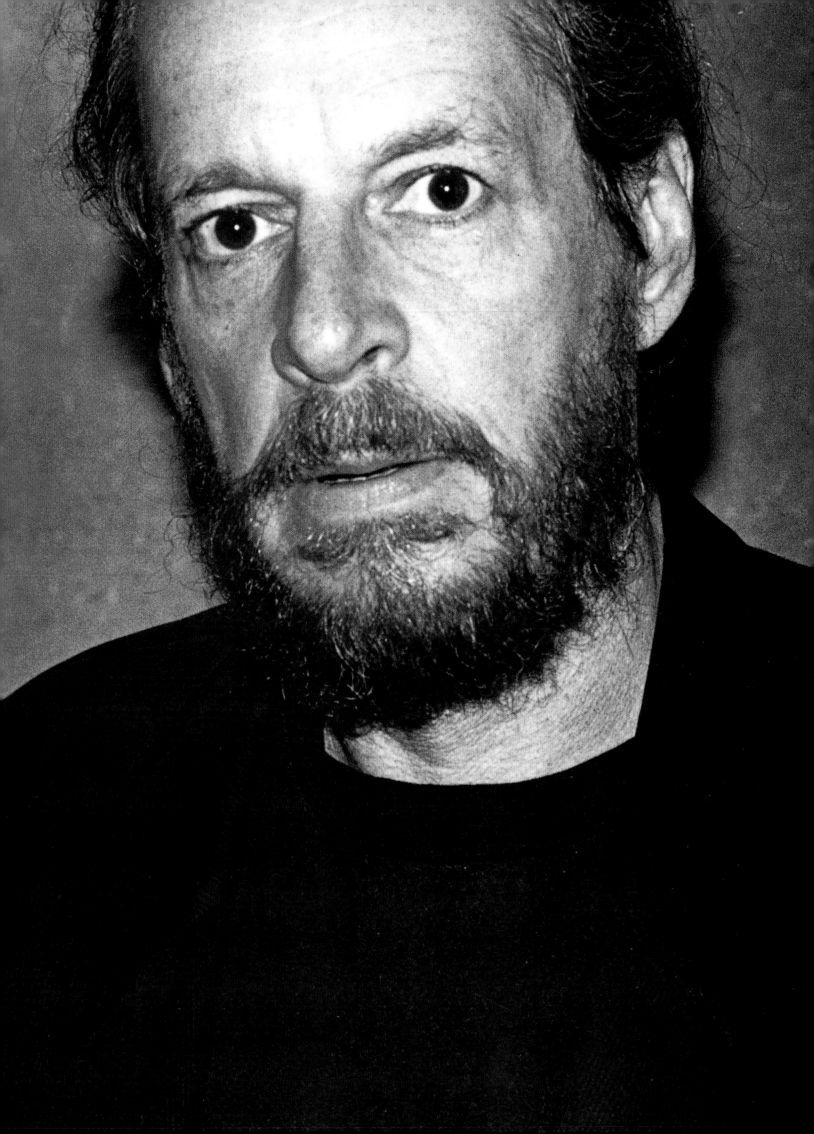

TOTALLY WIRED
The Fashion Of Cathy Edwards

"By the time you become the fashion director of *Dazed & Confused*, you're almost passing it on, weirdly. It's your job to see the new people coming up and to try and pick the right ones for the magazine – to facilitate a new tribe that goes on to become the one of the future. It's not really an ageist thing, but *Dazed* is a style magazine and it concentrates on youth culture. My flashpoint was 'New Rave', I think, because I could remember it the first time around. That's when I knew I needed to move on. Katy England had left *AnOther* so, again, I followed in her footsteps."

Cathy Edwards is fashion director of *AnOther Magazine* to this day and was fashion director at *Dazed & Confused* from 2003 to 2007. Shona Heath, Emma Cook and Sofia de Romarate (today senior fashion editor at *AnOther Magazine*) were among her contemporaries at Brighton University, where she studied fashion, arriving at the magazine in her third year, on a work placement, at the time when the magazine's co-founder, Katie Grand was presiding over the fashion department. "I arrived in March and stayed all through the summer assisting. I remember Katie telling me not to bother going back to college: 'We (Grand, Rankin and Jefferson Hack) didn't go back to finish our degrees. What a waste of time.' But I thought I ought to crack on. Katie said to let her know if I needed any help with my degree show and, true to her word, she was really kind and sorted everything out for me. I had a hairdresser, a make-up artist, models... I was such a spoilt brat."

After graduating, Edwards returned to the magazine as fashion editor. "Before I had even finished college I had a job. I was 24 and I knew that as long as I was here and my foot was in the door, I was going to stay."

And stay she did. "I've sat in the same space, or thereabouts, for 15 years. There's always been such a definite sense of energy about the magazine. It wasn't just a place you came to work, it was very sociable, very part of your life. It was independent, too. Jefferson and Rankin owned it and they sat on desks at the end of the office and answered the phone. The truth is that it didn't feel like a real job. We did it for the love of it. You had to really love it. And we all did. There was no question. You were totally aware that you were lucky to be here and to have that level of freedom."

Edwards remembers driving a model to Heathrow airport with Sølve Sundsbø, where the girl in question was scanned. "It was a 3-D scan of her whole body. There was this big fat man with a scanner and I think he didn't really know what was going on – he was used to scanning luggage." Later, the same image was used by Coldplay for the sleeve of *A Rush Of Blood To The Head*. "*Dazed* was one of those places that art directors looked at, and there was a lot of crossover from fashion into other parts of culture. I would constantly see things copied from *Dazed*. It was all about patenting some kind of new and fabulous idea and getting it out quickly so that people knew it was yours."

Edwards did the things she enjoyed most while Katy England was fashion director of the magazine. "I wasn't ready before that. I didn't know Katy very well when she joined, but she was very nurturing and embraced lots of different aesthetics. I remember doing work and thinking: 'I really like this and I don't care what anybody else thinks of it because it's what I want to do.'"

As with every era of the magazine, with Edwards as fashion director *Dazed & Confused* reflected the spirit of its time. "The aesthetic was very Noughties. It was post any shark fin haircuts, snake tattoos and mock-rock Ramones t-shirts. My style was the antithesis to that. It was twisted, a bit pervy – a feminine oddity that was about putting in things that were quite distasteful, a bit wrong. We did things that we would never be able to do now. Shona Heath and I did this project called *Fashion In The Community*. Shona painted old rubbish with a Miu Miu print and we photographed it in a skip in Docklands. She mocked up a mural of a girl wearing Dolce & Gabbana – that was the cover. We did a huge gold Prada logo on a stairwell on an estate in Tower Hamlets."

Edwards made a series of Super 8mm films with photographers including Benjamin Alexander Huseby that ran in the magazine, she shot with Mike Thomas, super-imposing flowers onto her Highbury home, and staged a one-woman campaign to bring back Zandra Rhodes from fashion obscurity, photographing rising model star Delphine in her designs for the cover of the magazine. Julie Verhoeven's career as a fashion illustrator was in the ascendant. One of her first major projects was to paint mannequins' heads for the front of a beauty issue of the magazine. "I remember doing a story with Viviane Sassen and Miuccia Prada saw it and, just from that story, we got the Miu Miu campaign.

"Some of it was a bit hyper-real; a bit weird. It was when retouching was starting to play a part in our aesthetic. But it was also about being subversive and being tongue-in-cheek, about irony. Everything was a bit shabby. Everything we hated was commercial and shiny. It was sometimes seen as very serious but actually there was always humour in it; it was always quite dry."

Dazed & Confused has long showcased the more avant-garde work of established photographers alongside newer names. "During my time it was the same. Nick Knight and David Sims would contribute but photographers like Magnus Unnar, Anders Edström, Benjamin Alexander Huseby, William Selden and Dan Jackson were all starting out. Sølve Sundsbø, Horst Diekgerdes, Cedric Buchet, Richard Bush and Martina Hoogland Ivanow were regular contributors, but there would also be guest covers by Damien Hirst, Peter Blake, David Bailey... It was always a very eclectic mix."

Stylists were equally diverse. "We would run big collection stories and I would ask people to shoot one image so we would have contributors – a mix of all the people we most believed in at that time. Katy England and Alister Mackie, Camille Bidault-Waddington, Hector Castro, Mattias Karlsson, and Marie Chaix, the then fashion editor, Jo Schlenzka and Nicola Formichetti, who was senior fashion editor by that time, were all regular voices. But we would have the best of the new crop too. I remember making sure – when I left – that Nicola [who inherited the title in 2007] kept on my assistant Karen Langley as I knew she would be fashion director one day. She had the same dedication and passion for it [Langley was appointed in 2010]. I think that's what's magical about *Dazed* – it's a group of people that really believe in each other. *Dazed* was always unique – it still is unique. It's very organic and there's nowhere else like that. It almost seems like fate that we all came together. Everyone's like-minded and we've all known each other for a very long time."

SUSANNAH FRANKEL

FIELD

PHOTOGRAPHY SERGE LEBLON STYLING CATHY EDWARDS

TRIP

ALL CLOTHES FROM EMMA COOK'S SPRING/SUMMER
2001 WOMENSWEAR COLLECTION

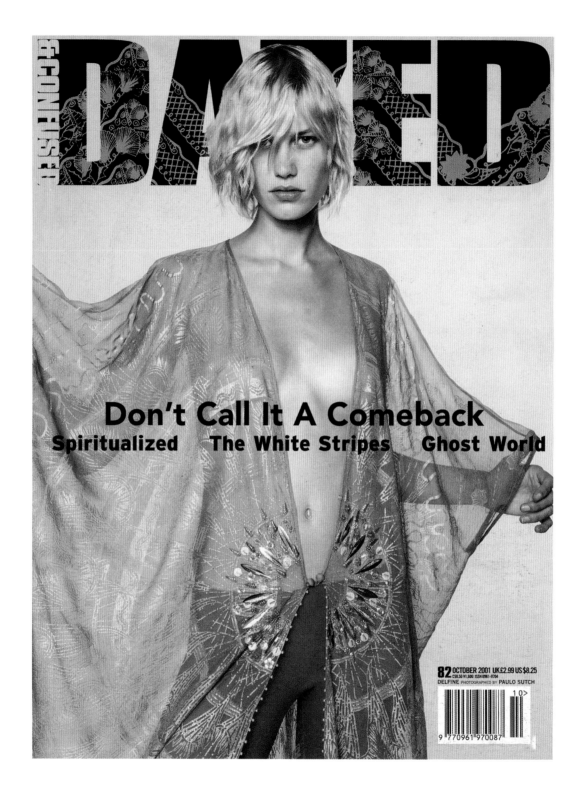

Don't Call It A Comeback
Spiritualized The White Stripes Ghost World

82 OCTOBER 2001 UK £2.99 US $8.25
C$8.50 ¥1,600 ISSN 0961-8704
DELFINE PHOTOGRAPHED BY PAULO SUTCH

[previous spread]
January 2001
FIELD TRIP
photography by Serge Leblon
styling by Cathy Edwards

[opposite and left]
October 2001
COVER + FUSCHIA HAZE
photography by Paulo Sutch
styling by Cathy Edwards

[this page]
October 2001
ZANDRA RHODES SPECIAL
archive photography by
Robyn Beeche
portrait by Maurits Sillem

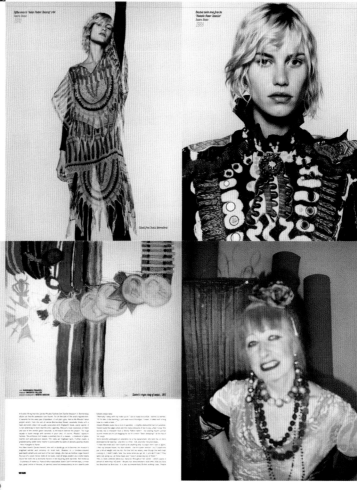

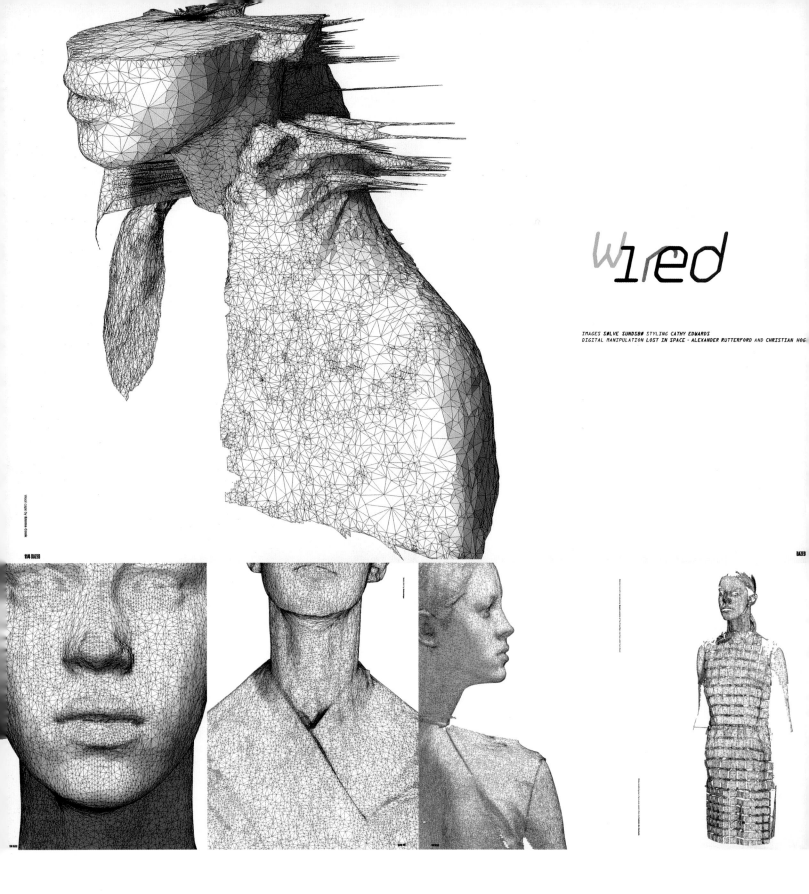

W1red

IMAGES SØLVE SUNDSBØ STYLING CATHY EDWARDS
DIGITAL MANIPULATION LOST IN SPACE - ALEXANDER RUTTERFORD AND CHRISTIAN HOG

Wool cape by Bernice Cook

114 DAZED

DAZED

December 1998
WIRED
photography by Sølve Sundsbø
styling by Cathy Edwards

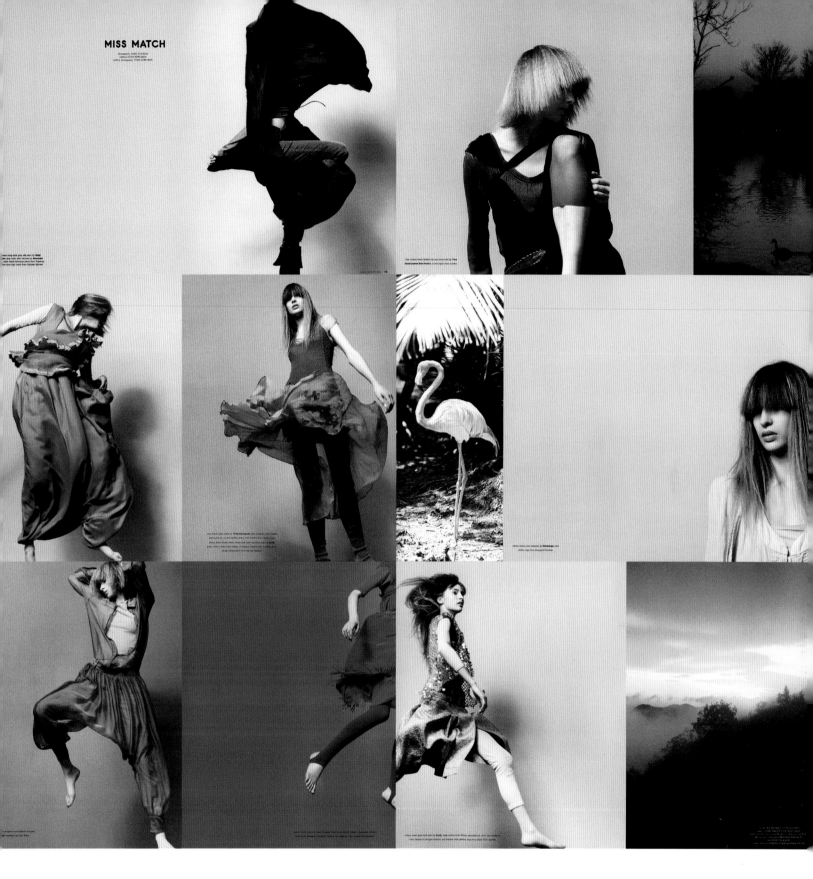

March 2002
MISS MATCH
photography by Mike Thomas
styling by Sarah Cobb and Gaby Dean
archive photography by Tony Edwards

PHOTOGRAPHY **BENJAMIN ALEXANDER HUSEBY**
FILM STILLS AND STYLING **CATHY EDWARDS**
PAINTING **SHONA HEATH**

VOODOORAY

October 2001
VOODOO RAY
photography by
Benjamin Alexander Huseby
styling and film stills
by Cathy Edwards
painting by Shona Heath

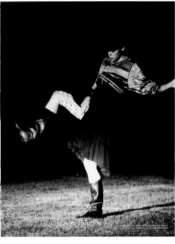

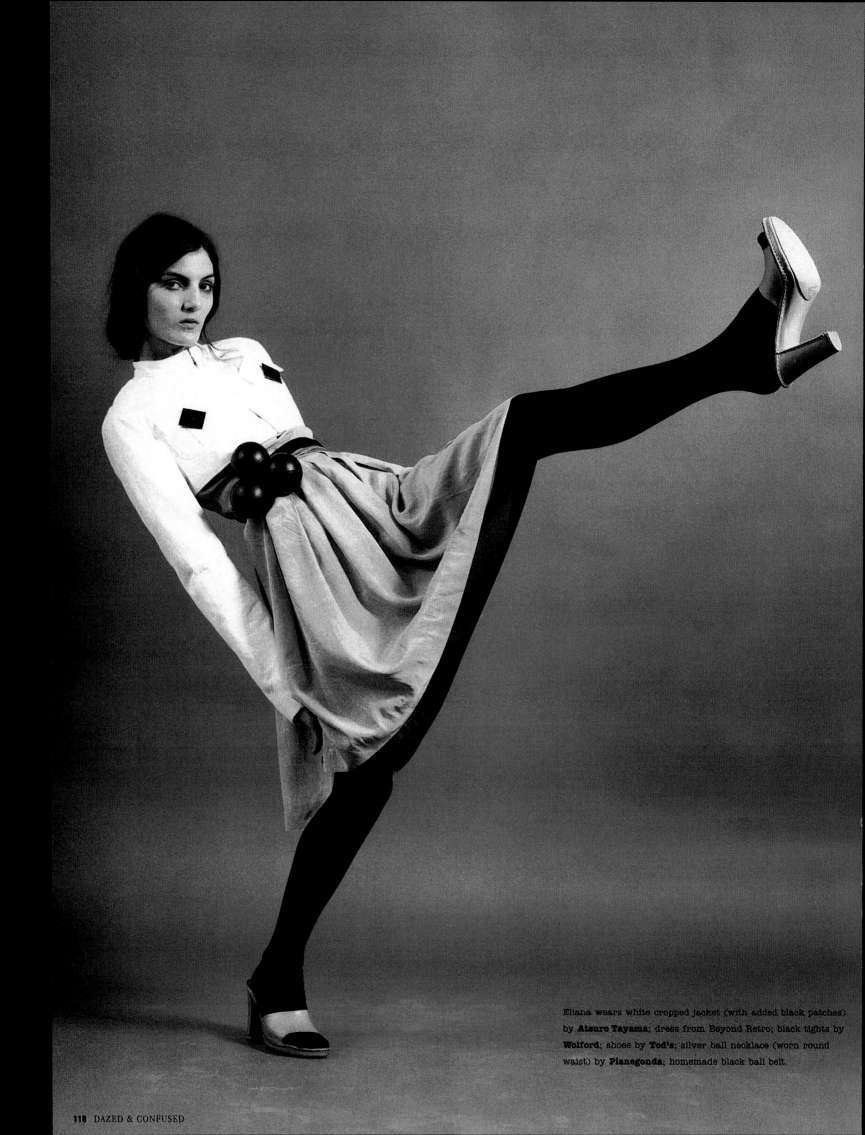

Eliana wears white cropped jacket (with added black patches) by **Atsuro Tayama**; dress from Beyond Retro; black tights by **Wolford**; shoes by **Tod's**; silver ball necklace (worn round waist) by **Pianegonda**; homemade black ball belt.

June 2003
ACCESSORIES STORY
photography by
Benjamin Alexander Huseby
styling by Cathy Edwards

[following spread]
January 2004
TREBLE CLEF
photography by Viviane Sassen
styling by Cathy Edwards

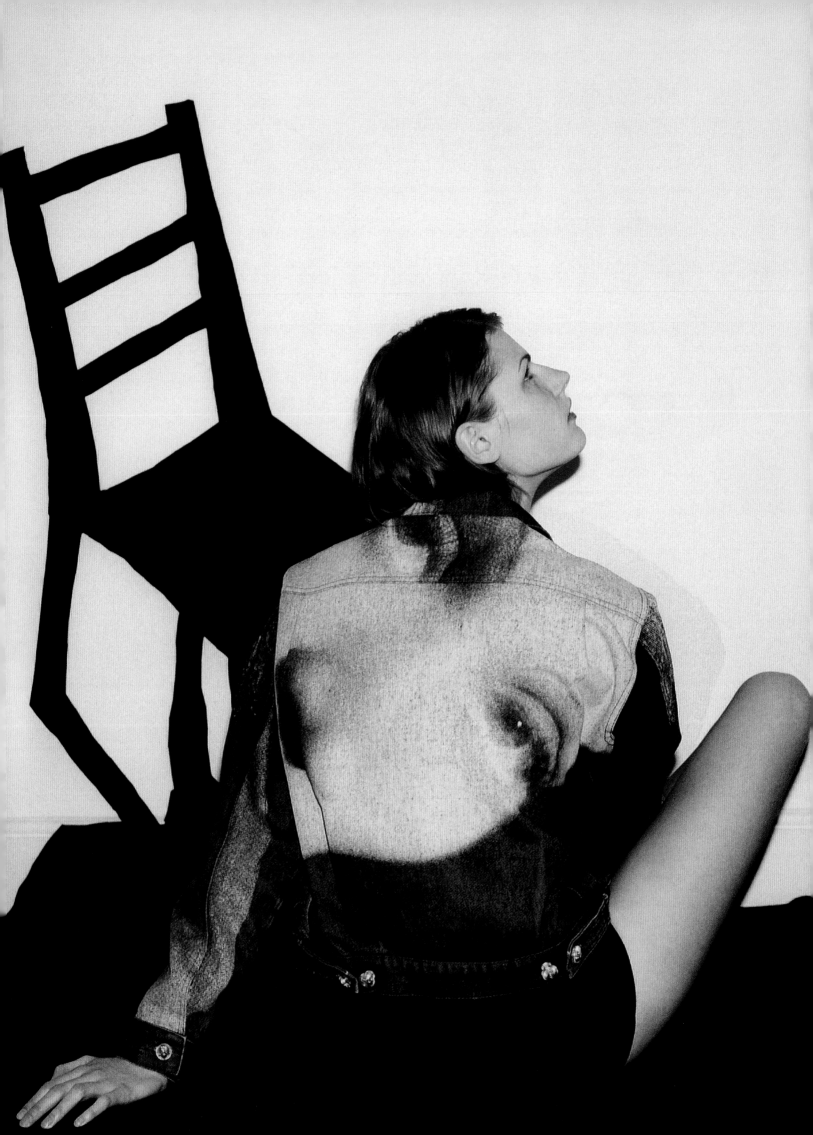

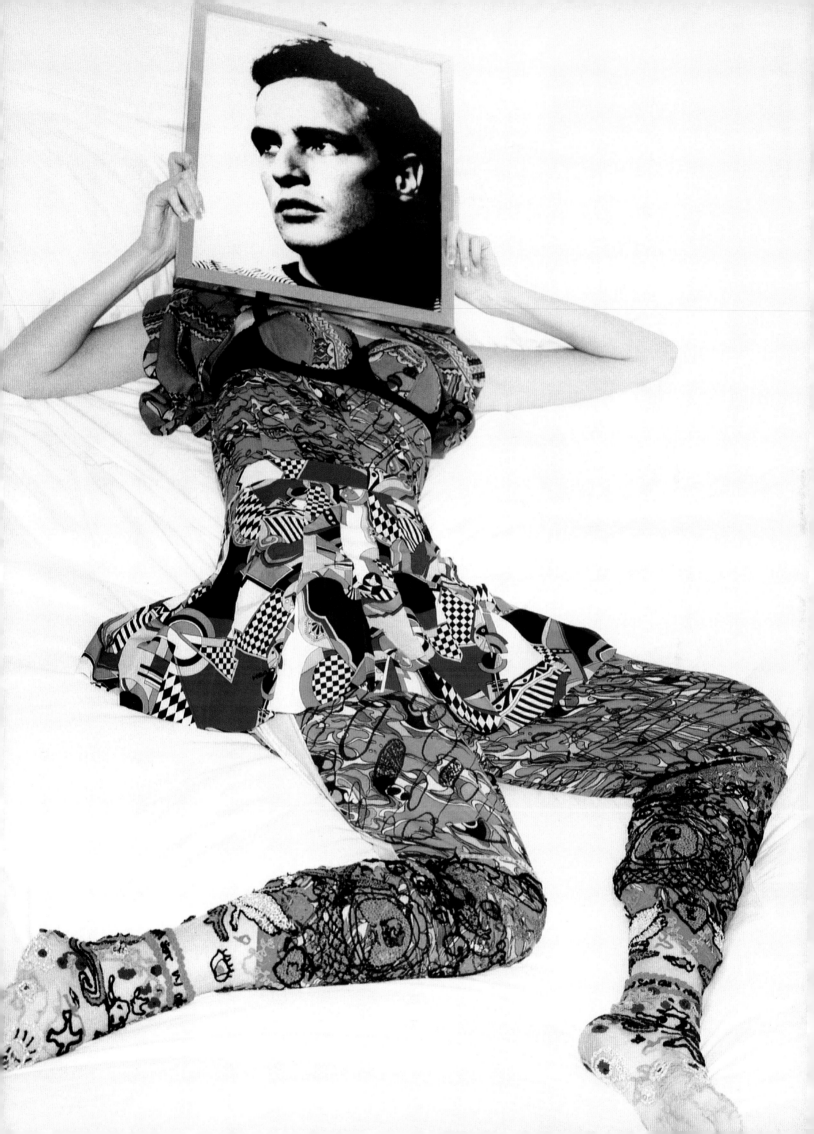

December 2003
LUDIVINE SAGNIER
photography by David Sims
styling by Cathy Edwards

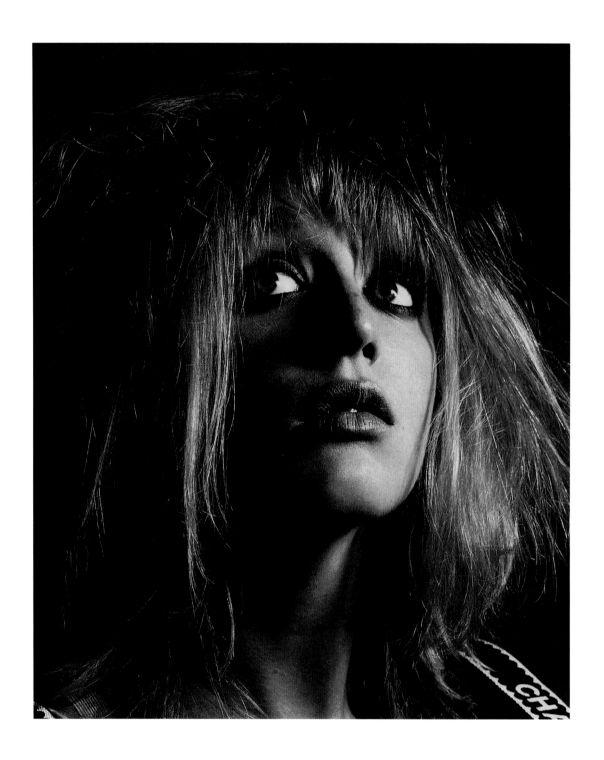

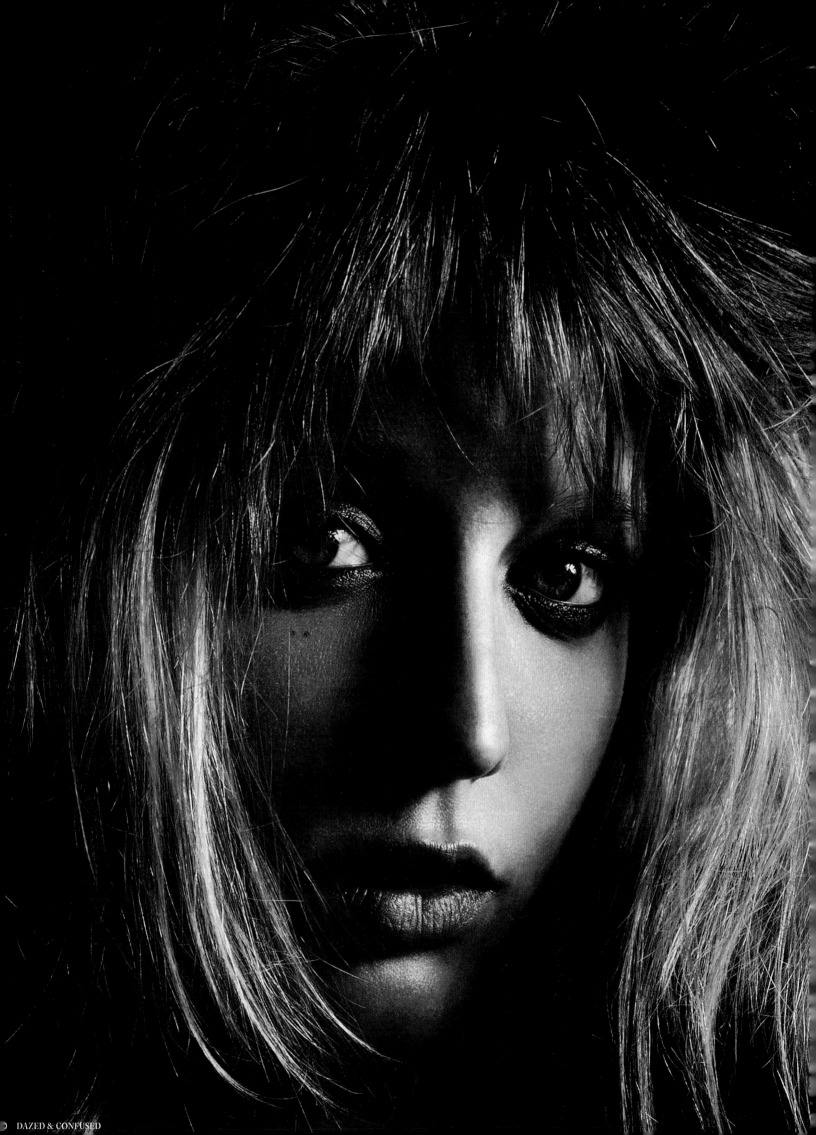

DANNIELLA WESTBROOK WEARS VERSACE
PHOTOGRAPHED BY GILLIAN WEARING

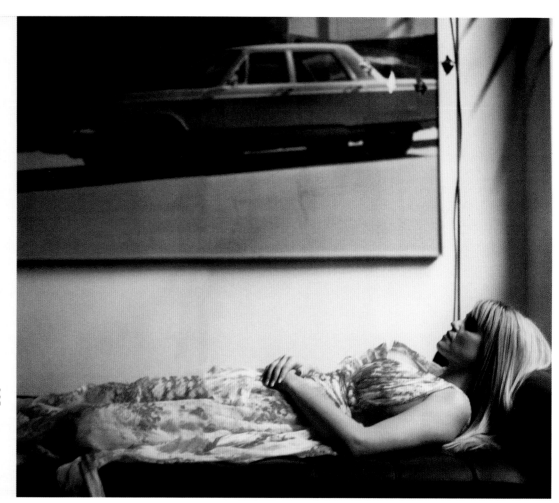

"I always thought Daniella's was one of the most interesting characters in *EastEnders* – she seemed very real. I have actually wanted to work with her for quite a while but through the trials she's had in life I have never felt like it was a good time to approach her. So this kind of makes up for that." - Gillian Wearing.

STYLING KAREN LANGLEY
HAIR SELENA MIDDLETON AT UNTITLED
MAKE-UP MICHELLE CAMPBELL AT UNTITLED
THANKS TO HELEN VAN DER MEIJ
FOR HER APARTMENT AND ENTERTAINMENT
AND KIKI PATSALIS FOR ASSISTING

March 2004
WOMEN ON THE VERGE
GRACE
photography by
Sofia Coppola
styling by Stacey Battat

GRACE WEARS HUSSEIN CHALAYAN PHOTOGRAPHED BY SOFIA COPPOLA

"Grace is my favourite model. She takes the job seriously and she's the cutest." -- Sofia Coppola

ART DIRECTION ANNE ROSS STYLING STACEY BATTAT

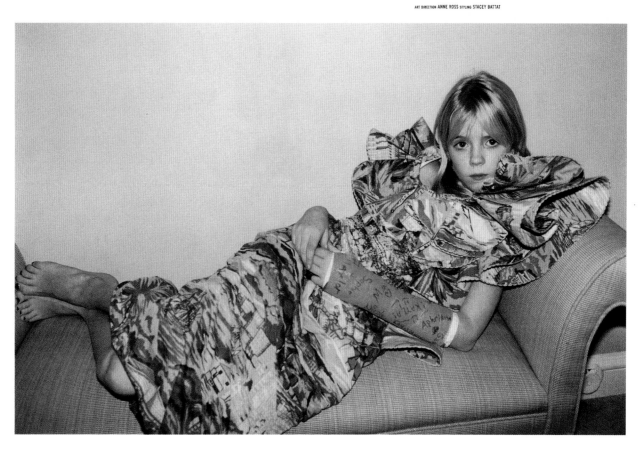

138 DAZED & CONFUSED

[following spread]
March 2006
MASTERS OF INVENTION
photography by
William Selden
styling by Cathy Edwards

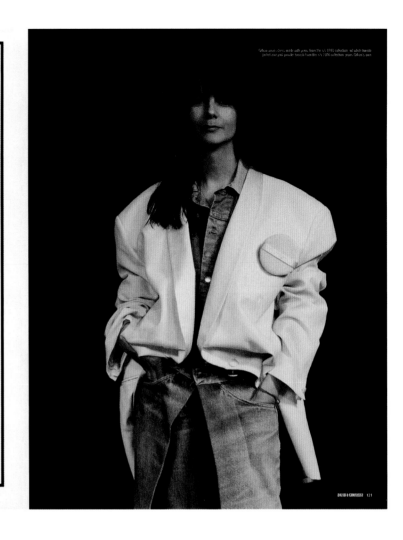

MASTERS
OF
INVENTION

For the past 20 years, Belgian designer
MARTIN MARGIELA's work has been more akin
to art than fashion. Dazed asked five suitably
maverick artists – GILLIAN WEARING, JANE AND
LOUISE WILSON, GOSHKA MACUGA and ALEXIS
MARGUERITE TEPLIN – to model some of his
most memorable pieces from the past two
decades. Meanwhile, SUSANNAH FRANKEL
explains why this master of his craft is more
relevant and original than ever before.

PHOTOGRAPHY WILLIAM SELDEN
STYLING CATHY EDWARDS

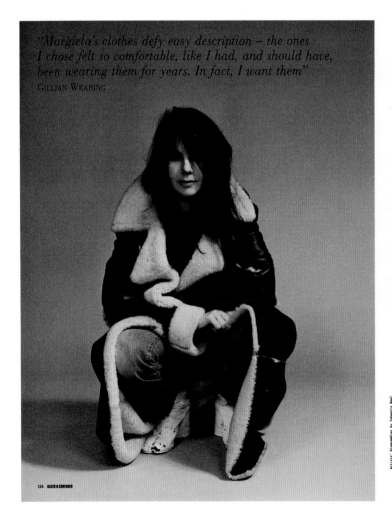

"Margiela's clothes defy easy description – the ones
I chose felt so comfortable, like I had, and should have,
been wearing them for years. In fact, I want them"
GILLIAN WEARING

THE PARIS SPRING/SUMMER SEASON WAS NOT A SHY ONE, EVEN BY such usually elevated standards. Riccardo Tisci's long-awaited debut for Givenchy came and went on a huge, white, circular stage, in a whirlwind of mid-90s style hype which featured shoulder pads to match. Karl Lagerfeld unveiled his collection for Chanel against a backdrop of the world's largest and most fashionable computer. The show ended with a different model standing on each key and, whichever way one chooses to look at it, that is a lot of inordinately tall, thin women in one place at one time. Then there was the Louis Vuitton party to celebrate the opening of the French megabrand's biggest and best store, a seven-storey monolith which looms over Paris' most famous shopping thoroughfare, the Champs Elysées. Élite some sort of fashion embrace. Sharon Stone, Catherine Deneuve and Uma Thurman were all dutifully in attendance to witness Vanessa Beecroft choreographing more of the world's most beautiful young women, stripped entirely of their clothes, to form a larger-than-lifesize LV monogram. It was a triumph of contemporary capitalist art if ever there was one.

Amid the madness – quietly and without ceremony – Martin Margiela filled an auditorium in a suburb of Paris with rather less obviously starry types, and sent out his clothes on proudly individual models balanced precariously on rusty old luggage trolleys, and wrapped in red and white packing tape marked "fragile". These outfits seemed, at times, to be only half-finished – one side was still attached to the rolls of fabric they were cut from. The models perched on the uppers of their shoes, their feet bound to them by straps of thick black elastic. Most remarkable of all, their jewellery was made out of brilliantly coloured ice cubes. Chokers, necklaces and bracelets melted in the glare of the lights to leave lovely trails of pink, blue and ultraviolet across garments deliberately crafted in fluid white fabrics, the better to show off the trickling stains – an extraordinarily thoughtful, unashamedly romantic and yet always fundamentally modern view. At the end of the show, and despite a rapturous response, the designer did not emerge to greet his audience. It is the stuff of fashion legend that Martin Margiela has never, in his two-decade career, stepped out to take his bows, agreed to a face-to-face interview or allowed himself to be photographed for any magazine. Among his other accolades, he remains fashion's most elusive designer.

For all his unwillingness to present himself in person, Margiela's status in the industry as the ultimate designer's designer remains unchallenged. Just this season, his influence can be seen in collections designed by everyone from Miuccia Prada to Viktor & Rolf and from Stella McCartney to Christian Dior.

"We appropriate, we do some vintage pieces – individual vision no longer exists," the God of French fashion Azzedine Alaïa, on characteristically unforgiving form, told French newspaper *Libération* recently. "The last designer (who still has individual vision) is Margiela."

In London, Alexander McQueen is no less impressed. "Of course I like Martin Margiela," says the designer. "I'm wearing him now. His clothes are

special because he pays such attention to detail. He thinks about everything, the cuff of a jacket, the construction of an armhole, the height of a shoulder. It's very much about cut, proportion and shape, the simplicity of it, it's so pared down. His clothes are modern classics. There's not a woman I know who doesn't have at least one near Martin Margiela piece in their wardrobe."

And so speaks Sophia Kokosalaki. "First of all, I admire his innovation, the way he designs is so clever, so human. I also like his ethos, he has been through a great many changes and has been working for years without compromising that. He's always kept to his beliefs. I think he has influenced a whole generation of designers and will continue to do so by helping us to realise how important it is to construct clothes in a different way, how important it is to consistently play down the garments themselves. In details like frayed hems and visible darts, he has invented a whole new vocabulary – a vocabulary of construction. Martin Margiela changed the way we make clothes."

Here's how it happened – it's also what little is known of him. Margiela was born in Limbourg, Belgium, in 1959. At the age of 18, he travelled to Antwerp to study fashion at the Académie Royale des Beaux Arts. For three years after graduation, he worked as an assistant at Jean Paul Gaultier, which served not only as his entry into the fashion world, but also as an eye-opener to the difficulties superstar designers face – a reason perhaps, as asserted by those close to Margiela, for his publicity-shy persona. Following graduation in the late 1980s, Margiela took the French fashion establishment by storm. This was, after all, the decade that would go down in history as symbolising everything that is brash and status-driven about designer fashion.

By contrast, Margiela's clothes were deliberately characterised by a more gentle silhouette – his proposition for the then ubiquitous shoulder pad, was the narrow "cigarette" shoulder which allowed the form of the wearer to show through. Loose silk threads hung like cobwebs from his clothes, seams and darts were reversed, laddered tights were worn over signature "tabi" shoes. And then there was the Martin Margiela label, a simple, white, rectangle, roughly tacked into clothes with stitches of thick white thread at each corner that was immediately recognisable by the tribe of people who wore the designer's creations, but looked, well, nothing short of a mess to the unenlightened among us.

Following a stint designing Hermès womenswear in the early years of the millennium, Martin Margiela sold a majority stake in his company to Diesel's Renzo Rosso to allow for expansion. Today, as well as the womenswear mainline (Line 1), there's Margiela menswear (10), basic garments for women (6), shoes (22) and a more expensive, classic line (4).

Although Maison Martin Margiela is now a global brand, with signature whitewashed stores in London, Paris and – soon to open – New York, the principles behind both his clothing and the way he handles himself as a designer remain the same. In a world that is overrun by faceless executives running luxury conglomerates, Margiela is that rare thing, a true maverick – brilliantly non-conformist and original to the core.

 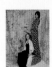

ALEXIS MARGUERITE TEPLIN
Teplin's work references an eclectic range of historical sources, and looks into perceptions of femininity and feminism. In an array of formats, her luminous paintings are often displayed as part of a panorama or sit between installations. Her work strives to re-appropriate the accepted feminine aesthetic, while testing the construct that created it.

GOSHKA MACUGA
Polish artist Goshka Macuga's work challenges traditional ways of exhibiting art as well as the relationship between custodian and artist, creating all-encompassing environments from other people's work. The exhibition then becomes an exhibit in its own right, the exhibits and their display appropriated as her own.

GILLIAN WEARING
Wearing graduated from Goldsmiths before showing at a range of exhibitions that brought the YBAs to public attention. She creates portraiture using photography, video and recordings, citing the influence of early 70s fly-on-the-wall documentaries. Wearing however sidesteps the obvious, coercing subjects into disguises before they make their revelations.

JANE AND LOUISE WILSON
For their degree, the identical twins submitted identical pieces – photographs showing one trying to drown the other. Their work deals with the dilemma of sharing a vision without having a single mind. Using video, photography and architecture, their art has included an analysis of women in contemporary society and of recent history as manifested in modern architecture.

Gillian wears white jacket from the s/s 1989 collection; cream v-neck t-shirt from the s/s 1998 collection; black wader boots from the a/w 2005/06 collection; jeans Gillian's own.

CUT OUT AND KEEP
A Decade Of Art Coverage By Mark Sanders

In the early 1990s, all eyes in the art world were firmly sighted on London, which was delivering an explosive shock to the status quo via the work of the "fuck you" generation that would come to be known as the YBA movement.

Damien Hirst, the Chapman brothers, Sarah Lucas and Angus Fairhurst were just a handful of cultural provocateurs developing an uncompromising and sometimes shocking new lexicon – one that demanded a new kind of media platform. "The big word being bandied around between Jefferson and I in the very beginning was 'collaboration'," says Mark Sanders, who presided over *Dazed & Confused*'s arts coverage throughout this defining decade. "What we didn't do – that we sometimes received criticism for – is set ourselves up as judge and jury. The art editorial stopped with us deciding who we wanted to work with, and when we did work with them it was about bringing them into the family and giving them complete open access. We wanted the magazine to be proactive culturally – as opposed to being a passive observer of culture."

Fresh out of university with an MA in Art History – "I knew I was pretty much unemployable" – Sanders first met Rankin and Jefferson when he began handing out flyers for their Leicester Square club night High And Dry. He quickly discovered he had a natural affinity with their "do-it-yourself" philosophy, and would go on to apply it to the arts coverage in the magazine. "What we decided to do was say: 'Let's get involved and let's include the artists in our playpen. We would bring artists like the Chapman brothers into the fold and say: 'Take eight pages and do whatever you want.' There were interviews with these artists in *Frieze*, of course, but it was very much 'art speak'. What we wanted was to make contemporary art accessible – we were people trying to be creative on our own terms and we gravitated towards people doing the same thing in contemporary art."

With the relationship between art and media evolving at an exponential rate, the time was right for a fresh approach, and the magazine's focus on boundary-defying art and forward-thinking aesthetic led to groundbreaking projects that pushed the edges of the envelope to the nth degree – earning the magazine its gutsy situationist-inspired reputation. "The situationists used to write about how they would take a map of Paris and then walk around Amsterdam with it because it opened them up to new ideas. We were trying to loosen things up in a very similar way with our interview techniques. We were saying to artists: 'The magazine is not just ours – it's yours as well.' I mean, I love Barbara Kruger's project where she took images from the magazine and then put her text over the top – it was just perfect. Then there was Jake & Dinos re-sitting their GCSE exams… These kinds of art projects turned the magazine into a platform for experimentation. The fake feature on Bruce Louden is a perfect example of that. I made that artist up with Jake Chapman – we figured if a magazine has the power to make people famous, then why can't we just make up someone and make them famous."

The subversive, self-referential manipulation of the market was absolutely key to creating features that – as Barbara Kruger states in these pages – contemporised the form of the magazine. "We all recognised the collusion of the media and art and I think *Dazed* was one of the first style magazines that was actually very conscious of that – it was producing its own 'self'. At the beginning of the 90s it was as though the whole of this country's previous 'shared media culture' was fragmenting around us – we were trying to understand that, so we took it back to doing it ourselves in the knowledge that culture is not some 'other'; culture is made by people and you can make it as well. That's what we tried to do with the arts coverage – not sit there and think culture was this thing that we have to just accept and consume, which is what most magazines do."

The desire of the magazine to engage in creating a new cultural paradigm arguably mirrored that of the post-Warholian generation of artists featured – artists who challenged accepted cultural mores with works that oscillated between moral observance and "perverse looking" in order to subvert commonly held perceptions of the human condition. "If you take the Warholian structure of contemporary art – who would say it was acting as a mirror to the bigger society around him – then when you start talking about the 'dirtier' work of the Chapman brothers, Sarah Lucas and Paul McCarthy, you start to talk about dysfunctional elements not only of our culture, but of ourselves, because culture is made by us, and at the core we are pretty dysfunctional things. It's that kind of Nietzschean argument between Dionysius or Apollo – which side of the line are you on? Obviously, the Chapman brothers are very much on the Dionysian side and our interests for the magazine were in playing with and pushing the boundaries of what a magazine could be, so we were interested in everything on that par. At that stage, those artists were pushing this idea of pleasurable disgust and were using an abrasive aesthetic, which resonated with the magazine."

It was an editorial mode that would land the magazine in trouble with the establishment on more than one occasion, with everything from Corinne Day's bloodied knickers to drunken conversations about the nature of being and the aforementioned fictitious self-mutilating artist Bruce Louden causing the magazine to be removed from stockists. "When the Bruce Louden feature hit the shelves, I got a call from Rankin saying 'Mark, what are you fucking doing? You are killing the magazine!' WHSmith had had an absolute hissy-fit when they saw the feature and returned about 30,000 copies to the offices. We had to spend an entire weekend cutting the pages out and sending the copies back to WHSmith so that they could be sold, with everyone moaning at me because I was the one who had kind of caused it! In the next issue we put out an ad saying: 'You might have noticed some pages were missing in our last issue – this was because they were banned by WHSmith – but if you would like to receive your missing pages, please send us a stamp-addressed envelope."

The *raison d'etre* that drove such in-your-face art editorial at the time was driven by a desire to break down existing hierarchies, which perfectly complemented what was happening in the art world, because contemporary artists were busying themselves tearing down notions of what constituted "art" – one of the last bastions of high culture. "It was almost like a punk explosion that happened in contemporary art in this country during that decade," asserts Sanders. "It happened in music in the 1970s and by the 1990s, young artists were doing it – they were opening up their own studio spaces, they were bypassing the galleries, they were creating work that attracted the attention of the police… *Dazed* was really about helping that to evolve and handing over the pages as a sort of curatorial space, making the magazine a catalyst for different ideas. Luckily for us, London was genuinely exploding at that time and what we had going for the magazine was that everything was on our doorstep, especially as we had no money!"

JOHN-PAUL PRYOR

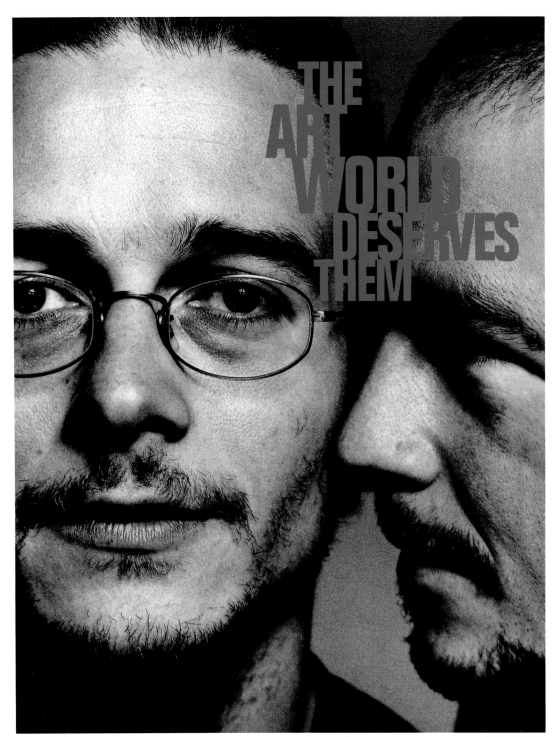

THE ART WORLD DESERVES THEM

1995
[previous page]
FAMILY FUCKFACE FREE POSTER
by Jake & Dinos Chapman
photography by Sam Taylor-Wood

"I think *Dazed* had an appetite for notoriety and for doing stuff other magazines wouldn't do. When we did the poster pullout it got taken off all the shelves in WHSmith. *Dazed* were very prepared to do stuff that would have negative feedback and they understood the point of that. It wasn't simply used as a method for attention. People forget that the artists that were knocking about at the time were not aiming or intending to be successful, they were just doing what they were doing. I think because it was early days for everyone the parameters of maturity hadn't been set, so it was just very, very funny and very chaotic really. The magazine was kind of doing the same thing in its own field. I can remember that every so often we would go back to the *Dazed* office – they had a pool table and an infinity curve and we used to try and chuck balls through it, it was just mayhem. When I met Jefferson for the first time, I remember thinking that he had the best name for an editor of a magazine – Hack, it's great."
JAKE CHAPMAN

1995
**THE CHAPMAN
BROTHERS**
*photographed by
Gino Sprio*

CHAPMAN INDUSTRIES
London
i small beauty salon

Invigilated by Mark **Sanders**

It was a long and totally unreal day for *Jake and Dinos Chapman* trim, stocky artists

with white well- brushed hair, thick white eyebrows and a ruddy complexion.

mr Chapman, are you out to shock me? said the fucking ugly journalist from the observer yes,boo It was not a wanton confusion why didnt someone bash your brains out as soon as they saw the first glimps of yor weird head protrude from the sows slit. picaso would hav loved you from the side, maybe from the front as well but I cant tell the difference anyway

"Enough ," said the EXAMINER dispiritedly,

"By now you should be confident enough to be adventurous in your work and the way that you carry it out. Do not be afraid to 'take risks'. Be ambitious. Mix your media in what you might have previously regarded as forbidden ways. Use the sometimes unexpected results this might produce in your work if they are appropriate; otherwise, document the experiments you have carried out and present them with your finished work. procreate monstrosity in your work to create dramatic effects. Look for unusual possibilities in your ideas and new ways of looking at what you see. Research how others have worked in ways which you think will help you. abruptly.

"I do have confidence in you, and I've no false feelings about your **Personal and critical ways of seeing the world.** You can 'tell a story' in clay or other constructional materials. The work of a potter making a commemorative plate is, in effect, telling a story. The work of Thomas Toft, a potter from the past, might prove to be a good example of this.

"We could probably make a go of a small pottery industry," nodded Dinos Chapman's airy clanger,

"I don't want to hear any more. It's quite light I don't want to hear any more! said the art teacher reduced to the least flambuoyant character of its many scattered personalities, Equilibrium takes hold, so Jake & Dinos begin their **GCSE Art Exam**

working from still life 'hands-on' Recreating the work of another in a new style and context. *Learning through discovery.* Using discoveries from other fields in art. *Cave Paintings.* cultural manufacture of bad conscience: COARSEWORK, a row of square pink and white cottages. *Theories of colour.* romantic comedy 'fruits de mere' Religious bliss, 'Akinesis algera', **Helping others to make discoveries.**

Stories of discoveries and explorations have always been popular with artists

This is the result of our *GCSE Art & Design Coursework* and Terminal Examination It embodies all that we have done and therefore includes a breath of pure pleasure and relief. ps ", no cocks and cunts

At Chapman (F)Arts, **39 Fashion** Street, London, E1, from **7th** October - 7th November

In association with Sadie Coles H.Q.

Best regards,
Dear Jake & Dinos,

October 1998
CHAPMAN BROTHERS INDUSTRIES
all images courtesy of Jake & Dinos Chapman

Chapman Brothers Industries was one of the magazine's situationist-inspired art projects and it exemplifies the way in which *Dazed* was becoming a unique platform for experimentation. The project involved the two now legendary artists re-sitting their GCSE exams at a night school.

"I think this all began because someone from a newspaper phoned me at the studio and said, 'How do you feel about being left out of the Turner Prize again?' They had some kind of sense that I would feel rejected or overlooked – or whatever – not that I gave a toss. In an off-the-cuff, joking way I said, 'Well, the reason we don't get in is because we don't have our Art O Levels.' I said it was a requirement of the Turner Prize that you have to have O Level Art. They went off and made a few phone calls, and then they got me on *Newsnight*?! It was just a joke, but the Tate actually gave out a press release saying that it wasn't a condition of the Turner Prize to have passed your O Level. Anyway, we just thought, 'That's fine, why don't we just do our O Levels?' So, it kind of came out of that. In everything we did with *Dazed*, they would say, 'Do you want to do something?' and we'd say, 'Yeah, we want to do this…' Then they'd say: 'Okay.' There was a kind of mutual consensus and irresponsibility that was symbiotic and fun. We went to a cramming college in Notting Hill and had to produce a year's body of work in about two months, and then sit an eight-hour exam." JAKE CHAPMAN

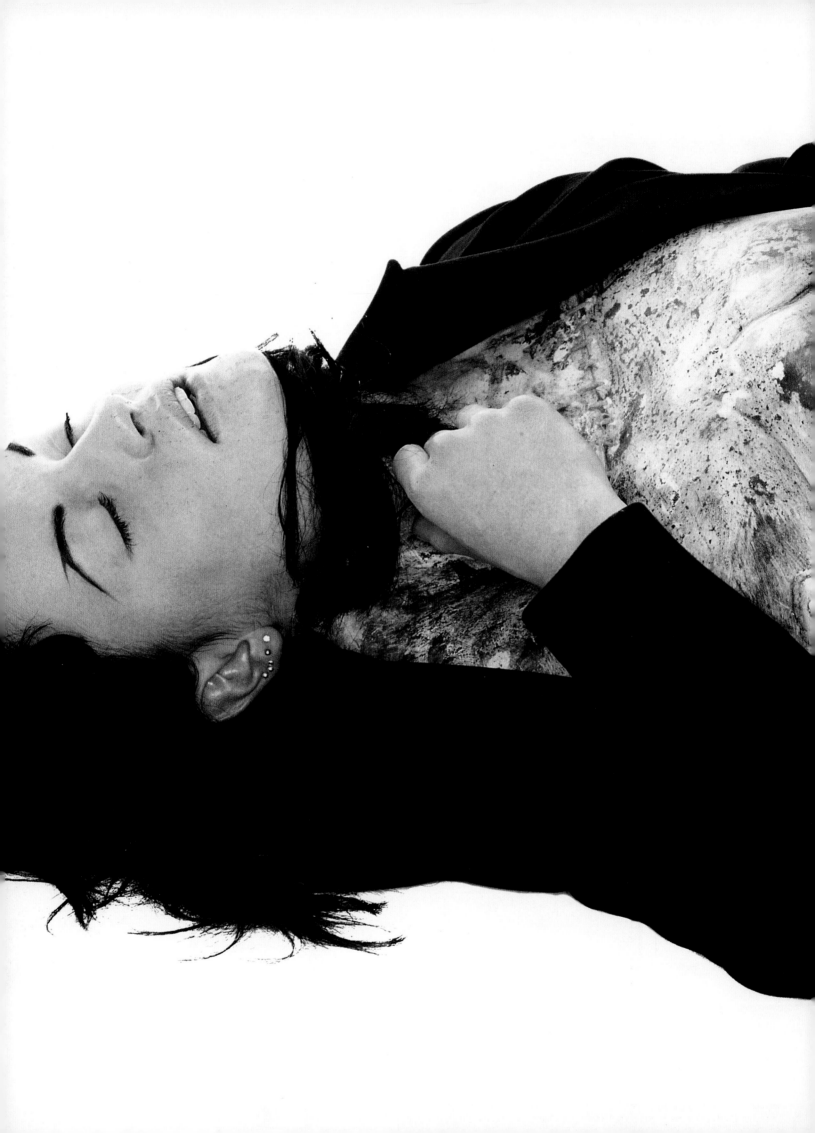

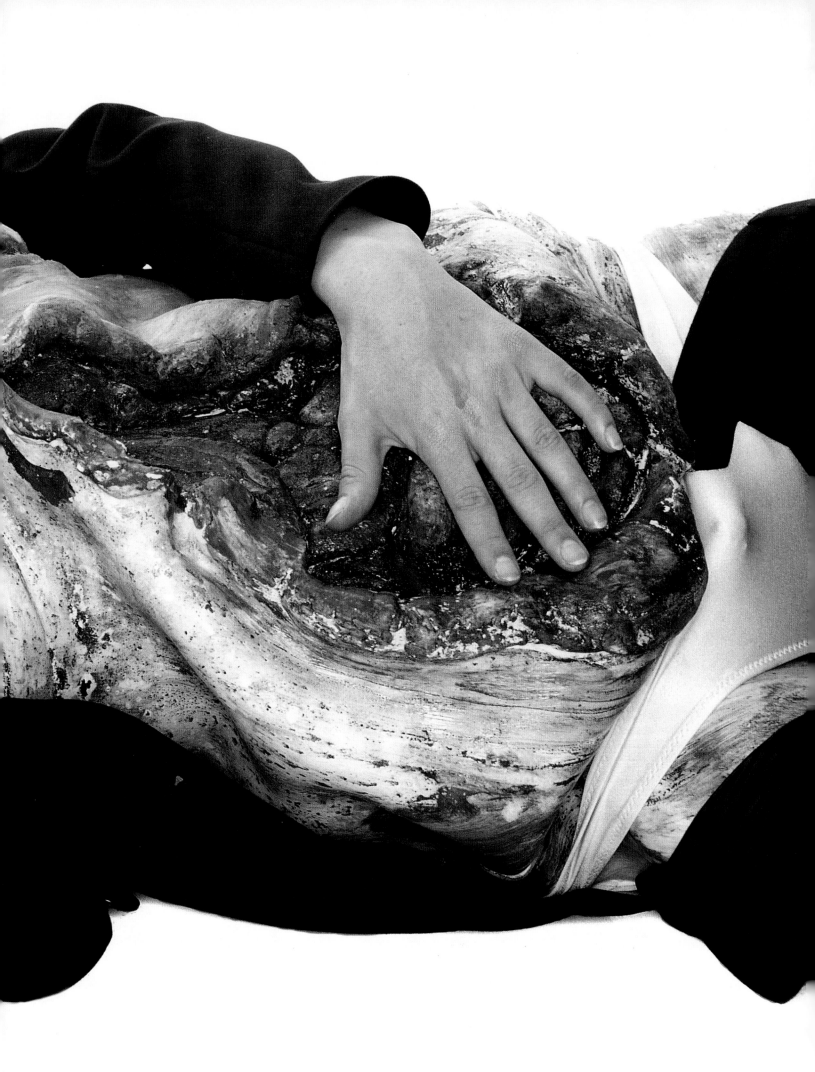

[previous spread]
September 1997
INTESTINE 1,2,3
by Jake & Dinos Chapman
photography by Phil Poynter

Phil Poynter collaborated with
Jake Chapman to apply a piece
of work from the show *Six Feet
Under* to a fashion model,
in a controversy-baiting image
that was about as anti-fashion
as you can get.

"I don't think that fashion
photographers are artists at
all – fashion photographers
are commercial photographers
– so working with an artist like
Jake Chapman gave me the
opportunity to do something
that could be looked upon as art.
To do that was fascinating, and
combining those kinds of things
was something you just couldn't
do anywhere else." PHIL POYNTER

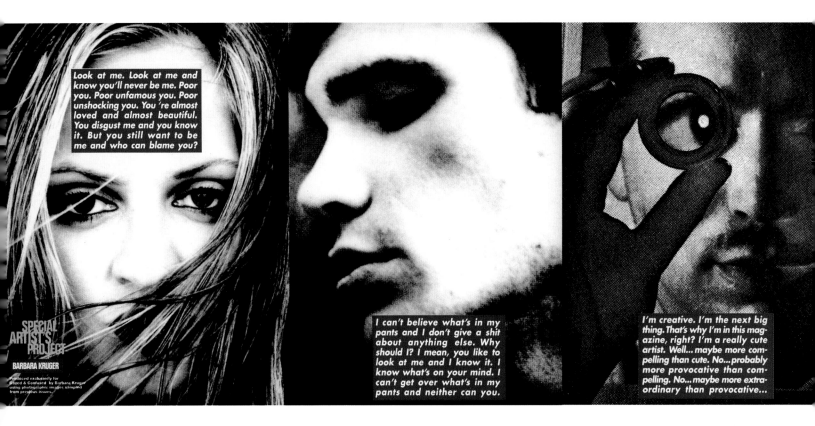

Look at me. Look at me and
know you'll never be me. Poor
you. Poor unfamous you. Poor
unshocking you. You're almost
loved and almost beautiful.
You disgust me and you know
it. But you still want to be
me and who can blame you?

SPECIAL
ARTIST'S
PROJECT
BARBARA KRUGER

Produced exclusively for
Dazed & Confused by Barbara Kruger
using photographic images sampled
from previous issues.

I can't believe what's in my
pants and I don't give a shit
about anything else. Why
should I? I mean, you like to
look at me and I know it. I
know what's on your mind. I
can't get over what's in my
pants and neither can you.

I'm creative. I'm the next big
thing. That's why I'm in this mag-
azine, right? I'm a really cute
artist. Well... maybe more com-
pelling than cute. No... probably
more provocative than com-
pelling. No... maybe more extra-
ordinary than provocative...

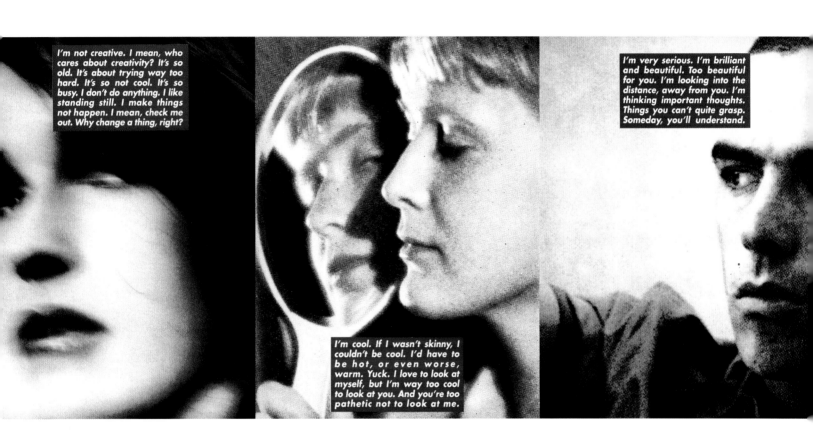

I'm not creative. I mean, who cares about creativity? It's so old. It's about trying way too hard. It's so not cool. It's so busy. I don't do anything. I like standing still. I make things not happen. I mean, check me out. Why change a thing, right?

I'm cool. If I wasn't skinny, I couldn't be cool. I'd have to be hot, or even worse, warm. Yuck. I love to look at myself, but I'm way too cool to look at you. And you're too pathetic not to look at me.

I'm very serious. I'm brilliant and beautiful. Too beautiful for you. I'm looking into the distance, away from you. I'm thinking important thoughts. Things you can't quite grasp. Someday, you'll understand.

June 1996
artwork by
BARBARA KRUGER
copyright Barbara Kruger
courtesy Mary Boone Gallery,
New York

"The pages I did for *Dazed* came out of my experience as an editorial designer. I always see my work as coming out of my experience in magazines, so coming back to the form and looking at the mechanisms at work when you look at a page or turn a page was thrilling, especially because it was *Dazed*. I remember when the magazine first came out – there was no equivalent in America and there probably still isn't. *Dazed* added a whole different edge – it contemporised the magazine form to some degree, and that was something that could only have happened in London at that time. In many ways, the work I produced in *Dazed* is just a commentary about how certain cultures think and see, and like to be seen. I think what they foreground is my continued use of direct address and the use of humour in my work, because laughter is an important device that isn't owned by either the left or the right... It can be sort of emancipatory."
BARBARA KRUGER

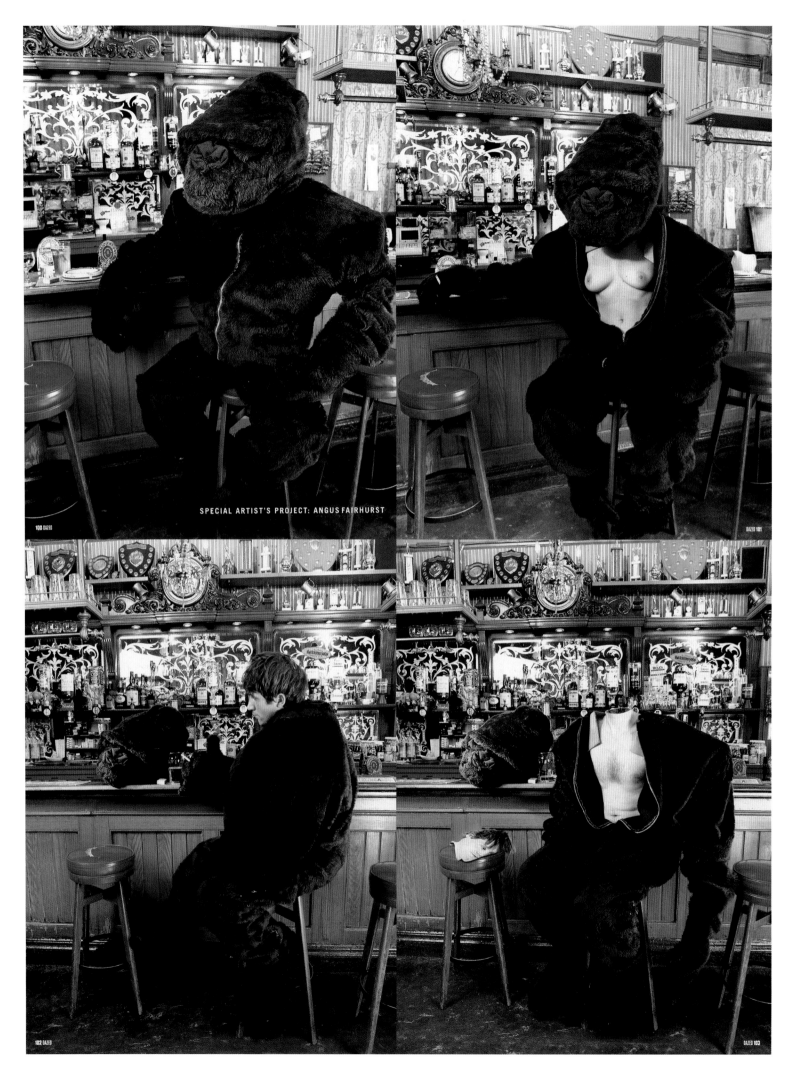

SPECIAL ARTIST'S PROJECT: ANGUS FAIRHURST

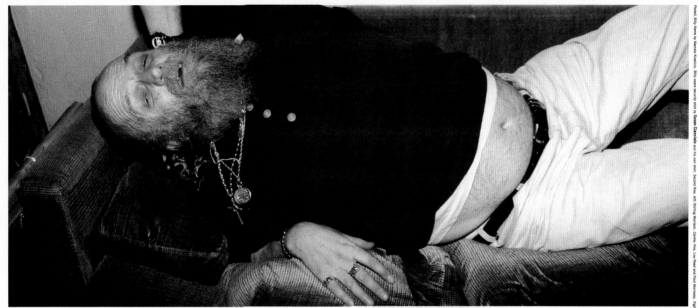

BILLY NAME
TEXT **SUR RODNEY SUR(HENDRICKS)** INTRODUCTION **MARK SANDERS**
PORTRAIT **MARCELO KRASILCIC** STYLING **JASON FARRER** FOR BEAUTYHEAD
PHOTOGRAPHS FROM THE FACTORY COURTESY OF BILLY NAME/GAVIN BROWN/*frieze* MAGAZINE

Of all the Warhol superstars, Billy Name is the one most shrouded in mystery. An avant-garde hairdresser in the early '60s with a penchant for black magic, he will for all eternity be remembered as the man who camped out in the loo of the Factory for over a year, dropping acid, shooting up, documenting, photographing and charting the excesses of in-house stars such as the Duchess, Mr Clean, Ondine and the Sugar Plum Fairy, not to mention those situated in the heavens. Responsible for both transforming Warhol's studio into a giant reflector decked out entirely in silver foil, and coming up with the name of the Factory itself, his life has been marked as one of the key documentalist and personalities of the Warholian '60s, with over 15,000 negatives captured for posterity.

44 DAZED DAZED 45

[above]
December 1996
BILLY NAME
photography by
Marcelo Krasilcic

[left]
October 1996
ANGUS FAIRHURST
photography by
Dean Chalkley

"I first met Angus when he was living with Sarah Lucas in Shoreditch. He was a very important figure in the art-world in the 1990s – part of its beating heart. The idea of our interview together was that we would start out sober and then drink as many pints and whisky chasers as we could. By the end of this experiment we could hardly stand but we had formed a connection between ancient Rome and the horror movies of Vincent Price... It was one of those interviews that gave *Dazed* its reputation."
MARK SANDERS

WARHOL IS...
AS EXHIBITED **STUART HORODNER/MARK SANDERS**
Just what is it that makes Andy Warhol so different, so appealing? We asked a group of NY based artists to answer the question: "What does Andy Warhol, or his work, mean to you?"

WARNING: SARAH LUCAS' ART MAY

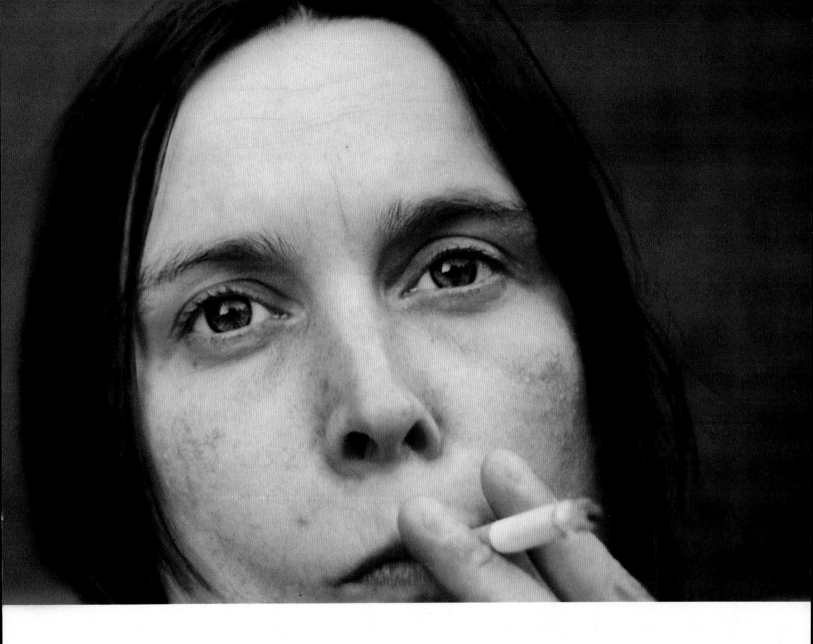

SERIOUSLY DAMAGE YOUR HEALTH

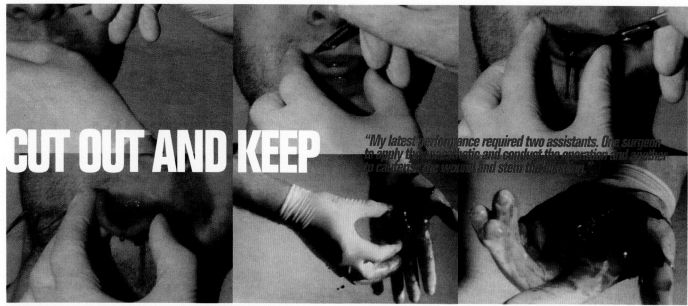

CUT OUT AND KEEP

"My latest performance required two assistants. One surgeon to apply the anaesthetic and conduct the operation and another to cauterise the wound and stem the bleeding."

South African-born performance artist Bruce Louden defies the imagination. For over a decade he has been cutting off parts of his body and displaying them in underground galleries all over the world.

BRUCE LOUDEN

Interview **Mark Sanders** Photographs courtesy of Bruce Louden

But this January Louden raised the stakes and completed his most hazardous performance yet. In the province of Kwazulu-Natal, in a secret location on the outskirts of Durban, he severed his own tongue and documented the act on film. The tongue is now due to be exhibited in a London gallery this March.

Body-art is nothing new. Ever since the '60s and the rise of the OM Theatre and the Viennese Actionists, artists such as Hermann Nitsch and Günter Brus have entered into the dark realms of self-mutilation and self-sacrifice through the use of slaughtered animals and scarification. In the early '70s Chris Burden had himself shot through the arm and crucified to the roof of a Volkswagen. Even today in LA, Ron Athey's performance pieces are centred on the ritualised scarring of his body and this month saw the death of one of the most famous sadomasochists of our times - Bob Flanagan, whose activities included the nailing of his genitals to a plank of wood.

Yet over the last ten years the disturbing activities of Bruce Louden have called into question exactly where the line is drawn between art and annihilation. Non-political yet obsessive, his own personal acts of dismemberment are rooted in an auto-erotic desire to dissect his own flesh and blood. To date he has severed over 12 pieces of his body, from toes to his tongue, fingers and an ear. The remnants of these performances are usually documented and then sold to collectors from around the world. Occasionally he keeps a body-part and records its slow decay.

Chillingly matter-of-fact in his observations, the following interview was conducted with him on the internet while he was still recovering from his latest performance in Durban.

Dazed & Confused: Why did you first decide to cut off parts of your body?
Bruce Louden: Curiosity. I was fascinated that my

body produced so much shit. It seemed that so much time was spent converting useful material into bodily waste, so I wanted to extend the proposition by converting useful parts of my body into waste.
D&C: Do you see yourself as separate from your body?
BL: No. The self is only an organ. It just seems to have precedence over all the others. 300 years ago the soul inhabited the heart; after psychoneurology the self inhabits the brain. It is a part of the body and can never be separated.
D&C: How many parts of your body have you cut off so far?
BL: 12 pieces.
D&C: Can you list them off the top of your head?
BL: No and I can't count them on my fingers either.
D&C: Is there any part of your body that you would never consider cutting off?

[previous spread]
July 1997
SARAH LUCAS
photography by
Phil Poynter

[this page]
March 1996
artwork by
BRUCE LOUDEN
all images courtesy of
Bruce Louden

The self-mutilating Bruce Louden was the entirely fictitious creation of Mark Sanders and Jake Chapman. Louden is a great example of the collaborative and proactive cultural aesthetic the magazine applied in its arts coverage. Ironically, the feature was entitled *Cut Out And Keep*, which is exactly what the *Dazed & Confused* team had to do with the feature when stockists refused to carry the issue.

"Bruce Louden was a figment of our imagination – a South African-born performance artist who cut off bits of his body for art, his most recent action being to have cut out his own tongue. The story was hugely controversial and picked up by newspapers all over the world. Jake and I met up at my apartment in Ladbroke Grove and the deal was that neither of us spoke to each other during the interview but did the whole thing by email. It's actually funny when you read between the lines. There is a moment where I ask Bruce Louden whether he considers his toenail clippings to be works of art. His reply was simple, 'Yes, but only as maquettes!'" MARK SANDERS

[right]
July 1996
artwork by
MARC QUINN
all images courtesy of
Marc Quinn

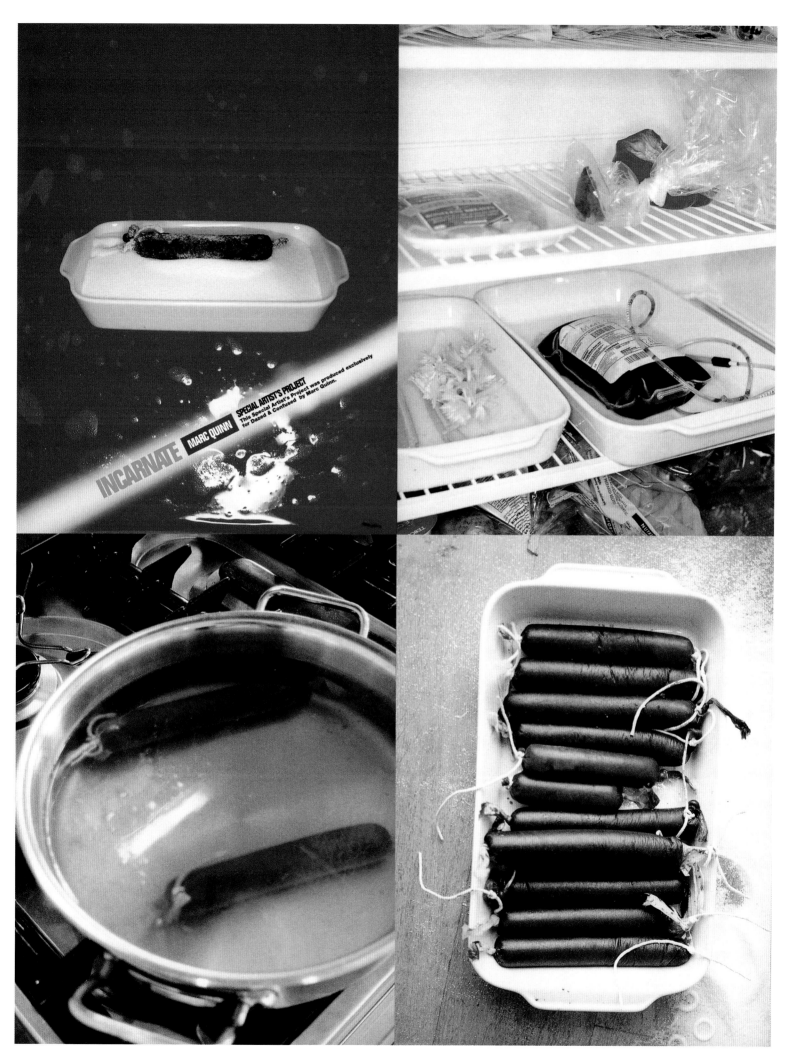

INCARNATE MARC QUINN SPECIAL ARTIST'S PROJECT This Special Artist's Project was produced exclusively for Dazed & Confused by Marc Quinn.

POP ART:
REVOLUTION
FOR YOUR BREAKFAST!

A 12-foot tiger shark in formaldehyde, a cow and her calf sawn in half, preserved sheep, black sheep, flies, butterflies, cabinets full of pharmaceutical bottles, surgical instruments, spinning canvasses, spot paintings, cigarette butts, billboards, beer bottles, designer clothes, album covers, pop videos, commercial advertising... Damien Hirst has caned the art world

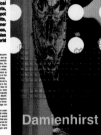

Damienhirst

"I THINK I AM DOING WHAT ANY ARTIST FROM THE PAST WOULD BE DOING IF THEY WERE ALIVE TODAY."

"I'VE GOT TWO WAYS OF LOOKING AT THIS. I AM EITHER A GENIUS, OR THE ART WORLD IS INCAPABLE OF DEALING WITH THE KIND OF ART THAT IS GOING ON TODAY. MY ANSWER IS THE ART WORLD IS FUCKED. I'M NOT A GENIUS."

Green shirt, by **Prada** from Browns

White V-neck T-shirt, by **Jigsaw For Men**

September 1997
artwork by
DAMIEN HIRST
photography by Rankin

Damien Hirst was the magazine's first art world cover star and would become a consistent collaborator. The celebrated YBA was being portrayed in the mainstream media as an artist at the forefront of a supposedly cynical and media-savvy movement. In his first *Dazed & Confused* interview Hirst talked extensively about the shared

language of art and advertising, and characteristically answered his detractors with a join-dots-portrait and an advertisement he created exclusively for the issue, simply titled *Suck My Cock*.

"I arrived on a Monday afternoon at Damien's house in Combe Martin and almost immediately he challenged me to an extensive series of pool games. Combe Martin is famous for its many pubs and very soon I was totally paralytic, but every time I tried

to begin the interview Damien refused. In the end he kept me there for a whole week, drinking day and night, until one morning he turned to me and asked, 'Are you alright?' My hangover was so bad I could hardly think let alone speak, at which point he said, 'Let's do the interview right now!' It was as if he was putting me through some form of rite of passage – waiting for me to achieve a state of physical and mental implosion before allowing the tape to roll." MARK SANDERS

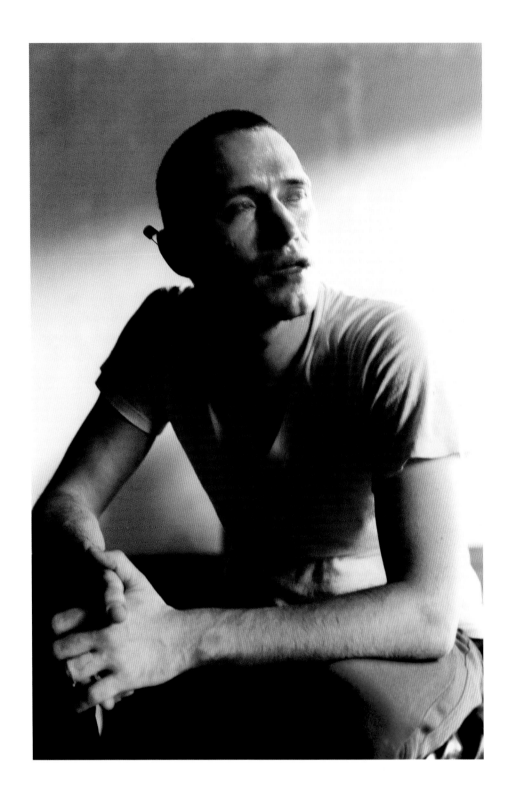

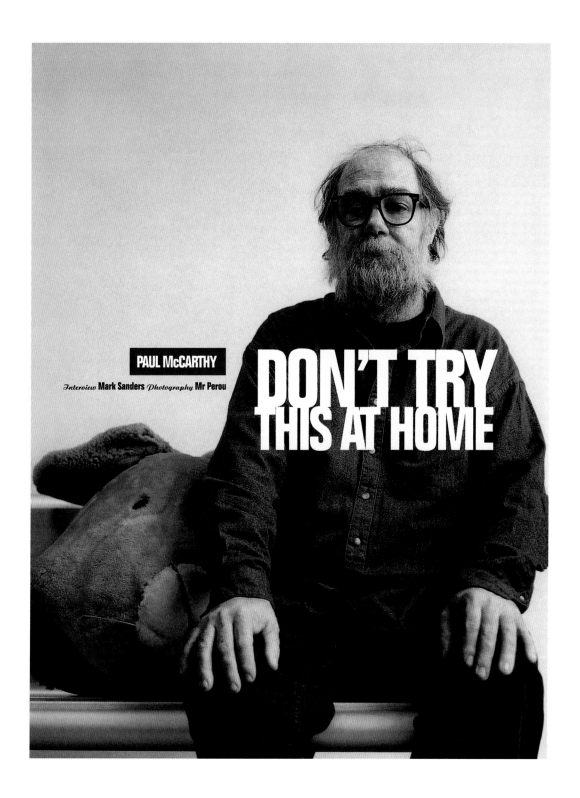

PAUL McCARTHY

Interview **Mark Sanders** *Photography* **Mr Perou**

DON'T TRY THIS AT HOME

1998
SOLILOQUY III
photography by
Sam Taylor-Wood

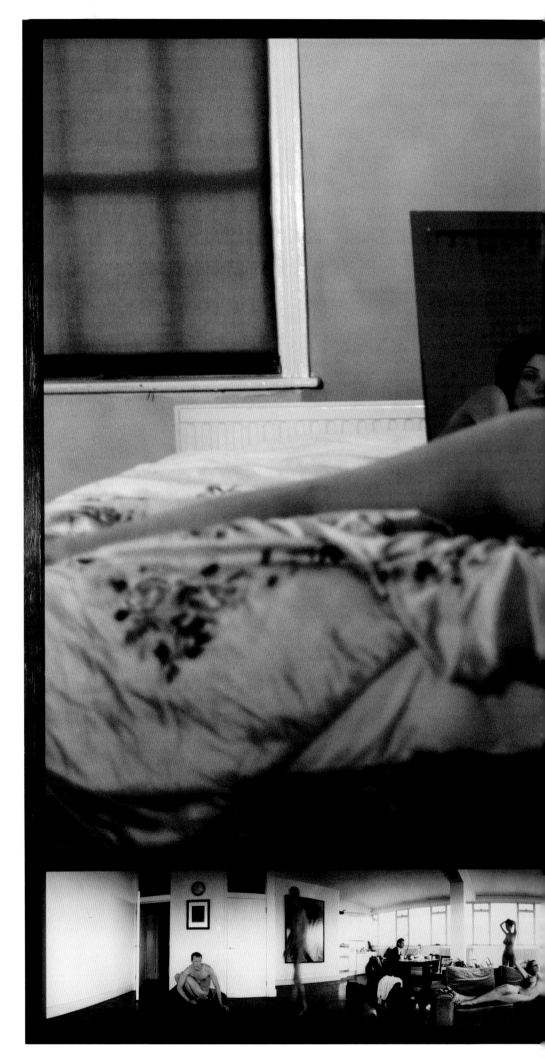

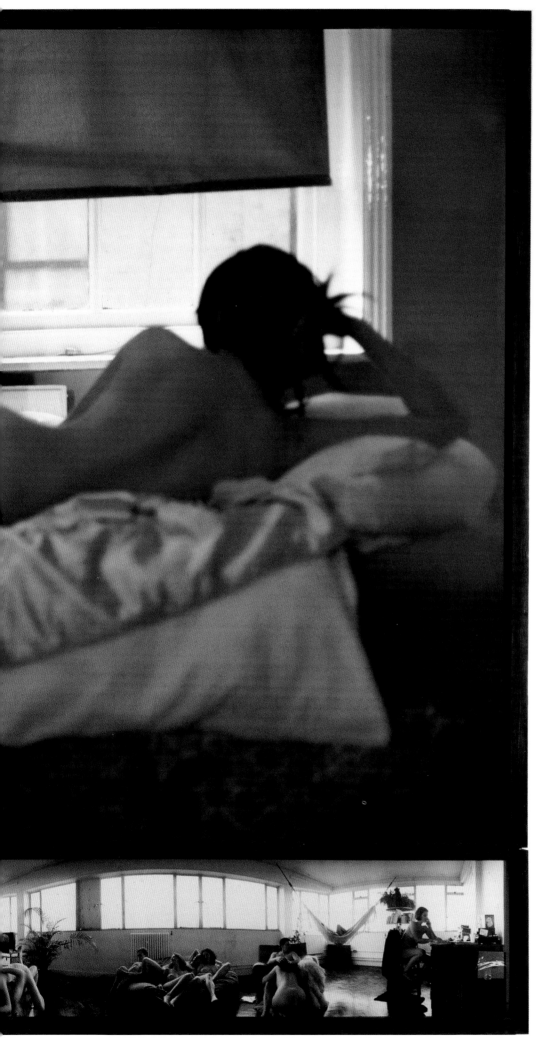

NO SEX PLEASE,
WE'RE BRITISH

AN EXHIBITION CURATED BY DAZED & CONFUSED FOR THE SHISEIDO ART SPACE, GINZA, TOKYO

Nick Knight, 'Tongues, 1998

Take several suburban leather clad moustachios, two female contortionists, a pair of chicken knickers, five girls with added appendages, a naked soiree, a British tongue flag, a gorilla with breasts, invisible sex, a red flare, a rubber doll, art, advertising and a sock fetishist and what have you got? Answer: just an everyday look at British sexuality by some of Britain's leading creatives, brought to you by *Dazed & Confused* and the Shiseido Corporation.

Dinosaurs roaming the earth. Walking like giant cranes machine guns in hand. Killing millions. Devils walking in jungles. Sending us all to sit at the side of the lake awaiting judgement. Children are burnt like matches in the desert. Steel lead birds expensive ties no rust.
A fairytale. Briefcases and kalashnikovs.

Featuring the likes of Sam Taylor-Wood, Damien Hirst, Alexander McQueen, Jack Webb, Nick Knight, Angus Fairhurst, Martin Parr, Sarah Lucas, Thom Yorke, Dan Rickwood, Jake and Dinos Chapman, Paul Davis, Adam Chodzko and the Dazed & Confused Creative, *No Sex Please, We're British*, is exactly what it looks like; a tongue-in-cheek look at British sexuality and self-censorship. Conceived in the bowls of London and transported to the technoscape of Tokyo, it spent its short life being pondered by our Japanese friends across the oceans. Apart from the odd offending article being censored by stylish frosted glass, the results, we are informed, were met with rapturous applause. Just one more nail in the coffin of sexual propriety.

No Sex Please, We're British was curated by Mark Sanders and Phil Poynter of Dazed & Confused and exhibited at the Ginza Art Space, Tokyo last month, in association with the Shiseido Corporation Ltd. It may well travel so beware!

Barbara (with David and Paul)

MARK and MARION

STEVE and ANDY

LYNNE &

SIMON

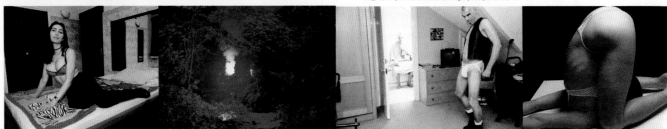

December 1998
NO SEX PLEASE, WE'RE BRITISH
TOKYO ART EXHIBITION

The ethos of *Dazed & Confused*
has always been to extend as
far beyond the page as possible
and *No Sex Please We're British*
was one of the magazine's first
exhibitions of contributors' work
in an international art institution.
Curated by Mark Sanders, Phil
Poynter and Jefferson Hack,
it featured key photographers
working with the magazine at
the time, such as Nick Knight,
Jack Webb and Nick Waplington.

[below]
February 1999
CAMERON JAMIE
photography by Justin Westover
Courtesy Galerie Nathalie Obadia,
Paris/Brussels

When *Dazed & Confused*
handed Cameron Jamie an
open remit he dreamed up this
apartment wrestling series,
which brought together the
worlds of art and fashion, and
was executed by our in-house
stylist Tabitha Simmons.

[previous spread]
March 1998
photography by
Richard Prince

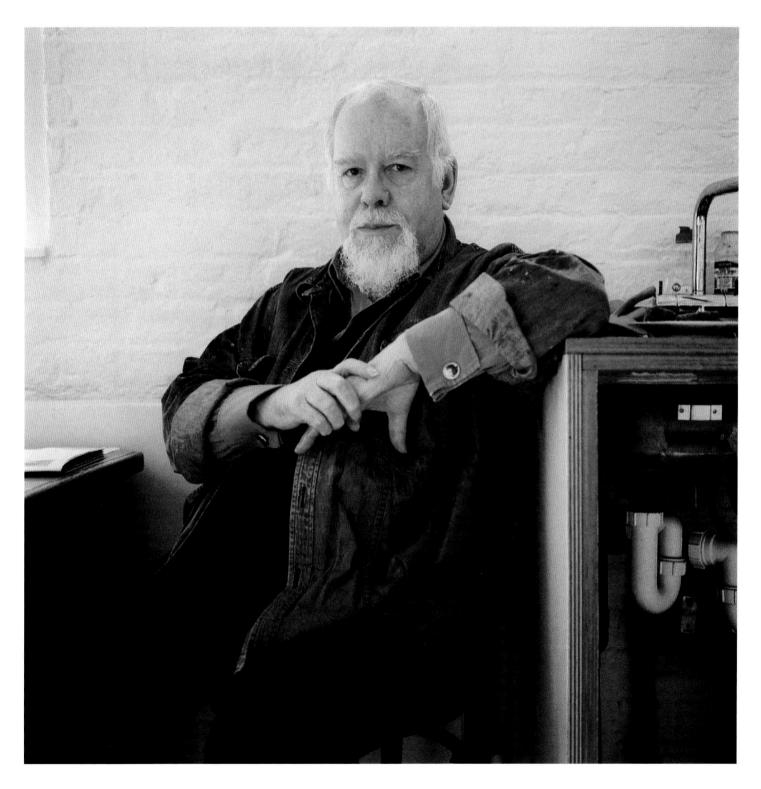

January 2004
PETER BLAKE
photographed by
Paul Wetherell

[left]
November 2003
MATTHEW BARNEY
photographed by
Benjamin Alexander Huseby

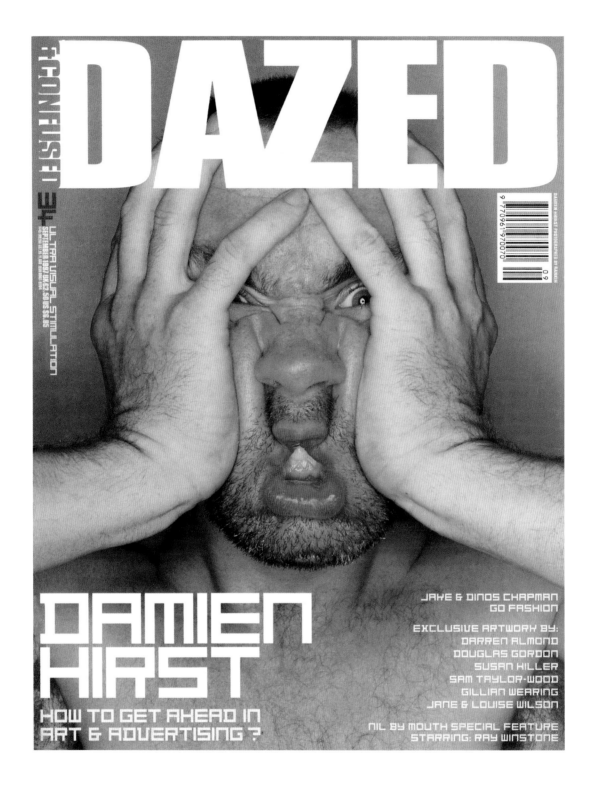

January 2004
THE ILLUSTRATED ISSUE
artwork by Peter Blake

"*The Illustrated Issue* was really exciting to work on. We were super-excited about illustration at the time and we managed to get it into nearly every page – everything was illustrated, even if it was photographic it had a collage element. Obviously, to get Peter Blake to do the cover was a wonderful coup, and he thought it was the funniest thing ever because he was paid less to do it than he was paid to do *Sgt Pepper*'s back in the day. He's been part of the *Dazed* family ever since." EMMA REEVES

CRAZY BANANA
The Fashion Of Nicola Formichetti

Ask Nicola Formichetti how he started working at *Dazed & Confused* and he says, 'Well, it's when Katy and Alister discovered me at the balloon shop!'

The Katy and Alister in question are England and Mackie respectively, and "the balloon shop" was otherwise known as The Pineal Eye — one of the most forward-thinking retail establishments in late-1990s London, selling clothes from luminaries such as Andre Walker and Bernhard Willhelm. Formichetti was its youthful manager — his post when playing truant from architecture school.

It is often joked among them that it was "a party shop selling balloons and deely boppers" that Nicola was plucked from. It wasn't. But it was certainly this endless sense of colour, fun, sex and stupid DIY sophistication that Formichetti brought to the pages of the magazine, very much ushering in a new era. "I had no idea how to be a stylist," he says bluntly, looking back. "I never assisted anyone. I had never even been on a shoot… nothing. They saw me, spoke to me, saw the way I looked… In a way, I think I expressed all of my love for fashion in the way I looked. When you're younger that's the only thing you have really. They trusted me because of the way I put together my haircuts and t-shirts. It's still the way I find my assistants now. Of course, they have to be lovely and kind and intelligent, but we do work in fashion and you don't have to be good-looking, but you do have to be fashionable."

In fact, the working methods of *Dazed & Confused* provided the blueprint for much of Formichetti's working life today: "They took me under their wing and I still go with what they told me, it's my motto — they said, 'Here's what you're doing, just do your best. Don't listen to anybody — do your thing.' And I thought that is just what you do. I never even knew what stylists or editors really did, I was a bit blind to their existence. I just got on with it. I put everything into it day and night —

into working on images or clothes — and I really haven't changed that." From the beginning, there was that mix of audaciousness and iconoclasm in the fashion at the magazine. Although it does often appear that much of this attitude came about through sheer — though blissful — ignorance. And Formichetti was no exception to this rule. "Nobody had had any magazine experience when they started there, so we just had no fear. We didn't know anything and that was absolutely the best way to start something because we were just completely free. We were not aware of anything to hold us back."

"You can't be too aware of or interested in fashion politics — but it is becoming a system now. That is why I felt I had to leave *Dazed* after 10 years. It wasn't because I didn't like it anymore, I just felt like I knew too much. I didn't feel I could give my freshness to them anymore. For example, I knew how to do a cover, so it became very repetitive. I thought I was not being true to my own rules if I carried on. I wanted *Dazed* to be about a young generation — not scared, always an outsider; always a punk."

Yet before that happened, and at a time when the fashion industry was becoming more rigidly structured than ever, the magazine had elevated Formichetti to the role of creative director precisely to maintain that spirit. And it was his first issue in this new position that set those ground rules, featuring then new model Luke Worrall on the split cover.

"That was Luke's first cover and that was my first cover as the creative director of the whole magazine," he says. "I had worked with Jefferson since day one and he had been very supportive and a great leader. He decided I was ready to take over the magazine as the creative director as he was becoming editorial director. My first decision was to make the whole issue black-and-white, in that punk spirit — I wanted it to feel like a fanzine we just did with friends, no rules."

Casting was always crucial for the stylist. It was as much about who was in the picture as what

they were wearing. And with the growing influence of the digital realm on Formichetti, the net was — quite literally — cast wider for new talent. "We found these amazing boys like Luke who was a BMX-er. I was the first person to ever shoot him — he was still an electrician at that point. An electrician BMX-er," he explains. "It was Emma Reeves [then photographic director of *Dazed & Confused*] who told me about Louis Simonon (opposite).

I showed him to Hedi Slimane and he said we should do something on British youth — we ended up doing a whole issue with Hedi shooting it. I was one of the first people to use casting from MySpace and Facebook. *Dazed* allowed for that. We didn't have to go through all the regular model agencies in the way conventional magazines do."

In the tradition of the publication, Formichetti had become adept at talent-spotting in many different fields. From his early work with designers Gareth Pugh — to whom he gave his first magazine cover — and Romain Kremer, to his long-standing relationships with photographers Magnus Unnar and Mariano Vivanco. And at the nascent stage of her career, before ever meeting her, he talked about Lady Gaga with evangelical zeal. "At *Dazed* it was always more about finding people in your own generation to work with — to emulate your heroes while doing something different from them. It was about creating something from scratch. It is like the first ever thing I did for the magazine — my first *Eye Spy* section. I just took Polaroids of my friend Simon Low. Around that time nobody was doing that sketchbook thing, with that made-on-the-spot quality — that would never have happened in any other magazine."

Perhaps more than any of the other main fashion people at *Dazed & Confused*, it is Nicola Formichetti who truly grew up within its pages. "I was an *Eye Spy* boy, menswear editor, fashion director and creative director. I really grew up in there and you could see it. For me, 10 years of *Dazed* was the best training ground I could ever possibly think of for anything I would possibly want to do. Now, I can go into any situation, any

major fashion shoot with a big photographer or a big client, and I'm fine. I can do it because I would be told at *Dazed*: 'Tomorrow you have to do a cover shoot and there is no budget.' But you would just do it and you would find a way. It actually made things more creative. It made me believe anything is possible."

Above all, as he learnt from the very beginning with that fateful meeting in the "balloon shop", it is the spirit of collaboration, that Nicola Formichetti holds dear in his current career. "I don't come up with anything independently. I do not stand still — I don't sit alone in silence and come up with these things, it's impossible. I need to talk and exchange ideas. It is always about collaboration, that is what is so important for me. For me, it is the only way of being creative and I learnt that at *Dazed*."

JO-ANN FURNISS

[right]
January 2009
BRITISH YOUTH
photography by Hedi Slimane
styling by Nicola Formichetti

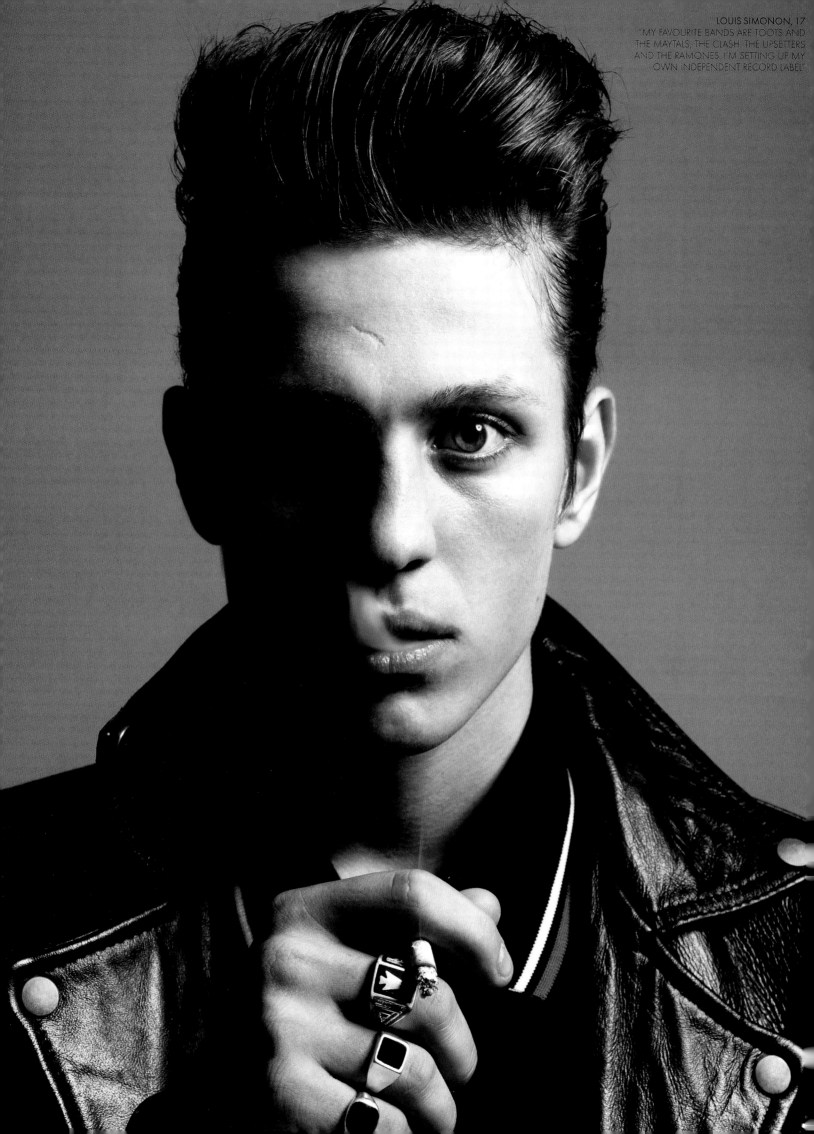

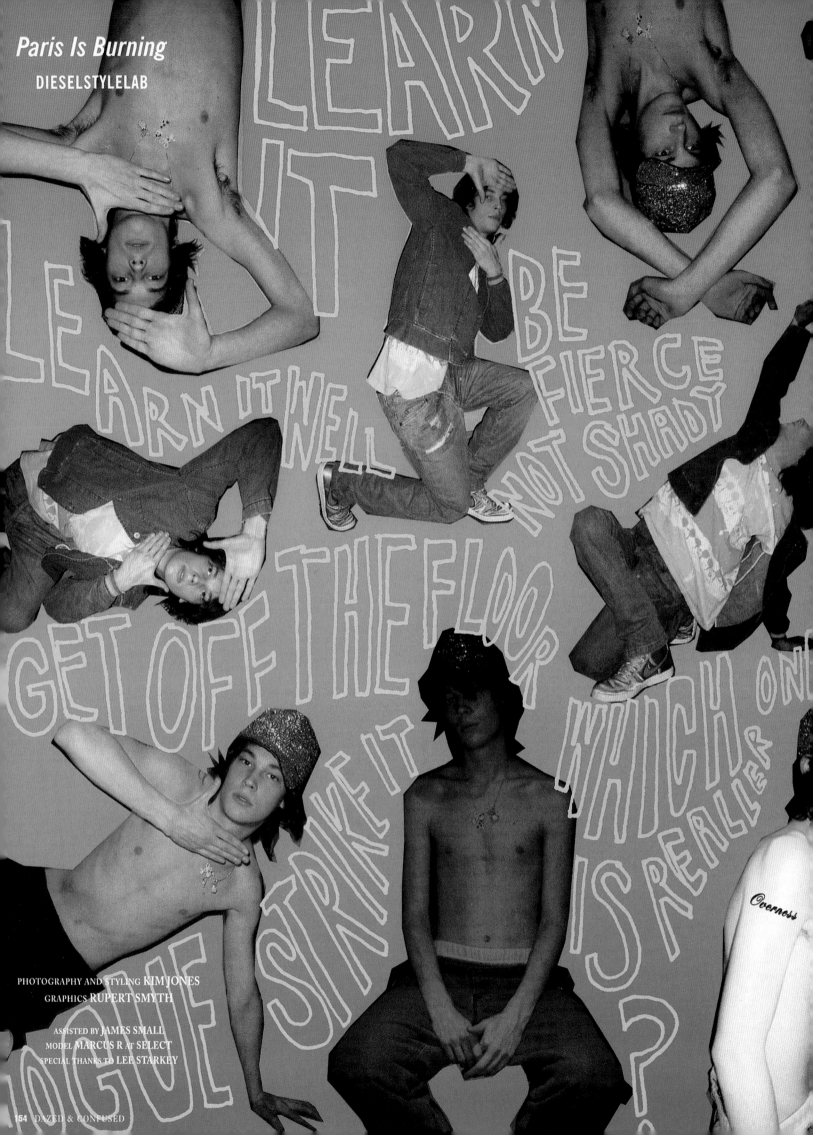

Paris Is Burning
DIESELSTYLELAB

PHOTOGRAPHY AND STYLING KIM JONES
GRAPHICS RUPERT SMYTH

ASSISTED BY JAMES SMALL
MODEL MARCUS R AT SELECT
SPECIAL THANKS TO LEE STARKEY

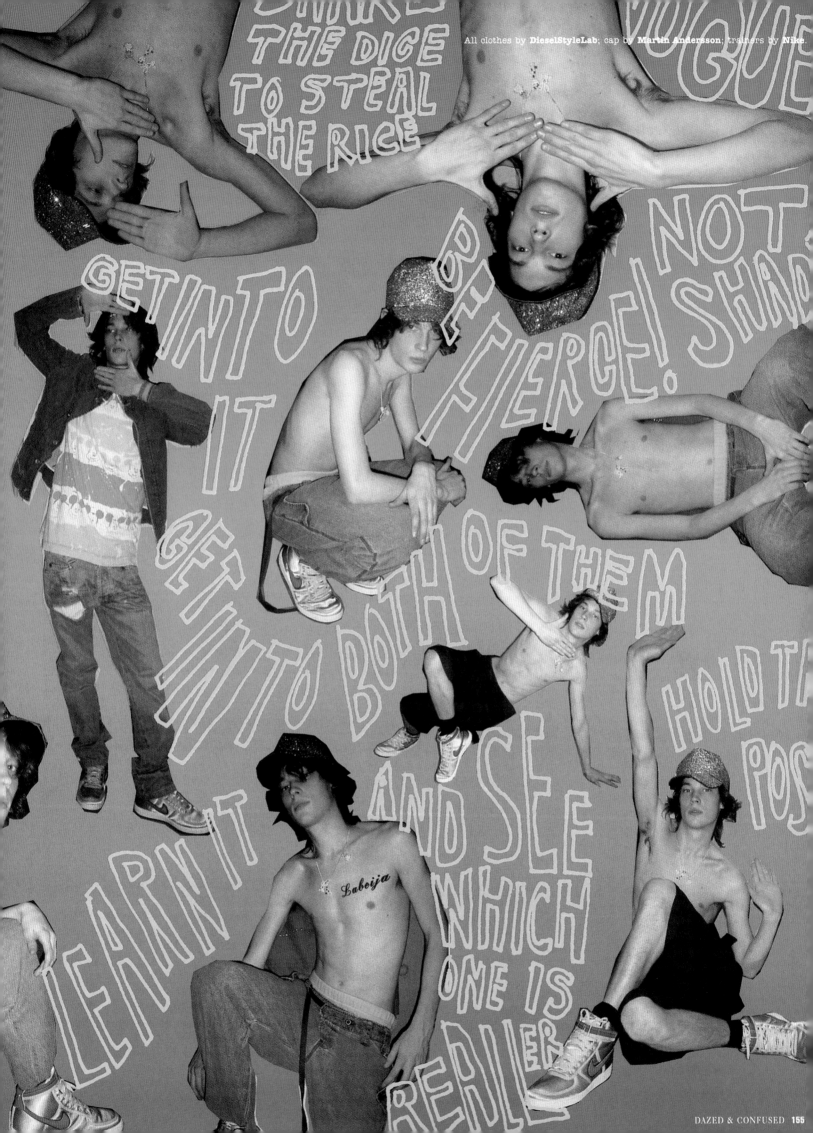

All clothes by **DieselStyleLab**; cap by **Martin Andersson**; trainers by **Nike**

INTERNATIONAL
neighbourhood

PHOTOGRAPHY WILLIAM SELDEN STYLING NICOLA FORMICHETTI

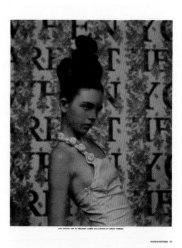
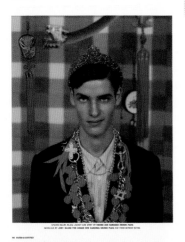
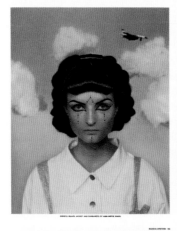

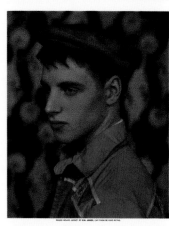
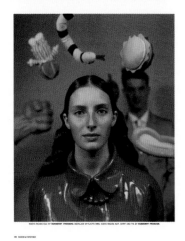
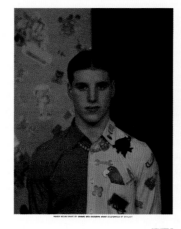
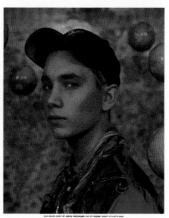
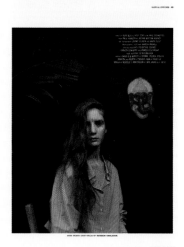

[previous spread]
March 2003
PARIS IS BURNING
photography and styling by
Kim Jones
graphics by Rupert Smyth

[this page]
March 2005
INTERNATIONAL
NEIGHBOURHOOD
photography by William Selden
styling by Nicola Formichetti

[right]
April 2006
LA GRANDE PARADE
photography by William Selden
styling by Nicola Formichetti

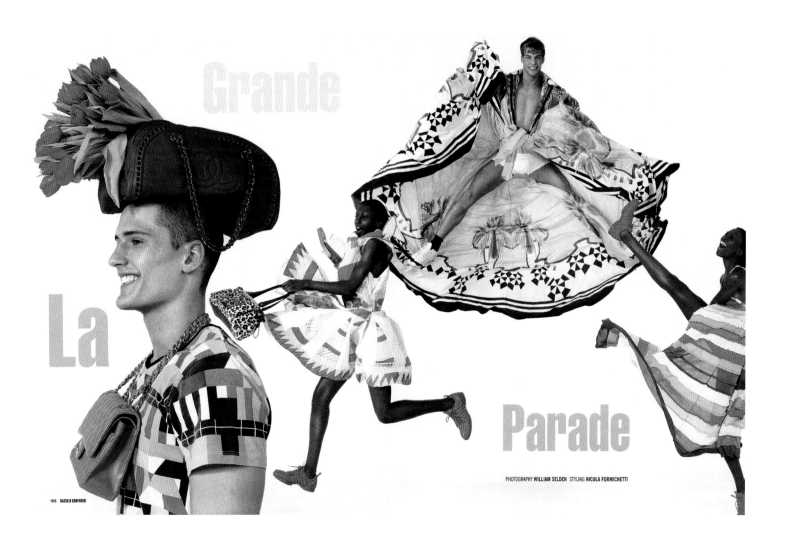

Grande

La

Parade

PHOTOGRAPHY WILLIAM SELDEN STYLING NICOLA FORMICHETTI

166 DAZED & CONFUSED

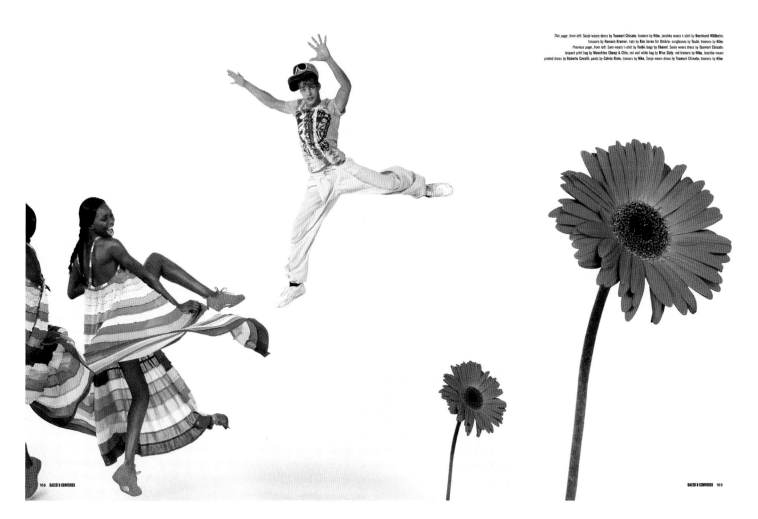

This page, from left: Sonja wears dress by Tsumori Chisato; trainers by Nike. Joschka wears t-shirt by Bernhard Willhelm; trousers by Romain Kremer; hats by Kim Jones for Umbro; sunglasses by Tsubi; trainers by Nike. Previous page, from left: Sam wears t-shirt by Tsubi; bags by Chanel. Sonia wears dress by Tsumori Chisato; leopard print bag by Moschino Cheap & Chic; red and white bag by Miss Sixty; red trainers by Nike. Joschka wears printed dress by Roberto Cavalli; pants by Calvin Klein; trainers by Nike. Sonja wears dress by Tsumori Chisato; trainers by Nike.

168 DAZED & CONFUSED

DAZED & CONFUSED 169

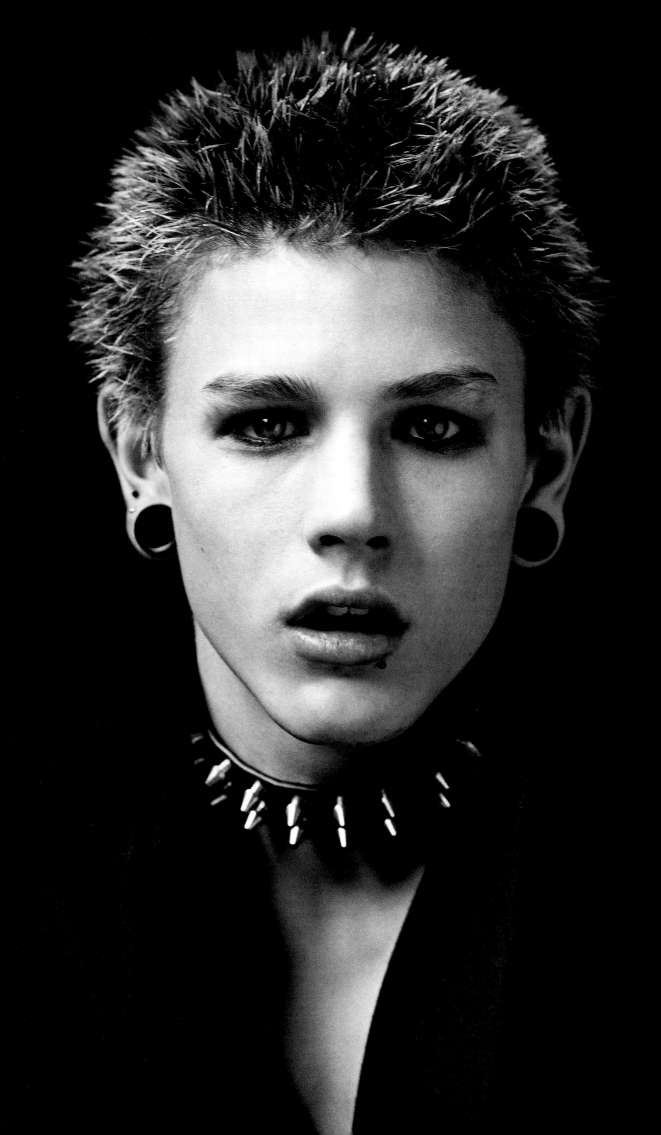

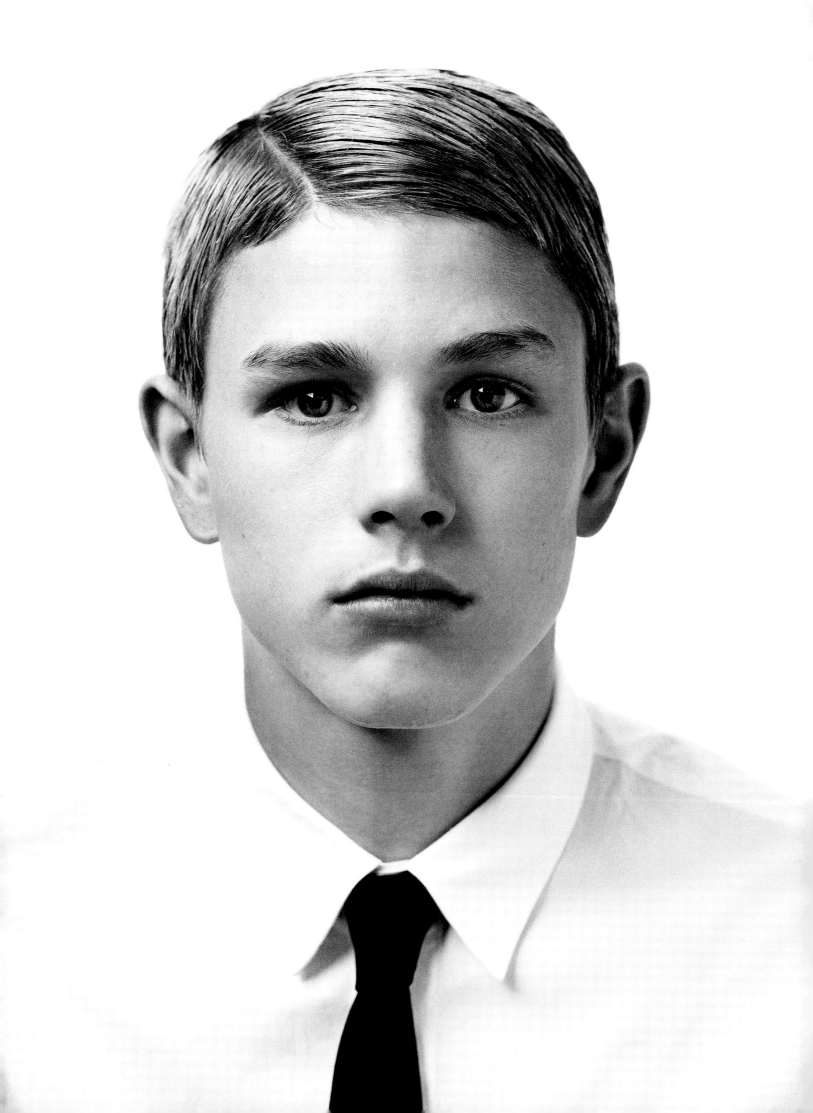

[previous spread]
August 2007
ON THE COVER
photography by Mariano Vivanco
styling by Nicola Formichetti

[below]
August 2007
photography by
Benjamin Alexander Huseby
styling by Nicola Formichetti

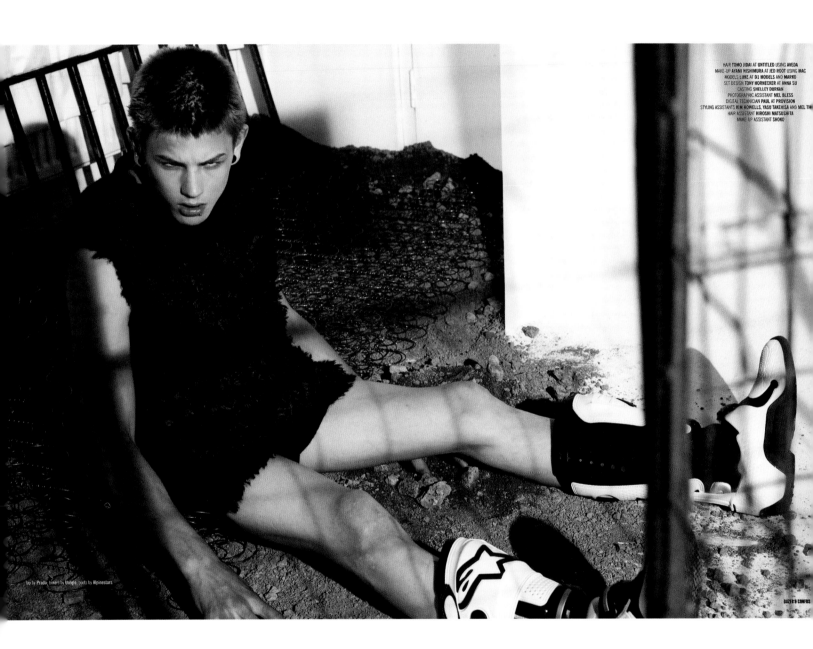

HAIR **TOMO JIDAI** AT **UNTITLED** USING **AVEDA**
MAKE-UP **AYAMI NISHIMURA** AT **JED ROOT** USING **MAC**
MODELS **LUKE** AT **D1 MODELS** AND **MARKO**
SET DESIGN **TONY HORNECKER** AT **ANNA SU**
CASTING **SHELLEY DURKAN**
PHOTOGRAPHIC ASSISTANT **MEL BLESS**
DIGITAL TECHNICIAN **PAUL** AT **PROVISION**
STYLING ASSISTANTS **KIM HOWELLS, YASU TAKEHISA** AND **MEL TH**
HAIR ASSISTANT **HIROSHI MATSUSHITA**
MAKE-UP ASSISTANT **SHOKO**

top by Prada, boxers by Uniqlo, boots by Alpinestars

DAZED & CONFUS

April 2008
LUKE DAY AS MADONNA
photography by
Alasdair McLellan
styling by Katy England

[following spread]
November 2007
SEXY
photography by Matt Irwin
styling by Nicola Formichetti

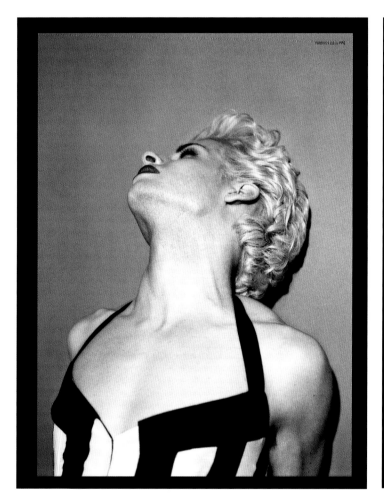
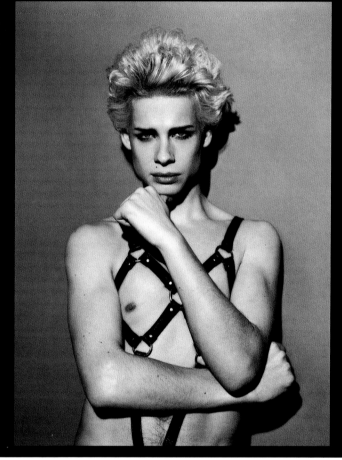

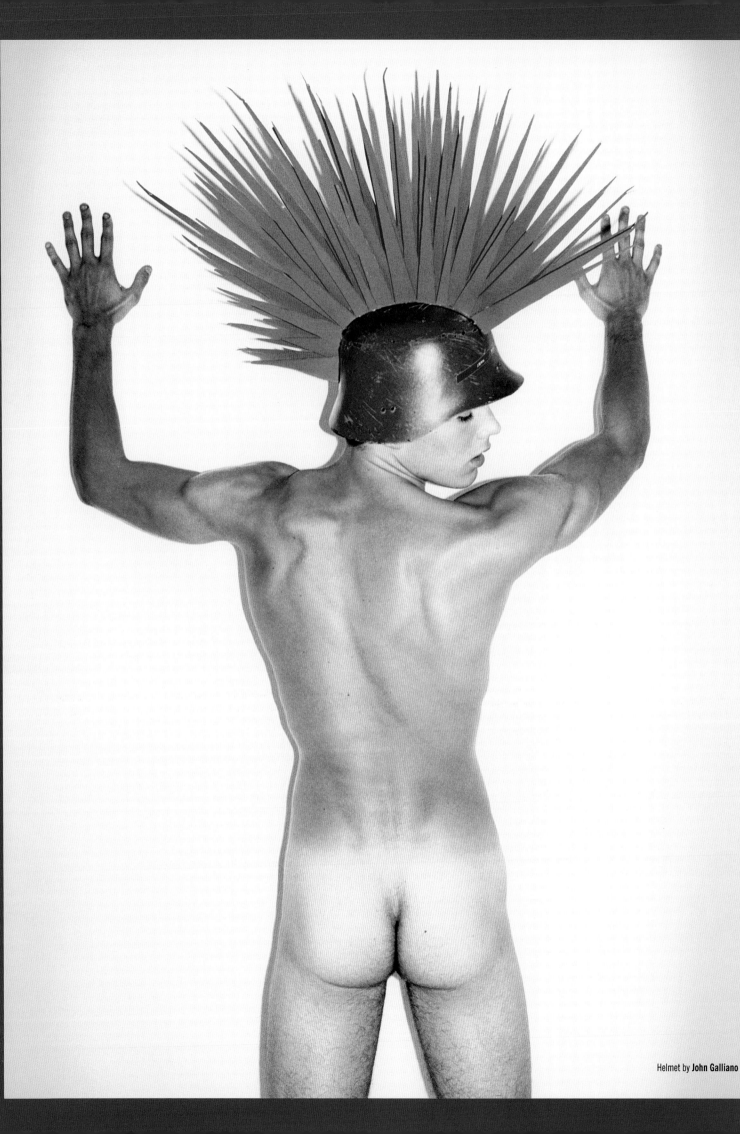

Helmet by **John Galliano**

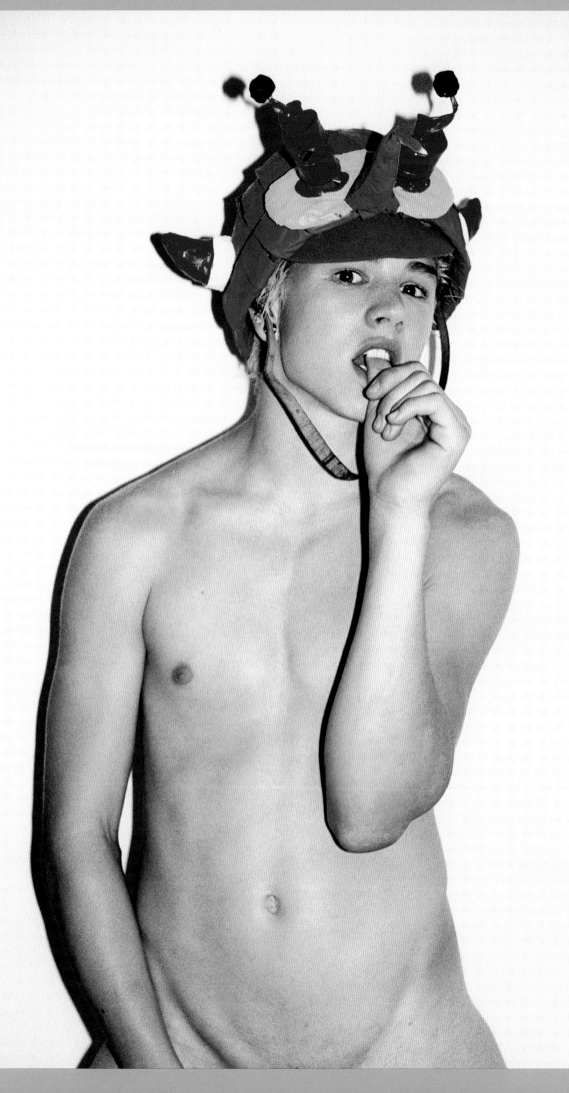

Headpiece by **Gary Card**

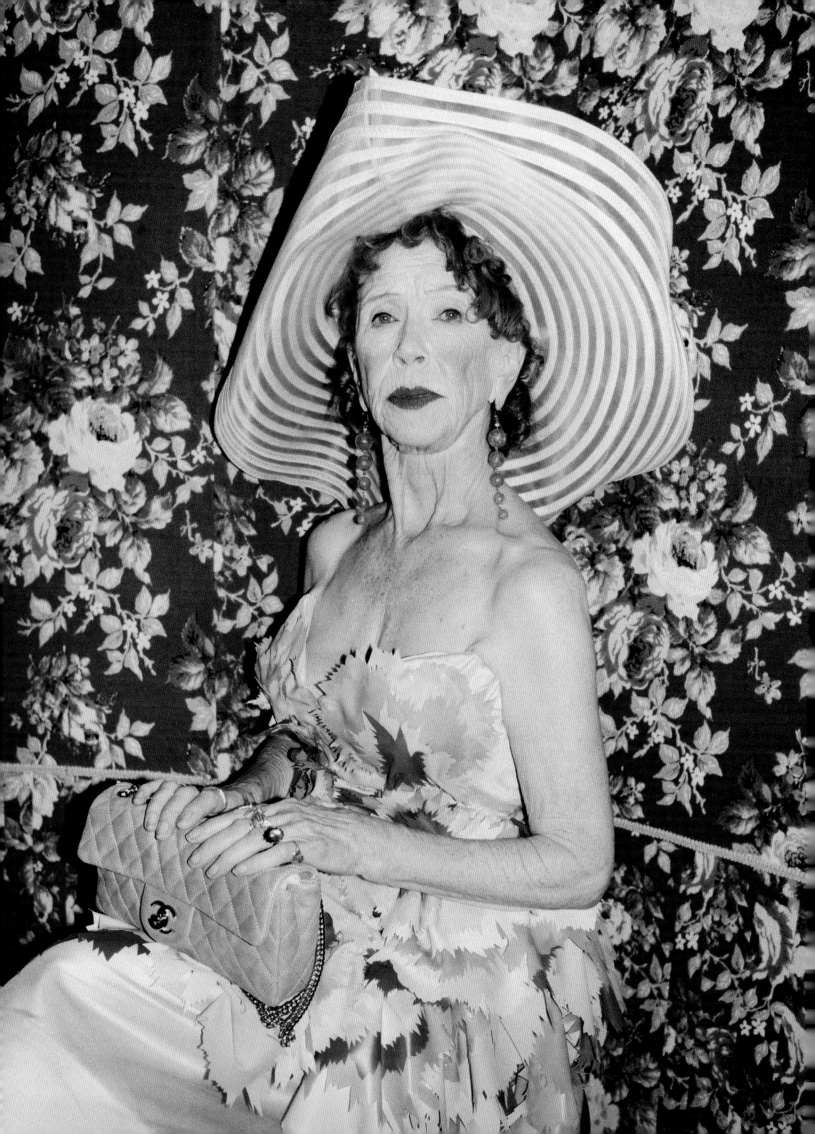

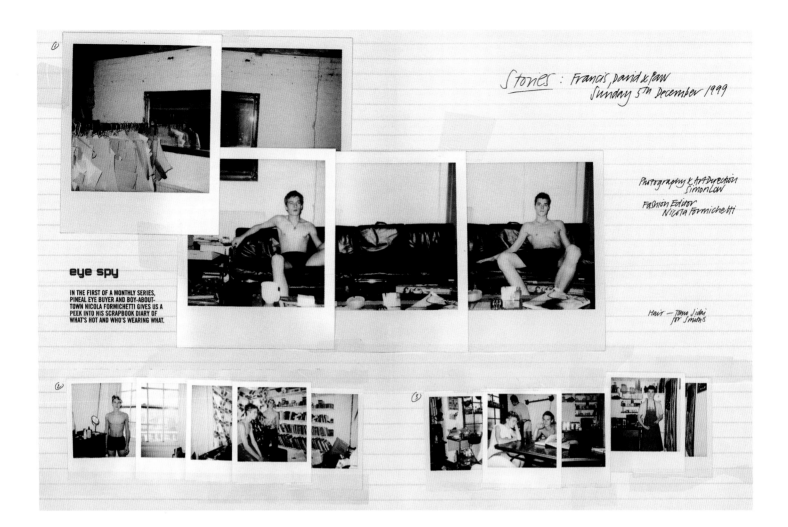

eye spy

IN THE FIRST OF A MONTHLY SERIES, PINEAL EYE BUYER AND BOY-ABOUT-TOWN NICOLA FORMICHETTI GIVES US A PEEK INTO HIS SCRAPBOOK DIARY OF WHAT'S HOT AND WHO'S WEARING WHAT.

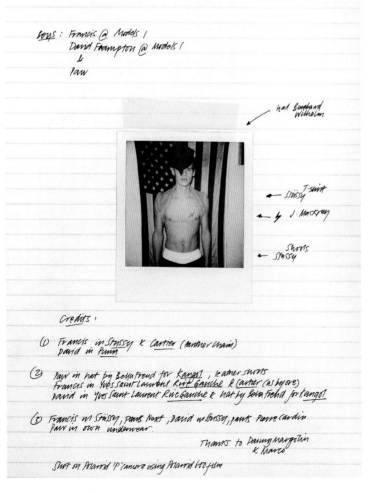

[previous spread left]
May 2009
O
photography by
Horst Diekgerdes
styling by Bryan McMahon

[previous spread right]
January 2008
PINK LADIES
photography by Matt Irwin
styling by Nicola Formichetti

[this page]
February 2000
EYE SPY
story by Nicola Formichetti
photography and art direction
by Simon Low

[right]
April 2004
GARETH PUGH - COVER
photography by Laurie Bartley
styling by Nicola Formichetti

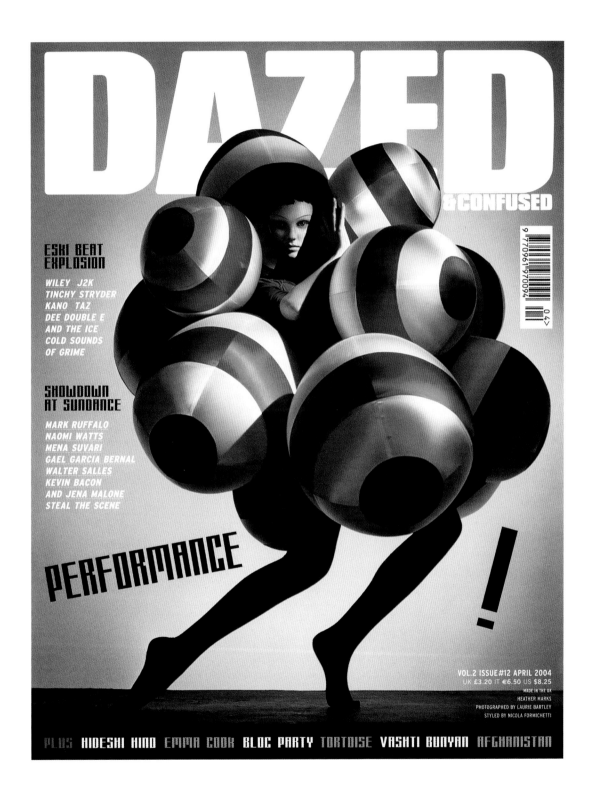

February 2008
LONDON'S YOUTH
photography by Sølve Sundsbø
styling by Nicola Formichetti

Scottee Scottee
wears dress by **John Galliano**

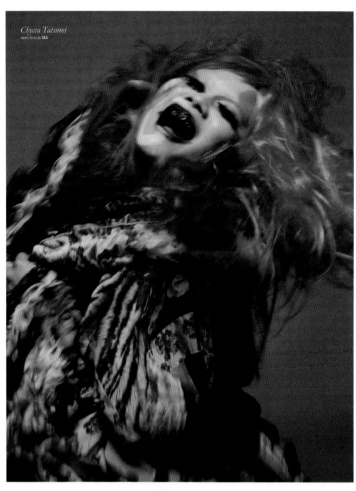

Chycca Tatsumi
wears dress by **D&G**

110 **DAZED & CONFUSED**

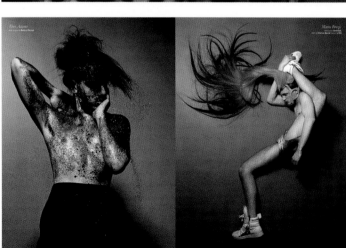

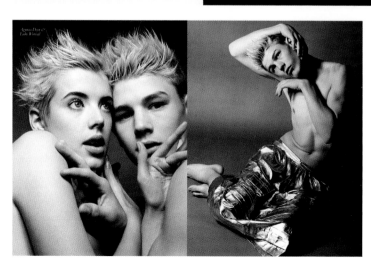

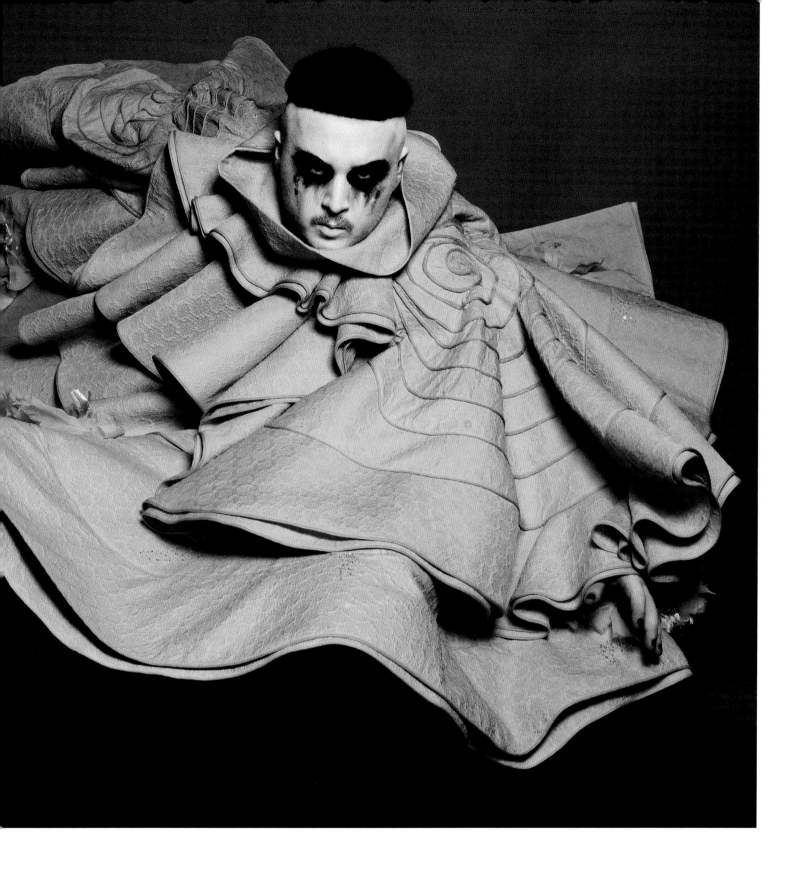

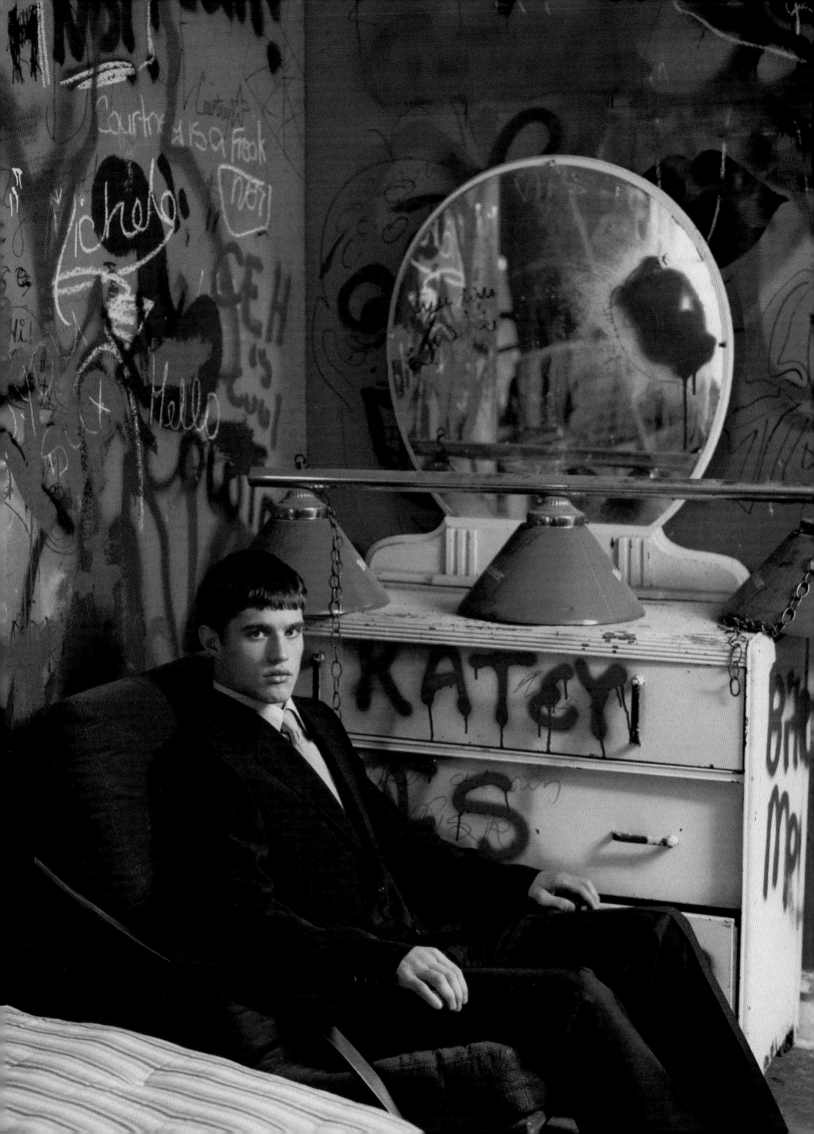

[left]
February 2005
BULLY BOYS
photography by Luke Smalley
styling by Nicola Formichetti

[below]
December 2008
JOSH & ASH
photography by Brett Lloyd
styling by Nicola Formichetti

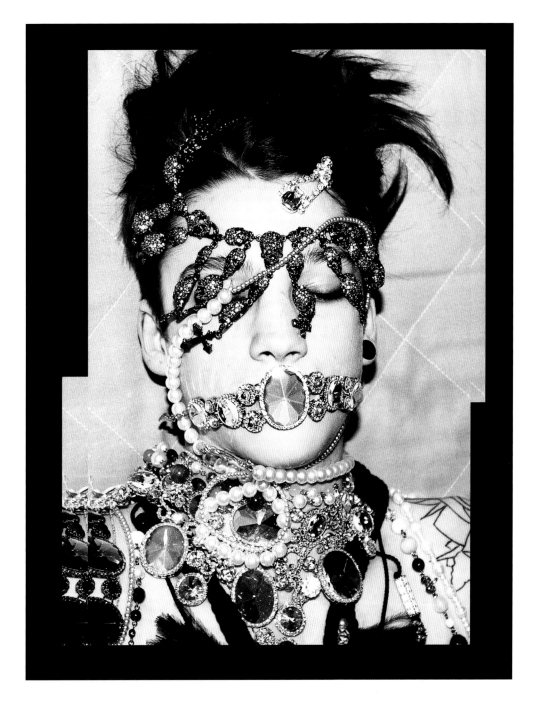

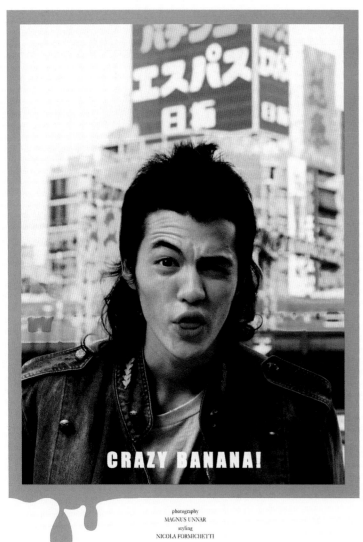

CRAZY BANANA!

photography
MAGNUS UNNAR
styling
NICOLA FORMICHETTI

Jun wears military denim jacket by **Energie**; t-shirt by **Kim Jones**

November 2002
CRAZY BANANA
photography by
Magnus Unnar
styling by Nicola Formichetti

CRAZY BANANA PART 2

PHOTOGRAPHY MAGNUS UNNAR
STYLING NICOLA FORMICHETTI

NAOMI WEARS HOODED WOOL TOP BY **STUSSY**; DENIM SHORTS BY **NEXUS 7**; BLACK AIR FORCE 1 TRAINERS BY **NIKE**.

TOP IMAGE: CAROLINA WEARS HELLO KITTY TOP STYLIST'S OWN. BOTTOM IMAGE FROM LEFT: CAROLINA WEARS MONKEY TOP STYLIST'S OWN; PRINTED SHORTS BY **MARJAN PEJOSKI**; WILLIAM WEARS BLUE TOP AND STRIPED SHORTS BY **KIM JONES**, NAOMI WEARS FROG TOP STYLIST'S OWN; PRINTED JACKET AND SHORTS BY **KTZ**.

November 2004
CRAZY BANANA PART 2
photography by
Magnus Unnar
styling by Nicola Formichetti

January 2009
BRITISH YOUTH
*photography by
Hedi Slimane
styling by
Nicola Formichetti*

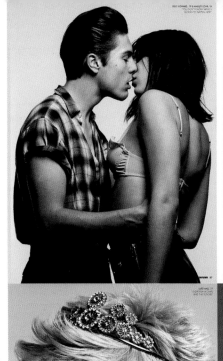

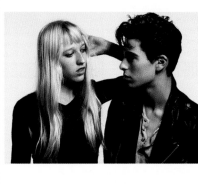

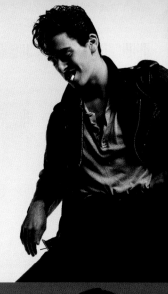

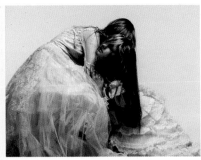

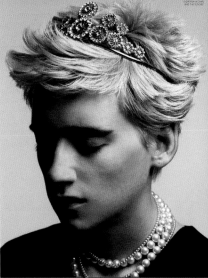

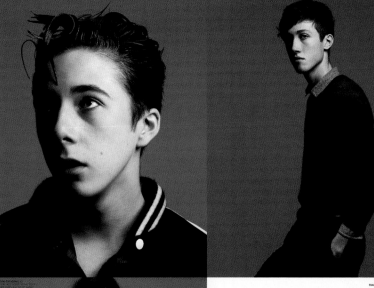

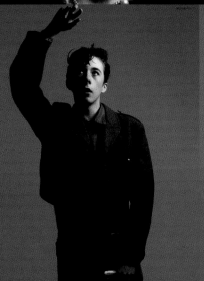

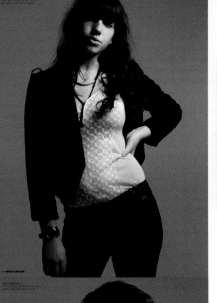

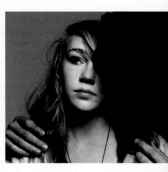

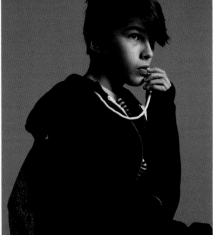

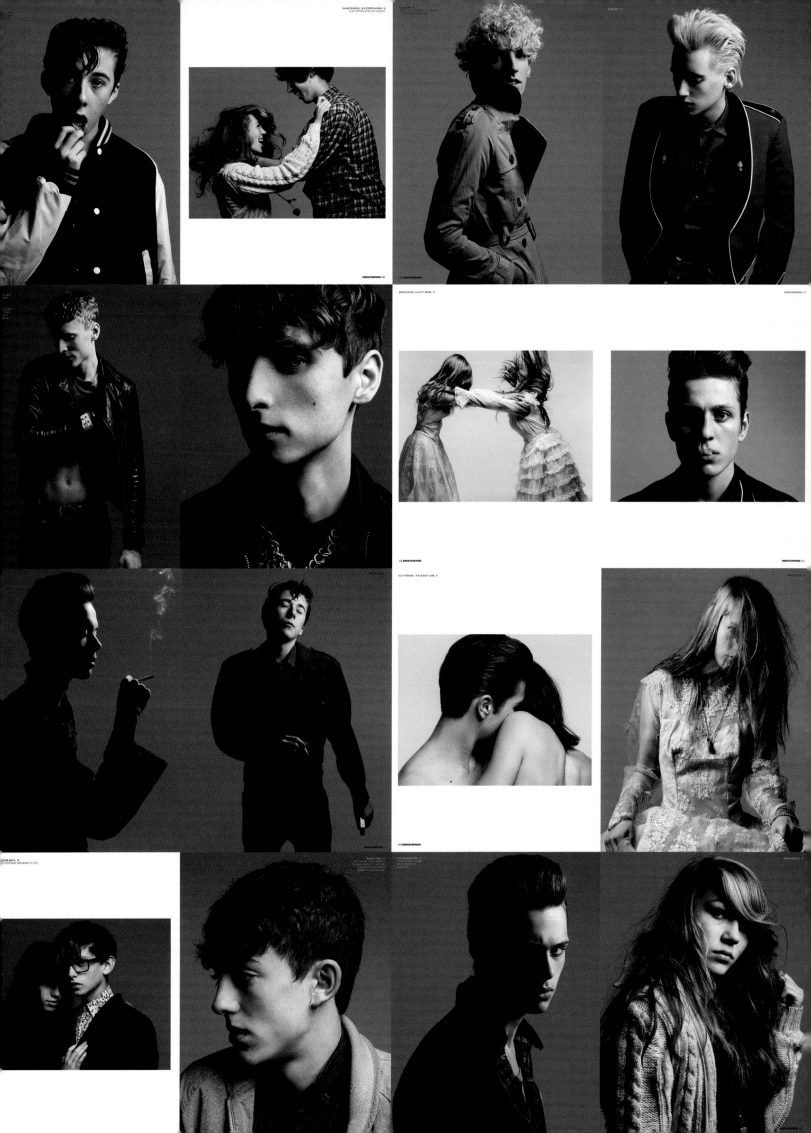

PORTRAITS
The Second Decade

"*Dazed & Confused* is a lightning rod force that has helped define every major cultural and political shift of the past two decades from an 'insider' outsider's perspective. They manage to play the game while constantly rearranging the field of play and changing the rules… all with humour, grace, attitude and style. The impact of the magazine is palpable and its contribution genuinely profound."

MICHAEL STIPE

[right]
September 2000
MARILYN MANSON
photography by Mr Perou

[following spread left]
February 2004
MICHAEL PITT
photography by Sandra Freij

[following spread right]
April 2005
EVA GREEN
photography by Cedric Buchet

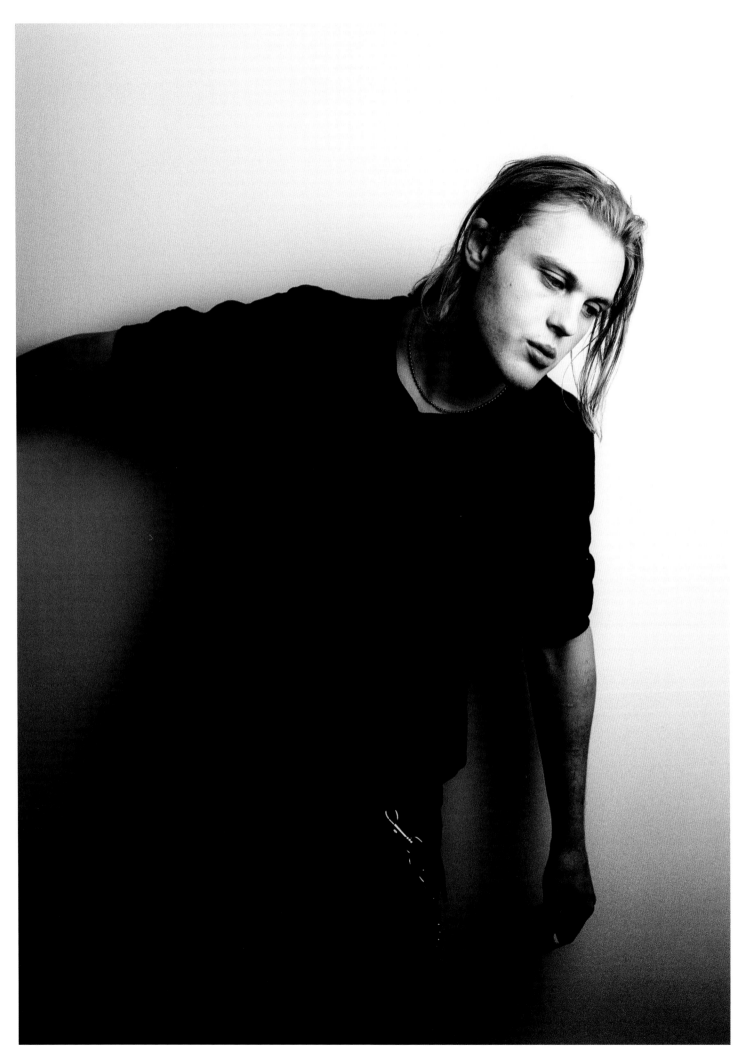

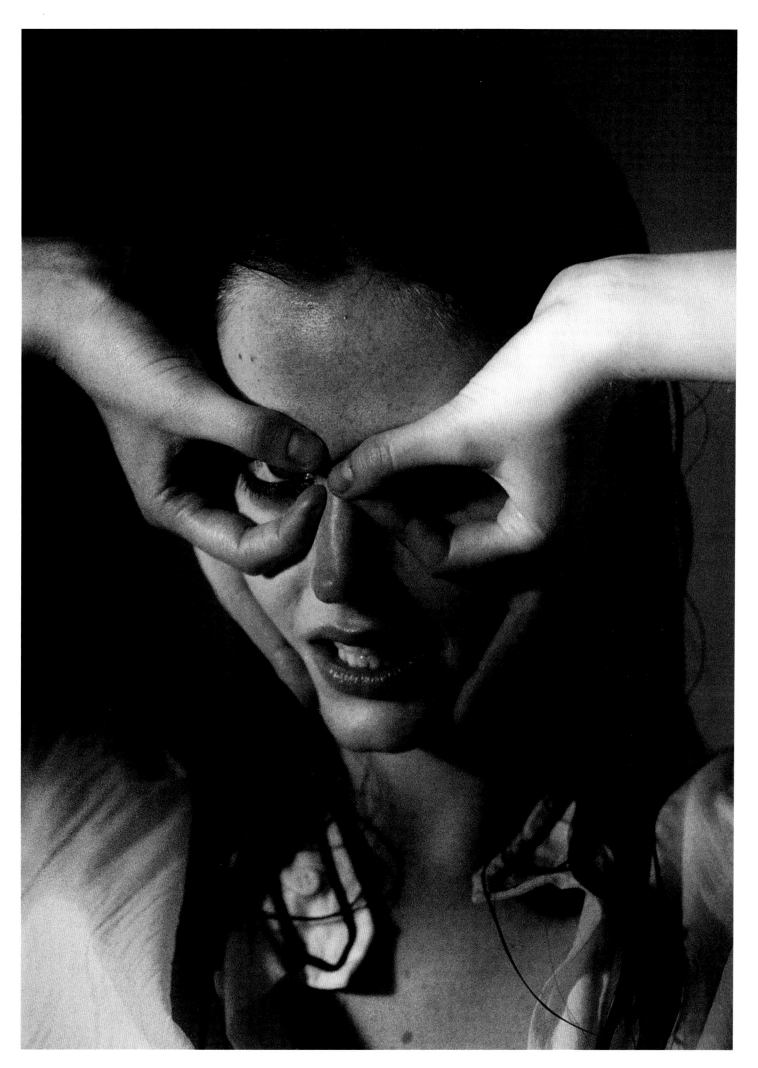

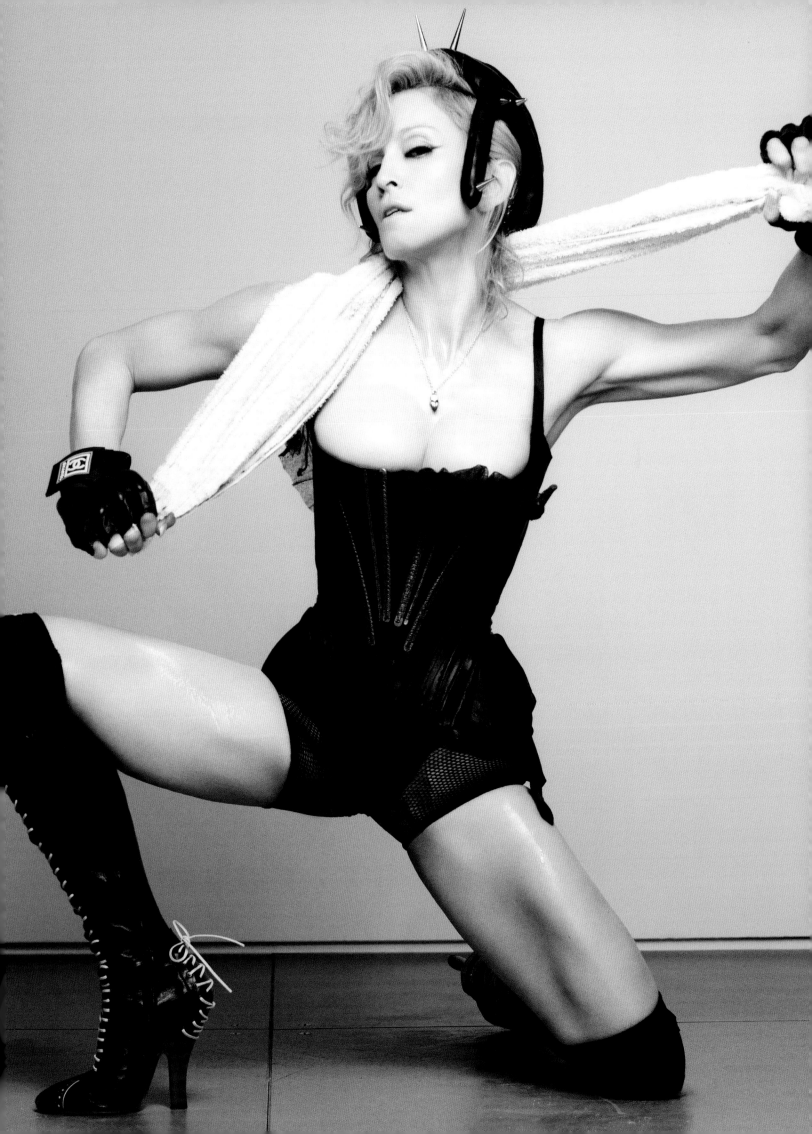

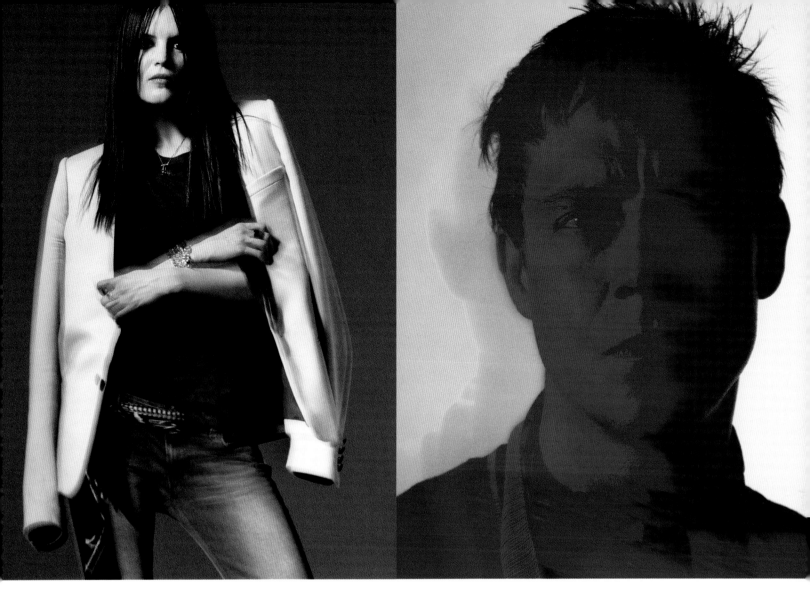

[above]
February 2005
THE KILLS
OUR TIME IS NOW
photography by Laurence Passera

[left]
April 2008
MADONNA
photography by Steven Klein

The Madonna issue explored the
profound influence of Madonna
on fashion and culture, featuring
a 70-page portfolio in which the
world's most influential designers
talked about her legacy. This
devotion of an entire issue to
an icon was a new move for the
magazine editorially, and would
be explored again in later issues.

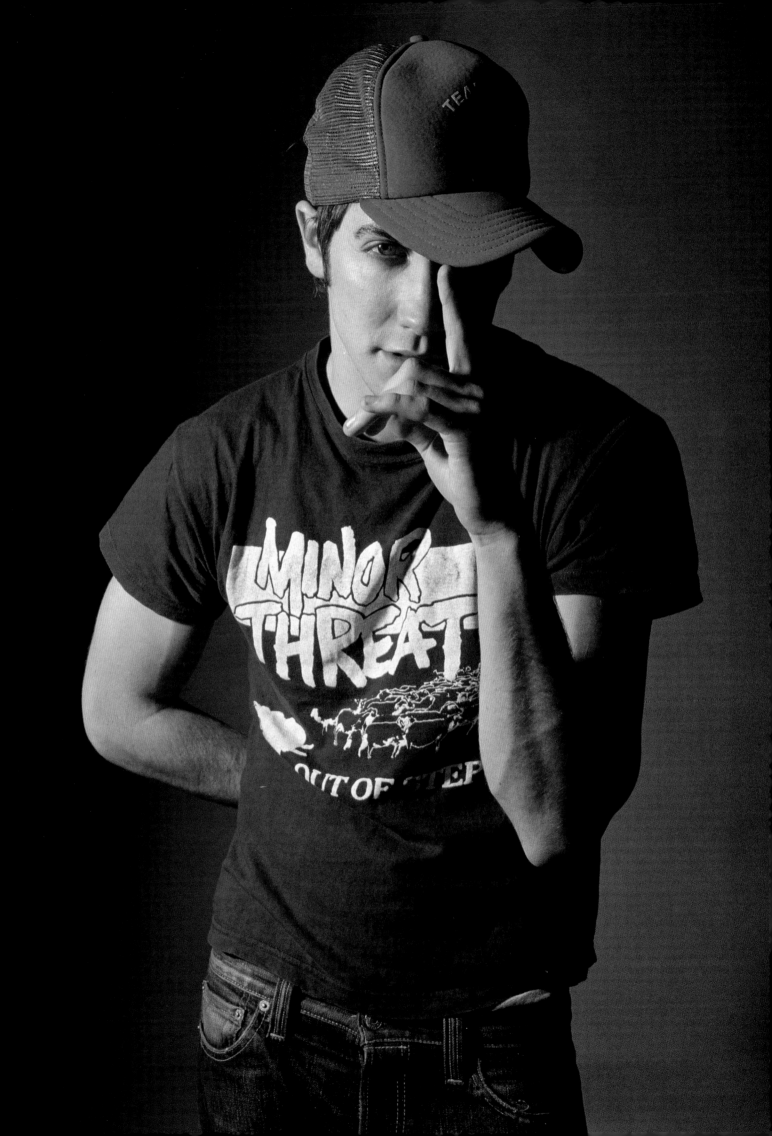

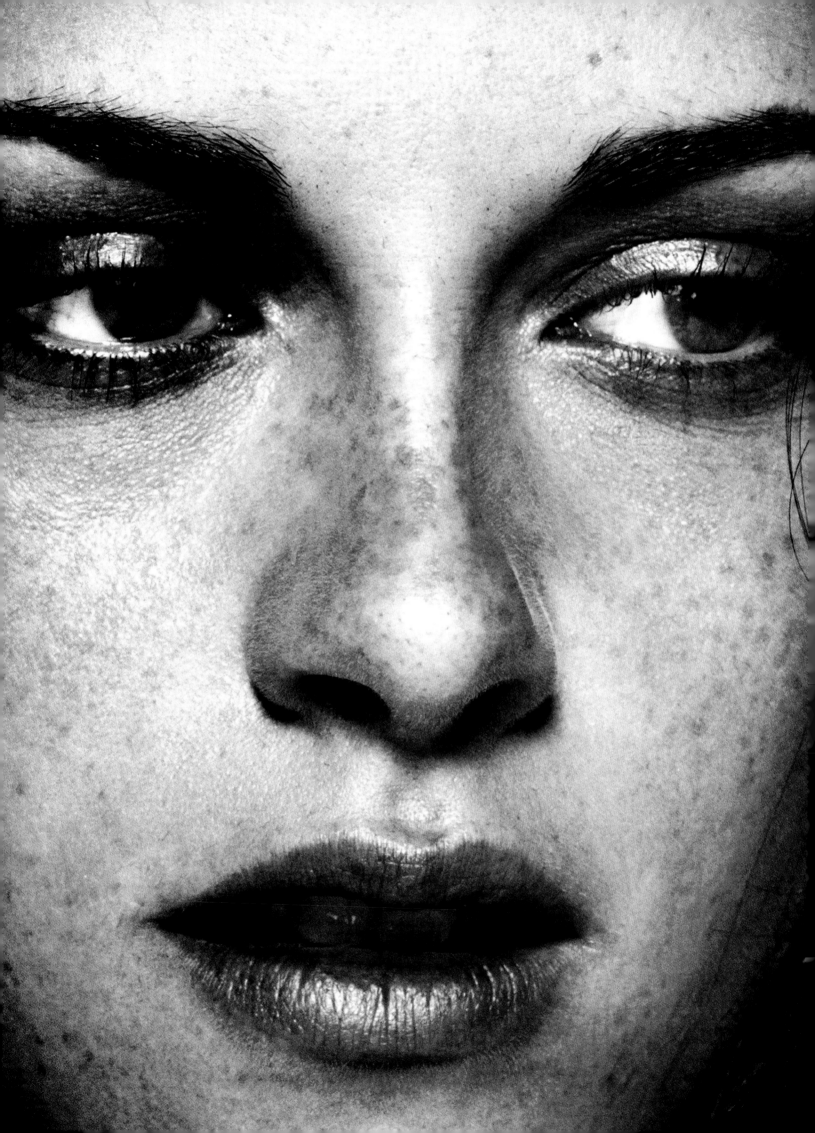

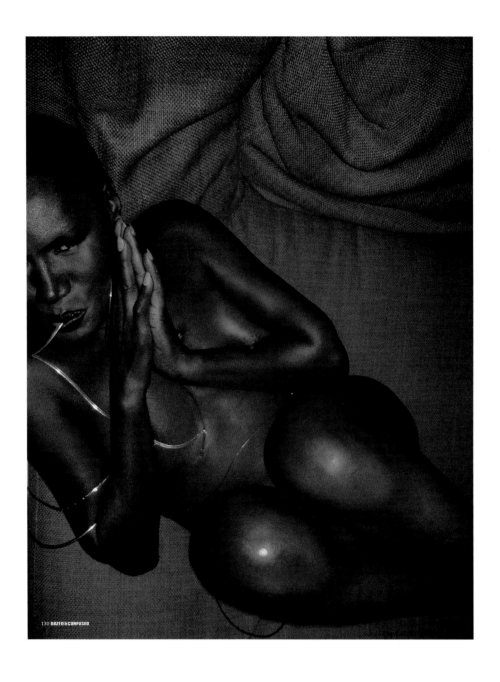

130 DAZED&CONFUSED

**November 2008
GRACE JONES
THE DEVIL IN MISS JONES**
*photography by
Chris Cunningham*

The Grace Jones and Chris Cunningham project was a major undertaking involving digital artist Cunningham manipulating his images of the 1980s icon in order to create unsettling exaggerations of the human form.

"When I made the images for my film *Rubber Johnny*, I wanted to make some Nubian versions to accompany them. That was the starting point for the shoot. But, when you start shooting Grace, her image is so strong that you

don't need to go too nuts with the tricks. For me, she has the strongest iconography of any artist in music. I went around her house, she got naked and she had complete trust in me to let me do what I wanted." CHRIS CUNNINGHAM

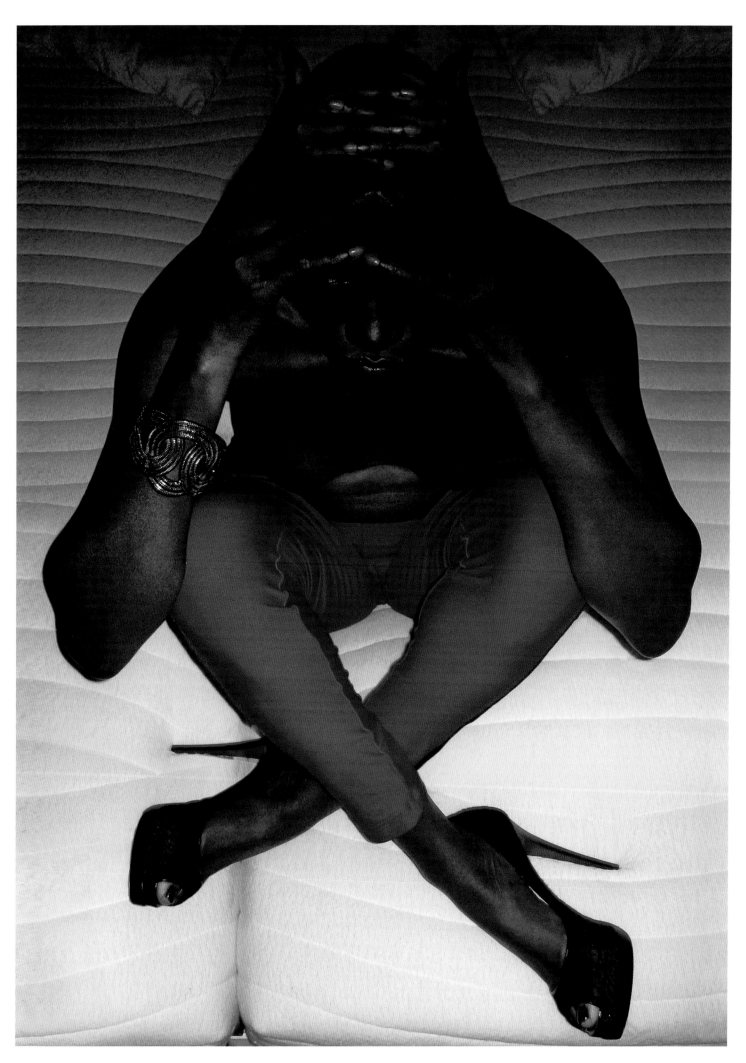

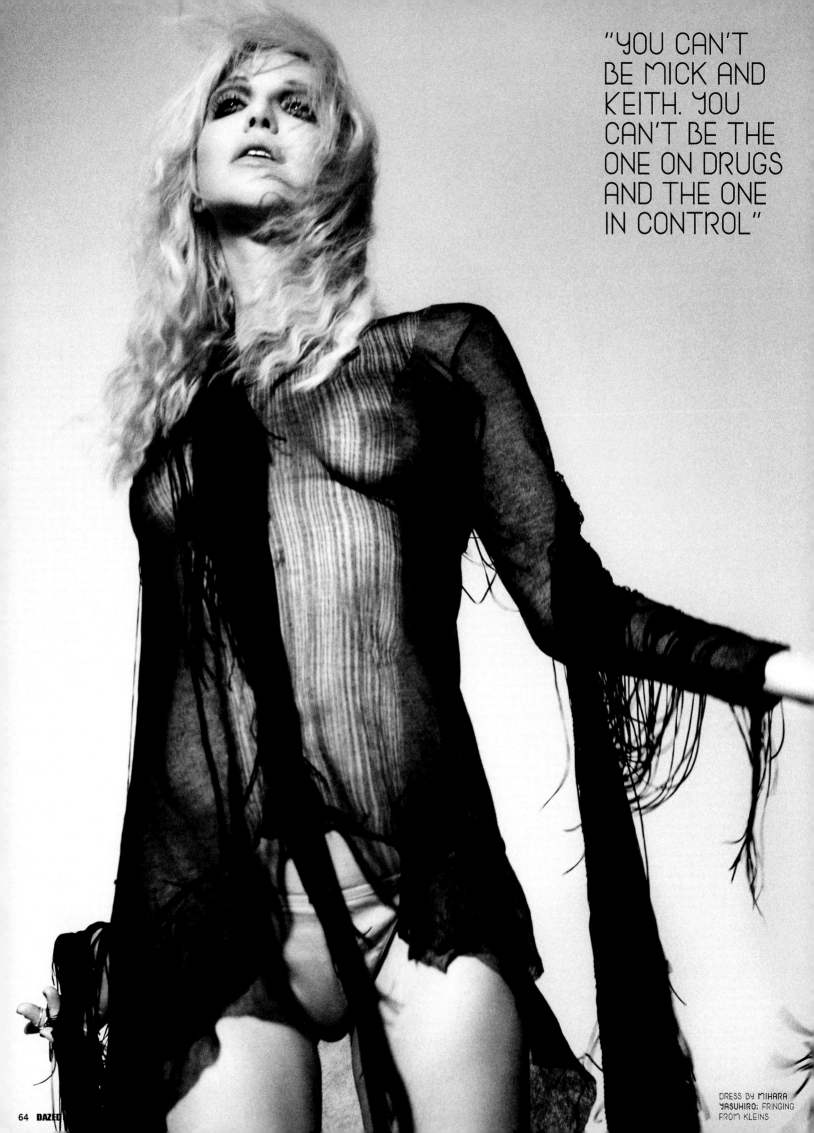

"YOU CAN'T BE MICK AND KEITH. YOU CAN'T BE THE ONE ON DRUGS AND THE ONE IN CONTROL"

DRESS BY MIHARA YASUHIRO; FRINGING FROM KLEINS

[left]
January 2010
COURTNEY LOVE
photography by Yelena Yemchuk

[below]
March 2010
MIA WASIKOWSKA
photography by Laurence Passera

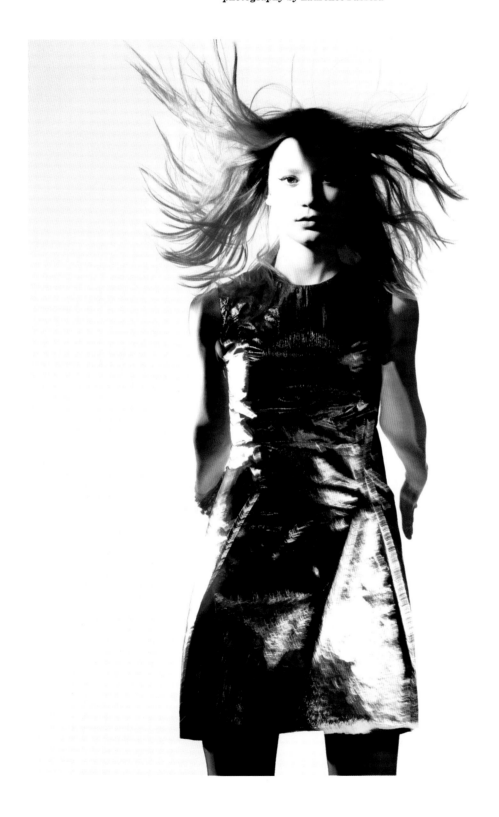

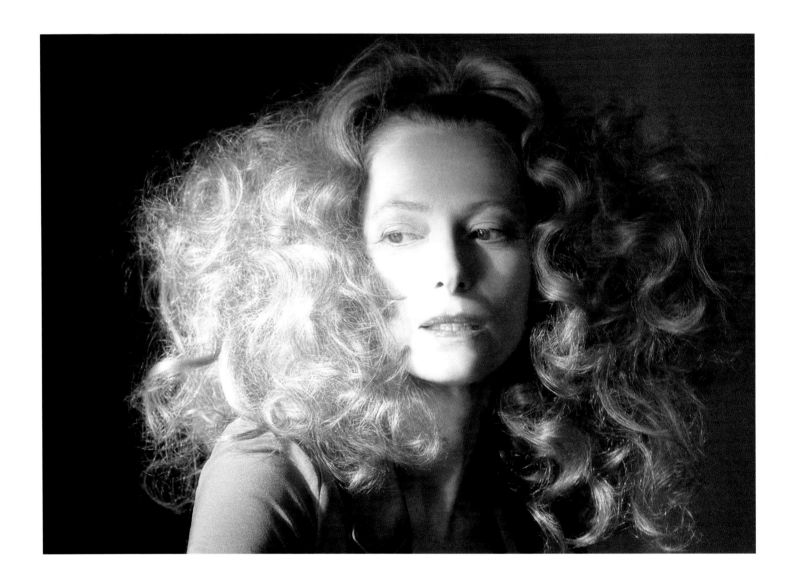

May 2010
TILDA SWINTON
DRAMA QUEEN
photography by
Glen Luchford

"I met Tilda in Paris at the legendary beat 'L'hotel' on the left bank – favourite hangout of bohemians from Oscar Wilde to Salvador Dali; stepping inside you could be back in *fin de siècle* Paris. It felt like an appropriately exotic setting for someone as extraordinary as Tilda Swinton. There was none of the obligatory entourage that comes with an Oscar-winning actress though – she arrived alone, ordered us both a pot of Earl Grey and switched her phone off; the interview only ended when we realised I was about to miss the Eurostar home. It was clear speaking to her that a defining relationship in her life was her creative connection with Derek Jarman – she carries that torch and it still informs her amazing spirit of collaboration today, which mirrors what we have always tried to do in *Dazed*. She's this lightning rod for the most interesting, creative, passionate people. They orbit around her because she's completely unafraid to jump into the unknown."
HANNAH LACK

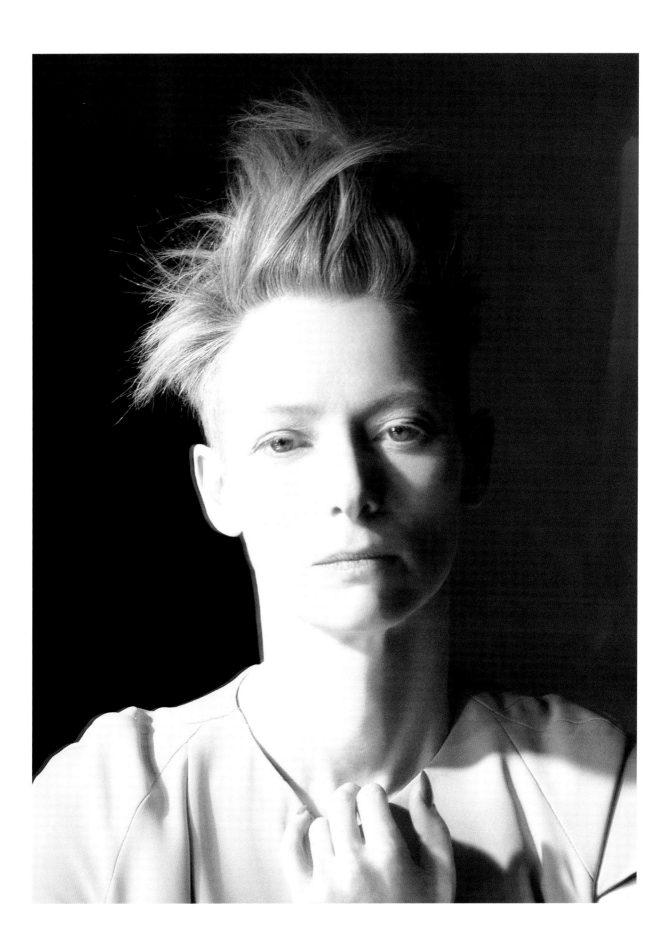

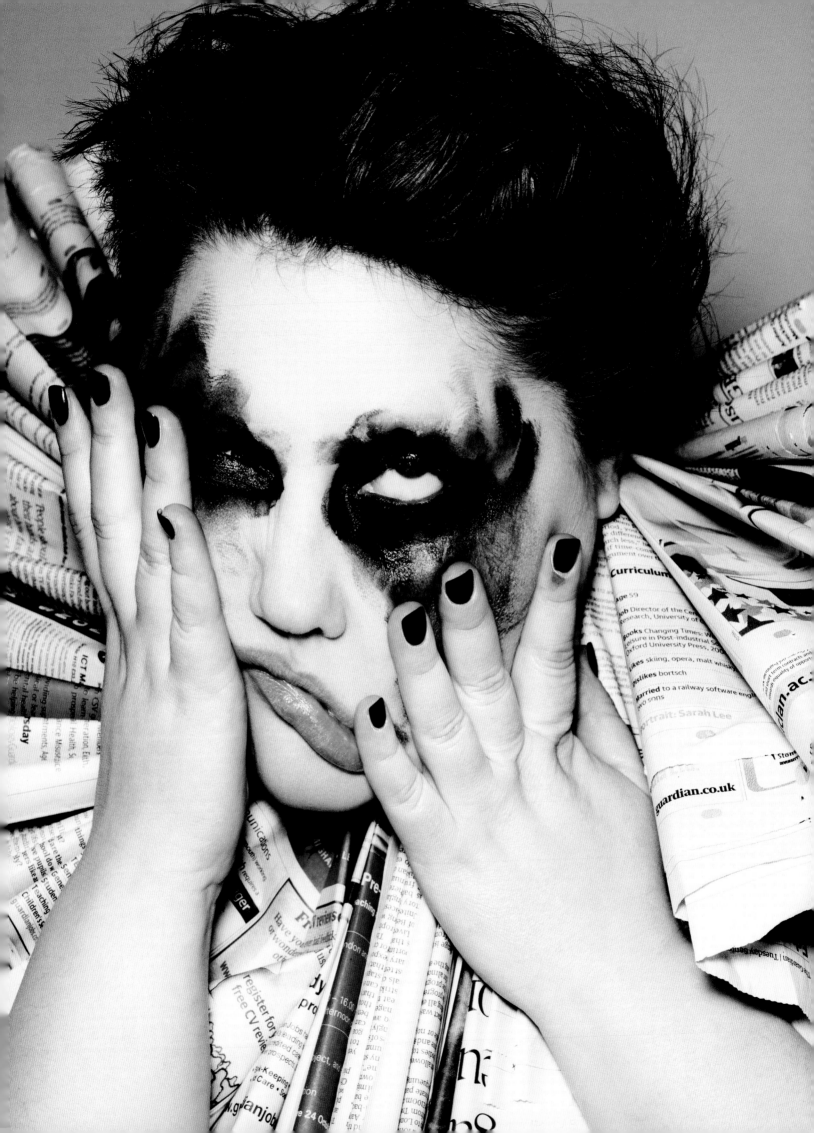

[left]
May 2009
BETH DITTO
photography by Rankin

[below]
November 2010
DANIEL RADCLIFFE
photography by Serge Leblon

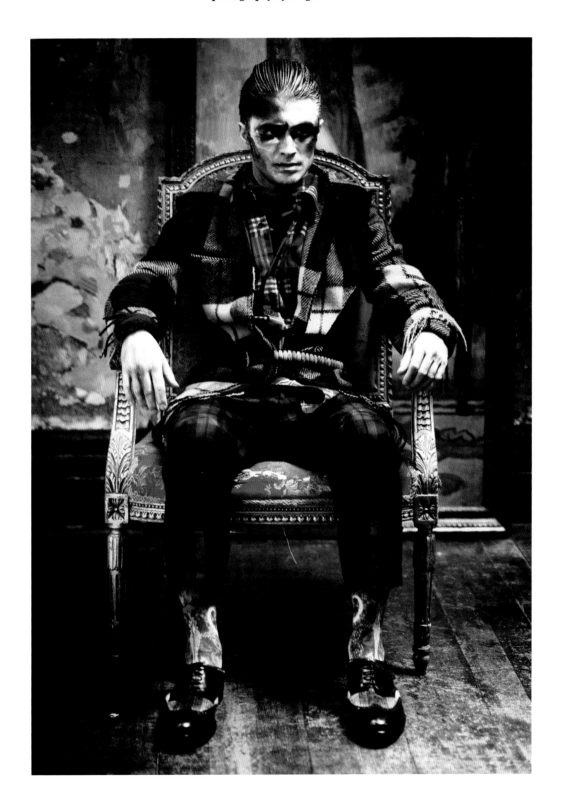

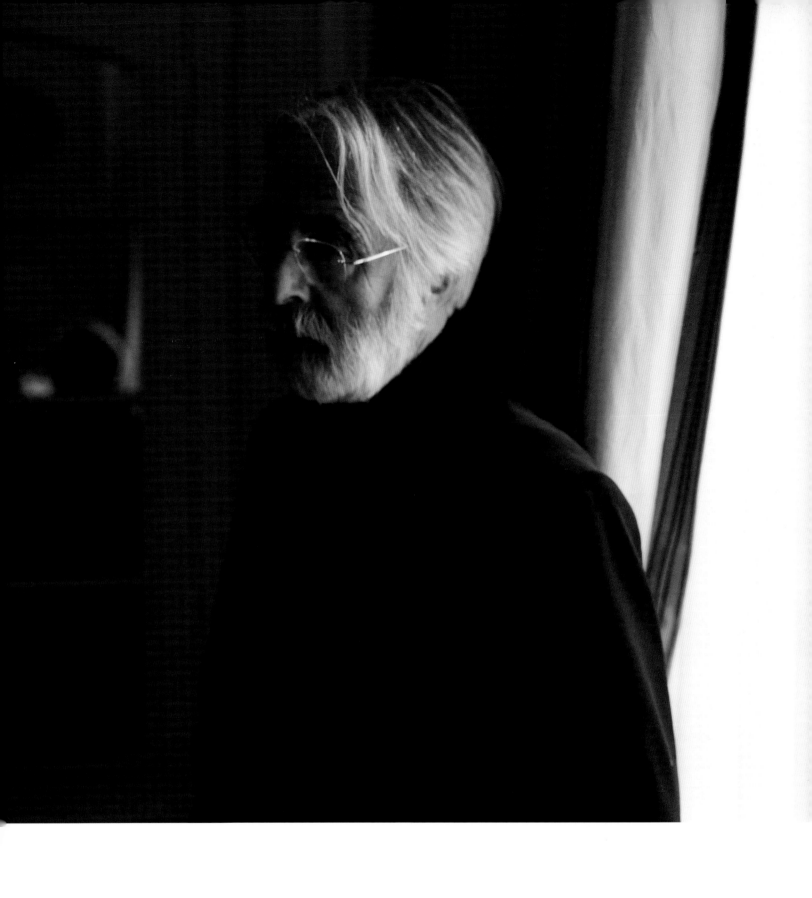

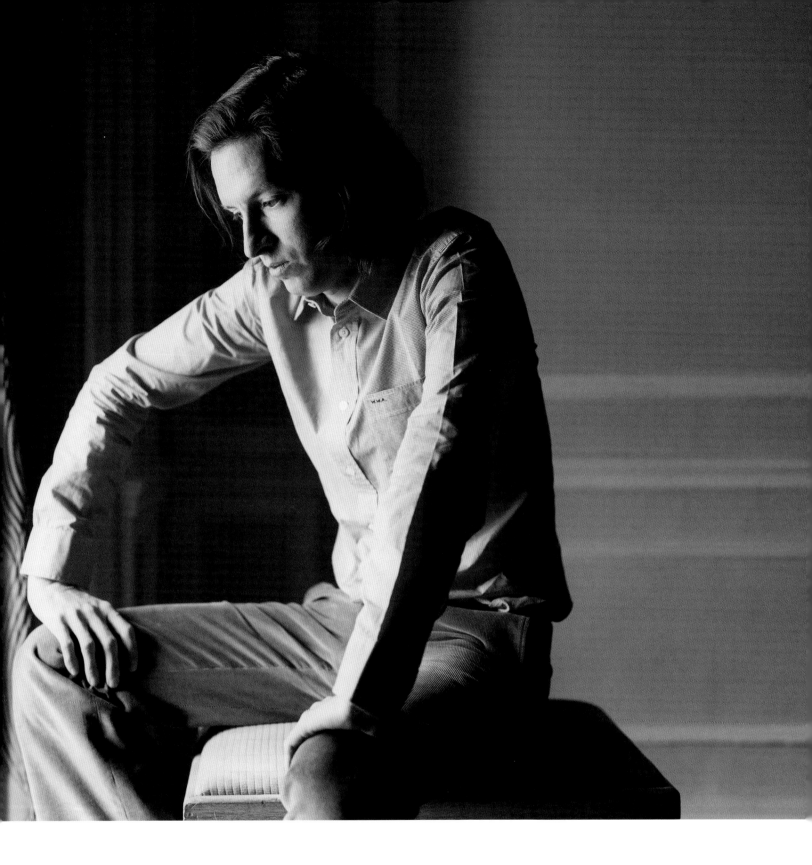

November 2009
WES ANDERSON
photography by
Adam Broomberg
& Oliver Chanarin

[left]
February 2006
MICHAEL HANEKE
photography by
Martine Houghton

[right]
September 2010
DAKOTA FANNING
photography by
Mark Segal

photography by
Anette Aurell

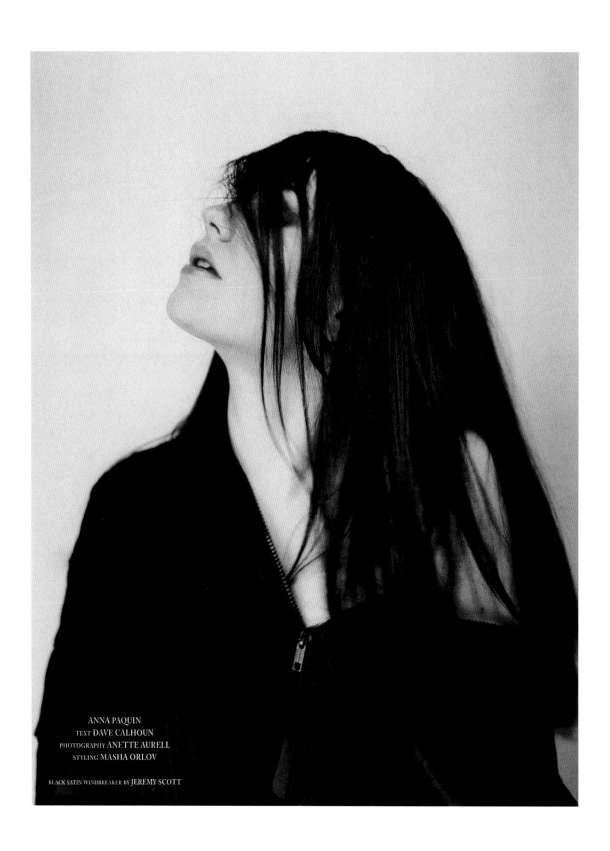

ANNA PAQUIN
TEXT DAVE CALHOUN
PHOTOGRAPHY ANETTE AURELL
STYLING MASHA ORLOV

BLACK SATIN WINDBREAKER BY JEREMY SCOTT

[above]
April 2003
ANNA PAQUIN
photography by
Anette Aurell

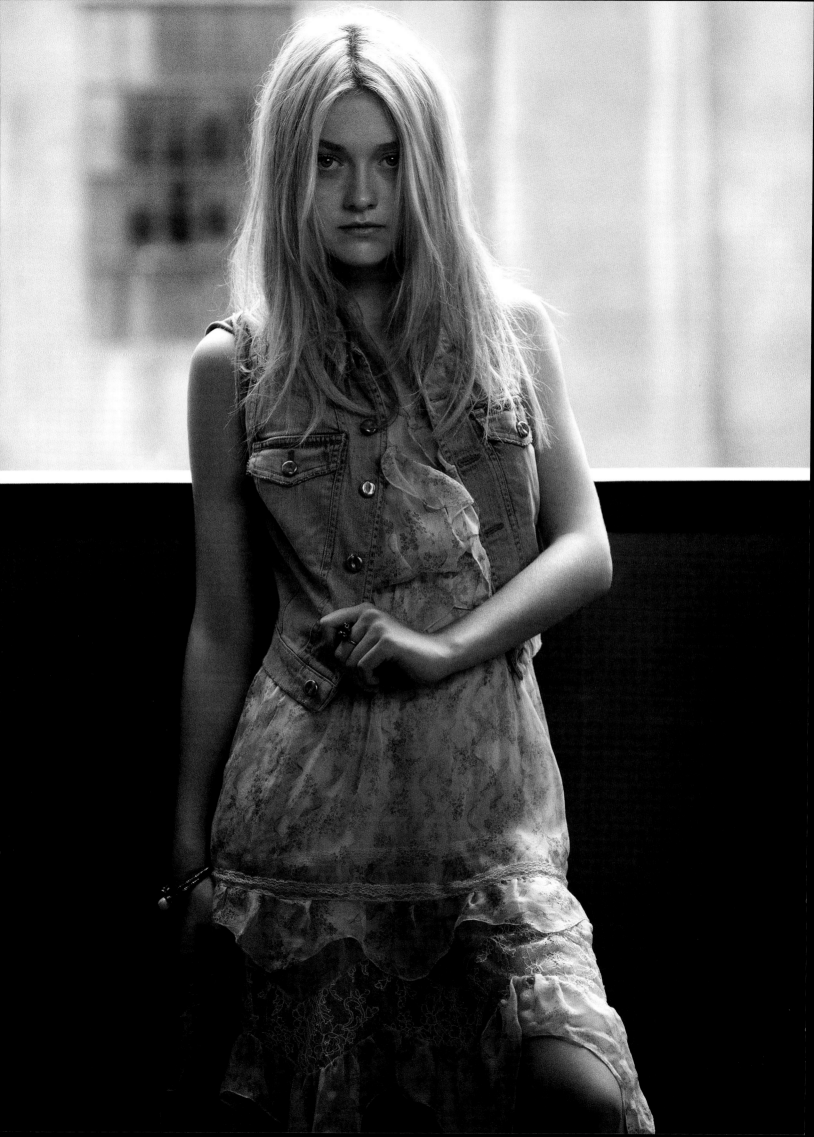

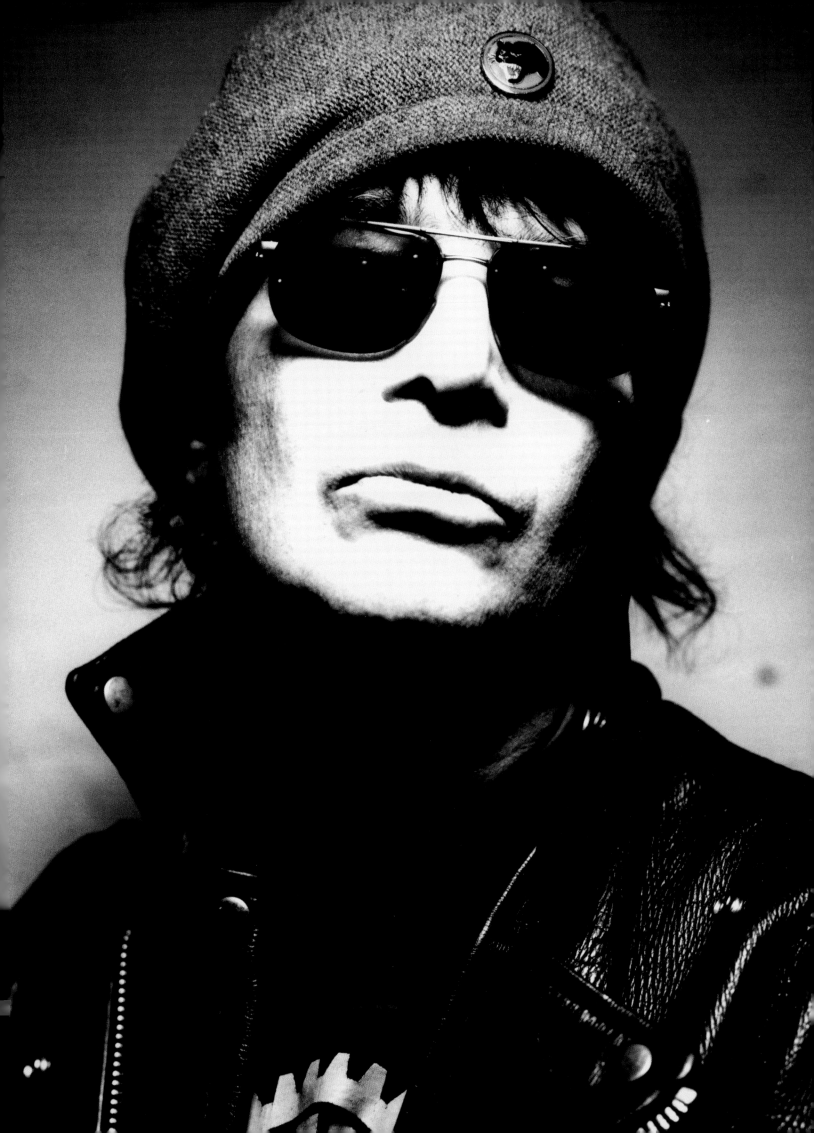

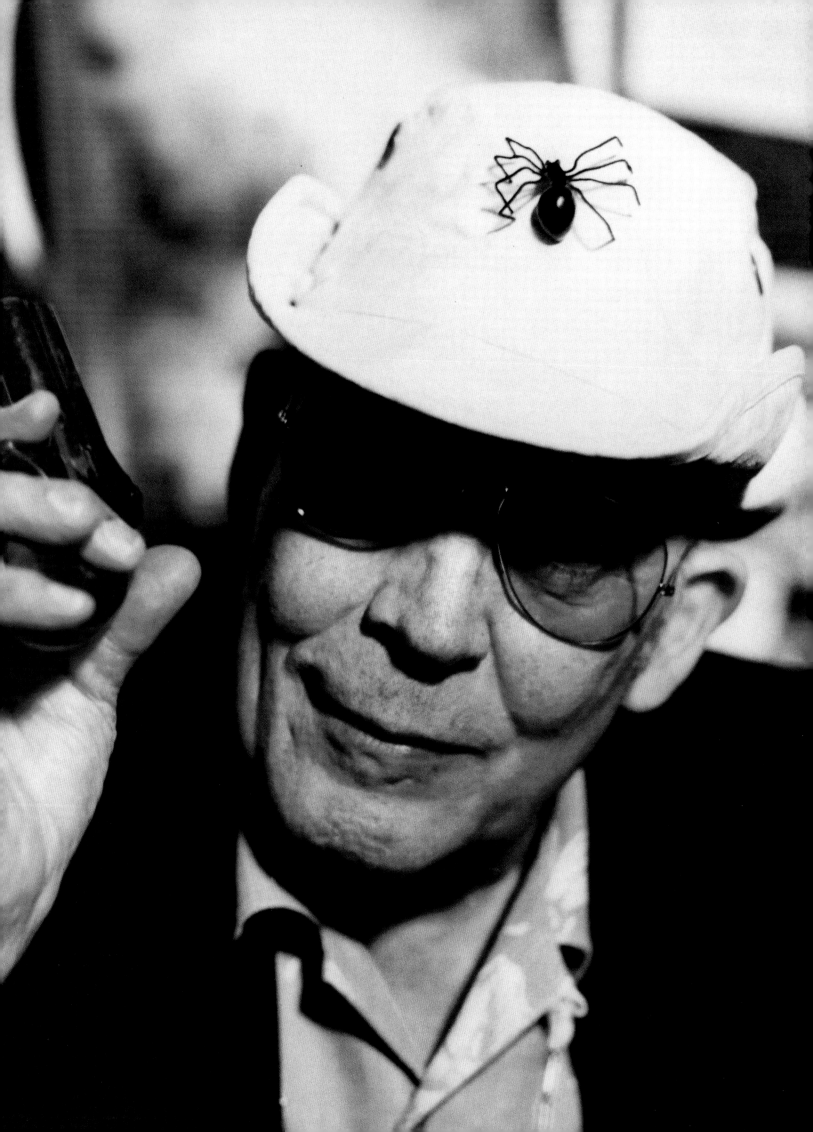

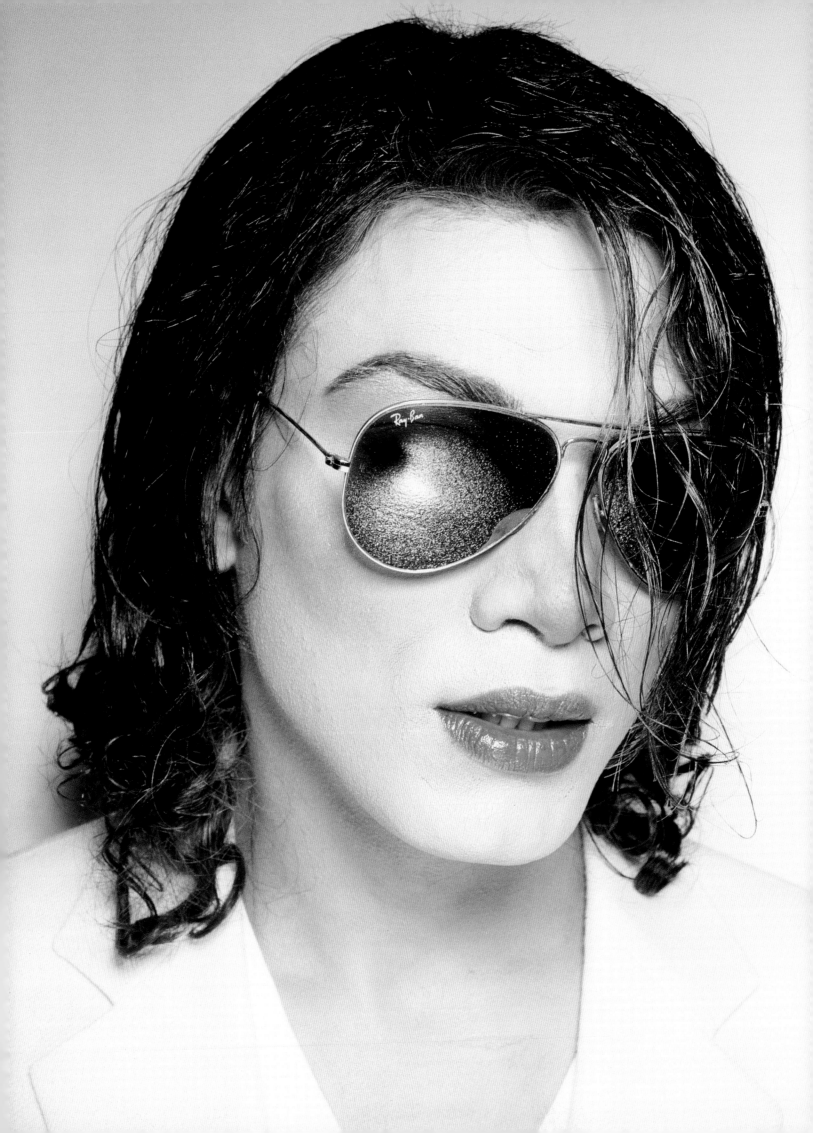

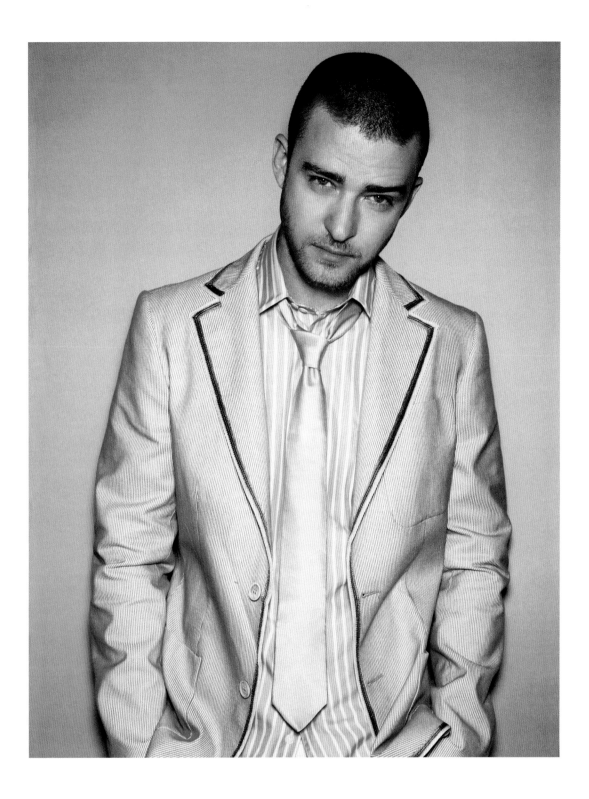

[left]
July 2001
MICHAEL JACKSON
ISSUE COVER
photography by Rankin

The fake Michael Jackson cover was a comment *Dazed & Confused* wanted to make about celebrity culture and the notion of the artificial versus the real. It flew off the shelves of the stockists because people thought the cover star was the man himself.

"The fake Michael Jackson shoot came from me being very obsessed by this idea of being able to use digital enhancement and retouching. I realised that I could make somebody that didn't look like Michael Jackson, but was making a living looking like Michael Jackson, *actually* look like Michael Jackson. Taking this guy and morphing him was a commentary on the real Michael Jackson, who had morphed himself with plastic surgery. It was that

moment in time when plastic surgery and enhancement had got to a really fascinating point, and Michael Jackson was the epitome of that. At that point people didn't really understand how much retouching was taking over in fashion photography, it was becoming absolutely the norm to digitally enhance everything – every single photo you would see. I wanted to show how ridiculous that had become."
RANKIN

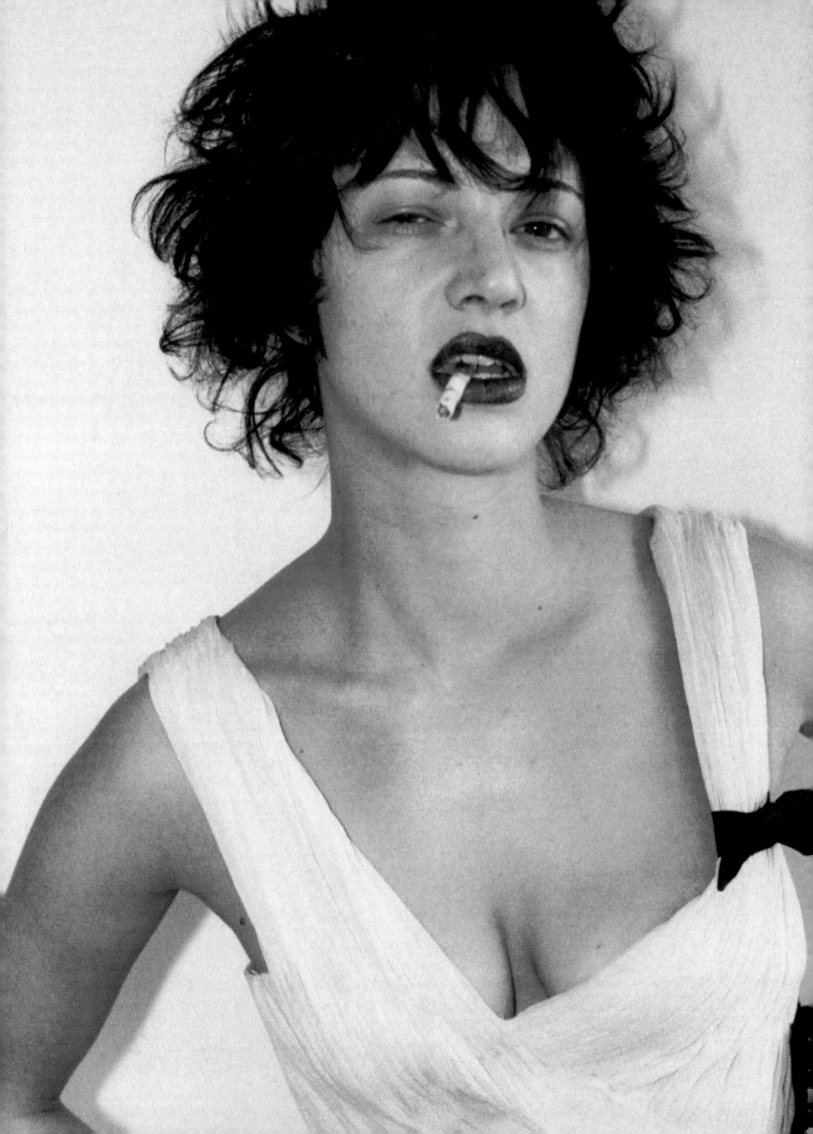

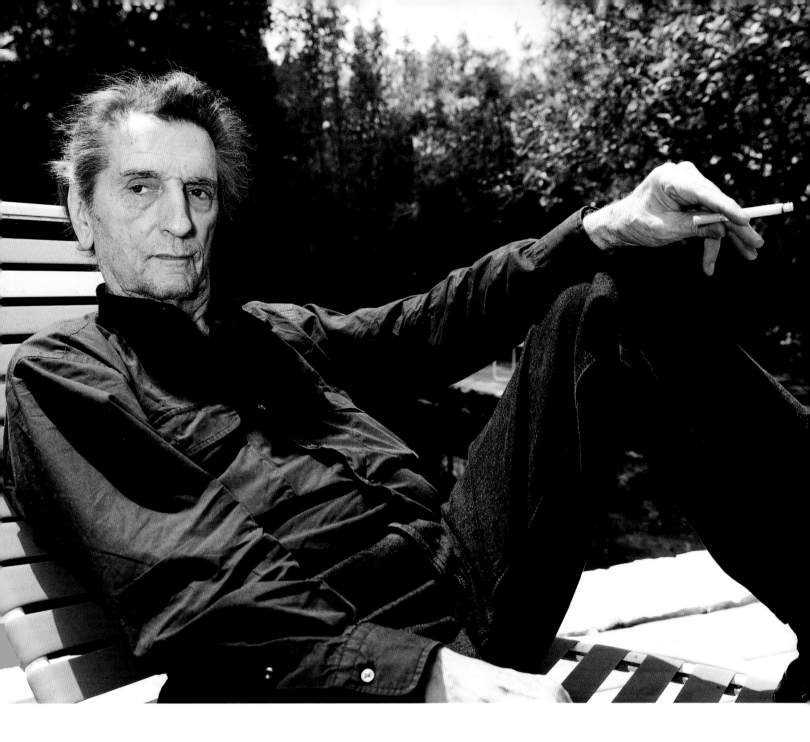

[above]
July 2003
HARRY DEAN STANTON
photography by Tom Fowlks

[left]
November 2004
ASIA ARGENTO
photography by Magnus Unnar

[following spread left]
February 2003
PHARRELL WILLIAMS
photography by Rankin

[following spread right]
August 2000
MICHAEL STIPE
photography by Rankin

[second spread]
July 2011
BEYONCÉ
photography by Sharif Hamza
styling by Karen Langley

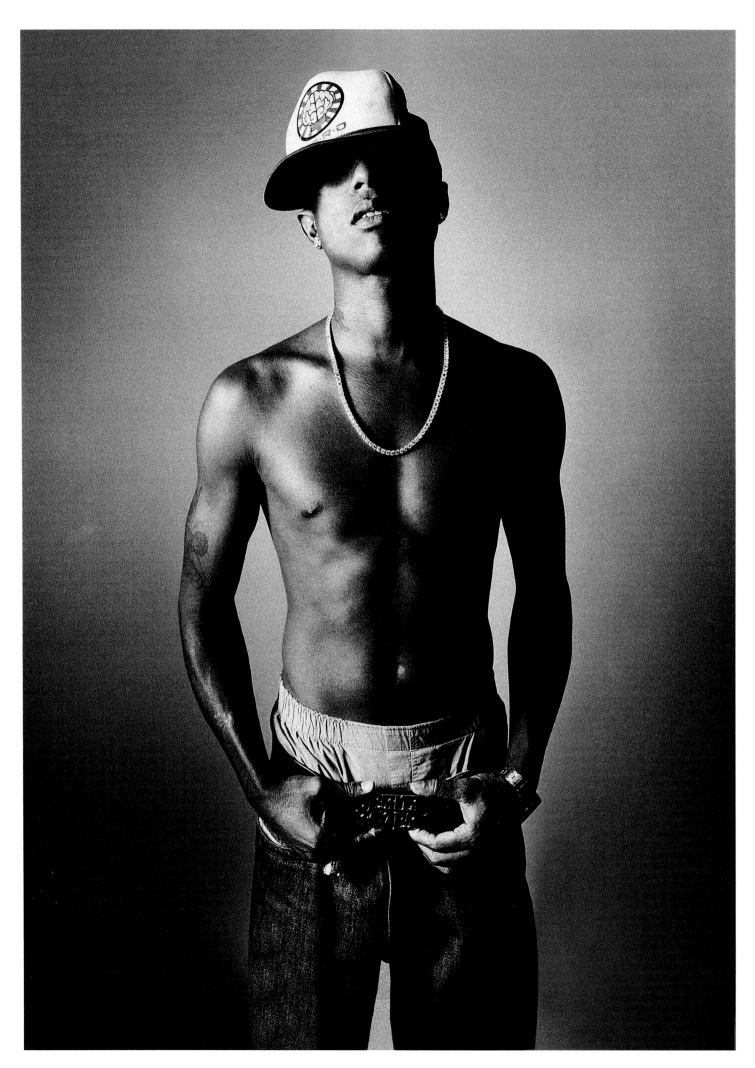

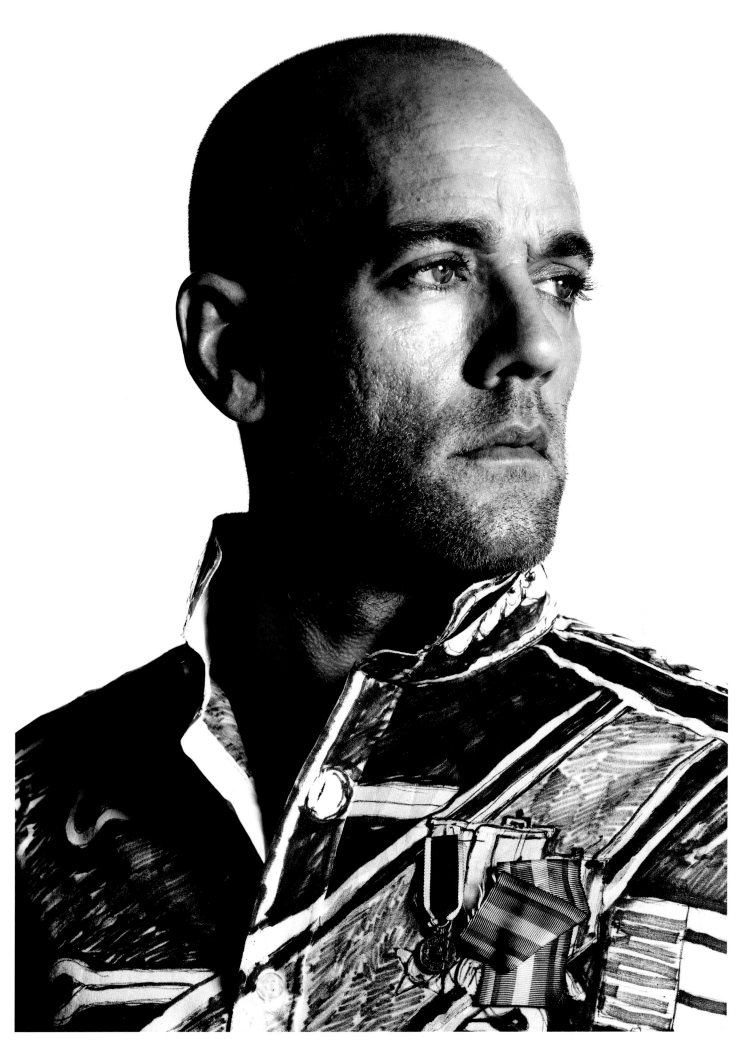

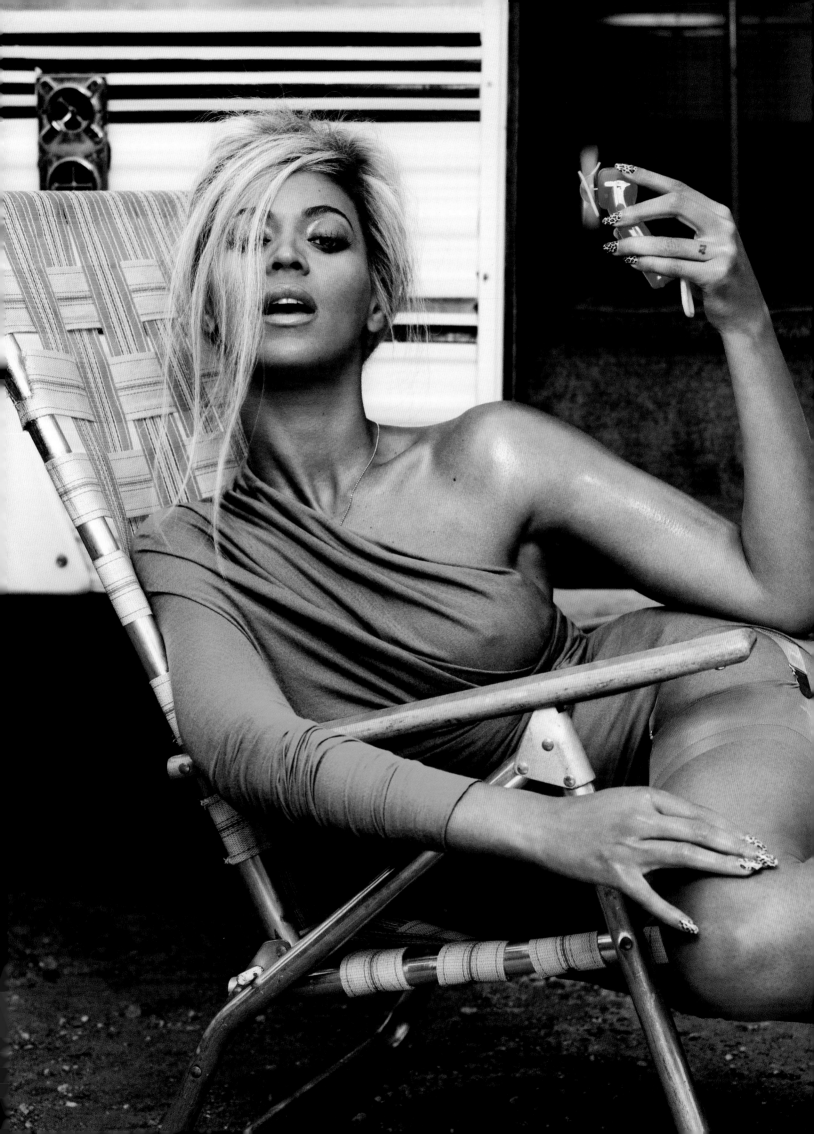

SCARY MONSTERS, SUPER CREEPS
The Fashion Of Karen Langley, Katie Shillingford And Robbie Spencer

"We were the generation that tore out the pages of the original *Dazed* and stuck them on our walls," says Karen Langley, fashion director of *Dazed & Confused* since 2010. "We were the readers."

But the current fashion team is just as personally connected to the magazine's history as its predecessors. For her part, Langley did a month's work placement with Katie Grand when she was 18, returning to help Katy England in her gap year at Central Saint Martins and, following graduation, to assist Cathy Edwards full-time. *Dazed & Confused*'s senior fashion editor, Katie Shillingford, a graphic design graduate, was helping Gareth Pugh when Nicola Formichetti suggested she might like to assist him at the magazine. "I was friends with Gareth," she says. "His graduate collection did really well and Nicola put it on the cover of *Dazed*. Then Nicola was looking for an assistant... I just fell into it really." Robbie Spencer, the magazine's senior fashion editor (menswear) arrived just before, assisting both Formichetti and Alister Mackie while completing a journalism degree at the London College of Fashion. "I met Nicola and Alister and gradually began assisting on *Dazed*. Over the years, I became more and more involved. It's the kind of place where the more you put into it, the more you get in return," he says. "It's not one person's vision. It's the three of us working together as friends – we all have slightly different aesthetics but collectively it works. I couldn't do this without them. It's a team effort," is how Langley describes the dynamics of the team today. As with those who staff the magazine, contributors, too, are either linked to its past or helping to form the future – and in many cases both. Very much part of the history of *Dazed & Confused* is Björk. "She'll always come to *Dazed* a long way in advance with a new album because she knows we can do something interesting together."

Shillingford cites working on the *Elevation* Gareth Pugh cover story with Nick Knight as among her most inspiring moments – a fashion story that marked a significant moment for the magazine, being one of the first shoots to travel from the page into the realm of film. "Shooting with Nick and Gareth was an experience I will never forget," she says. "That season felt like a real turning point for Gareth. It was his last season in London and we were moving onward and upward. I remember casting Abbey Lee. It was her first season and she was relatively unseen but she came to the shoot fresh from shooting Gucci with Chris Cunningham. I suppose it was the calm before the storm for her as well as for Gareth and I. Nick has always been hugely supportive of Gareth and this was the ultimate collaboration. He really took the spirit of the collection on board and propelled it into the most mind-blowing images. We were all hypnotised by *Insenate* – the film we shot alongside the editorial. It was a magical shoot."

Robbie Spencer's high points include the opportunity to work with Hedi Slimane: "At Dior Homme Hedi influenced a generation and he was one of the reasons I became interested in fashion in the first place. His connection with youth culture really inspired me, so working with him on shoots for *Dazed* now is very exciting." He also cites collaborations with the photographer Richard Burbridge and make-up artist Peter Philips. "It's so rare to work with such amazing artists and do something with creative freedom. That is the thing about *Dazed*. We have this limitless creative license to make images and explore ideas." Dan Jackson and the model Guinevere are similarly established names who collaborated on a mask project with Langley. "Not only did we have an extraordinary line-up of designers who made masks for the project, which went way beyond runway and into the realms of fantasy," she says, "but also there aren't many supermodels who would allow a fashion editor to cover their face with a mask, but still somehow have this weird identity coming through their presence, in a way that doesn't take anything away from them." People such as the Chapman brothers, Vivienne Westwood, Hussein Chalayan and Riccardo Tisci are still in the magazine's extended family, and identifying new talent remains very much part of the magazine's *raison d'etre*. "It's a youth magazine and it's very important that the focus is on a new generation and new talent," says Langley. Ben Toms, Karim Sadli, Pierre Debusschere, Kacper Kasprzyk and Sharif Hamza are just some of those who now contribute to the magazine's pages.

In the end, working at *Dazed & Confused* is a labour of love, as it always has been. "You wouldn't work at a place like this unless you wanted to do it 100 per cent," Spencer says.

"It's incredible to be in a position where there's a group of people working on something and you know that every single one of them is there because they want to be," Langley concludes. "They're working on that image, for that moment, and they're doing it purely for the love of it. A lot of it is about gut instinct, you can never underestimate that. It's about association and trust. Of course we pay attention to what is going on at the shows each season and work closely with big brands. Mainly, though, it's about trying not to think about anything too much. You can so easily talk yourself out of a good idea or worry about taking risks but, in the end, it's all about going: 'Oh, what the hell, let's just do it.'"

SUSANNAH FRANKEL

[right]
June 2007
GOD SAVE THE QUEEN
photography by Matt Irwin
styling by Katie Shillingford

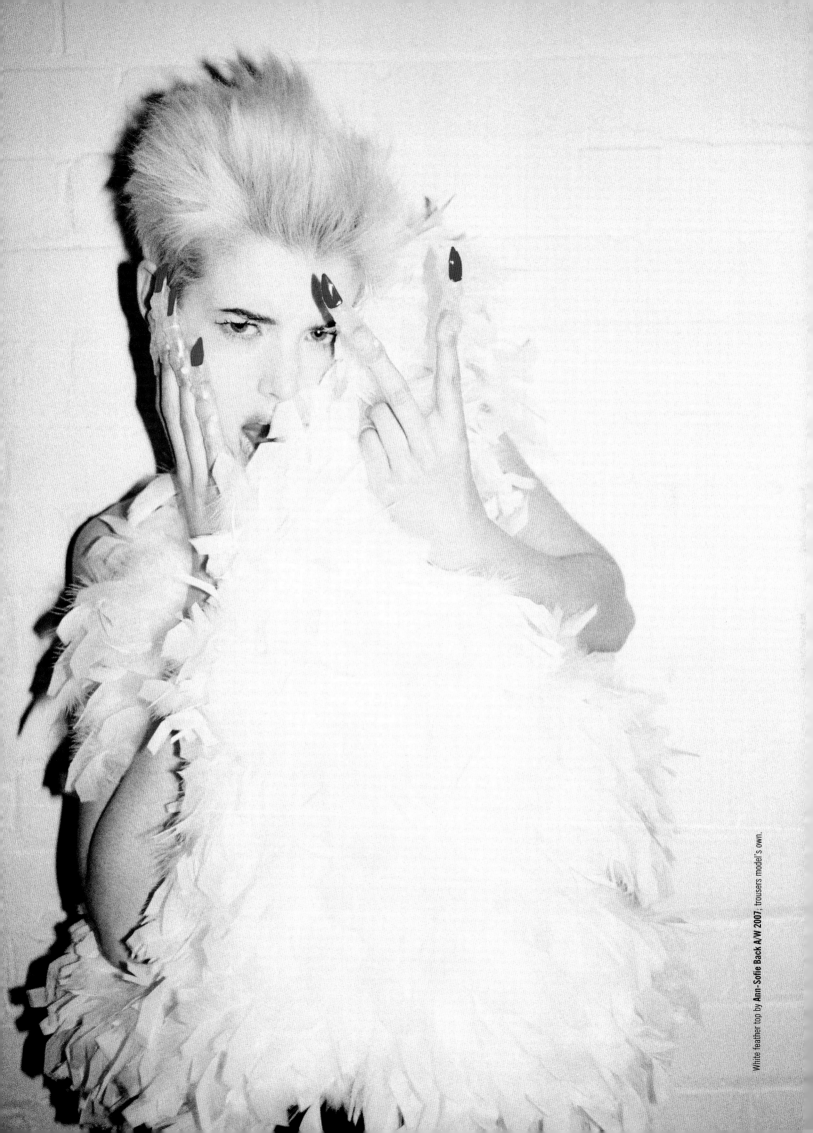

White feather top by **Ann-Sofie Back** A/W 2007; trousers model's own.

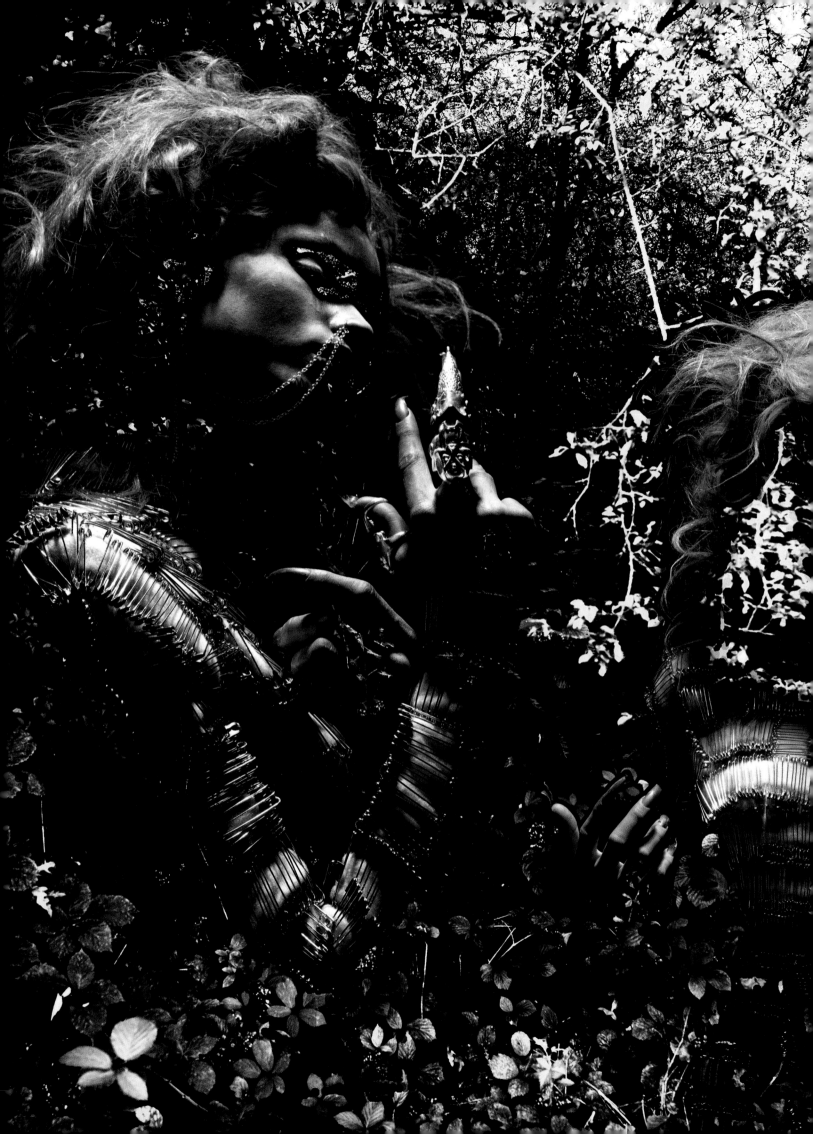

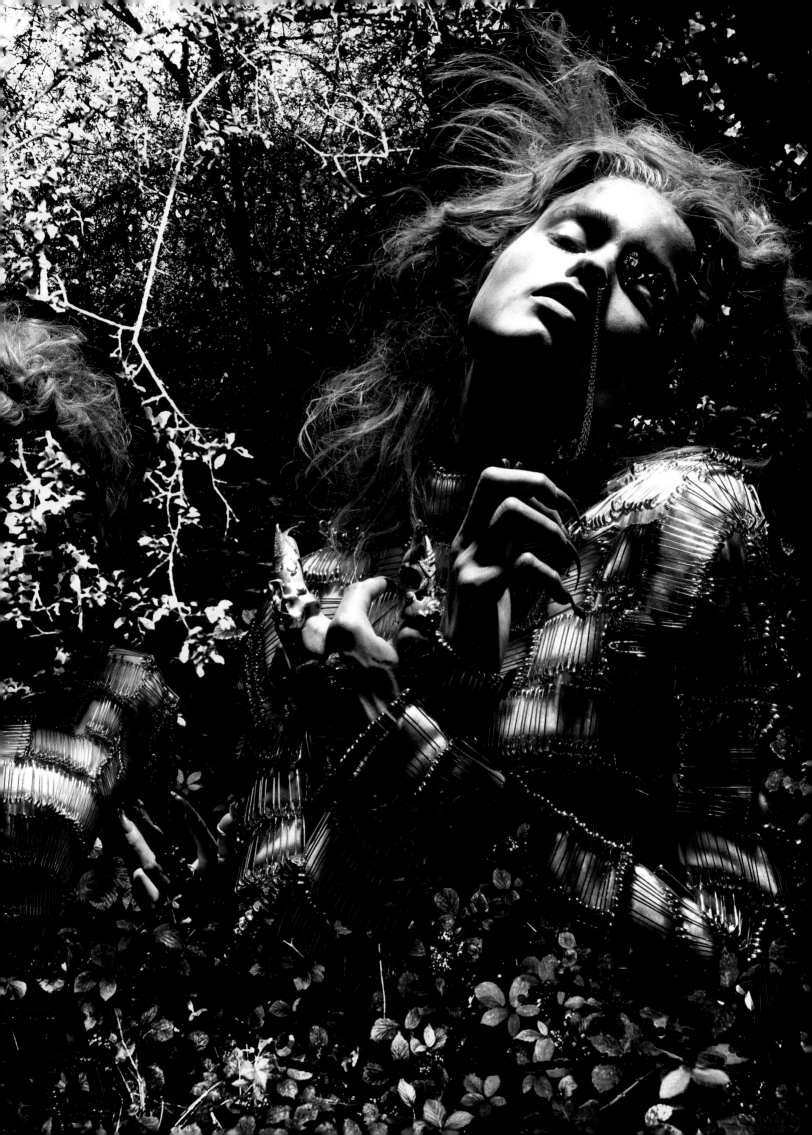

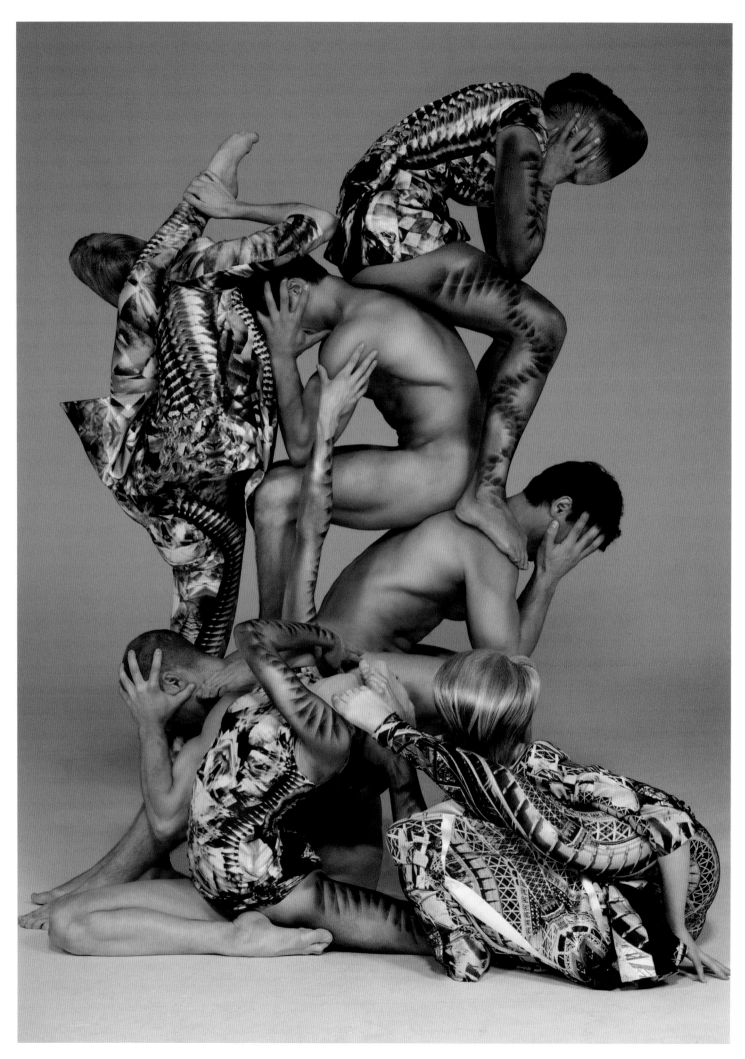

[previous spread]
October 2008
ASCENSION
art direction by Gareth Pugh
photography by Nick Knight
styling by Katie Shillingford

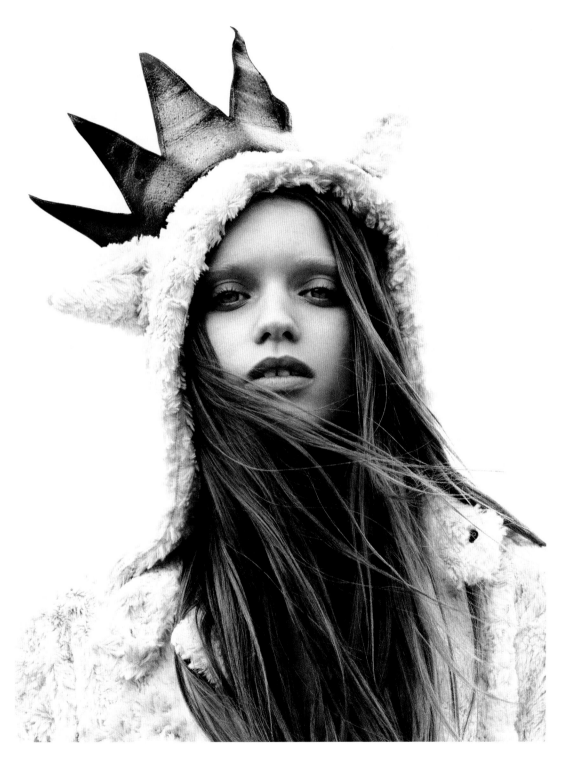

[this page]
December 2009
WHERE THE WILD THINGS ARE
photography by Daniel Jackson
styling by Karen Langley

[left]
March 2009
A
photography by William Selden
styling by Karen Langley

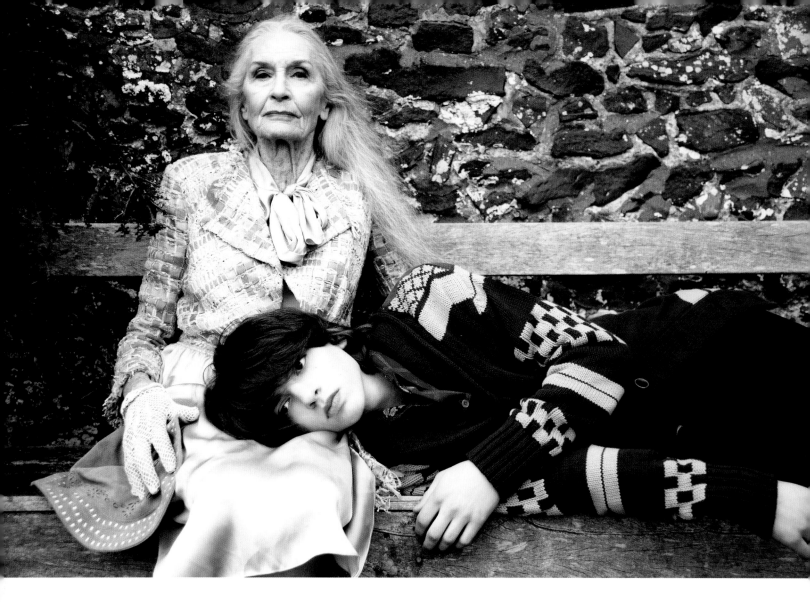

[above]
May 2011
TROUBLE
photography by Ben Toms
styling by Robbie Spencer

[right]
June 2011
IT CAME FROM THE SKY
photography by Richard Burbridge
styling by Robbie Spencer
artwork by Maurizio Anzeri

[following spread]
February 2011
YOHJI YAMAMOTO FEATURE
photography by Serge Leblon
styling by Karen Langley

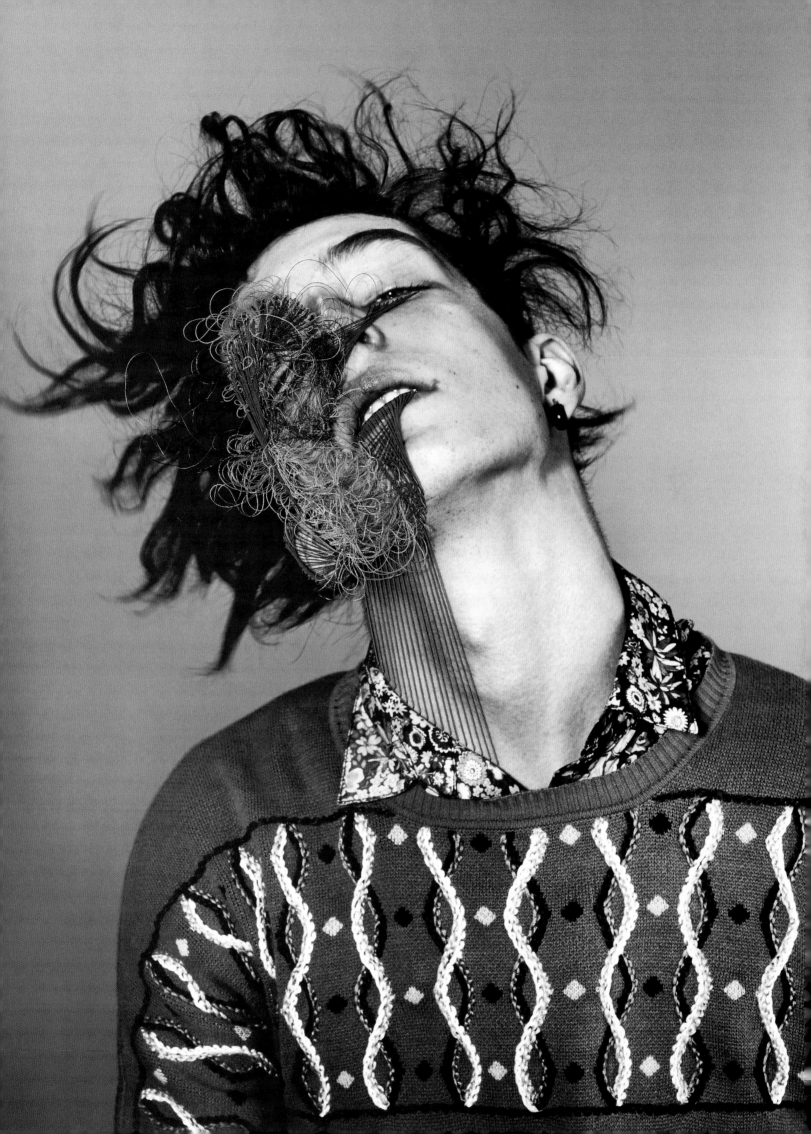

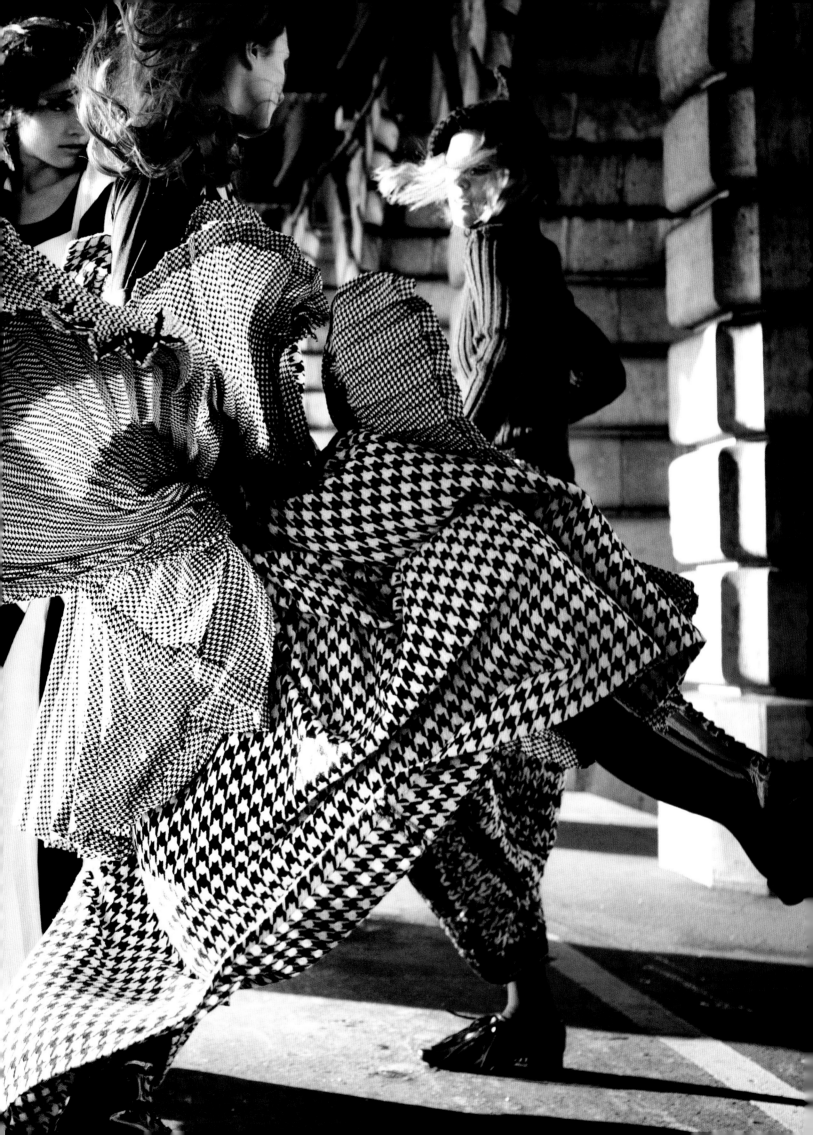

Touched by Youth

"A PERFECTLY UNFINISHED STATE WHERE
EVERYTHING IS STILL NEW" - ARTIST COLLIER SCHORR
CREATES A SCRAPBOOK OF YOUTH

PHOTOGRAPHY
COLLIER SCHORR

WOMENSWEAR STYLING MENSWEAR STYLING
KATIE SHILLINGFORD ROBBIE SPENCER

[this page clockwise
from top left]
TATI wears leather
t-shirt by CELINE; trousers
by JO NO FUI, ALEKS
wears jacket-dress by
LANVIN, ALEKS wears
dress by DOLCE &
GABBANA, ANN wears
white t-shirt by MAISON
MARTIN MARGIELA

[opposite page]
TATI wears braces from
BEYOND RETRO

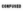

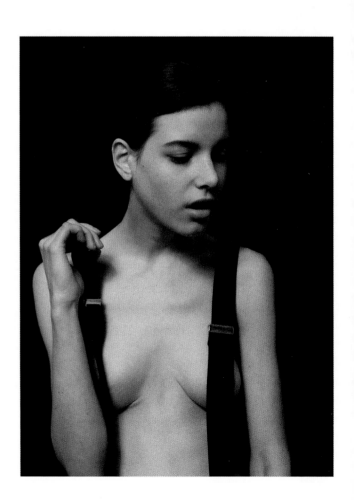

[opposite page]
TATI wears t-shirt by
FORTE FORTE; trousers
by MIU MIU

[this page]
ALEKS wears pants by
ALEXANDER WANG

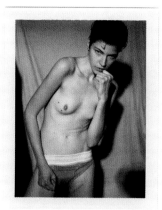
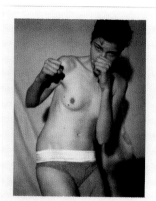

[opposite page]
MIKHAEL wears leather
jacket stylist's own

[this page]
WES wears headpiece by
SIBLING; jeans by LEVI'S

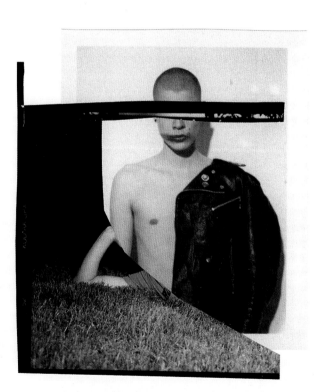
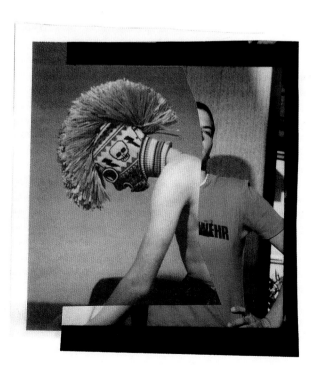

[previous spread]
June 2010
TOUCHED BY YOUTH
photography by Collier Schorr
womenswear styling by Katie Shillingford
menswear styling by Robbie Spencer

[this page]
April 2010
ENJOY THE SILENCE
photography by Niall O'Brien
styling by Katie Shillingford

[following spread]
December 2009
TIE-DYE HAIR
photography by Mark Pillai
styling by Katie Shillingford

ENJOY
THE
SILENCE

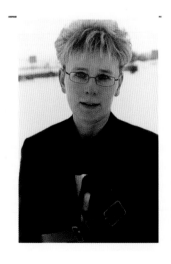

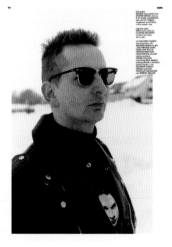

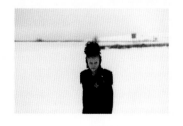

October 2009
MAKE ME A MONSTER
photography by Daniel Jackson
styling by Karen Langley

GARETH PUGH

"IF I WERE DR FRANKENSTEIN,
I WOULD MAKE MYSELF A CROSS
BETWEEN A SEAMSTRESS, A CLEANER,
A FIT MODEL AND A COOK!"

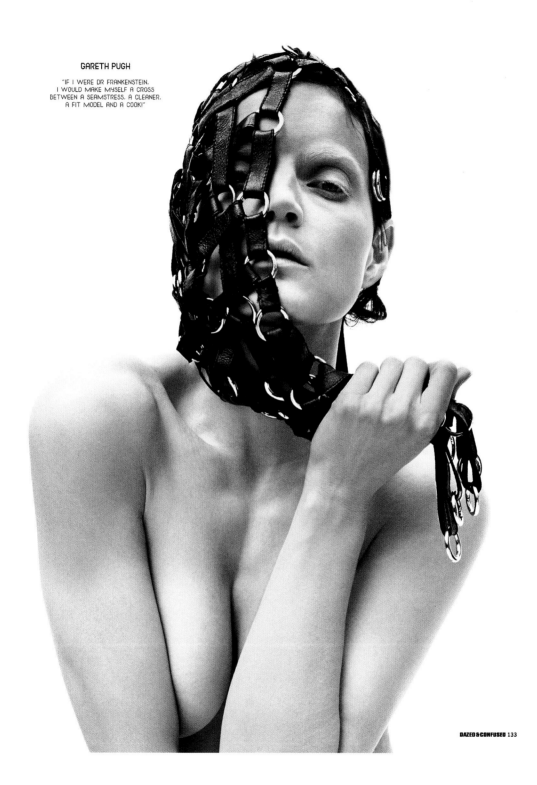

DAZED & CONFUSED 133

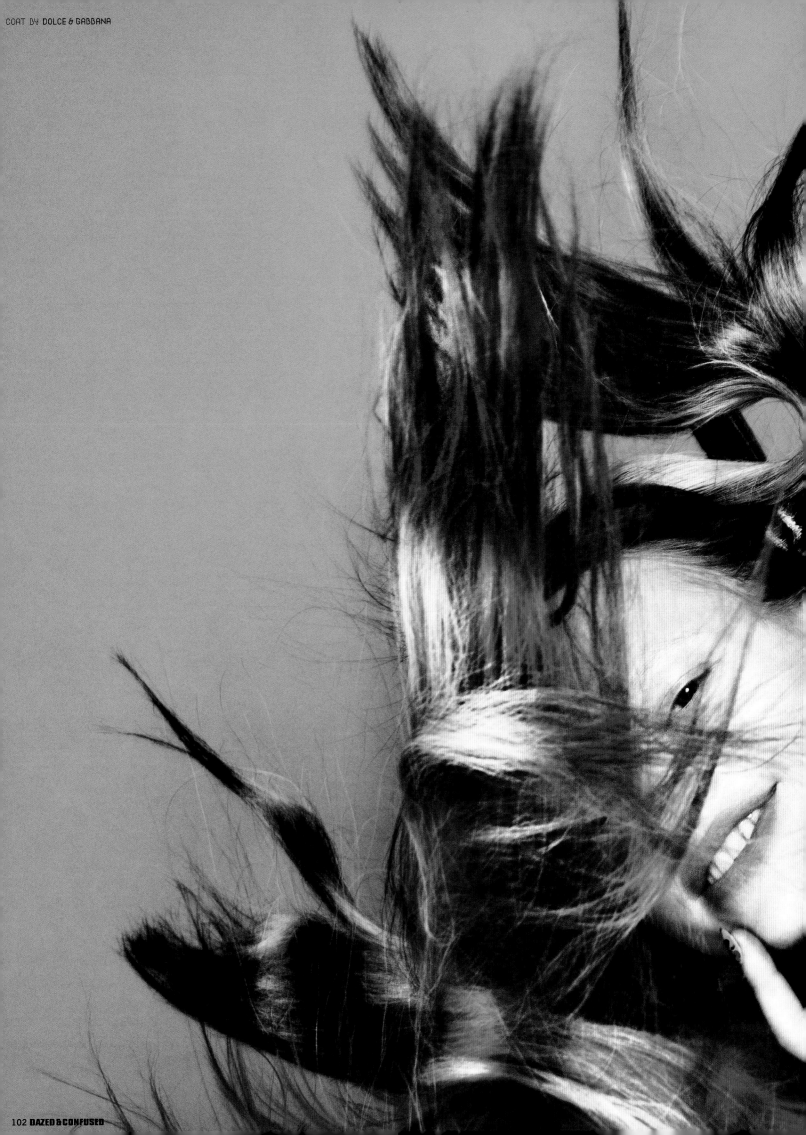

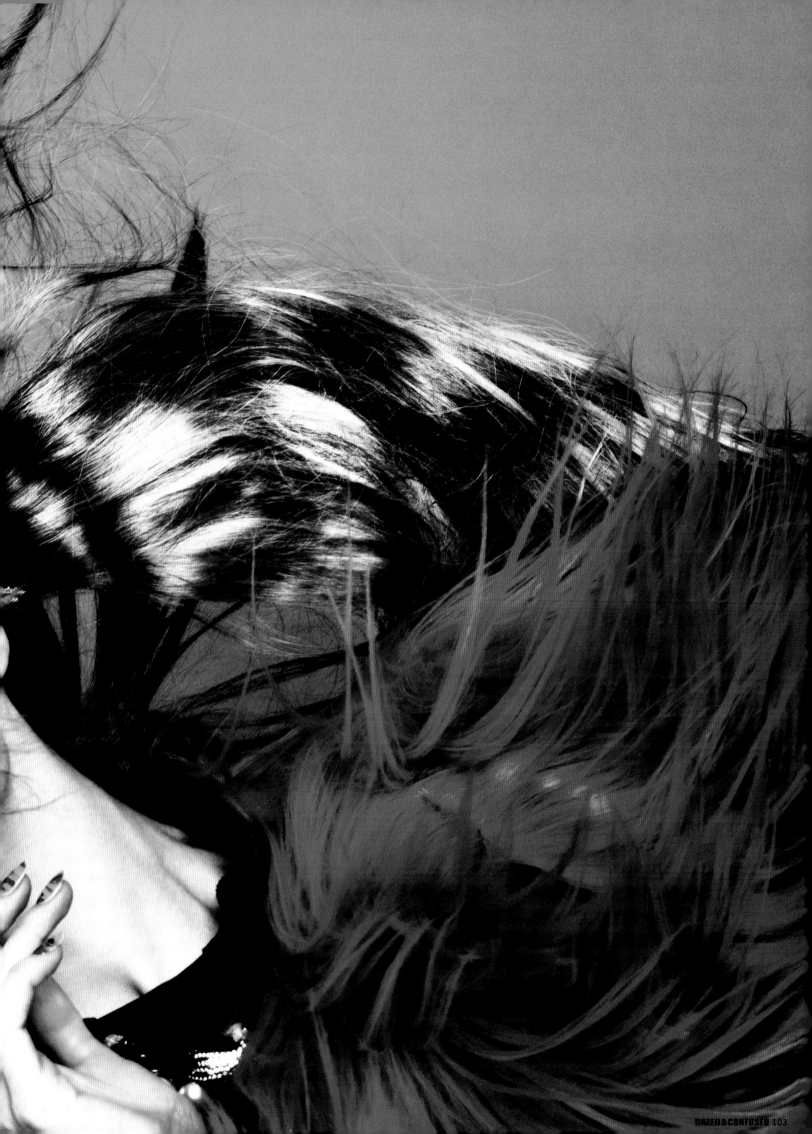

August 2010
KRISTEN MCMENAMY
photography by
Tierney Gearon
styling by Karen Langley

fashion / langley, shillingford, spencer / 318

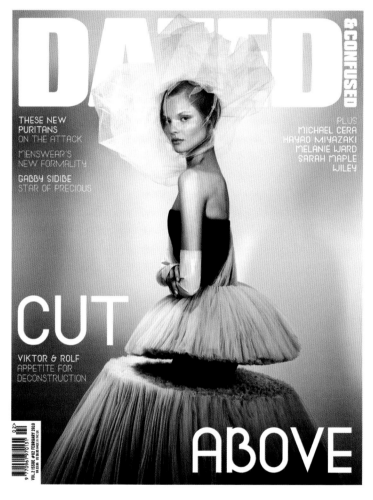

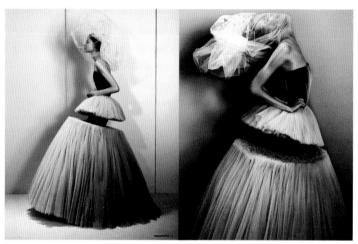

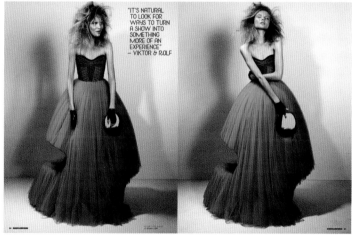

February 2010
**THE AMSTERDAM
CHAINSAW MASSACRE**
*photography by Josh Olins
styling by Katie Shillingford*

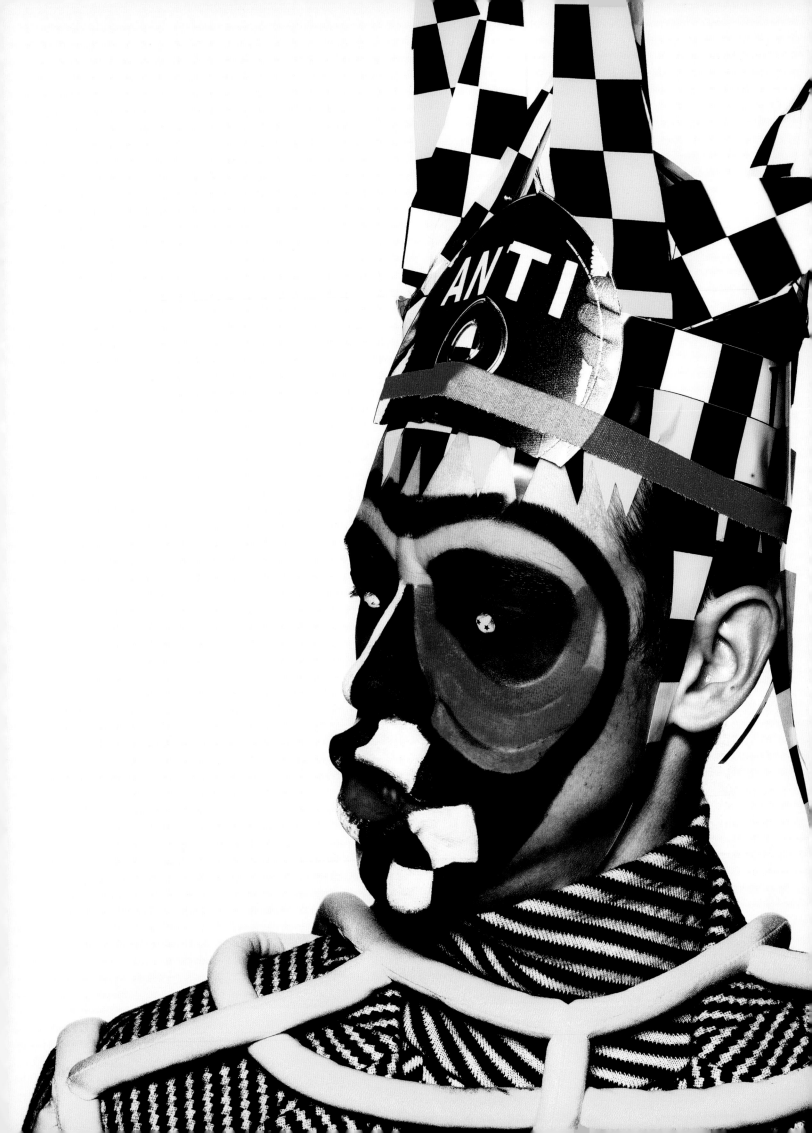

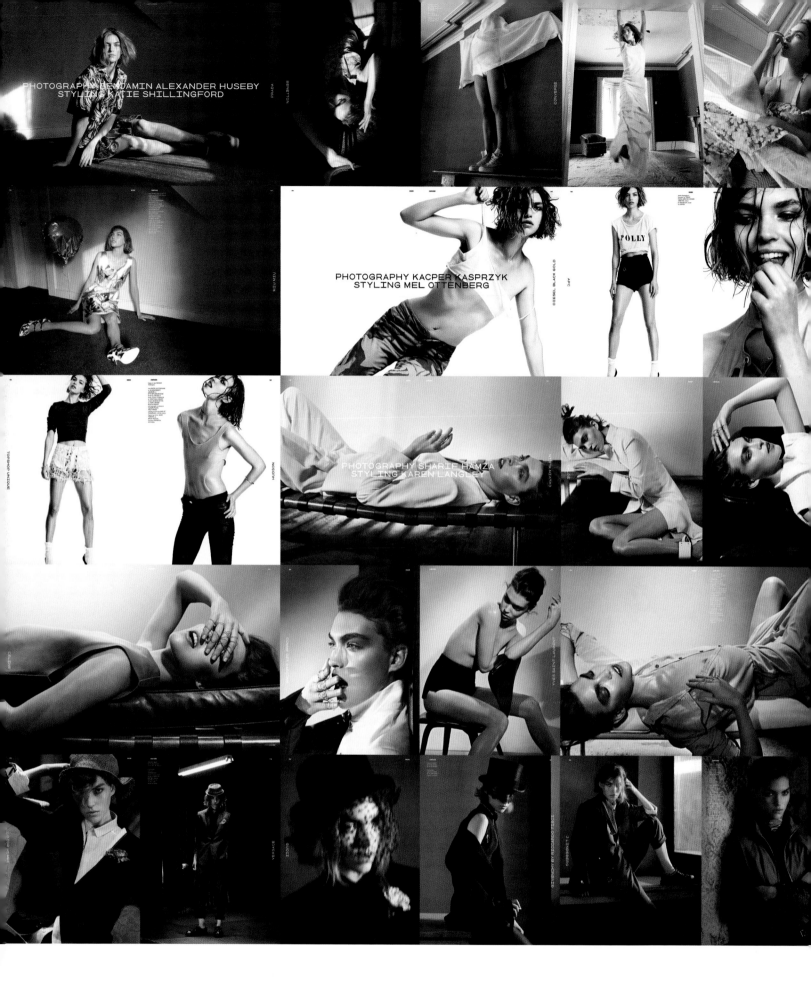

PHOTOGRAPHY BENJAMIN ALEXANDER HUSEBY
STYLING KATIE SHILLINGFORD

PHOTOGRAPHY KACPER KASPRZYK
STYLING MEL OTTENBERG

PHOTOGRAPHY SHARIF HAMZA
STYLING KAREN LANGLEY

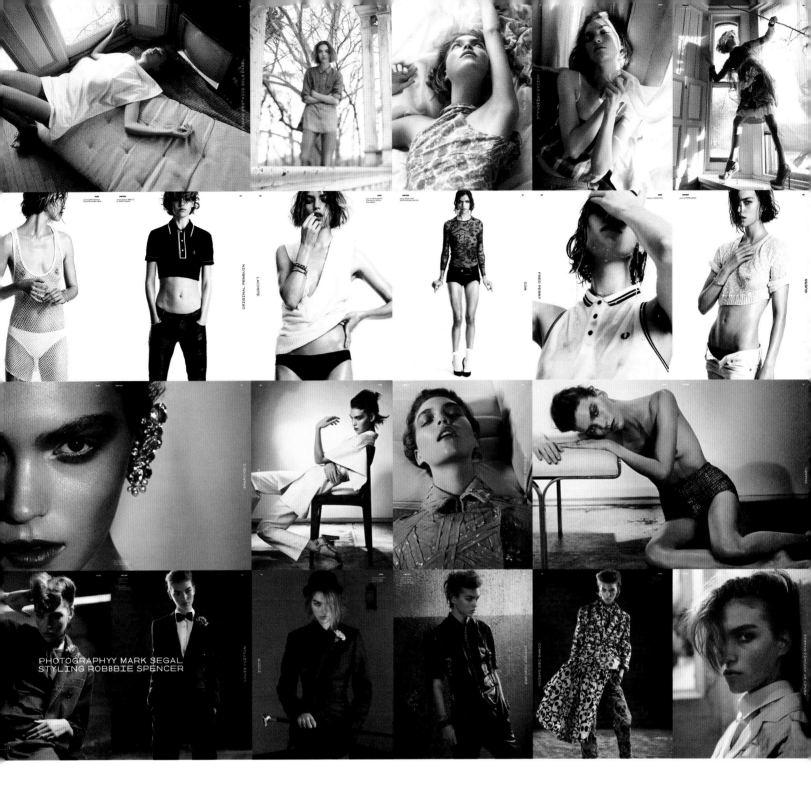

PHOTOGRAPHYY MARK SEGAL
STYLING ROBBBIE SPENCER

[previous spread]
October 2009
SCRAPHEAP CHALLENGE
photography by Richard Burbridge
styling by Robbie Spencer

[this spread]
March 2011
BIRTH OF A MUSE
photography by
Benjamin Alexander Huseby
styling by Katie Shillingford

photography by Kacper Kasprzyk
styling by Mel Ottenberg

photography by Sharif Hamza
styling by Karen Langley

photography by Mark Segal
styling by Robbie Spencer

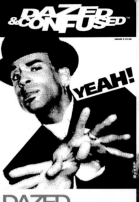
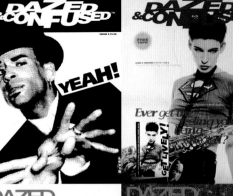
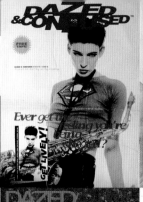
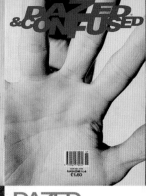
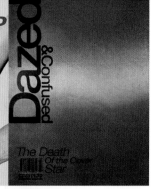
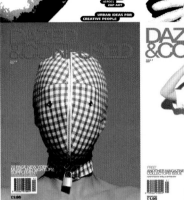
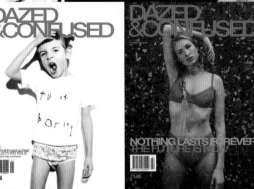
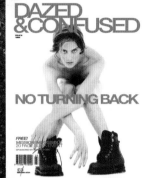

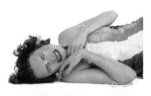
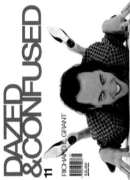

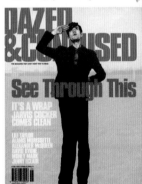
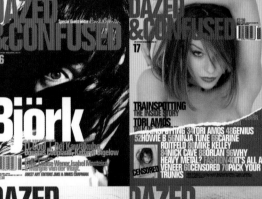

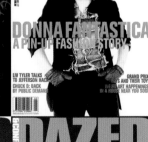
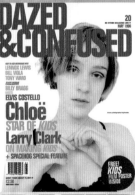
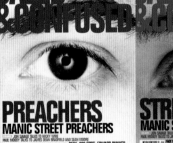

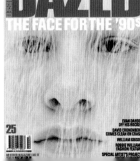

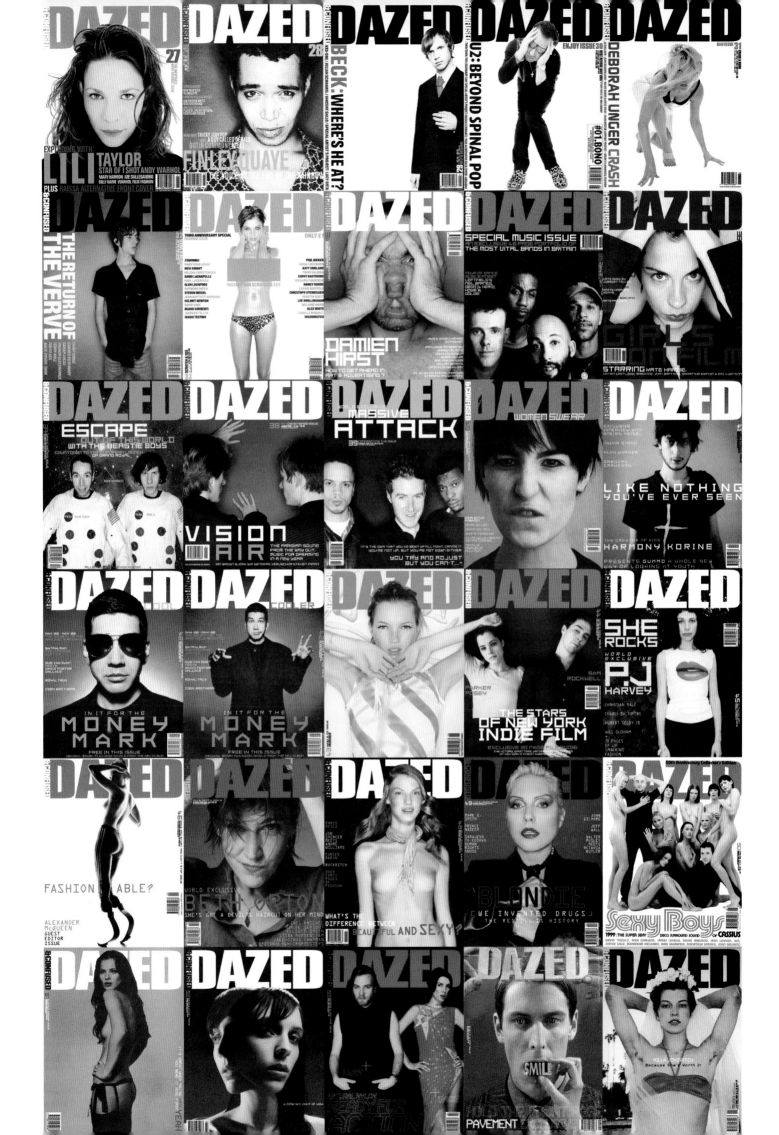

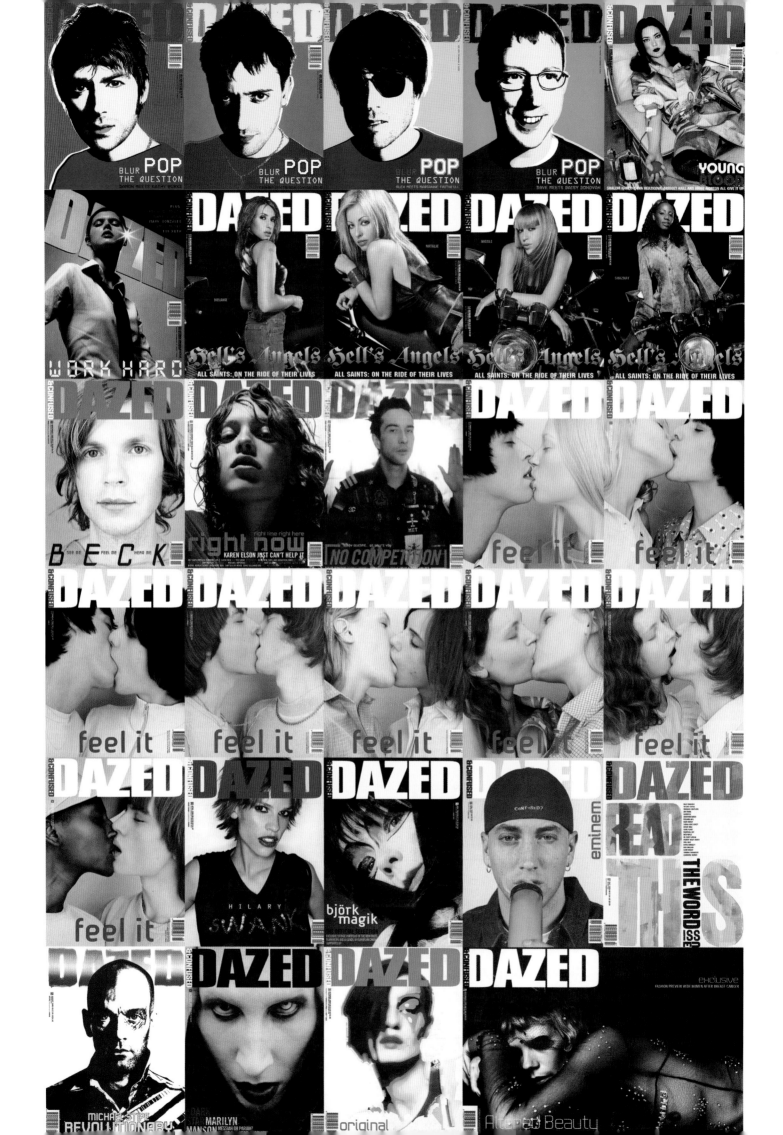

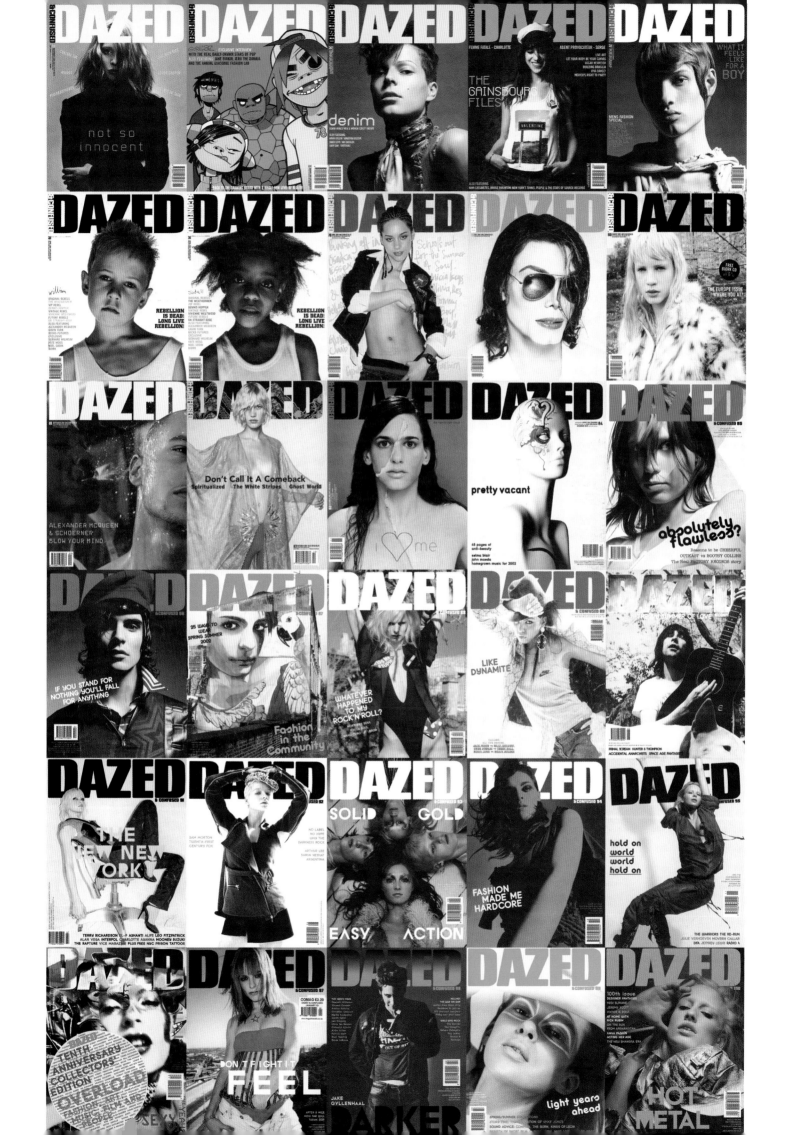

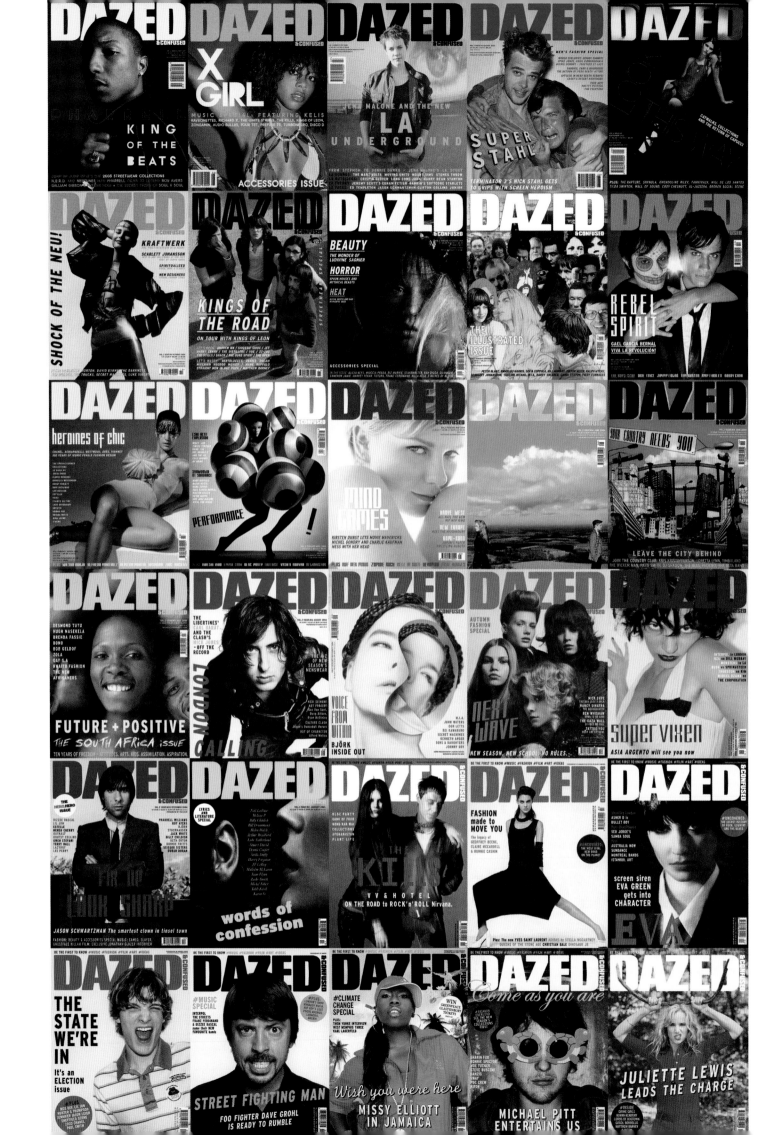

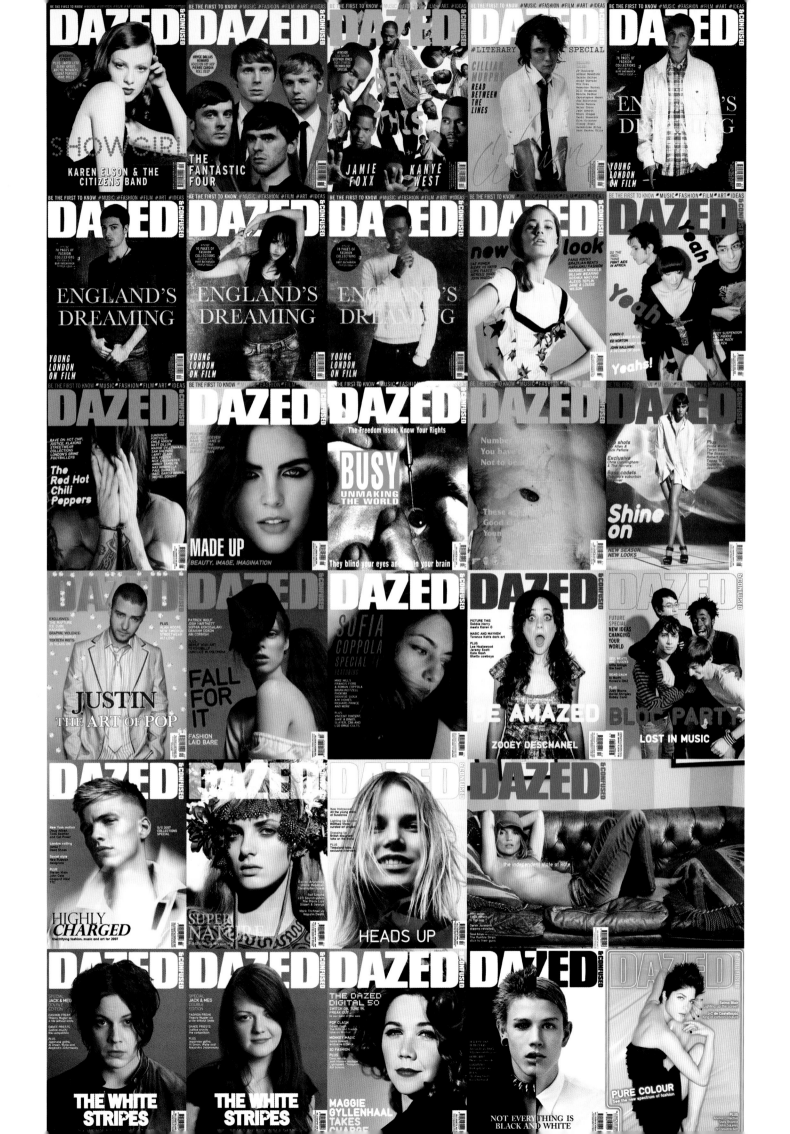

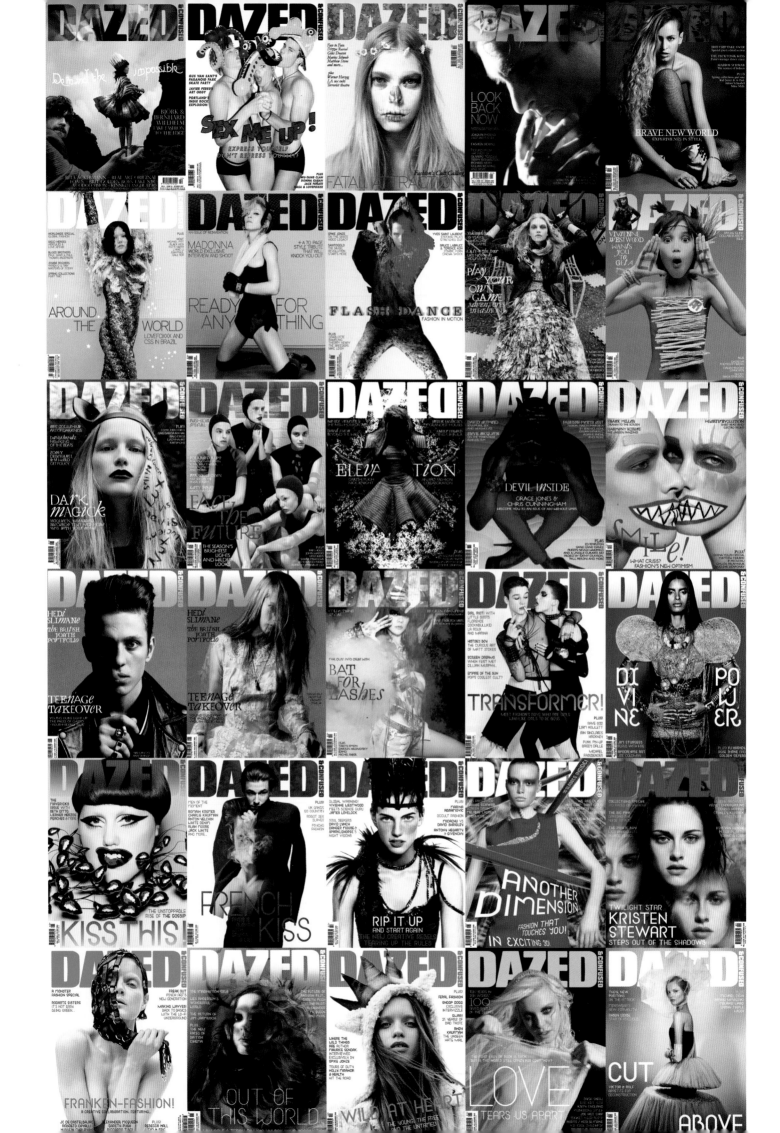

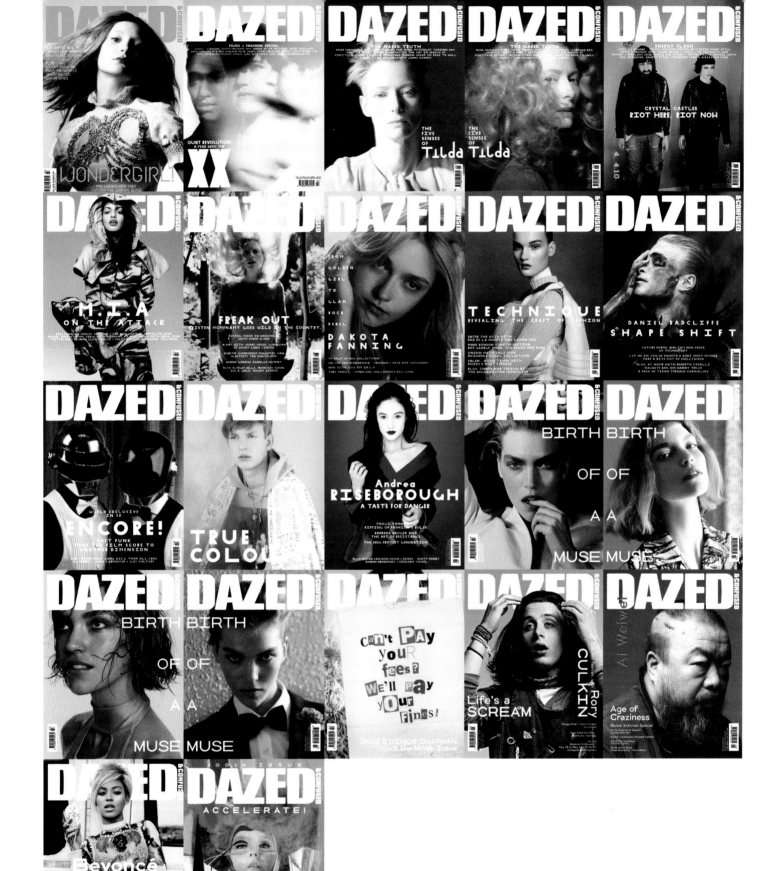

CONTRIBUTORS TO THE BOOK

Theo Adams, Air, John Akehurst, Mert Alas, Rachel Alexander, Muhammad Ali, All Saints, Tori Amos, Celine van Amstel, May Anderson, Wes Anderson, Naveen Andrews, Maurizio Anzeri, Asia Argento, Katherine Arnold, Richard Ashcroft, Attica Blues, Anette Aurell, Paul Auster, Howie B, Delfine Bafort, David Bailey, Carl Barât, Frances Barber, Neil Barnes, Matthew Barney, Laurie Bartley, Bat for Lashes, Stacey Battat, Beastie Boys, Danny Beauchamp, Beck, Josh Beech, Robyn Beeche, Małgosia Bela, Liz Bellamy, Ola Bergengren, Glen Berry, Beyoncé, Sita Bhuller, Ana Bi, Jane Birkin, Björk, Peter Blake, Brenda Blethyn, Bloc Party, Blondie, Blur, Aldo Bonasias, David Bowie, Sue Bramley, Ewen Bremer, Jodi Broadhurst, Adam Broomberg, Gavin Brown, Marko Brozic, Cedric Buchet, Arjen Buitelaar, Richard Burbridge, Kathy Burke, Jeff Burton, Richard Bush, Kenneth Cappello, Jim Carter, Katrin Cartlidge, Robert Carlyle, Jim Cartwright, Cassius, Hector Castro, Georgina Cates, Hussein Chalayan, Dean Chalkley, Oliver Chanarin, Jake & Dinos Chapman, Neneh Cherry, Anna Chisholm, Kristina Chrastekova, Helena Christensen, Donald Christie, Larry Clark, Michael Clark, Michael Cleary, George Clinton, Harriet Close, Sarah Cobb, Lily Cole, Charlotte Coleman, Jenna Collins, Liz Collins, Dennis Cooper, Georgina Cooper, Sofia Coppola, Katie Corner, Quentin Crisp, Élise Crombez, Crystal Castles, Mark Croall, Rory Culkin, Ian Cumming, Eliza Cummings, Chris Cunningham, Ryan Curry, Daft Punk, The Dandy Warhols, Ben Daniels, Phil Daniels, Philip Davis, Corinne Day, Luke Day, Gaby Dean, Pierre Debusscherre, Dego 4hero, Alice Dellal, Kevin Deredec, Zooey Deschanel, Agyness Deyn, Horst Diekgerdes, John Dietrich, Beth Ditto, Diana Dondoe, Minnie Driver, Kirsten Dunst, Clare Durkin, Denisa Dvoráková, Ms. Dynamite, Tony Edwards, Sasha Eisenman, Donna Elastica, Claire Elliott, Missy Elliott, Sean Ellis, Gordon Elwood, Karen Elson, Eminem, Roe Ethridge, Michael Evanet, Angus Fairhurst, Dakota Fanning, Fellina – TV is Boring, Bryan Ferry, Mike Figgis, Martha Fiennes, James Fox, Jamie Foxx, James Frain, Franz Ferdinand, Edward Ferguson, Jenna Fischer, Anne Fletcher, Chris Floyd, Tom Fowlks, Magdalena Frackowiak, Seb Franklin, Laura Fraser, Mat Fraser, Stephen Frears, Sandra Freij, Carmen Freudenthal, Sadie Frost, Charlotte Gainsbourg, Gael García Bernal, Tierney Gearon, Andrea Giacobbe, Louise Gibb, Aiden Gillen, Bobby Gillespie, Terry Gilliam, Goldie, Kim Gordon, Gorillaz, Richard E. Grant, Eva Green, Peter Greenaway, Dave Grohl, Kate Groombridge, Gayle Gunawardena, Tim Gutt, Jake Gyllenhaal, Maggie Gyllenhaal, Julia Hafstrom, Courtney Hamilton, Sharif Hamza, Michael Haneke, Kate Hardie, Shalom Harlow, Jared Harris, Ian Hart, PJ Harvey, Alexei Hay, Salma Hayek, Jamie Hawkesworth, Shona Heath, Jamie Hewlett, Natasha Hibbitt, Michele Hicks, Damien Hirst, Danny Hole, Barry J. Holmes, Matt Holyoak, Martina Hoogland Ivanow, John Lee Hooker, Philippa Horan, Martine Houghton, Kate Howerd, David Hughes, Pipsa Hurmerinta, Benjamin Alexander Huseby, Matt Irwin, Daniel Jackson, Sir Derek Jacobi, Cameron Jamie, Jamiel, Jim Jarmusch, Marianne Jean-Baptiste, Eric Johnson, Grace Jones, Kim Jones, Michael Thomas Jones, Nick T. Jones, Milla Jovovich, Tibor Kalman, Abdulai Kamara, Nadav Kander, Kacper Kasprzyk, Kelis, Patsy Kensit, Alicia Keys, The Kills, Kings of Leon, Catherine Long, Steven Klein, Francesca Knowles, Hannelore Knuts, Nick Knight, Suvi Koponen, Harmony Korine, Marcelo Krasilcic, Doutzen Kroes, Barbara Kruger, Christina Kruse, Hanif Kureishi, Lacey, Dalai Lama, Lamb, Inez van Lamsweerde, Alison Lapper, Lisa Lauwaert, James Lavelle, Jude Law, Phyllida Law, Serge Leblon, Abbey Lee, Juliette Lewis, Angela Lindvall, Dana Lixenberg, Brett Lloyd, Lyle Lodwick, Catharine Long, Sue Loosley, Bruce Louden, Courtney Love, Lovefoxxx, James Lovelock, Simon Low, Sarah Lucas,

Glen Luchford, Hettie Macdonald, Kelly Macdonald, Steven Mackintosh, Victoire Maçon-Dauxerre, Goshka Macuga, Madonna, Jena Malone, Manic Street Preachers, Taryn Manning, Marilyn Manson, Tony Marchant, Ari Marcopoulos, Heather Marks, Jon Martin, Thoko Masilela, Massive Attack, Vinoodh Matadin, Paul McCarthy, Barry McGee, Ewan McGregor, Helen McIntosh, Malcolm McLaren, Alasdair McLellan, Kristen McMenamy, Alexander McQueen, Baader Meinhof, Lakshmi Menon, M.I.A, Helen Mirren, Moloko, Thurston Moore, Morcheeba, Laura Morgan, Emily Mortimer, Samantha Morton, Kate Moss, Aimee Mullins, Cillian Murphy, Arizona Muse, Navi (Michael Jackson lookalike) Billy Name, Eric Nehr, Beryl Nesbitt, Helmut Newton, Thandie Newton, Jason Nocito, Niall O'Brien, Erin O'Connor, Kristy O'Connor, Will Oldham, Josh Olins, Lucy Orta, Beth Orton, Mel Ottenberg, Anna Paquin, Alan Parker, Andrea Parker, Martin Parr, Ellis Parrinder, Laurence Passera, Jo Paul, Pavement, Sarah Penman, Mr Perou, Sean Pertwee, Vincent Peters, Joaquin Pheonix, Marcus Piggott, Mark Pillai, Michael Pitt, Jonny Phillips, Iggy Pop, Parker Posey, Phil Poynter, Carl Prechezer, Warren du Preez, Marcole Price, Richard Prince, Astrid Proll, Yannis Psomas, Gareth Pugh, Pulp, Kirsi Pyrhonen, Finley Quaye, Marc Quinn, Daniel Radcliffe, Katja Rahlwes, Mark Ramos-Nishita, Charlotte Rampling, Rankin, Lisa Ratliffe, Frankie Rayder, Red Hot Chilli Peppers, Lou Reed, Dusan Reljin, Alison Renner, Miguel Reveriego, Hilary Rhoda, Zandra Rhodes, Keith Richards, Miranda Richardson, Terry Richardson, Alan Rickman, Jeff Riedel, Felicity Rigway, Philip Ridley, Andrea Riseborough, Maggie Rizer, Linus Roache, Miranda Robson, Iain Robertson, Bruce Robinson, Coco Rocha, Sam Rockwell, Nicolas Roeg, Lee Ross, Liberty Ross, Rick Rubin, Helena Saddler, Ludivine Sagnier, Yves Saint Laurent, Peter Salmi, Hanna Samokhina, Daniel Sannwald, Vivien Sassen, Greta Scacchi, Lina Scheynius, Norbert Schoerner, Collier Schorr, Sabina Schreder, Ingrid Schroeder, Jason Schwartzman, Venetia Scott, Scottee Scottee, Guinevere van Seenus, Mark Segal, Shea Seger, Dirk Seiden Schwan, Lisa Seiffert, William Selden, Chloë Sevigny, David Benjamin Sherry, Marc Shoul, Maurits Sillem, Valerie Sipp, Taryn Simon, Louis Simonon, David Sims, David Slijper, Hedi Slimane, Luke Smalley, Rupert Smythe, Sneaker Pimps, Jenny van Sommers, Susan Sontag, Hana Soukupová, Spacehog, Kendra Spears, Sharleen Spiteri, Gino Sprio, Nick Stahl, Jennifer Stanley, Ann Stansell, Harry Dean Stanton, Zora Star, Imelda Staunton, Kristen Stewart, Michael Stipe, Charlotte Stockdale, Karlheinz Stockhausen, Charles Sturridge, Ash Stymest, Sara Sugarman, Sølve Sundsbø, Emma Sullivan, Paulo Sutch, Hilary Swank, Archie Swinburn, Tilda Swinton, Ice-T, Edine Talti, Sam Talti, Chycca Tatsumi, Lili Taylor, Sam Taylor-Wood, Juergen Teller, Ed Templeton, Alexis Marguerite Teplin, David Thewlis, Dan Thomas, Mike Thomas, Paula Thomas, Hunter S. Thompson, Katrin Thormann, Wolfgang Tillmans, Justin Timberlake, Gilles Toledano, Ben Toms, David Toole, Oliviero Toscani, Toyin, Tricky, Donna Trope, George Tsonev, Eddie Tucker, Jimmy Turrell, Desmond Tutu, U2, Nikki Uberti, Gaspard Ulliel, Magnus Unnar, Richard Varnden, Alan Vega, Elle Verhagen, Julie Verhoeven, The Verve, Miranda Vicente, Mariano Vivanco, Nataša Vojnovic, Jackie Volker, Erika Wall, Andy Warhol, Mia Wasikowska, John Waters, Emily Watson, Gillian Wearing, Emma Webb, Jack Webb, Aline Weber, Ai Weiwei, Irvine Welsh, Dominic West, Jonathan West, Kanye West, Daniella Westbrook, Justin Westover, Vivienne Westwood, Paul Wetherell, Vicky Wetherill, The White Stripes, Sarah Wietzel, Pharrell Williams, Jane Wilson, Louise Wilson, Chloe Wilton, Kate Winslet, Ray Winstone, Luke Worrall, Kaja Wunder, The XX, Yeah Yeah Yeahs, Yohji Yamamoto, Yelena Yemchuk, Thom Yorke, Gao Yuan, Kirk Zammit

DAZED & CONFUSED

Nick Abrahams, Elizabeth Alker, Alastair Allan, Vanessa Altman-Siegal, Rachael Ames, Dan Annett, Faye Anthony, Mark Anthony, Iphgenia Baal, Catherine Baba, Suzie Babchick, Darren Bailey, Daron Bailey, James Baker, Sandra Barron, Steven Barron, Laurie Bartley, Luella Bartley, Abby Bennett, Ned Beauman, Hughes Behrendt, Agata Belcen, Martin Bell, Alex Betts, Phil Bicker, Phil Bickingham, Camille Bidault-Waddington, Nicki Bidder, Marc Bird, Dan Blackledge, Joe Blanchard, Emma Blau, Alixe Boardman, Abi Bowman, Tal Brener, Sarah Broom, Phil Buckingham, Sara Burn, Abi Burnton, Jodie Byrne, David Calhoun, Chris Campion, Jessie Cape, Hayley Caradoc-Hodgkins, Elizabeth Cardwell, Claire Carnegie, Ed Cartwright, Darren Carty, Alex Cassel, Hector Castro, Thomas Changeur, Michelle Chardin, Andrew Chidgey, Paola Cimmino, Scott Robert Clark, Cath Clarke, Grace Cobb, Sarah Cobb, Sally Coe, Aimee Coles, John Colver, Alisa Connan, Pia Constenius, Fiona Cook, Celestine Cooney, David Corbett, Poppy Corby-Tuech, Hassana Cornelius, Trevor de Cotta, Nicki Cotter, Ian Crawford, Elissa Cray, Phil Crean, Melanie Crété, Dean Curtis, Neil Dawson, Tevi de la Torre, Betty Demonte, Abi Dillon, Pamela Doherty, Jon Duckett, Jessie Economakis, Cathy Edwards, Nicole Elias, Rebecca Eling, Emma Ellwood-Russell, Katy England, Gareth Evans, Justine Fairgreave, Sarah Fakray, Shelley Fannell, Sylvia Farago,Gavin Fernandez, Lara Ferros, Steve Fisher, Tim Fleming, Chris Flloyd, Simon Fly, Paul Flynn, Paul Flyns, Luke Ford, Lauren Ford, Michael Fordham, Nicola Formichetti, Emma E. Forrest, Nina Fourie, Jermaine Francis, Elizabeth Fraser-Bell, Tim Freeman, Pauline Gaiger, Emma Gammon, Andrew Gardner-Williams, Francesca Gavin, Mhairi Gibb, Andy Gillette, Sean Glynn, Lisa Godwin, Karen Goss, Katie Grand, Johnny Greig, Gareth Grundy, Jefferson Hack, Julia Hackel, Nick Hackworth, Cheyne Hall, Louise Hall-Strutt, Sarah Hamilton, Courtney Hamilton, Stuart Hammond, Matt Hanson, Marlene Harris, Paul Harris, Chris Hatherill, Hayley Hatton, Laura Havlin, Sarah Hay, Matthew Hayman, Shona Heath, David Hellqvist, Sasha Hinchfield, Tatsuo Hino, Sasha Hirschfeld, Erin Hirsh, Phil Hoad, Guy Holden, Michael Holden, Matt Holyoak, Alicia Hood, Amy Hoskins, Nick Howells, Kim Howells, Jessica Hundley, Hannah Hunter, Caitlin Hume, Tabya Hussein, Wendy Ide, Matt Irwin, Guy Isherwood, Samantha Jackson, Sophie Jackson, Emily James, David St. John-James, Rachel Johnson, Kim Jones, Claire Jones, Matt Jones, Paul Joseph, Geetha Joseph, Jason Jules, Lauren Juska, Martis Justesen, Rasha Kahil, Deep Kaily, Nelma Kalonji, Mattias Karlsson, Liam Kelly, Alexander Key, Imran Khan, Andrew King, Sam Knapp, Phil Knot, Gemma Knox, Johanna Lacey, Hannah Lack, Caroline Lambie, Karen Langley, Susannah Lau, Cynthia Lawrence-John, Kristen Lazaric, Damian Lazarus, Ronny Leach, Suzie Lechtenberg, Stephen Ledger-Lomas,

Marcel Lelienhof, Caroline Lever, Joel Lewis, Christopher Lockwood, Katy Louis, Chico Lowndes, Rebecca Lowthorpe, Thanh Ma, Alasdair MacGregor, Carmen MacKenzie, Alister Mackie, David Manders, Colin Martin, Lilli Maunuula, Katja Mayer, Ginny McAllister, Simon McAuslane, Craig McCarthy, John McCarty, Jamie McCartney, Callum McCullough, John McFarlane, Callum McGeoch, Paul McGuinness, Salma McHugh, Bryan McMahon, Alexander McQueen, Anna McQueen, Tasha Meradji, Ali Mobasser, Stephen Monaghan, Kate Monro, Rob Montgomery, Sara Moonves, Eleanor Morgan, Jon Morgan, Becki Morris, Conran Morrison, Benjamin Moulder, Samantha Murray-Greenway, Rachel Newsome, Tracey Nicholson,Tim Noakes, Jeremie Nuel, Christina Nunziata, Artour Oganissian, Alexandra Olenska, Deirdre O'Callaghan, Charlotte O'Malley, Harriet Orman, Karen Orten, Joseph Ortenzi, Sarko Orzki, Sam O'Shaughnessy, Tara O'Shea, Mel Ottenberg, Lottie Ould, Briar Pacey, Shelley Palmer, Usha Panchal, Rémi Paringaux, Hetal Patel, Russel Pegrum, Daren Peter Ellis, Celia Peterson, Soula Petrou, Greta Pistaceci, George Plainter, Charlie Post,Alex Poulson, Phil Poynter, Marcole Price, Caroline Prothero, John-Paul Pryor, Myles Quin, Jo Radcliffe, Katja Rahlwes, Lee Ramsay, Rankin, Becky Rawlinson, Alex Rayner, Peter Rayner, Ben Reardon, Monica Rebella, Emma Reeves, Simon Renaud, Helen Rhodes, Rickie Richardson, Calum Richardson, Charlotte Rickwood, Conrad Rivers, Matt Roach, Simon Robins, Miranda Robson, Nancy Rohde, Shari Roman, Michael Rook, Dan Ross, Vanessa Rubio, Stephanie Rushton, Jo Russell, Simon Russell, Mat Ryalls, Chris Ryan, Joanna Sadowska, Sadia Salam, Steve Salter, Francisco Salvadore Weiss, Mark Sanders, Johnny Sapong, Steven Savigear, Joanna Schlenzka,Kate Sclater, Cath Scott, Emily Scott, Priya Sehgal, Milena Selkirk, Alix Sharkey, Andy Shepherd, Skye Sherwin, Katie Shillingford, Akiko Shishido, Steven von Shultzler, Luke Shumard, Christopher Simmonds, Tabitha Simmons, Nina Singer, Ben Singleton, Jenny Slapper, Natalie Smith, Rupert Smyth, Wendy Smyth, Stuart Spalding, Robbie Spencer, Luke Spice, Rod Stanley, Carl Stanley, Peter Stitson, Courtney Stockdale, Lee Swillingham, Hayden Syers, Nobuko Tannawa, Roger Tatley, Nik Taylor, Ian C. Taylor, Kristin Taylor-Wood, Esther Teichmann, Errol Thomas, Henrietta Thompson, Clarke Tolton, Ben Toms, Anna Trevelyan, Issy Virden, Sam Voltage, Susanne Waddell, Genevieve Waites, Andre Walker, Alison Walker, Ben Walker, Gary Wallis, Nadya Wasylko, Nancy Waters, Adrian Webb, Rowena Webber, Kirsti Weir, James West, Stephen White, Stuart White, Moses Wiener, Adrian William, Greg Williams, Rob Willingham, James Willis, Nicky Wise, Flora Wong, Suzy Wood, Stuart Wright, Agata Wycichowska, Emma Wyman, Charlotte Young, Victoria Young

Making It Up As We Go Along

Edited by
Jefferson Hack, Jo-Ann Furniss

With foreword by
Ingrid Sischy

Additional text & editing by
Susannah Frankel,
John-Paul Pryor, Lotte Ould

Produced by
Genevieve Waites, Felicity Shaw,
Steve Savigear, Steven Barron,
Zoe Maughan, Fiona Cook

Art Direction by Simmonds Ltd
Senior Designer Alex O'Brien

Reprographics by
Imaging MM Ltd

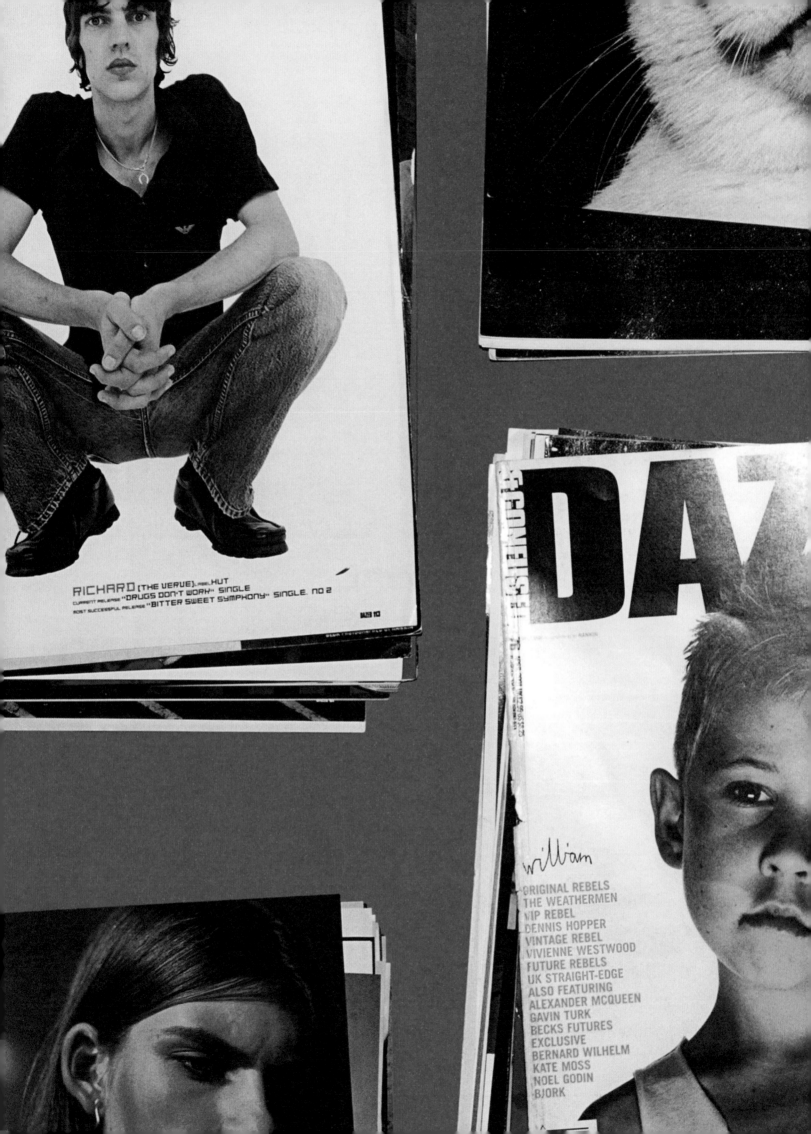

RICHARD [THE VERVE] LABEL HUT
CURRENT RELEASE "DRUGS DON'T WORK" SINGLE
MOST SUCCESSFUL RELEASE "BITTER SWEET SYMPHONY" SINGLE. NO 2

DAZE

william

ORIGINAL REBELS
THE WEATHERMEN
VIP REBEL
DENNIS HOPPER
VINTAGE REBEL
VIVIENNE WESTWOOD
FUTURE REBELS
UK STRAIGHT-EDGE
ALSO FEATURING
ALEXANDER MCQUEEN
GAVIN TURK
BECKS FUTURES
EXCLUSIVE
BERNARD WILHELM
KATE MOSS
NOEL GODIN
BJORK